Imagery in the 21st Century

Imagery in the 21st Century

edited by Oliver Grau
with Thomas Veigl

The MIT Press
Cambridge, Massachusetts
London, England

Supported by the State of Lower Austria (Land Niederösterreich, Austria)

For information about special quantity discounts, please email special_sales@mitpress.mit.edu

This book was set in Stone Sans and Stone Serif by Toppan Best-set Premedia Limited. Printed and bound in the United States of America.

Library of Congress Cataloging-in-Publication Data

Imagery in the 21st century / edited by Oliver Grau with Thomas Veigl.
 p. cm.
Includes bibliographical references and index.
ISBN 978-0-262-01572-1 (hardcover : alk. paper)
1. New media art. 2. Visual sociology. I. Grau, Oliver. II. Veigl, Thomas. III. Title: Imagery in the twenty-first century.
NX460.5.N49I43 2011
302.23—dc22
 2010046314

10 9 8 7 6 5 4 3 2 1

Contents

1 Introduction: Imagery in the 21st Century

Oliver Grau and Thomas Veigl

Never before has the world of images changed so fast; never before have we been exposed to so many different image forms; and never before has the way images are produced transformed so drastically. Images are advancing into new domains: private platforms, like Flickr with its billions of uploads or Facebook with several hundred million members, have become very powerful tools (figure 1.1, plate 1). Second Life, micromovies, or vj-ing are keywords for a ubiquitous use of images. Television is now a global field of thousands of channels (figure 1.2, plate 2); projection screens have entered our cities (figure 1.3, plate 3); a hundred thousand and one new videos are published every day, in video communities like YouTube and the interactive three-dimensional world of images: a virtual and seemingly authentic parallel universe is expanding. This book offers systematic and interdisciplinary reflections on new forms of images and visualization. The historical development of images, between innovation, reflection, and iconoclasm, is reaching a new level of global complexity in the twenty-first century. These transformations have hit a society that is to a large extent unprepared. Nevertheless, we have to recognize that we will not be able to handle the knowledge explosion of our time without further development of new forms of visualization and "orders of visibility." Digital images have become ubiquitous tools within the global reorganization of labor.

Through digital images, the old dream of talking architecture receives new impetus and an entire new arsenal of options. We are witnessing the rise of the image as a virtual, spatial image—images that appear capable of changing interactively or even "autonomously" and formulating a lifelike, all-embracing audiovisual and sensory sphere where temporal and spatial parameters can be altered at will. Traveling through time in 3D images, ART+COM (figure 1.4, plate 4) allows us to dive into deepening layers of historic sights, while Google Earth (figure 1.5) opens up Earth's spaces to our eyes to an unprecedented degree (figure 1.6, plate 5).

The digital image represents endless options for manipulation. These options also become available for political iconography, which has a long tradition within art history but has only recently been discovered by political scientists. In addition,

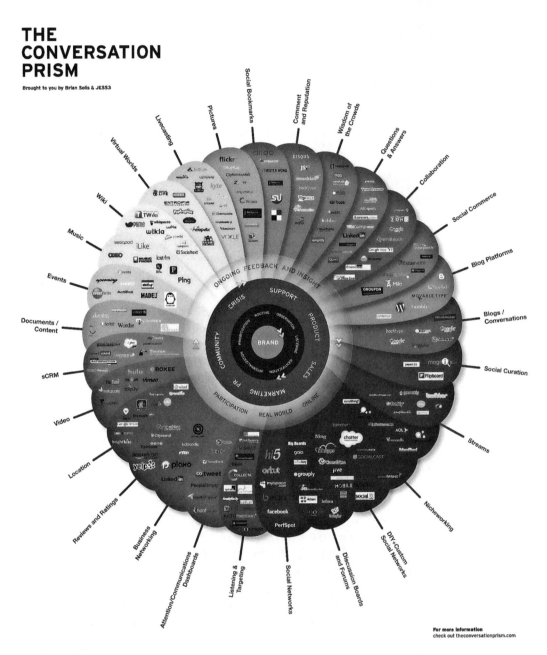

Figure 1.1
The Conversation Prism, <http://www.theconversationprism.com>, Creative Commons. See plate 1.

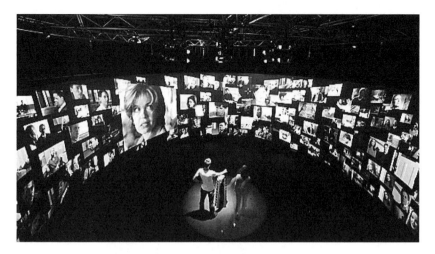

Figure 1.2

T_visionarium. By kind permission of Jeffrey Shaw, <http://www.icinema.unsw.edu.au/projects/prj_tvis_II.html>. See plate 2.

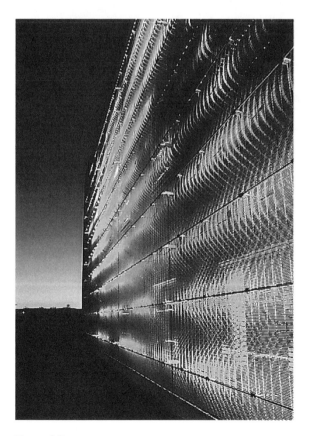

Figure 1.3

Atelier Torce 2007/2009—*Illumesh*, <http://www.medienfassade.com>. See plate 3.

Figure 1.4
Traveling through time in 3D images. By kind permission of ART+COM, <http://www.artcom .de>. See plate 4.

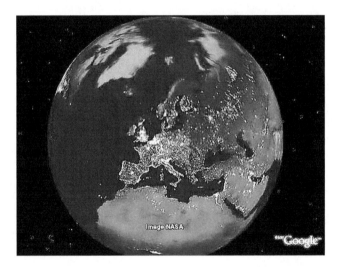

Figure 1.5
Google Earth.

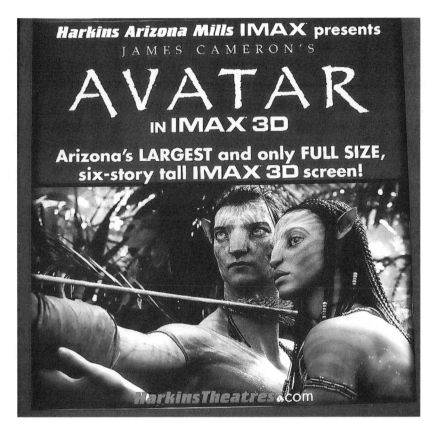

Figure 1.6
Promotion for *Avatar*, James Cameron (dir.), 2009. See plate 5.

science, politics, and entertainment all profit from new dimensions in the creation of images and their emotive effects (figure 1.7).

These new worlds of the image are creating democratic opportunities and risks, which require sensitive handling and expanded archiving projects; historians of science understand that images in the natural sciences are not only empirical instruments, they are keystones in the creation of knowledge and the "order of things"— to use a Foucaultian term. Images can certainly become instruments of political hegemony; one only has to think of the manipulative use of satellite images to legitimize the Second Iraq War, which were submitted to the U.N. Security Council by the United States. Critical image science has the goal of unmasking such politically motivated visualization strategies, of exposing manipulative image politics, and of shaking the widespread naive faith in the truth of supposedly objective documentary pictures.

Figure 1.7
Department for Image Science in Goettweig, <http://www.flashearth.com/?lat=48.365923&lon =15.612105&z=18.3&r=331&src=msl>.

Historians understand images no longer as illustrations, but as historic documents *sui generis*. Mathematics is fascinated by the beauty of visualized algorithms and their unpredictable chaotic forms (figure 1.8, plate 6), while astrophysicists and nanoscientists receive images out of the depths of the macro-cosmos and the micro-cosmos, respectively. Without massive developments to visualize complex ideas, structures, and systems, the explosion of knowledge we face today is not manageable. This process is inciting vital discussions about images in many disciplines. Images increasingly define our world and our everyday life: in advertising, entertainment, politics, and even in science, images are pushing themselves in front of language. The mass media, in particular, engulf our senses on a daily basis. It would appear that images have won the contest with words: Will the image have the last word (figure 1.9, plate 7)?

We face great difficulties in synthesizing the broad field of the visual: what images are and what they do, how they function and what effects they have—even the concept of the image cannot be clarified by an ontological or elementary definition.

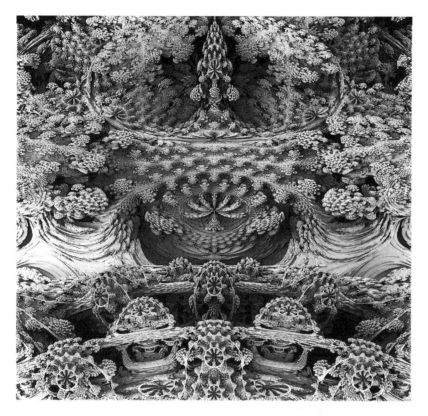

Figure 1.8
Daniel White, *Mandelbulb 3D*, 2009, <http://www.skytopia.com/project/fractal/mandelbulb
.html>. See plate 6.

Images cannot be reduced to a specific technology (gravure printing or X-ray), to genres (portrait or silhouette), to practices (taking photographs or programming), to specific instruments or devices (pencil or microscope), to symbolic forms (perspectives), to a social function (edification or diagnosis), to materiality or symbolism—and yet images operate in all of these. To manage the veritable deluge of images, a competence in images is vital, but this is lacking in our culture that is still dominated by writing. Illiteracy has largely been overcome in most countries, but aniconism—the inability to interpret images adequately—until very recently has not even been a matter of public concern.

Thus, a systematic ordering is indispensable for understanding the new image phenomena. It has been recognized that the study of networks and the study of visualizations of these networks complement each other, much in the same way that

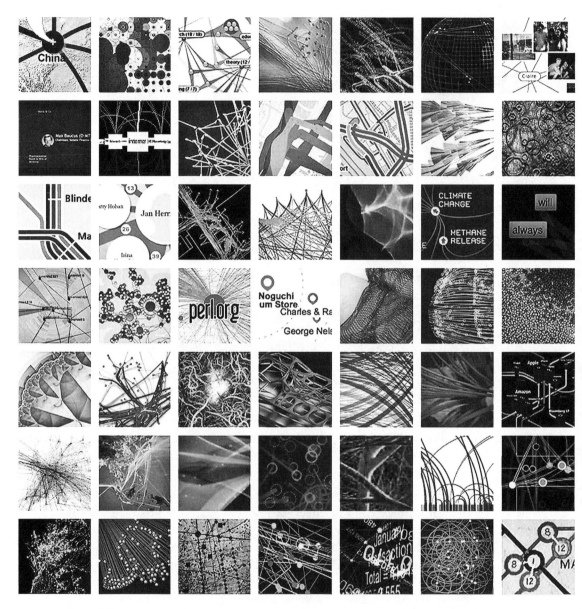

Figure 1.9
For insight in the increasing variety of different visualization methods across the disciplines, see
<http://www.visualcomplexity.com>. By kind permission of Manuel Lima. See plate 7.

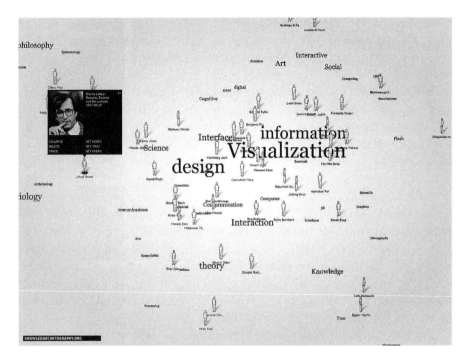

Figure 1.10
Knowledge Cartography, <http://www.knowledgecartography.org>.

archaeology cannot live without self-reflective art history; so to systematize our visualization methods, we must engage in complex network studies (figure 1.10). Recently, the High Throughput Humanities conference in Portugal[2] and the NETSCI 2010 conference in Boston[3] concentrated on this subject area.

Moreover, numerous projects have emerged on the categorization and analysis of visualizations methods. Gerd Dirmoser's great studies on diagrammatics, for example, the monumental diagram *Performance Art Context*, which shows the manifold network of artists, authors, institutions, and galleries; Lev Manovich's *Cultural Analytics*; Christa Sommerer's *Netlife*; and Jeffrey Shaw's *T-Visionarium* have to be mentioned here, to name just a few. Another pioneer project, *Many Eyes*,[4] is a public Web project allowing users to gather and visualize data, and then discuss their visualizations. The platform tests the hypotheses that visualizations spur communication and social interaction and asks how these activities may yield new insights into data.

There is also some research being done in connection with the term "visual literacy": some educators are recognizing the importance of helping students to develop visual literacy in order to survive and communicate in a highly complex world.[5] However, the ongoing image revolution requires that all of us have the ability to

engage with images and the opportunity of continuing our image education. The concept of life-long learning (LLL) provides an adequate response to the fact that, in increasingly shorter spans of time, our knowledge loses its power and impact once we leave school or university. While our written culture has produced a differentiated and dedicated pedagogy, our society still lacks educational programs dedicated to understanding images—to a degree where we can even speak of visual illiteracy. A further central problem of current cultural policy stems from the serious lack of knowledge about the origins of audiovisual media. This stands in complete contradistinction to current demands for more media and image competence.

The multitude of new possibilities in producing, projecting, and distributing images has led to the formation of new image genres. The spiral movement of image history from innovation, understanding, and iconoclasm has resulted in the twenty-first century in a globally interwoven fabric. In an age where many people are skilled in using graphics and image-editing software, making home videos, and creating websites, we are now dealing with consumers and producers of visual culture. Former recipients of cultural products have become actors who extract their own meanings from what they see. This volume seeks to trace what seeing means on a social level, both in the arts and the worlds of popular images. Answers are sought to essential questions such as: What inspiration do these new worlds of images gain from art and/ or science? What influence does the given medium have on the iconic character of the image? What opportunities and challenges do image dealers and museums face given the "liquidity" of the image? This volume, whose incubation began during the international conference "Gazing into the 21st Century,"[6] analyzes new image phenomena, such as machinima, collectively made videos, the images of bio art and the life sciences, and the scientific image in neurobiology and various other disciplines, and discusses new critical terms like the Web 2.0 revolution, interface, software, cute engineering, database economy, new strategies to create emotional image worlds, the dramaturgy of hypermedia, and more. The book offers systematic discussion and critical scholarly reflection by some of the most influential researchers in the field of the inventory, classification, and historiography of the latest image worlds in the domains of publicity, art, entertainment, and science.

In general we must ask ourselves whether the power of the image will supersede our current ability and quality of reflection, or if new worlds of images will enable new support for the development of human consciousness. We are looking for more and more deeply understood, competent, and useful definitions of image phenomena. Finally, the volume examines new tools for image research in the early twenty-first century, as well as their potential in view of the need for scientific tools to deal adequately with the questions that challenge the humanities now and in the coming decades; tools not only for research, but also for museums, universities, and schools. The goal is to offer detailed discussions of image phenomena and landmarks to expand

visual competence concerning new image worlds and also to build cross-disciplinary exchanges between the humanities, arts, and natural sciences.

The individual chapters do not merely stand alone but also refer to each other. Ideas and models reappear viewed from different perspectives. The book should thus be understood as a collaborative text, where each contribution is a coherent discussion of a particular theme, yet in combination with the others represents a collection that is more than the sum of its parts.

Although in many instances "visualization" means the use of imaging techniques to gain cognitive knowledge, it has another definition that is more precarious: visualization as the translation of the invisible into the visible. This could be the trigger for "iconoclastic panic,"[7] for even in technological and scientific imaging the resulting images are not entirely reliable. Confusion tends to arise in connection with the character of the images' construction, through interpretative distortions or even considerations of aesthetic design. Yet here the illusion of accessibility, of seeming presence, can practice an easy deception. Competence in image analysis is needed more than ever before. This can be facilitated by the realization that visualizations—as Hans Belting most importantly differentiates between the "visual" and the "visible"—operate with technological adjustments.

I Image Phenomena of the 21st Century

The first section of the book introduces the subject, discussing new image phenomena that recently emerged in art, popular culture, and science. The contributions showcase various new visual technologies, their background of emergence, as well as their social and cultural impact. Along with visualizations from art, computer games, screen technologies, television, and online video platforms, particular attention is paid to life sciences such as medicine and neuroscience.

Opening the discussion with contemporary screens, Sean Cubitt deals with the relationship between technologies and the public life of citizens and consumers. He explores the *database economy*, where screens are normative technologies that shape and articulate social structure and, in this way, are the central tool of management of markets and populations. From this Cubitt deduces the necessity to observe media through examining the social organization in which they emerge.

Martin Schulz uses examples from Michael Moore's *Fahrenheit 9/11* to highlight the connection between face, mask, image, and medium with regard to *telepresent* images. From the fact that every instance of pictorial representation is followed by a chain of prescriptions, Schulz argues that images are both subsequent and antecedent at the same time. This anachronic imagery principle of masking demonstrates that modes of representation persist in new electronic media that have a much older history.

In science, the image has become an independent tool of thought. Images count as arguments and proofs; they document and project, model and simulate, show things visible and invisible. The Nobel Prize in chemistry rewarding the initial discovery and later important developments of green fluorescent protein, GFP, was only awarded in 2008. Art, however, had made this a theme years before: The artist Eduardo Kac created a transgenic green fluorescent rabbit by inserting the DNA sequence of a Pacific jellyfish with GFP into the rabbit's DNA. Kac, who pioneered telecommunications art back in the 1980s, now more than ten years later explores and experiments with the exploitation of genetic engineering technologies for creating new artistic visualizations. His exhibitions of bio- and transgenic art, which address key questions of our times that have emerged from the life sciences, have social ramifications and have provoked heavy public debate. Stressing the necessity of respect and care for the living organisms created, in his chapter Kac points out milestones and the current status of these developments. Here the step-wise shifts of ethically discussed boundaries are especially apparent.

It is well known that in just a few years the gaming sector has overtaken the film sector in terms of economic performance and has also created a large number of new genres. Discussing the historic development and current status of machinima, Thomas Veigl shows how social and cultural change, evoked by unanticipated user interaction with computer games, is occurring in our new media environment. With examples of economically exploitable forms, which have provoked legal reverberations, Veigl argues that machinima has to be seen as an emancipatory new visual media technology that has far-reaching consequences for the future of computer games, legal questions of copyright, and established production techniques of computer animation, as well.

Expanding video theory of recent years, Stefan Heidenreich offers an approach for explaining the emergence of a future Web-based video aesthetic. With reference to existing platforms such as Flickr, YouTube, or Online Games, Heidenreich argues that the increased variety of videos produced on the Web, such as videowikis or videoblogs, are currently being reshaped and will ultimately emerge in a new dominant form. Depending on the given conditions of our ecosystem the dominant form consolidates and sets the general conditions for the crucial parameters of time and authorship, which are decisive for the aesthetic form.

Discussion is just beginning in the natural sciences about the role of new imaging techniques, although the theoretical and practical instruments for their analysis is lacking and in science education images are absent from the curriculum, in spite of the fact that in the meantime they have become perhaps the most important tool of communication. It is significant that the two most important science journals, *Nature* and *Science*, have begun to engage with images, and between the lines mention is often made now of the "art of science." However, so far the natural sciences appear

to be unwilling to subject their basic tenets, which over the course of history have undergone dramatic changes, to rigorous scrutiny, as the current debate about brain research demonstrates. Although doubts are now surfacing in this discipline about the veracity of their new image worlds, images are still being utilized as arguments, while the extremely artificial conditions under which the images are generated are hardly analyzed at all. Whereas the scientific images produced by Leonardo or Dürer were drawings that were as accurate as possible, today in medicine, for example, practitioners readily admit or even flaunt the fact that the massive and increasingly "designed" use of images is common practice today when applying for research funds. Thus, it is hardly surprising that more and more "science images" are being processed by advertising agencies: They create images that look like scientific images, which then replace the originals. The same phenomenon can be observed in connection with images from nanotechnology.

Today the life sciences rely heavily on images to demonstrate the performance of models that otherwise could hardly be communicated or even thought of. New visualization techniques are needed; they are being produced as well as analyzed. In the area of neuroscience, Olaf Breidbach illustrates the necessity to overcome adaptations to former visual schemata to develop an alternative theory of brain functionality. For Breidbach a skin-deep examination of the visual is lacking; he asks: How can models be used as tools to put forward certain hypotheses? Can they be ascribed a certain heuristic value? How can we think in pictures, without taking them to be the reality we use them to argue about? To select the right way of visualizing, Breidbach demonstrates a kind of experimental approach to using new types of pictures, model machines, and performances.

Resulting from their practical experience as medical scientists and developers of sophisticated tools for visualizing blood flow, Dolores and David Steinman provide first-hand insights into the challenges that medical text illustrators have confronted over the centuries: the integration of scientific truth, aesthetic trends, and established scientific and medical conventions. Like the bloodstream's dynamics, organic processes elude the human view, which makes computer-aided imaging techniques indispensable for timely diagnosis and therapy. The absence of a predefined visual vocabulary makes it a necessity to develop both the medical technology and its novel visual conventions.

As an important representative of the American image science community, James Elkins provides an interdisciplinary overview and classification of scientific visualizations, showing the diversity in function and form of imaging practices. Based on the commonplace that ours is a visual culture and that learning today is increasingly done through images, Elkins argues for university-wide courses of image use to take up this challenge and develop a more unified practice.

II Critical Terms of the 21st Century

The character of current images underwent radical changes in recent years. To discuss images at the beginning of the twenty-first century, we need a critical conception that reflects these changes to our theoretical foundations. The book's second section therefore deals with examinations of significant aspects of computer-generated images, user interfaces, and emotive effects, as well as presentation and distribution of images.

With a critical view of new media studies moving in the direction of software studies, Wendy Hui Kyong Chun argues against theoretical conceptions overestimating *source code* at the expense of a network of machines and humans. She points out that source code serves as a kind of fetish and that the notion of the user as superagent, buttressed by real-time computation, is the obverse, not the opposite, of this "sourcery."

For a current concept of "image," the link between image and interactivity is decisive: the interface. Christa Sommerer and Laurent Mignonneau uncover the roots of interactive cultural *interfaces* in a variety of fields, such as social psychology, human computer engineering, cybernetics, interface design, and interactive arts. They show how interactivity as a concept has influenced media artists and researchers alike, and moreover has led to applications and appliances in the fields of mobile computing, intelligent ambiances, smart homes, intelligent architecture, fashionable technologies, ubiquitous computing, and pervasive gaming.

Assessing the current renaissance of feelings and emotions, Marie-Luise Angerer sees a fundamental shift in modes of "thinking the human" that is neurobiological rather than humanistic. Because there is no perception without *affection*, for Angerer the affective and emotional addressing of recipients of digital media leads to a massive manipulation of the body by images (*Bilderflut*), which connects the classic term of liberalization with image politics.

Peter Weibel discusses the new role of the *museum* under the aspects of *Web 2.0*, user-generated content, and the new quality of interactivity. In Weibel's view, to avoid becoming obsolete for presenting experiences of contemporary cultural behavior, museums must adapt to these new circumstances and enter into an alliance with the Internet. As an example of the Internet-based nonlocality of museums, Weibel introduces the ZKM project *FLICK_KA*, where the interactive virtual world comes together with the localized museum.

As is widely known, almost all landmark technologies in history have been used by people to try and create artificial life, androids, or at least simulations thereof; the history of the Golem or the previous century's many fantasies about robots provide a wealth of examples. With "cuteness" a further chapter is now being written in the

projection of attributes of the living onto machines and human interactions with them. Cuteness is a relatively new development in interactive systems. Focusing on the Japanese culture of *Kawaii*, which has had a large impact around the world, especially in entertainment, fashion, and animation, Adrian Cheok describes the concept and its history, and further introduces *cute engineering*, the approach of a next generation of interactive systems.

Tim Otto Roth and Andreas Deutsch, referring to the 1940s concept of *cellular automata* by Stanislaw Ulam and John von Neumann, question the notion that digital images really do constitute a pictorial novelty. Driven by simple rules, cells in a grid undergo self-organized dynamic growth without a central directing instance, simply by interacting with their neighbor cells. Cellular automata are cybernetic pictures that constitute a mathematical picture model with no predecessors in human cultures, which is open for media theory and new artistic concepts.

The need for improvement in the dramaturgy of museum websites is highlighted by Harald Kraemer. By classifying *hypermedia* applications and analyzing several case studies, he argues that in to simplify the complexity of the information the recipient should be integrated through a feeling of solidarity, by empathy, which can be achieved through a holistic attempt at the symbiosis of content, navigation, and design. In this way information design would be created that is at the same time complex yet still intuitive.

III New Tools for Us: Strategies for Image Analysis

The book's final section demonstrates that image science and digital humanities cannot progress without new technologies of image collection management, new forms of distribution within a global science community, and new forms of analysis. The development of the field is supported in an increasingly enduring manner by new scientific instruments. Discussing examples from a variety of projects, this section demonstrates the strategic importance of collective projects, especially in their growing importance for the humanities.

Although nowadays interactive visualizations are essential for progress in dozens of scientific fields, humanities research and cultural institutions rarely use them for either study or presentation of cultural artifacts. Lev Manovich and Jeremy Douglass describe the methodology they have developed to quantify, measure, and visualize patterns in visual and media cultural data sets. On the basis of case studies they show how cultural analytics can be used, for example, to visualize cultural epoch changes or patterns of user interaction with digital media artifacts.

The heuristic use of computing for research on visual media brings new challenges for analyzing images. Digital humanities offer unique new possibilities for archiving

and analyzing, simultaneously connected with new questions. How do these media affect scientific research, and what do our disciplines have to contribute to our knowledge of computing?

Martin Warnke introduces *HyperImage*, a Web-based digital medium for image-oriented research, which meets the long-wished-for requirement of not treating visual forms in a semiotic way. The user may mark, arrange, utilize, and publish observations on images to discover pictorial similarities prior to any verbal categorization. In this way *HyperImage* implements a digital version of the Warburg Image Atlas with a Luhmann-filing box in its background. The nonverbal methodology of pointing instead of naming is eminently suitable for expressing pictorial similarities without falling into verbal categorization, thus taking the evolutionary aspect of images seriously.

Although digital art became "the art of our time," Oliver Grau claims that it still has not "arrived" in the core cultural institutions of our societies. Meanwhile, we even witness a total loss of digital art, including its documentation, and with that the erasure of a significant portion of the cultural memory of our recent history. To overcome the typical placement of media arts in an academic ghetto, Grau proposes to learn from other fields to develop a strategy to solve the problems of media art and its research, to answer the challenges image science is facing today in the framework of the digital humanities. Just as research in the natural sciences has long recognized team efforts, a similar emphasis on collaborative research should make its way into the thinking of the humanities. Only when digital art gains entrance to our science and culture systems and is collected systematically will its entire technological and intercultural potential be able to enrich our culture.

The iconic turn is definitely capable of holding its own in the face of the overpowering fixation on language and text—by conferring on the image its own cognitive capability. The image is not just some new theme; rather it concerns a different way of thinking. Images are much more than just objects of study; they are an important category of analysis. This entails thinking with images: images as an independent means of cognizance. Yet even here we see that the iconic turn remains reliant on language.

IV Coda

With the acute eye of the historian of the visual, Martin Kemp critically highlights the main topics of this volume. With his extensive historical knowledge Kemp unmasks connotations of the *new image*, such as increasing democratization or the new quality of ubiquity, as being overvalued by an idea of progress that has shadowed us since the Renaissance. To better analyze novel imaging, Kemp reminds us to consider which aspects are new, and which aspects are inherited.

Notes

1. According to the military online resource "Strategy Page" (<http://www.strategypage.com/htmw/htintel/20070102.aspx>): "Google Earth has revolutionized military intelligence, but the military doesn't like to admit it. . . . Just enter certain coordinates and 'Fly to' . . . The Pentagon: 38.87, −77.506 . . . The North Korean nuclear test site; 41.279, 129.087 . . . Russian subs in Kamtschatka; 52 55' N 158 29' 25 E." Or go directly to a very different site—our Department for Image Science in Goettweig (see figure 1.7).

2. See <http://www.arts-humanities.net/event/high_throughput_humanities_eccs2010>.

3. See <http://www.netsci2010.net>.

4. See <http://manyeyes.alphaworks.ibm.com/manyeyes>.

5. See various contributions in the *Journal of Visual Literacy* of the International Visual Literacy Association: <http://www.ohio.edu/visualliteracy>.

6. The Second international Conference on Image Science, Goettweig/Austria, which took place in autumn 2008, resulted out of a call for papers with applicants from 19 countries and a variety of different disciplines.

7. W. J. T. Mitchell, *Bildtheorie* (Frankfurt: Suhrkamp, 2008).

I Image Phenomena of the 21st Century

2 Current Screens

Sean Cubitt

It is ironic that, as our aesthetics have become more and more materialist, our awareness of screens, which are today the ubiquitous medium of reception, has shrunk to nothing. This is not to say that there are no sociologies of screens: Writers and thinkers from Virilio[1] to McQuire[2] engage in intense discussions of the impact of screens on public and domestic space. Yet there is little attention paid in media and communications to the nature of the screens as material technologies. This chapter addresses screen technologies of the early twenty-first century, from handhelds to billboards. It looks at the material construction of various screen technologies, at the fundamentals of their organization of imaging, and at the bases of the software they use. These issues may be of limited interest in themselves, but, it will be argued, these technological features both express a particular quality of contemporary social life and retransmit it: They are normative technologies. Here lies their importance, for such structures express the nature of public life in particular, and they rearticulate it. Although there is a great deal of innovation in screen design, there remains a curiously static quality to the underlying features. This chapter argues that contemporary and near-future screens have abandoned important potential screen technologies in favor of a particular genus of screens, and that this articulates with a consensus on what we expect from our communications. It concludes that the road not taken can tell us as much about the kind of world we inhabit as the road that we have pursued, and recommends the development of alternative technologies as a key to reconceptualizing the nature and role of public life. The argument is framed by discussions of the environmental limits to growth that must constrain future screen technologies, thus providing a second, ethical layer to the discussion of the mediated life of populations.

Materials

For much of the twentieth century, cathode ray tubes (CRTs) were the fundamental unit of both television and computer displays. The CRT is a glass tube with at one

end an emitter of negatively charged electrons (the cathode) and at the other a posi-
tively charged anode, which attracts the beam of electrons (the cathode ray) to a
flattened area covered with phosphorescent materials that light up when struck by
the particles. A magnetic coil or electrostatic system focuses the electron beam, and a
second magnetic deflector yoke directs the beams' flight toward the desired destination
on the screen. In color CRTs, three electron guns fire beams toward phosphors that
glow red, green, or blue, separated from one another by a mask. The technology, which
derived from both vacuum tubes (perfected in the 1850s) and cathode rays (demon-
strated in the 1870s), was first used with the goal of visual display in the Braun tube,
the CRT oscilloscope demonstrated by Karl Ferdinand Braun in 1897. CRT oscillo-
scopes, like CRT radar screens, use phosphors, which tend to keep their glow for some
time after being struck by an electron.

The phosphors in television, computer, ATM, and video-game CRTs have a shorter
illumination, fading swiftly to allow the next image to differ from the one before.
They use innovations pioneered by Vladimir Dzworykin in the Westinghouse and RCA
laboratories in the 1920s, where he had fled the Russian Revolution. The central inno-
vation, probably introduced by Dzworykin's mentor Boris Rosing, was the scanning
of images prior to transmission. Here the difference from the oscilloscope is critical:
Unlike oscilloscope and radar screens, TV and computer CRT displays are formed as
grids of phosphors organized in a Cartesian X-Y surface (like graph paper) called a
raster display. The electron gun responds to incoming signals by modulating its beams
as they scan of the whole screen area regularly from left to right and from top to
bottom. The level of charge as the beam strikes a given square on the grid determines
the "luma" or brightness signal, with a correspondingly brighter reaction from the
phosphor targeted at that specific address on the screen. Oscilloscope and radar
screens, in which the intensity of the charge is kept constant, steer the electron beam
directly on the X and Y axes using magnetic plates seated inside the electron gun.
This allows arbitrary movement in response to incoming signals from various elec-
tronic instruments like microphones and radar telescopes. This was the type of screen
used in Ivan Sutherland's Sketchpad, an invention to which we will return. This first
application of the CRT has been abandoned in television and subsequently (and
perhaps consequently) in computer technologies, where signals such as component
or composite video and RGB are organized to match the raster grid.

The materials involved in CRTs are expensive and many of them toxic and poten-
tially dangerous to dispose of. Color CRTs require up to 32,000 volts in the screen
anode (though monochrome sets use much lower voltages): The energy requirements
of such devices are intense. Since the voltage/brightness connection means that unil-
luminated phosphors require no charge, bright images such as the typical white of a
computer word-processing package require higher degrees of energy than darker
images (the avowed reason for Google's *Blackle* experiment, which reproduces Google's

search pages reversed out to reduce power usage: see <http://www.blackle.com>). The glass tube is under extreme pressure—implosion as a result of the vacuum can send fragments ricocheting at lethal speeds—requiring very strong glass in substantial quantities, and often metal reinforcing bands, also under extreme tension. Recycling these components can be a risky process. The glass itself is leaded to minimize the radiation risks associated with both the high energies of the cathode ray, which generates X-rays on impact with the screen, and ions generated as a by-product of running the electron beam. This lead in the glass, the often toxic phosphors which line the screen, and the frequent use of barium in the electron gun assembly all add to the toxicity of the recycling process. Legislation in the United States and the EU prevents throwing CRTs into landfill, but cannot legislate for the recycling villages of Southern China[3] and West Africa, where most Northern hemisphere electronic equipment ends up. The Basel Action Network[4] estimated that in 2005 approximately 400,000 junk computers were arriving in Lagos alone.

Liquid crystal displays (LCDs) pose similar problems, although their power usage is much lower than CRTs, which they have largely displaced in the computer market. Overtaking CRT sales in 2004, LCDs were projected to sell 50 million units worldwide in 2008, and to double in total by 2011. Found in digital watches, mobile phones, laptops, and increasingly in flat-screen TV and monitor screens, waste LCDs constitute one of the fastest growing recycling problems of recent years, with increases in end-of-life statistics projected at 16 to 25 percent every five years. The LCD backlights are the most serious pollution hazard, as they contain significant quantities of mercury. The perfluorocompounds used in the crystals themselves have a far higher greenhouse effect than carbon dioxide: up to 22,000 times higher on the global warming potential (GWP) index.[5] While the mercury can be recovered in demanufacturing processes (so long as manufacturers, mainly based in China, Korea, and Japan, abide by regulations established in key markets like the EU), the crystals are typically incinerated. The manufacturers association has established high-heat incinerators, backed up with alkaline scrubbers to react with remaining perfluorocompounds, but these too use very significant amounts of energy (though Sharp established a "green-powered" recycling plant in 2008). Many appliances are dumped when the screens have relatively minor failures: Recyclers can frequently repair and reuse them. But many will find their way into the recycling industry, where the mercury and cadmium from the integral batteries, the indium-tin oxides used in electrodes, and the unpredictable breakdown products of the organic compounds used through the assembly, from polarization and orientation layers to screen coatings, all contribute to the hazards. The problem is exacerbated by the economics of waste recovery, which suggest that the most cost-effective method is manual disassembly.[6] Despite disputes over the toxicity of the components on LCDs, there is general agreement that they are poorly biodegradable, and are potentially significant water contaminants.

The ubiquity of LCDs in mobiles places them alongside other dangerous rare earths like selenium and germanium, pointing to a further material problem: the limit to the availability of these materials, essential to the production of chips and batteries. The levels of penetration of personal devices in the West is not sustainable across the rapidly developing markets of India and China, let alone the remaining portion of global population living in the underdeveloped world. The screens in mp3 players and digital cameras, and the other components associated with them, pose not only recycling and recovery problems but suggest that without radical change in their design, there will not be enough raw material to reproduce the West's expectation of multiple, individually owned and used devices for each member of the population. The strategic importance of rare earths has sparked fears that China, which produces 95 percent of the world's lanthanides, may be introducing export controls, placing its electronics industries in a powerful position to dominate twenty-first-century manufacturing, either through domestic firms, or by forcing transnationals to move their manufacturing to China in order to access the necessary raw materials. Though global reserves include 42 percent outside China's borders, refining capacity is limited, extraction costs are often higher, and in some instances, as with Arafura, an Australian rare earths mining company, China has moved to purchase significant shares.[7] The possibility of trade wars on a level with those currently being fought over access to oil may loom for the high-tech industries, and indeed for green technologies: Hybrid cars require up to two kilograms of rare earths for their batteries alone.

Architecture

It is clear that our "immaterial" culture is highly material, especially when we consider its ecological footprint in raw materials, in use and at end-of-life. Without delving into the manufacturing process, which would require another chapter, suffice it to point out that Dell Computers, a large but otherwise typical U.S. computer brand, uses up to 98 OEM/ODM (original equipment manufacturer/original design manufacturer) sources to produce their equipment, the vast majority in developing countries or in export-friendly free-trade zones like the notorious *maquiladoras* of the Tijuana U.S.–Mexico border country, where pay and conditions are far below developed nation standards. Screens are a typical OEM/ODM item, installed without the manufacturers' name attached, and only sometimes branded by an on-seller. For example, the disc drive in my MacBook Pro is credited to Matsushita, who almost certainly has outsourced its manufacturing offshore, while the memory manufacturer is listed as "0x127F000000000000," and the LCD has no vendor or manufacturer named in any form. As is typical of information capitalism, key brands like Apple, Matsushita, and Sony (who provide my batteries) do not manufacture components themselves, and frequently do not even own the assembly plants where the final products come

together. Instead they concentrate on the core business of intellectual property: trademarking the brand, patenting hardware, and copyrighting interlinked software and content. Although corporate research and development is now also often outsourced, for example to India in the software industry, or to increasingly corporatized universities in the materials science field, core trade secrets and the development of core innovations will typically be the one area of corporate concern to be kept as close as possible to the center of operations.

This situation suggests the following important question: Is it the case that, because of the proximity of hardware innovation to corporate headquarters, there is a structural homology between the design of major components of digital devices such as screens and the corporate culture in which they are formulated? The question is not entirely naive. Isabelle Stenghers[8] points out that the history of science and technology studies has presented two competing paradigms, that of the autonomy of science and technology and that of symptomatic technology and science. In recent decades, however, the work of investigators including Stenghers and Bruno Latour[9] has increasingly suggested that the assemblage of agencies involved in scientific and technological innovation are neither rational—a presumption of the autonomist thesis—nor necessarily efficient—a correlative of the symptomatic thesis. The emerging new digital architectures, for example those of the LCD, LED (light-emitting diode), and DLP (digital light processing) screen technologies, are of necessity built on existing standards. They must, for example, be able to at least speak to component and composite video, recognize different color spaces like RGB and YPbPr, and connect to existing infrastructures such as the electricity grid, broadcast transmission wavebands, and the Internet. These accumulated elements of the environment into which new technologies emerge is also a regulated environment, and as several commentators have suggested, at both national and global levels, media regulation rarely gives evidence of a unifying policy goal. Rather, governance accumulates in layers, with regulations for each technology framed inside the policy objectives of the epoch in which it emerged: freedom of speech for the U.S. press, for example, but universality of access for telephony.[10] The regulatory environment "reflects the fact that law-makers simply wrote a new law for each new network as it arrived."[11] It is therefore perhaps understandable that, given the principle that the more deregulated a market is (and this is surely the case for the global market in electronics), the more regulations are required to govern it,[12] electronic screen design is formulated not only on the technological affordances of the day, but on the accumulated technical practices of the past, and the regulatory framework of the present, which itself is typically a historical aggregation. We can observe this in the economics of recycling: Manual labor (and therefore, the labor of developing nations) is the most efficient way to get rid of WEEE *because*, prior to regulation, there was no incentive for manufacturers to make automated demanufacturing a possibility. Even today, regional (NAFTA, EU) and international

(the Basel Framework) agreements notwithstanding, the global trade in e-waste is to all intents and purposes an export trade in toxins. This trade is the more insidious to the extent that the electronics industry depends on innovation for success. Even the biggest market, such as that for personal mobile phones, flattens out once it reaches saturation. At such junctures, the industry must innovate or die. Thus we enter a cycle of built-in obsolescence equivalent to that of the Detroit motor industry in the 1950s and 1960s. The necessary by-product of such speedy electronic obsolescence is e-waste.

This is not to say that innovation is never virtuous. The LCD is a far less power-hungry technology than equivalent CRTs, for example. It is to say, however, that innovation is never undertaken without a cost, nor is it undertaken in an environment of absolute creative freedom. As an example, let us return to the raster grid, incorporated as a core technique in the innovation of the CRT. The raster grid has its own genealogy, specifically in the development of wire photography, initially demonstrated by Edward A. Hummel and Arthur Korn in 1900 and 1907 respectively, and industrialized by Bell Labs and Associated Press in 1935. This technology, which used a rotary scanning technology related to the earliest experiments in television, produced a halftone grid of dots that assembled into a still image, transmitted over telegraph wires. The halftone process itself had been pioneered by one of the key figures in the invention of photography, William Fox Talbot, in the 1850s and in industrial use by the 1870s. Half-tone printing uses a similar grid of dots and remains the core technology of photolithography, the printing technology common to both book production and chip manufacture. The halftone's unique characteristic is that it lays its grid at a 45 degree angle to the horizontal, on the basis that the human eye sees parallel lines less acutely when they are not aligned with the horizon. With that exception, it may trace its own ancestry as far back as the Renaissance, to the engraving of lozenges for shading in intaglio printing. The significant properties of the raster grid are, then, threefold: It is aligned on the horizontal axis; it is automated; and it is attached to a clock function in which the whole screen is scanned in numerical order and refreshed at regular intervals (typically 120Hz in NTSC and 200Hz in PAL and SECAM). It is in this sense a Cartesian coordinate space, each pixel enumerated along the X and Y axes, and distinguished over set increments of duration. It is a thoroughly mathematical space, and one that has been strongly identified with both modernity and the broad cultural project of modernism.[13]

Thus, we should not be surprised that the technical innovations of the LCD rest on a far older substrate of the grid, not least since computers are now almost universally calibrated to produce video signals designed to play out on raster screens. CRTs, however, are rather less rigid than LCDs. The scattering of phosphors on the luminescent surface is itself more random, and the illumination of one phosphor tends to blur into the light from its neighbors, so that even if the electron gun tracks over the

screen in linear order, the phosphors themselves are less rigidly contained. Sony's Trinitron aperture grille system for color reproduction in CRTs was designed to limit this fuzziness, by laying a grid of vertically aligned thin black wires over the screen in order to minimize the interference between phosphors, and so increase apparent resolution. This step preceded and pointed the way toward the increasingly rigid mathematicization of the raster array, much as Fox Talbot's textile screen preceded the lined glass sheets of the industrial halftone process.

LCDs do not rely on electroluminescent phosphors for their illumination but on mercury-vapor fluorescent backlights. Requiring much less power than the high voltages associated with CRTs, they both produce far less unwanted radiation than the older technology, and are eminently suited to battery-powered personal devices like laptops and handhelds. LCDs sandwich their crystals between two layers of polarized glass, arranged so that if no voltage is applied, light cannot travel through one layer and through the next. The liquid crystals (so called because although they are liquid they retain some structural characteristics of crystals) carry light between the polarized plates and change their orientation according to whether they receive a voltage from transparent indium-tin oxide electrodes placed over the glass sheets. When charged, they untwist their "relaxed" helical shape, and the light is blocked, creating black pixels; uncharged, they let the light pass through. Small displays have a discrete pair of electrodes for each pixel. Larger displays reinforce the grid structure by supplying electrodes in rows on one side of the screen and columns in the other, so that each pixel has a unique row-column address, without requiring an independent power source. The surface on the visible side of the screen is covered in a layer of red, green, and blue color filters, one of each to each pixel, allowing millions of color combinations. There is a general feeling, however, that LCD color is less subtly graded, has a narrower gamut, and in inexpensive models is less bright than CRT screens.

The same raster grid structure is apparent in other screen technologies, such as the plasma displays competing for dominance in the domestic high-definition television market. Here noble gases (neon, argon, and xenon) contained in phosphor-coated cells are ionized and heated to a plasma by voltage difference, controlled as in large LCDs by long electrodes, in this instance in rows along the back plate and columns inside the front. The ultraviolet photons given off by the plasma then trigger the phosphors to illuminate as subpixels of red, green, and blue, as in LCD technology. Indeed, this release of photons from agitated phosphors is the basis for shadow-mask CRTs, in which a triad of red, green, and blue-emitting phosphors was first established as the basis for electronic color screens. Plasma screens use power comparably to CRTs, but the size of screen, the relative brightness, and the viewing angle are all greater than that of LCDs.

Similarly, the digital micromirror device (DMD), the chip at the heart of digital light processing projectors and rear-projection TVs, sets up an array of tiny mirrors,

each corresponding to a pixel, brightly illuminated and controlled to shift very swiftly on their axes. One orientation is "on," another is "off," and rapid oscillation between the two provides grayscale by reflecting some of the light away from the screen. In single-chip DLP projectors, color wheels spinning up to ten times per frame deliver the color component of the image; three-chip projectors for high-end use a prism to split the illuminating white light, passing one of the red, green, or blue wavebands to one of the three chips, which then reflect that color component onto the screen. This too has its roots in an older color technology, the three-color Technicolor camera of 1932. Though they began with mercury-vapor arc lamps (with the same color signature as LCDs), since 2006 patented LED (light-emitting diode) technology has increasingly been applied to DLP projection, with longer life, lower power consumption and comparable illumination, at least for domestic uses. At the opposite end of the market, Texas Instruments, who devised DLP and DMD, announced in 2009 its intention to develop the technology for use in handheld devices. But again, like other emerging competitor technologies in the high-definition and projection markets such as LCoS, DLP once more reproduces the raster grid, even if it has managed to exceed competitor technologies' color gamuts, an issue to which we return in the next section. The Cartesian grid is hardwired into the architecture of the DMD chips used DLP, as it is into the screen displays of plasma and LCD. The question then becomes, does this architecture also shape the use of these devices? Is the mathematicizing instrument of the Cartesian grid, which dominates the architecture of dedicated visualization chips and screens, also the overwhelming structure of twenty-first-century visuality? If the answer is yes, then the following question must be: Does it matter? Does it matter whether our images come to us in the random spatter of silver halide molecules or the ordered arrays of the raster display? Does it tell us anything about who we are, how we live, and, perhaps most of all, how and what we communicate?

Protocol

In the influential book *Code and Other Laws of Cyberspace*, Lawrence Lessig[14] gave the phenomenon a catchphrase: Code is Law. He was writing specifically about the use of digital rights management (DRM) code, which at the time was threatened as a new way of preventing copyright infringements. As we have seen, copyright and other intellectual property laws are of vital significance to contemporary corporations. Lessig does not suggest that it should be otherwise, although he offers nuanced arguments concerning the degree and duration of protection that can be considered just. But he does have a lawyer's disagreement with the principle that copyright owners have the right to make it impossible to infringe on their property rights. DRM effectively does this: It undertakes to make it impossible to commit the offense of infringing copyright.

Alex Galloway[15] coined the term "protocol" to express a more widespread phenomenon. Software comes in various forms: as operating system (Windows, Linux), as applications (Adobe, Autodesk), and as protocols. Protocols are common on the Internet: SMTP is standard mail transfer protocol; HTTP indicates pages using the hypertext transfer protocol; and below such familiar protocols lie more pervasive ones, specifically the TCP/IP suite (transmission control protocol/Internet protocol), which provides layers of nested protocols (applications, transport, Internet, and link), which together allow the entire system of computers communicating with each other to perform. Drawing on Deleuze and Foucault, Galloway sees protocol as the next period in a historical process, first described by Foucault, which has seen power migrate from sovereignty (the king's right to decide the life or death of a subject) to discipline (the inculcation of rules of behavior in the individual subjects of a state), and from thence to governmentality and biopolitics (the management of populations according to statistical norms). Deleuze added a fourth period: the "societies of control," where the codes operating in society effectively determine what can and cannot be done in it—much as the highway code determines how one may or may not drive a car. Technically we are free to drive—or to behave in electronic environments—just as we please, and to take the consequences if we do something illegal. But in the emergent societies of control, and more particularly in the era of protocol as the governing feature of the Internet and so of a vast swathe of contemporary life from correspondence to global finance, we are not free to disobey. The very same protocols that allow us to disport ourselves in cyberspace also constrain us to act according to the rule-set that underpins it.

It is in this vein that we turn our attention to the parallel infrastructure of software that underlies the electronic image. We have already noted in passing one or two such infrastructural themes. One of these is the question of color gamuts, the range of colors that a given screen is able to reproduce. The visible spectrum spans the waveband between, roughly, 400 and 800 nanometers. On average, a human eye has 120 million rods and 7 million color-sensitive cones, the latter concentrated in the fovea, at the center of the field of vision where they reach densities of 60,000 per square millimeter; the equivalent numbers for digital cameras are about 20,000, and for color photographs about 30,000.[16] At their best, digital screens can reproduce only about 50 percent of the visible spectrum. To make the most of a bad business, the outlying colors are moved inward toward the reproducible sector—the gamut of the screen. But that process does not account for the acute perceptual facility we have, especially within that foveal arc of one or two degrees where we focus our attention, for distinguishing between colors. It is then not the absolute hue or saturation that is at stake but the differences between them. Screens are calibrated (as are the signals they coordinate) so that the color gamut squeezes the full spectrum into the available gamut *while preserving the relationships of difference between colors*. This would be more

acceptable, perhaps, if all screens used the same algorithms to redeploy colors, and if all computers shared a single color space. Unfortunately, they do not. The manufacturers of LED versions of DLP boast a much wider gamut than is available on LCD, which in turn is widely regarded as having a poorer gamut than modern CRTs. Likewise, different chips used to gather images have different gamuts: CMOS chips, previously considered only good enough for low-resolution applications like mobile phone cameras, have found a significant place in scientific imaging, partly because of their greater gamut than their competitor CCD chips.

The fact remains that digital outputs (including both screens and printers) have a much reduced color gamut compared either to normal human vision or to older color technologies like oil paint. Worse still, in network conditions, where it is impossible to know in advance which kinds of display will be used to view some piece of content, there is no way to prepare the file for optimum viewing by the far-end user. This may be critical when the files in question are being prepared for analog media such as cinema film or color printing, and is also significant for such uses as the color branding of companies or the standardization of flags and other important insignia. Here the standard recourse is to entirely nondigital media, such as the color "chips" purchasable from the Munsell Corporation, or the printer's standard recourse, the Pantone color system, both of which use printed materials for comparisons, and a numerical reference that can be passed in a more reliable, nonvisual form, to network collaborators. The mathematicization of color, which began with Newton in the seventeenth century, resulted in its commodification at the end of the twentieth.

Can anything similar be said of the other elements composing the protocological layer of screen technology? Perhaps the most important of these are the codecs, compression-decompression algorithms used to compress signals for transport, and to "unpack" them on arrival. The codecs sit a layer below such standards as PAL and NTSC, and have historically developed in relation to emergent uses such as Internet, satellite, and high definition. They have also historically been involved, because of their importance to emerging hardware and architectures, in heavily regulated environments where design can be as much influenced by national interests (for example, in protecting domestic equipment manufacture) as by elegance or efficiency. Many codecs are in use, generally standardized through the International Organization for Standardization (ISO), and some of them are wholly proprietary. The major ones, however, are MPEG-2 and MPEG-4, both used as standard codecs for broadcast television, though MPEG-4 has much broader additional capacities, for example for high-definition applications like Blu-Ray, and for encoding and decoding bitstreams representing 3D objects and surface textures. The MPEG-4 codec was devised, like the other MPEG formats, by the Motion Picture Expert Group, now a subcommittee of the Internet Engineering Task Force, but elements of the codec are owned by 640 institutions (including the military, a feature that goes back to the 1916–1918 period

when the U.S. Navy took control of all radio patents[17]) and corporations. The complexity of its organization is compounded by its composition in "Parts," sometimes referred to as "layers," many of which are optional for people implementing them in specific circumstances. Thus, few nonprofessional users will require VRML support for 3D rendering, while others will find a use for Part 13, which provides for encoding DRM in MPEG-4 signals. But what is important is not such features, nor the ownership of patents, nor even the protracted negotiations required before licenses could be agreed between the patent owners, but the fact that, as Adrian Mackenzie has it, "Codecs affect at a deep level contemporary sensations of movement, color, light and time."[18]

The MPEG codecs, which lie at the deep level of such familiar tools as Windows Media, VLC, and commercial DVDs, use "lossy" compression, a term that refers to the way the decompressed signals lose resolution and color information compared to the original uncompressed signal. Although some rare codecs do promise lossless transmission, the continuing problem of bandwidth economics continues to foster lossy standards. For terrestrial and satellite broadcast transmission, digital signals are far more efficient than analog, but competition for wavebands with cell phone and other uses makes bandwidth a valuable commodity. Even in wired environments, speed of transmission is regarded as more valuable than the quality of the received image, while the carrying capacity of laser-read discs like DVD and Blu-Ray also requires considerable compression to fit feature films plus associated extras on a single side. Of the various tools used, perhaps the most significant is vector prediction.

Common to the various MPEG codecs, and especially visible in the H 261 codec that underlies the YouTube proprietary .flv format,[19] vector prediction works by assembling pixels into blocks, macroblocks, units of 4×4 or 16×16 pixels that can be treated as average hue, saturation, and brightness values. On the presumption that, for example, green grass and blue sky areas will remain the same from frame to frame, the codec "guesses" that the next frame will be by and large similar to the current one. To aid this process, the codec interpolates key frames, in the manner developed by animators around 1915, each of which establishes the beginning and end of an action, allowing the codec to interpolate the most likely sequence of changes that will take the image from the first key frame to the last. This economically satisfying system leads to advice to users to minimize movement in the frame, which tends to demand more frequent key frames and therefore more bandwidth. The result is the self-fulfilled prophecy of YouTube populated by talking heads and minimally animated flash video, or, alternatively, slow downloads (with attendant loss of interest among downloaders) for those videos that ignore the advice.

Such technologies allow a signal to be decoded that is legible. They are good-enough technologies, confining expectations to the likely loss of resolution and color depth. The vector-prediction algorithms are based on the typical broadcast, and

function both normatively, by accommodating genres, like sport, that have the greatest uptake among users, and descriptively, deploying the averaging techniques first developed by Alphonse Quetelet in the nineteenth century to establish the concept of the "average man."

Conclusions

As Mackenzie[20] notes, the way a codec "pulls apart and reorganizes moving images goes further than simply transporting images. . . . Like so much software it institutes a relational ordering that articulates realities together that previously lay further apart." Quetelet's "social physics" was an ultimately successful attempt to apply the mathematicizing principles of physical sciences to the emerging idea of the social sciences. Statistical norms provided in the first instance data on the average height and weight of citizens, but then increasingly on their average opinions, habits, and behaviors. It was the sociological expression of the idea of the market that had developed out of eighteenth-century radicalism in the hands of Immanuel Kant, Adam Smith, and Jeremy Bentham, and which in Foucault's analysis would form the fundamental liberal and later neoliberal formation of biopolitics: the management of populations.[21] If on the one hand, as we have seen in the case of color gamuts, the kind of mathematicization espoused by Quetelet and later opinion pollsters tended toward commodification (of audiences as sold to advertisers, for example), on the other it had a direct impact on the concept of liberal government.

The invisible hand of the market first identified by Adam Smith is at heart the aggregate rationality of individual acts of exchange influenced by such irrational factors as advertising and brand loyalty. Though every individual act can be construed as undertaken in a free environment, averaged across the whole of a market, they become statistical probabilities, much as the likelihood of death from drunk driving or smoking-related illnesses can be calculated from actuarial records. The contention implicit in the foregoing analysis is that the raster grid of dominant screen displays is indistinguishable from the Cartesian space deployed by Quetelet and every subsequent statistical sociologist to analyze the existence of *l'homme moyen*, the average person, in the environment not only of historically accumulated technological practices, nor of the historical layering of architectures and protocols, but of a regime of commodification and power whose fundamental premise is the exchangeability of any one good for another, any one person for any other, and all possible behaviors as norms or departures form the norm: a regime of accountancy rather than accountability. At the microlevel, our technologies, this chapter has argued, take the shape of the biopolitical and information-economic structures that shape our society at the macrolevel. To call this regime a database economy is perhaps to succumb to the same demand for efficiency that characterizes government in our epoch, yet it is

also a way of throwing into question what has become of the publics of such tech-nologies, as they traverse cityscapes on the one hand decorated with huge urban screens, and on the other characterized by individuals bent into the increasingly screen-dominated intimacies of handheld devices. In materials, architectures, and protocols, we can observe the structuration of contemporary media not only by their histories and by the immediate and conscious influence of regulatory environments, but by the very shape of the social organizations in which they emerge. Contemporary innovation, while it seems to churn far faster, is only the more deeply hamstrung by the rapidly accumulating mulch of previous inventions and previous regulatory interventions.

In our haste to populate our lives, intimate and public, with screens, we have opted for the good enough over the best possible, and in the process abandoned technical trajectories that might have suggested other social and political capacities and affor-dances. The biopolitical management of populations that Foucault describes is entirely congruent with, and in some ways reflective of the liberal conception of the market: In both systems, innumerable interactions and exchanges are aggregated in the mass and there mathematically rendered. The Cartesian grid is the tool of choice for statisti-cal graphing, not least because once a line has been drawn of number against time, it can be extended into the future. This is the central tool of planning, of the manage-ment of markets and populations that constitute the database economy. It not only shares the grid formation, but is the managerial expression of the kinds of vector prediction analyzed above in the H.261 codec. Prediction, foreknowledge based on statistical aggregation, the enumeration of the enumerable: These have become the ingrained characteristics of the contemporary screen in all its manifestations.

All, that is, bar one: the oscilloscope screen technology utilized in early experiments in computer graphics by Ivan Sutherland, mentioned briefly in the opening pages of this chapter. Sutherland's vector screen, free from the obligation to scan the raster grid in clock time, remains an available technology still deployed in air-traffic control and scientific instrumentation. Its capacities have been ignored in the development of the Cartesian raster display. Yet the vector display is the natural way to display the vector graphics that increasingly constitute the central platform of object-oriented visualiza-tion. The loss of vector screens in the age of vector graphics, and their replacement with codecs whose central innovation comprises new tools for making vectors visible on raster displays, suggests both a concrete avenue for twenty-first-century technical innovation, and the kind of lacuna in innovation that may only be typical in situa-tions where there is a diagrammatic or structural interchange, a homological assem-blage, operating between key technologies like contemporary screens, and core values and processes of both economic and political life. The oscilloscope allows for the arbitrary. Unlike our common screens, which have become attuned to the normative workings of the database economy, the vector screen is an expression of a freedom we

have sensed, that we have imagined as potential, and which still lies unrealized in the storeroom of residual media. If technologies are articulations of social formations, then genuine innovation, or turning back to follow the road not taken, may well introduce us to a new way of imagining and realizing alternative social formations. Perhaps this cannot be achieved with respect for the poor and for the ecosphere, but we know for a certainty that the road we did take has not benefited either of them. It is time to set the vector free.

Notes

1. Paul Virilio, *The Vision Machine*, trans. Julie Rose (London: BFI, 1994).

2. Scott McQuire, *The Media City: Media, Architecture, and Urban Space*, (London: Sage, 2008).

3. The Basel Action Network and Silicon Valley Toxics Coalition, *Exporting Harm: The High-Tech Trashing of Asia*, <http://www.ban.org/E-waste/technotrashfinalcomp.pdf>, 2002.

4. The Basel Action Network, *The Digital Dump: Exporting High-Tech Re-use and Abuse to Africa* (photo documentary); see <http://www.ban.org/BANreports/10-24-05/index.htm>, 2005.

5. Avtar S. Matharu and Yanbing Wu, "Liquid Crystal Displays: From Devices to Recycling" in *Electronic Waste Management: Issues in Environmental Science and Technology*, ed. R. E. Hester and R. M. Harrison (Cambridge: RSC Publishing, 2008), 180–211.

6. B. Kopacek, "ReLCD: Recycling and Re-use of LCD Panels," in *Proceedings of the 19th Waste Management Conference of the IWMSA (WasteCon2008)*, October 6–10, 2008, Durban, South Africa; <http://ewasteguide.info/Kopacek_2008a_WasteCon>.

7. "China Builds Rare-Earth Metal Monopoly," *Australian*, March 9, 2009.

8. Isabelle Stenghers, *The Invention of Modern Science*, trans. Daniel W. Smith (Minneapolis: University of Minnesota Press, 2000).

9. Bruno Latour, *Aramis, or The Love of Technology*, trans. Catherine Porter (Cambridge, MA: Harvard University Press, 1996).

10. François Bar and Christian Sandvig, "U.S. Communication Policy after Convergence," *Media, Culture, and Society* 30(4) (2008): 531–550.

11. Tim Wu, "Why Have a Telecommunications Law? Anti-Discrimination Norms in Communications," *Journal of Telecommunications and High Technology Law* 5 (2006–2007): 19.

12. S. K. Vogel, *Freer Markets, More Rules: Regulatory Reform in Advanced Industrial Countries* (Ithaca: Cornell University Press, 1996).

13. Rosalind E. Krauss, *The Originality of the Avant-Garde and Other Modernist Myths* (Cambridge, MA: MIT Press, 1986).

14. Lawrence Lessig, *Code and Other Laws of Cyberspace* (New York: Basic Books, 1999); see also Lawrence Lessig, *Code v.2: Code and Other Laws of Cyberspace* (New York: Basic Books, 2006), downloadable from <http://codev2.cc>.

15. Alexander R. Galloway, *Protocol: How Control Exists after Decentralization* (Cambridge, MA: MIT Press, 2004).

16. Noboru Ohta and Alan Robertson, *Colorimetry: Fundamentals and Applications* (New York: Wiley, 2005).

17. Douglas Gomery, *A History of Broadcasting in the United States* (Oxford: Blackwell, 2008).

18. Adrian Mackenzie, "Codecs," in *Software Studies: A Lexicon*, ed. Matthew Fuller (Cambridge, MA: MIT Press, 2008), 48–55, 49.

19. Sean Cubitt, "Codecs and Capability," in *Video Vortex*, ed. Geert Lovink (Amsterdam: Institute of Network Cultures, 2008), 45–52.

20. Mackenzie, "Codecs," 48–55, 49.

21. Michel Foucault, *The Birth of Biopolitics: Lectures at the Collège de France 1978–1979*, ed. Michel Senellart, trans. Graham Burchell (Basingstoke: Palgrave Macmillan, 2004).

3 The Unmasking of Images: The Anachronism of TV-Faces

Martin Schulz

"The unmasking of images": This title has to be understood in a quite literal sense. Indeed, it does not point to an unmasking in the conventionally metaphorical and negative sense, as in the unmasking of a deeper truth, an unconscious structure, or the exposure of political calculation, which conceals itself behind the shimmering appearance of a media-based masquerade. With regard to the floods and battles of images brought forth from our powerful mass media, it is generally appropriate to suspect that behind images is a truth that is different from their colorful surfaces. All images are staged and manipulated. Therefore, they lie and conceal something with their obtrusive visibility, which inevitably remains unseen. Every one of today's consumers of images is as subject to an ancient belief in images as he is an enlightened iconoclast. Although the examples from film and television, which are foregrounded in this context, only serve to confirm the suspicion of deceit and make it transparent with the intention to expose it, a different kind of perspective is taken up concerning the following image-faces, a perspective that focuses on their media-related stratifications: the many layers between natural faces, their practiced facial expressions and artificial masking, as well as their disembodied and technologically reconfigured image-faces, which are dispersed by mass-media, perceived billions of times, and can be unmasked literally. They indicate that, even regarding all the most obvious differences, the anachronic imagery-principle of masking actually looms over the most modern electronic images of the twenty-first century; they furthermore show that modes of representation persist that have a much older history. Thus, here it is not the cultural encoding, which determines and shapes these faces, that is analyzed with respect to the face-to-face communication between image and viewer. It is more important in this context to highlight the connection between face, mask, image, medium, and representation.

1 The Culture and Science of Images and Visual Studies

The matter of course with which streams of images are turned on and perceived every day on all TV channels makes it easy to forget that, facing the spectacle of remote-controlled images easily permeating time and space, their consumers are "only" dealing with images, after all. Just to move toward the featured examples, which are representative of many others: It is now quite undemanding and ritualized to, at the touch of a button, summon the familiar face of a newsreader to the household TV screen, to view it and hear it speak at an intimate proximity and yet at a safe distance, and to be viewed and spoken to while being neither seen nor heard (figure 3.1). Although one likes to be deceived, we all know only too well that the telepresent face is invariably a staged, symbolic picture-face merely brought to life and relayed by the media, a face that seems to be alive, but is not. More importantly, it becomes apparent as an image within an image insofar as the picture-face that is transmitted is already predefined by a made-up, stylized face whose expressions are informed by certain cultural conventions and which is, in any case, perceived from the viewer's perspective as the surface of a potential image. Thus, every TV-face is integrated into a long chain of prior images and afterimages, imaginary images and perceived images; and conse-

Figure 3.1
ARD-Tagesschau with Eva Hermann, 2004.

quently, it is impossible to determine precisely where the actual image might be located and at what point the presence and identity of a "real" face differs from its artificial represence.

On the one hand, in this context one should not rely on the distinction between a unique, metaphysically true source-image and a more or less accurate and similar reflection that represents it. On the other, it would not be opportune to proceed from the often-diagnosed hyperreality of images, which is said to superimpose itself on all that is real, making any distinctions infeasible. As a result, it is sensible to agree in advance about an understanding of the culture of images in a narrow sense. Even as one is dealing assuredly with images in everyday life or confidently speaking about images—that is, pictures on walls, in frames, images on the stage or on the screen, or even in dreams—it is still problematic to give images an abstract definition concerning their phenomenal diversity.

But instead of presupposing the necessity of a narrow concept of images, it is possible to have a more open and flexible debate, if one proceeds on the assumption of a symbolical culture of images; more precisely: of different cultures of images that prescribe specific attitudes, framings, technologies, formats, formattings, and settings of images, but which most importantly also have inseminated, provoked, and ritualized certain techniques and operations of culture, which are only meaningful with respect to images and would appear inappropriate otherwise:[1] to place oneself in front of a painting in a museum, to sit in a theater, to turn on the TV set at a certain time or to wait in a cinema for the lights to finally fade and an otherworldly universe of images to light up. Obviously, a culture of images that is perceived thus is closely connected to media, which materialize these images, embody them in a metonymical sense, and make them visible for all in the first place; it is also closely connected to the viewing and acting bodies in a specific cultural situation, without which they likewise would not exist and register as images.[2]

Yet, many phenomena of visual culture can be understood as pictorial in the broadest sense; for instance: bodies presenting themselves adorned with makeup, styling, clothes, and jewelry; the design of a car; a beautiful landscape or vast architectonic spaces, in which certain orders of perspective manifest. The long-established *visual studies*, in all their heterogeneous breadth, link to these manifestations. There is an ongoing and lively debate about what the visual and visuality are exactly meant to be; what, if everything visual is the object of discussion, constitutes the subject matter and the authoritative methodology; and finally, if in this sprawling, inclusive view the images' historical, cultural, media-related, and qualitative differences are not blended with each other and leveled.[3]

In this context, it would be undesirable to dwell on this far-reaching and differentiated discussion. But in this possibly endless variety of hypothetical topics, one is able to make out a common denominator of visual studies, which consists primarily in the

iconoclastic critique concerning strategies grounded on the expediencies of power-politics and their effect on images, their media, and their scopic regimes of the twenty-first century.[4] There are quadrillions of images available to this end, and each one, irrespective of all differences, demonstrates something that is genuinely pictorial. Of course those pictures are always more suitable which, via their own characteristics and thus in a metapictorial way, show their historical, media-related, or political conditions as images. Typically, these can be images of self-reflexive and autonomous art; yet, even regarding all qualitative differences, they can also be the most trivial and nevertheless the most powerful images disseminated by the mass media: the television images beamed every day from a great distance into the most private of spaces. Without doubt, these are among the most influential images that exist per se, and they are equipped with the greatest potential for distribution—with a potential that scarcely an institution has been faster and better at recognizing than the Catholic Church, which right up to the present day continues to impressively demonstrate its visual power and competence (figure 3.2). Marshall McLuhan, the father of the theory of new electronic media and himself a converted Catholic of profound faith and with a strong sense of mission, not incidentally possessed an attuned sensitivity for this; and it was no coincidence that he was appointed by the Vatican in 1973 as official media adviser.

Even more influential is the manner in which political powers have long since employed the "magic channels." Their official TV images are no less calculated and staged, but are, as it would seem, more porous and fertile concerning unmasking actions that reveal what images are all about—and not only in a political sense. A montage from a popular film that was widely circulated appears to be well suited for a case study: the opening sequence of the film *Fahrenheit 9/11*, which was compiled by Michael Moore in 2004 with obviously polemic and tendentious intentions. Here-after, only the picture-faces assembled in the opening sequence will be singled out for an abstract analysis in order to return to the actual topic, that is to say the masklike quality of picture-faces.

2 The Power in Makeup: *Fahrenheit 9/11*

If one freezes the moving images, removes them from their cinematic sequence, and orders them side by side, one gets the impression of pictures belonging to a somewhat odd portrait gallery. Do they show individual faces, or rather the standardized and thus exchangeable masks and appointed bodies of modern political power? These are, in any case, the globally recognizable and already departed TV-faces belonging to politicians of the most powerful nation on earth: the picture-faces of George W. Bush, Condoleezza Rice, Donald Rumsfeld, Colin Powell, John Ashcroft, Tom Ridge, and not least of Paul Wolfowitz, the former director of the World Bank; picture-faces that,

Figure 3.2
Pope Benedikt XVI, 2007.

involuntarily comical and unfiltered, reveal their masquerade and double-facedness in the very media that also produce, stage, and distribute their faces; faces that share with many other television-faces the privilege, the competence, but also the risk of having an omnipresence as images in the glaring light of the public sphere, which are intricately bound up with success and defeat; pictures of the preparation of picture-faces and their preceding models, which present the powerful as puppet-like, passive, and disempowered entities; procedures that, as a rule, will not (and are not supposed to) be visible any longer when they are shown live and publicly as perfectly staged images with all the regalia of power; and hence they are also images that show

themselves to be images before they actually become images, thus revealing the paradox of all forms of masks, which consists in their revealing and emphasizing something while at the same time replacing and hiding something else. This film—which, however, as a filmic readymade, and thus found in the archives of TV stations, selected and assembled into new montages—very easily offers itself as symbol for the Janus-faced nature of these made-up and styled faces, these talking heads, behind whose faces there are always other faces, behind whose speeches, as the statement provocatively suggests, there are always concealed intentions actually tied to self-interested politics of war.

The process of iconoclastic dismantling, which is as straightforward and simple in this film as in any other and which looks back on many predecessors of the mocking, demasking, or destruction of political idols or bogeymen, did not stay undisputed for long. The high distinction of the 2004 Cannes film award alongside the initial rubbernecking concerning exactly such pictures has in the meantime turned into a significant amount of criticism directed at the film's suggestive intentions, which—ineffectively—were primarily meant to prevent the reelection of Bush; there was also criticism concerning this polemical and in many aspects dubious documentary, especially with regard to the manipulation of the readymades, which were clipped from very different contexts, put into new montages, zoomed and slowed down, and which originated from vague sources that were not cleared up in the closing credits. Only the shots of the American president George W. Bush can be identified and correlated. These originate from the minutes and seconds before his TV address to the United States on March 20, 2003, in which he announced the commencement of armed hostilities against Iraq (see figures 3.3, 3.5).

Even if Michael Moore probably did not intend it, this opening sequence is also especially fruitful for more general questions of image theory and the history of images, questions that put the particular relations between face, mask, picture, and their specific media into focus. Even if everything appears to be banal, obvious, and

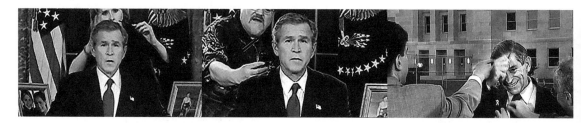

Figure 3.3
Stills from *Fahrenheit 9/11*, dir. Michael Moore, 2004. Left, middle: George W. Bush. Right: Paul Wolfowitz.

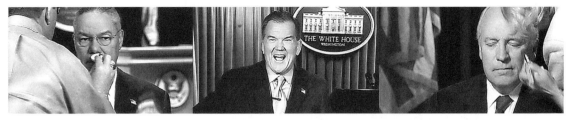

Figure 3.4
Stills from *Fahrenheit 9/11*, dir. Michael Moore, 2004. Left: Colin Powell. Middle: Tom Ridge. Right: Richard Cheney.

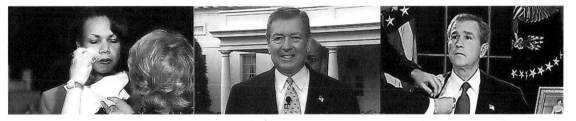

Figure 3.5
Stills from *Fahrenheit 9/11*, dir. Michael Moore, 2004. Left: Condoleezza Rice. Middle: John Ashcroft. Right: George W. Bush.

familiar, it is revelatory to follow the procedure of the faces becoming and being pictures, which not only in contemporary television culture make up a large, if not the largest, proportion of all images. A process of natural faces becoming pictures becomes visible, faces that in themselves can already be regarded as dynamic masks of a visible-invisible interior. A transformation of bodily and thus visible faces becomes recognizable, a transformation via their artificial masking into TV-faces, which are configured by electronic devices, focused, framed, recorded, stored, multiplied, and isolated from the rest of the body, in a metamorphosis and pupation that is finally perceived by the viewers who receive, gaze at, evaluate, reassemble, and ultimately project these images again (see figure 3.5).

In recent works of media art, this relation between body, masking, transference, and media-based represence was reflected, for instance, in the cinematic installation *Make Up* by Bruce Nauman in 1968 (figure 3.6). Imagine these pictures in color, projected singly as ten-minute films on the four walls of a square room. One sees the artist as he covers himself with white paint, followed by pink, green, and finally black paint, until his whole body each time is covered by the coat of paint. The "natural" body vanishes beneath a coat of paint, while at the same time becoming present in a

Figure 3.6
Bruce Nauman, *Make-Up*, Stedelijk Museum Amsterdam (photos by Glenn Halvorson, Walker Art Center, Minneapolis).

new way. A body is present as a self-painting subject, which simultaneously turns into an object, a picture-object; the body, one could say, is carrier of a picture and, then again, itself a picture within the framework of cinematic pictures; consequently, different pictorial layers superimpose each other in this case: the "natural" body, the body in makeup, the technically recorded, changed, and then transmitted body, and, finally, the body perceived as a sequence of cinematic pictures.

3 Prehistories of the 21st Century

Furthermore, the modes of representation of TV-faces are, even given all technological advances, far from new. The format of the frontally aligned half-figure portrait, which is indeed distinctly visible in the techniques of the modern media, in fact belongs to a very old convention and tradition of imagery. The millions of picture-faces that surround us daily on billboards, newspapers, on all TV channels, which look at us, attract us or repulse us, persuade us or tyrannize us, have—even with respect to all significant differences—a long history. The fact that the career of any politician has few prospects if he does not have those masking possibilities at his disposal which are prerequisite for any media appearance is one result; hence we live with the politics of televisual picture-faces, which decide elections. Thomas Macho has retraced the

deep historical dimensions of the dominant "facial messages" and their "late-industrial animism," just as "birth from the spirit of masking," to the Neolithic.[5] And it is possible to take this history even further, if one wants to follow Peter Sloterdijk, who understands anthrophogeny, the becoming of man, as the becoming of faces in an interfacial space, as a "protraction" of the face, which thus is no longer limited to snarling and swallowing, but the senses of which become free, cultivated, and open.[6]

In this context one should refer to the prominent and frequently cited theses of Gilles Deleuze and Felix Guattari.[7] In *mille plateaux* they interpret the modern face—and this is the European face, white and male—which, in the mass media, is amputated from the body and transformed into an optical-effect surface, singly as a mechanized mask of a subject despotically controlled by pastoral and capitalistic power. But the following will not deal primarily with constructions and disseminations of faces in the service of power politics, with nonautonomous encodings, ascriptions, and masquerades; it will not be about the possibilities of fictive role-playing, about the performance or expression of a subject or the soul and physiognomy; and thus not as much about the face as a canvas of interior and exterior inscriptions, compared to the topic it is in close-ups, especially in film theory.[8] The dictated allocation of a set of semantics, the codification and thus legibility of the face as a "strong organization"—with their frequently interpreted breaks concerning the histories of media and discourse—are, in this case, not the actual topic, although the above-mentioned picture-faces are certainly very closely connected to this perspective.[9] Instead, these images are analyzed under the perspective of a continuity of modes of representation and their conditions. They shed light on presets, which, even with regard to all historical differences, make sense only in the larger context of the history of images.

Just a brief digression into the history of the term *mask*, which is of no small importance here: The original Greek term for this is *prósopon*, which may denote face and mask at the same time, with and no contradiction. Translated literally, *prósopon* is: "That which lies before the view." My "natural" face is already an external mask, which is seen by another. The Latin translation of *prósopon* is *persona*, which actually denotes the mask, mainly the theater mask, but also the social role. The mysterious, paradoxical body of Jesus Christ for example, the mystery of his death and resurrection as celebrated on Easter, was called a *persona* after long arguments about its double nature: the human, natural body he also possessed was in a way the *persona* of his supernatural, godlike nature. Again, the term has no negative connotation. For a long time it was thought, incidentally, that the word *persona* derived from the verb *personare*, thus from "sounding-through," on the assumption that this derived from the speaking-hole of the theater mask through which the *persona* would sound. According to the latest research, this is wrong. Rather, it seems that the ancient Etruscan god of

earth *Persu* is behind *persona*, at whose gory rituals a masked dancer would partici-
pate—something one should keep in mind when looking at one's personal identity
card today.[10] Today's common word "mask" has been borrowed since the eighteenth
century from the Arabian language and has had since then the negative connotation
that the mask is always showing a false and hiding a true face.

4 Face and Image

Thus, the critical starting point consists primarily in the close cultural relationships
between image and body, culture and face, image and human being, and especially
between image, mask, and face, which Claude Lévi-Strauss, for instance, perceives as
the first and original picture frame, as a picture frame "par excellence," as he calls it
(figure 3.7).[11] In this sense, the face was a frame for pictures, for paintings and tattoos,
before the artificial face—and this would be the continuation of the thesis—detached
itself, was transferred to external media and not only marked it as a social, religious,
or magical face and basically confirmed it as a cultural face, but also re-presented it.
But one could make a connection between the anthropo-logic of the mask and the
specific phenomenon of the Western portrait: The tremendously rigidified tradition
of the half-figure picture, which, as pertinent examples imply, can be imagined as a
mask stripped from a face, as a mask that remains when its wearer has died and left
nothing behind but the denuded and hollow skull. It is possible to deduce the close
relationship between face and mask as one of the oldest implicit theories of the image,
as well as one of complex interplay between invisible interior and visible exterior,
between the dynamic, expressive, and projective screen of the face and the principal
issues of the self.

The image engraved on a portrait cover from Florence, created around 1520 by an
anonymous artist, may serve as a concise example. This cover concealed a portrait
which itself is missing today (figure 3.8).[12] These types of pictures, which were designed
to enable the staging of discovery and concealment, principally existed within a
private context. But even as they are very specific concerning their history and their
humanistic ideas and concepts, they yet allow information about a fundamental dia-
lectic of faces turned into pictures. In the center of the image, surrounded by grotesque
dolphins and chimeras, is a flesh-colored mask of simple and genderless typecast. It
is characterized by large eyes, a beautiful nose, and an indifferent mouth. Above it on
a simulated marble tablet one reads an inscription in Roman capitals: *Sua cuique
Persona.* This ambiguous elliptical form makes both "To each one's own mask" and
also "Everyone has a mask" possible readings. It is not feasible to elaborate on the
multilayered term of *persona* in this context, which, as indicated above, additionally
and decidedly denotes the *social* role and derives from the modern concept of
"person."[13] In brief: One would misunderstand the inscription together with the mask,

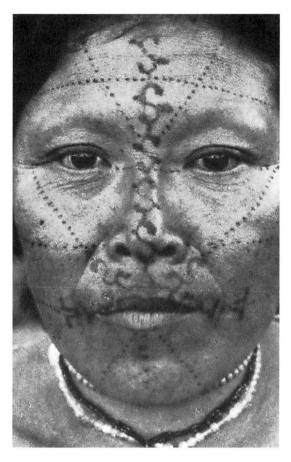

Figure 3.7
Caduveo-Woman with face painting, 1935, from Claude-Lévi-Strauss, *Traurige Tropen* (Frankfurt, 1978).

if one were to read it as a simple antithesis to the painted, individual portrait that is hidden behind it, and thus ultimately to the natural face of the person, which was once painted as a picture. In fact it hints at the close connection to the natural face as the carrier of a *persona* and therefore at the unity of possible differences (and not, as one might think, at their contradiction): between natural and artificial, private and public, self and other, moved and unmoved, and finally in a concrete manner between the natural face as the carrier of a mask, the painted face as a mask of a natural face that is transmitted by a medium, and finally the artificial mask itself, which enables one to take over a specific role in society.

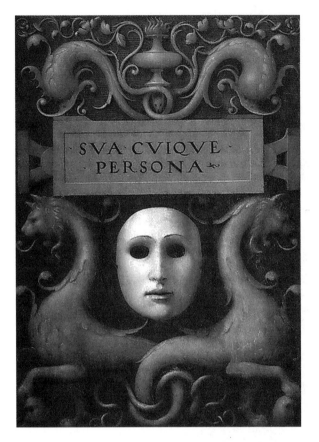

Figure 3.8
Anonymous, ca. 1520, Florence, Uffizien.

5 TV-Masks

The anachronism of TV images, which are here only presented as stills, and which are additionally considered abstracted from their cinematic as well as their political context, should not gloss over the characteristic manner of their medial creation and dissemination, a manner that is not only philosophically and phenomenologically new, but is also new to the history of images. In the age of mass media, they show an extremely multiplied layering, fragmentation, proliferation, arbitrariness, and disembodying with regard to this relationship between face and picture, while, in contrast to the rigid mask, the imitative activity of the animated TV pictures corresponds more closely to living faces. But the transformation of natural faces into artificial picture-faces can be identified as processes of masking, and as processes of masking that

progressively detach themselves from the body. These processes of masking initially require a passive, sleep- or deathlike posture from which, as the images suggest, one awakens with a new facelike mask feeling dazed and alienated; with this new face one enters into the ritual of actually becoming an image (see figure 3.4).

Pose and facial expression, which one has to adopt facing the directors and in expectation of being captured in a picture, are part of this; as are, furthermore, the relaxation of the facial muscles, which serves the preparation of facial performance; and, moreover, the work of the makeup artists and hairstylists as well as of the soundmen and video engineers. Yet these film prerecordings only show the moments of preparation and, one could say, the "foreplay" of the transformation into a literal *interface*, which positions itself between the living faces and their viewers; moments of the translation of faces that, in the preliminary stages, can still be touched and spoken to as natural bodies, before they acquire an entirely media-centered, disembodied, and disconnected distance, becoming a mere moving surface, completely visual; before they are transferred from a real presence at a fixed place into an interchangeable represence at countless places.

This second transformation into a lasting picture or, more precisely, into the sequence of moving pictures that are lasting but still appear as temporary, is delegated to an external medium. In turn, this medium—always with regard to the use of its technical, but also its symbolic properties—disengages the masks from the body, reconfigures, stores, and transmits them. In this case, the faces are turned not into the painted portrait of a panel picture, but into electronic TV images, which are scattered to innumerable places and reproductions—reproductions that appear on millions of screens, which can be formatted and revised at will, which have long been digitalized, cut, and transferred to DVD, and which can be recorded and bought by the public.

But death still lurks at both ends of the transformation from a natural face into the masked face of the medium: It lurks behind the living face that covers the *hardware* of the bones with skin and muscle, the faceless and thus anonymous dead skull, the consummate symbol of transience and death and the picture of pictureless-ness, which on the back of some modern portraits reminds one of the actual state of the person who can be seen on the front as seemingly alive (figure 3.9, 3.10). The back of a painting by Giovanni Antonio Boltraffio shows a skull in a dark alcove; with teeth missing and without its lower jaw, it appears in a state of advanced decomposition. An inscription can be read, in which the hollow skull addresses the viewer personally, although it ultimately is no longer an individual. Death, which equalizes all individuals, thus seems to speak as a person: *Insigne sum Hieronimi Casii*—"I am the coat of arms of Hieronimus Casius." The dead skull, according to this macabre as well as baldly trenchant statement, is the actual carrier, the vanishing point, the matrix of each and any individual, living, and thus transient face, quite independent from the status, rank,

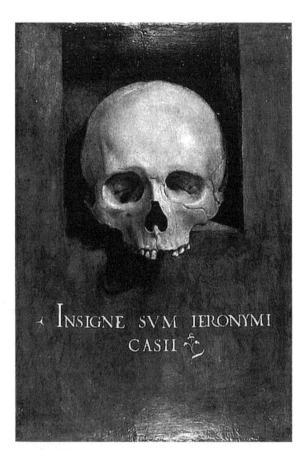

Figure 3.9
Giovanni Antonio Boltraffio, portrait of Hieronymus Casius (back), ca. 1510. Collection Chatsworth.

or estate of the person belonging to it. It is the other side of that which appears on the front of the painting as the living face of a youthful and handsome poet. In reality, the picture itself consists of dead matter, and the painted and media-transformed individual, which is its subject, is long dead itself or will die in due course. The rigid surface of a mask which no longer has a living wearer remains—and will remain. But then again, premature death waits in front of the living face (see figure 3.5): a media-based decapitation, which isolates the head from the rest of the body in an inclusive and exclusive framing, a media-based mummification into an artificial face and into a death mask to be animated henceforth; a translation that, according to the old Platonic critique of all artificial media, separates it from life itself and thus leaves it

Figure 3.10
Giovanni Antonio Boltraffio, portrait of Hieronymus Casius (front, detail), ca. 1510. Collection Chatsworth.

crippled, amputated, falsified, lifeless, and, most importantly, no longer able to take part in a dialogue.

6 Face; Mask; Image; Medium; Culture

We are led to a cardinal question concerning visual studies, which perceives itself as a cultural history of images: Do these technological TV images denote a new and completely new stage in the history of images compared to those analog images that were created by hand and eye, using paint, brushes, canvas, and wood? Is the one completely disconnected from the other, and if not, is the only connection based on matters of outward appearance? Concerning the purely technological dimension and with respect to the enormous changes of spatiotemporal organization as well as the boundless multiplication, manipulability, circulation, and availability of images, the first question has to be answered with an unreserved "yes." But on the other hand, the present examples fulfill general conditions and rites of transmission that are only meaningful and self-evident within a specific culture; in a different culture of images, they may well be unintelligible, disturbing, or even obscene, blasphemous, and forbidden. This was shown not least by the masked television appearance of Susanne Osthoff, who was kidnapped in Iraq in 2005, and who covered her face with a *chador* during recording and transmission (figure 3.11). But during her first, hurriedly organized interview every German expected to see a tired, suffering, but also happy face, a face with a glad expression about being reintroduced to the civilized and peaceful community of enlightened Western society and its familiar culture of images. Accordingly, there was a collision with the differently masked TV-face of the German news icon Marietta Slomka, a collision that deeply jarred and was perceived as provocation, gaffe, ingratitude, and even betrayal; a pointed *iconoclash*, which evidently also exposed the masquerade of Western TV-faces.[14] Obviously, the character of these images as portraits, where—seemingly naturally—the controlled, made-up face with well-coiffed hair is the central and isolated carrier of expression, is historically and culturally determined (see figure 3.5).

As they were found and used unfinished, and in a state in which they were not intended for the public, the preceding examples from Michael Moore's film basically show caricatures of prospective portraits. In a rather involuntary and subconscious way, they clarify the close analogy between face, mask, and picture. These image-faces demask themselves in a literal sense as they make the various layers of masking visible which make up their transformation into images. Michael Moore exploited these images for a political caricature and demasking within the rhetorical structure of a film relying heavily on montage, a film whose claim to being a truthful documentary, even the suggestion of such a claim, has to be doubted. In the perspective proposed here, these images are more apt to emphasize the literally spatial and temporal anterior

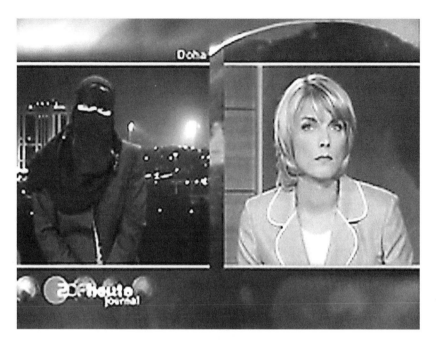

Figure 3.11
Susanne Osthoff and Marietta Slomka in ZDF, 2006.

and posterior of masking. As has been mentioned beforehand, this should neither be perceived as putting forward a case for the infinite and hyperreal linking of images, nor, as frequently observed, for a crisis of the natural face, which, despite all of today's surgical procedures and digital constructions, never possessed a stable, unmasked, and natural pattern. But the question remains fundamental for visual studies of the twenty-first century, whatever its self-conception might be: Where do the images begin and end? Are they already written into the natural face, which covers the naked skull? Do they start with the masking? Do they develop during the recording? Do they only exist on a carrier of data? Do they emerge during the moment of their transmission or, in the end, only in the heads of their viewers? One will have to say that pictures form via the interaction of all these layers, which are moreover in the phase of their greatest expansion and multiplication. Thus, the rudiments of the new, technical pictures presented here shimmer with something different and anachronic, which cannot be located singly in the culture of media technology—something that not only developed as a cultural convention during the long history of culture with all its alterations, but that also justifies speaking of an anthropology of images and their media.

Notes

1. See *Kulturen des Bildes*, ed. Birgit Mersmann and Martin Schulz (Munich: Fink, 2006).

2. See W. J. T. Mitchell, *Picture Theory: Essays on Verbal and Visual Representation* (Chicago: University of Chicago Press, 1994); Hans Belting, *Bild-Anthropologie: Entwürfe für eine Bildwissenschaft* (Munich: Fink, 2001); Martin Schulz, *Ordnungen der Bilder: Eine Einführung in die Bildwissenschaft* (Munich: Fink, 2005).

3. See especially the criticism in *October* 77 (1999); also W. J. T. Mitchell, "Showing Seeing: A Critique of Visual Culture," in W. J. T. Mitchell, *What Do Pictures Want? The Lives and Loves of Images* (Chicago: Chicago University Press, 2005), 336–356; Mieke Bal, "Visual Essentialism and the Object of Visual Culture," *Journal of Visual Culture* 1/2 (2003): 5–32; Margaret Dikovitskaya, *Visual Culture: The Study of the Visual after the Cultural Turn* (Cambridge, MA: MIT Press, 2005); Keith Moxey, "Visual Studies and the Iconic Turn," *Journal of Visual Culture* 7 (2008): 131–146.

4. Concerning this and in contrast to the German "Bildwissenschaft," see Schulz, *Ordnungen der Bilder*; Moxey, "Visual Studies and the Iconic Turn."

5. Thomas Macho, "Vision und Visage: Überlegungen zur Faszinationsgeschichte der Medien," in *Inszenierte Imagination. Beiträge zu einer historischen Anthropologie der Medien*, ed. Wolfgang Müller-Funk/Hans-Ulrich Reck (Vienna/New York: Springer, 1996), 87–108.

6. Peter Sloterdijk, *Sphären I: Blasen* (Frankfurt: Suhrkamp, 1998), 141ff.

7. Gilles Deleuze and Felix Guattari, "Das Jahr Null: Die Erschaffung des Gesichts," in *Tausend Plateaus: Kapitalismus und Schizophrenie* (Berlin: Merve, 1997), 229–262; English translation, *A Thousand Plateaus: Capitalism and Schizophrenia*, trans. B. Massumi (Minneapolis: University of Minnesota Press, 1987).

8. Jacques Aumont, *Du visage au cinema* (Paris: Cahiers du Cinéma, 1992); Gertrud Koch, "Nähe und Distanz: Face-to-Face-Kommunikation in der Moderne," in *Auge und Affekt. Wahrnehmung und Interaktion* (Frankfurt: Fischer, 1995), 272–291; Ernst H. Gombrich, "Maske und Gesicht," in Ernst H. Gombrich, Julian Hochberg, and Max Black, *Kunst, Wahrnehmung, Wirklichkeit* (Frankfurt: Suhrkamp, 1977), 10–60.

9. The face as image and the "facial society" has been the booming topic of many discussions, especially with regard to media-related upheavals and crisis. See the contributions in *The Portrait in Photography*, ed. Graham Clarke (London: Reaction Books, 1992); *Das Gesicht ist eine starke Organisation*, ed. Petra Löffler and Leander Scholz (Cologne: Dumont, 2004); *Medium Gesicht: Die faciale Gesellschaft*, ed. Gerburg Treusch-Dieter and Thomas Macho (Berlin: Elefanten-Press, 1996); *Blick Macht Gesicht*, ed. Helga Gläser, Bernhard Groß, and Hermann Kappelhoff (Berlin: Vorwerk, 2001); *Das Gesicht im Zeitalter des bewegten Bildes*, ed. Christa Blümlinger and Karl Sierek (Vienna: Sonderzahl, 2002).

10. Manfred Fuhrmann, "Persona, ein römischer Rollenbegriff," in *Identität*, ed. Odo Marquard and Karlheinz Stierle (Munich: Fink, 1979), 122–146.

11. Claude Lévi-Strauss, "Die Zweiteilung der Darstellung in der Kunst Asiens und Amerikas," in *Strukturale Anthropologie*, vol. 1 (Frankfurt: Suhrkamp, 1977), 27–291; Lévi-Strauss, "Eine Einge-borenengesellschaft und ihr Stil," in *Traurige Tropen* (Frankfurt: Suhrkamp, 1982), 168–189.

12. For a more extensive discussion of this image see Hannah Baader, "Anonym: Sua cuique Persona," in *Porträt*, ed. Rudolf Preimesberger, Hannah Baader, and Nicola Suthor (Berlin: Reimer, 1999).

13. See Fuhrmann, "Persona, ein römischer Rollenbegriff."

14. The term "iconoclash" is taken from Bruno Latour and the eponymous exhibition, which was jointly curated with Peter Weibel: Bruno Latour, *Iconoclash: Gibt es eine Welt jenseits des Bilderkriegs?* (Berlin: Merve, 2002); English translation, *Iconoclash: Beyond the Image Wars in Science, Religion, and Art*, ed. Bruno Latour and Peter Weibel (Cambridge, MA: MIT Press, 2002).

4 Bio Art: From *Genesis* to *Natural History of the Enigma*

Eduardo Kac

For almost two decades my work has explored the boundaries between humans, animals, and robots.[1] Thus, transgenic art can be seen as a natural development of my previous work. In my telepresence art, developed since 1986, humans coexist with other humans and nonhuman animals through telerobotic bodies. In my biotelematic art, developed since 1994, biology and networking are no longer co-present but coupled so as to produce a hybrid of the living and the telematic. With transgenic art, developed since 1998, the animate and the technological can no longer be distinguished. The implications of this ongoing work have particular social ramifications, crossing several disciplines and providing material for further reflection and dialogue.

The presence of biotechnology will increasingly change from one found mainly in agricultural and pharmaceutical practices to a larger role in popular culture, just as the perception of the computer changed historically from an industrial device and military weapon to a tool of communication, entertainment, and education. Terms formerly perceived as "technical," such as *megabytes* and *ram*, for example, have entered the vernacular. Likewise, technical jargon that may seem out of place in ordinary discourse, such as *marker* and *protein*, will simply be incorporated into the larger verbal landscape of everyday language. This is made clear by the fact that high school students in the United States already create transgenic bacteria routinely in school labs, using affordable kits. The popularization of technical discourse inevitably risks the dissemination of a reductive and instrumental ideological view of the world. Without ever relinquishing its right to formal experimentation and subjective inventiveness, art can—art should—contribute to the development of alternative views of the world that resist dominant ideologies. In my work I subvert contemporary technologies—not to make detached comments on social change, but to *enact* critical views, to make present in the physical world invented new entities (artworks that include transgenic organisms) that seek to open a new space for both emotional and intellectual aesthetic experience.

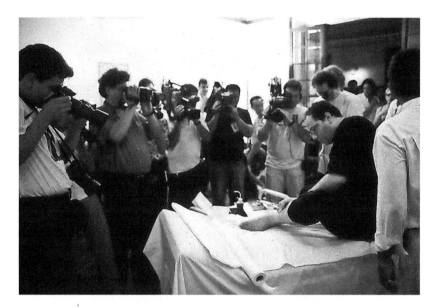

Figure 4.1
Eduardo Kac, *Time Capsule*, 1997. Microchip implant, simulcast on TV and the Web, remote scanning of the microchip through the Internet, photographs, X-Ray. Dimensions variable. Collection BEEP—Data Logic, Madrid. © Eduardo Kac.

I coined the phrase "bio art" in 1997, in reference to my own works that involved biological agency (as opposed to biological objecthood), such as *Time Capsule*[2] (figure 4.1) and *A-positive*,[3] both presented in 1997. The difference between biological agency and biological objecthood is that the first involves an active principle whereas the second implies material self-containment. In 1998 I introduced the phrase "transgenic art" in a paper-manifesto with the same title[4] and proposed the creation (and social integration) of a dog expressing green fluorescent protein. This protein is commonly used as a biomarker in genetic research; however, my goal was to use it primarily for its visual properties as a symbolic gesture, a social marker. The initial public response to the paper was curiosity laced with incredulity. The proposal is perfectly viable, but it seemed that few believed the project could or would be realized. While I struggled to find venues that could assist me in creating the aforementioned project, entitled *GFP K-9*, I realized that canine reproductive technology was not developed enough at the time to enable me to create a dog expressing green fluorescent protein.[5] In the meantime, I started to develop a new transgenic artwork, entitled *Genesis*, which premiered at Ars Electronica '99.[6]

Genesis

Genesis is a transgenic artwork that explores the intricate relationship between biology, belief systems, information technology, dialogical interaction, ethics, and the Internet. The key element of the work is an "artist's gene," a synthetic gene that was created by translating a sentence from the biblical book of Genesis into Morse code, and converting the Morse code into DNA base pairs according to a conversion principle I developed specifically for this work. The sentence reads: "Let man have dominion over the fish of the sea, and over the fowl of the air, and over every living thing that moves upon the earth." It was chosen for what it implies about the dubious notion—divinely sanctioned—of humanity's supremacy over nature. Morse code was chosen because, as the first example of the use of radiotelegraphy, it represents the dawn of the information age—the genesis of global communication. The *Genesis* gene was incorporated into bacteria, which were shown in the gallery. Participants on the web could turn on an ultraviolet light in the gallery, causing real, biological mutations in the bacteria. This changed the biblical sentence in the bacteria. After the show, the DNA of the bacteria was translated back into Morse code, and then back into English. The mutation that took place in the DNA had changed the original sentence from the Bible. The mutated sentence was posted on the *Genesis* website. In the context of the work, the ability to change the sentence is a symbolic gesture: It means that we do not accept its meaning in the form we inherited it, and that new meanings emerge as we seek to change it.

While presenting *Genesis*, I also gave a public lecture in the context of the symposium "Life Science," presented by Ars Electronica '99. My lecture focused on the *GFP K-9* proposal. To contextualize my presentation, I reviewed the long history of human-dog domestication and partnership, and pointed out the direct and strong human influence on the evolution of the dog up to the present day. Emphasizing that there are no packs of poodles and chihuahuas running in the wild, and that the creation of the dog out of the wolf was a technology—a fact that we seemed to have lost awareness of—I proceeded to point out the complex relationship between dogs and humans throughout their long history together, going back at least fourteen thousand years according to archaeological records. While some showed support and appreciation for the work, others reacted against the project and voiced their position. The stage was set for a very productive dialogue, which was one of my original intentions. As I see it, the debate must go beyond official policymaking and academic research to encompass the general public, including artists. *GFP K-9* was discussed in art magazines, books, science journals, daily papers, and general magazines. While specialized publications showed greater appreciation for *GFP K-9*, the response in the general media covered the whole gamut, from forthright rejection to consideration of multiple implications to unmistakable support. The shock generated by the proposal curiously

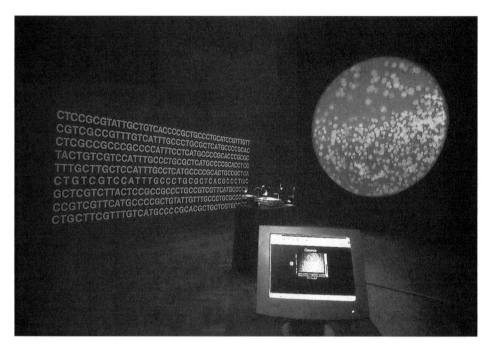

Figure 4.2
Eduardo Kac, *Genesis*, 1999. Transgenic work with live video, light box, microvideo camera, petri dish with Genesis gene, website. Edition of two. Dimensions variable. Collection Instituto Valenciano de Arte Moderno—IVAM, Valencia. © Eduardo Kac. See plate 8.

caused one critic to declare "the end of art."[7] As I see it, there's no reason to see the beginning of a new art as the end of anything (figure 4.2, plate 8).

GFP Bunny

This pattern of response repeated itself, at a truly global scale, when I announced in 2000 the realization of my second transgenic work. Entitled *GFP Bunny*, the work comprises the creation of a green fluorescent rabbit (named Alba), the public dialogue generated by the project, and the social integration of the rabbit. This work was realized with the assistance of Louis Bec and Louis-Marie Houdebine. Louis Bec worked as the producer, coordinating the activities in France. Bec and I met at Ars Electronica (September 1999) and soon afterward he contacted Houdebine to propose the project on my behalf. Months later, in 2000, Alba was born, a gentle and healthy rabbit. As I stated in my paper entitled *GFP Bunny*,[8] "transgenic art is a new art form based on

the use of genetic engineering to create unique living beings. This must be done with great care, with acknowledgment of the complex issues thus raised and, above all, with a commitment to respect, nurture, and love the life thus created."

In June of 2000, *GFP Bunny* attracted local media in the south of France when Paul Vial, the former director of the French institute where Alba was born, used his authority to overrule the scientists who had worked on the project; he refused to let Alba go to Avignon and then come to my family in Chicago. Contrary to what many believe, there were no public protests. Vial made this arbitrary decision unilaterally. He never explained his reason for the refusal, and it remains unknown to this day. Bec and I denounced this censorship through the Internet and through interviews to the press.[9] If the objective was to silence the media, the result backfired. *GFP Bunny* became a global media scandal after a front-page article appeared in the *Boston Globe*,[10] sharing headlines with articles about the 2000 Olympics and U.S. presidential debates. Articles about Alba were published in all major countries, with wire services further spreading the news worldwide.[11] Alba was also on the cover of *Le Monde*, the *San Francisco Chronicle*, and *L'Espresso*, among others. *Der Spiegel* and the *Chicago Tribune* dedicated full pages to *GFP Bunny*. She also appeared on the front page of the Arts section of the *New York Times*. Broadcasts by ABC TV, BBC Radio, and Radio France also brought the Alba story to the whole planet. The relentless response to *GFP Bunny* has been equally intense and fascinating, with fruitful debate and both strong opposition and support. From October 15, 2000 to December 2, 2004, the *Alba Guestbook* collected general opinions about the work and expressions of support to bring Alba home.[12] Through lectures and symposia, Internet postings and email correspondence, the debate intensified and became richer, more subtle and nuanced, as I had hoped. The response to *GFP Bunny* constitutes extremely rich material, which I hope to revisit in the near future.

As part of my intercontinental custody battle to obtain Alba's release, between December 3 and December 13, 2000, I staged a public campaign in Paris, which included lectures, broadcasts, public and private meetings, and the public placement of a series of seven posters. I placed individual posters in several neighborhoods, including: Le Marais, Quartier Latin, Saint Germain, Champs de Mars, Bastille, Montparnasse, and Montmartre. The posters reflect some of the readings afforded by *GFP Bunny*. They show the same image of Alba and myself together, each topped by a different French word: *Art, Médias, Science, Éthique, Religion, Nature, Famille*.[13] Between December 3 and December 13, 2000, parallel to radio (Radio France and Radio France Internationale), print (*Le Monde, Libération, Transfert, Ça M'intéresse, Nova*), and television (*Canal+, Paris Première*) interviews and debates, I posted these images on the streets in an effort to intervene in the context of French public opinion and gather support for my cause to bring Alba home. I also engaged the public directly through

a series of lectures (Sorbonne, École Normale Superior, École Superior des Beaux Arts, Forum des Images) and through face-to-face conversations on the street sparked by the public's interest. In total, I reached approximately 1.5 million people (about half of the population of Paris). This was an important step, as it allowed me to address the Parisian public directly. In 2001 I created *The Alba Flag*, a white flag with the green rabbit silhouette, and started to fly it in front of my Chicago-area house. The flag signals publicly the green bunny's home, but most importantly it stands as a social marker, a beacon of her absence.

Continuing my efforts to raise awareness about Alba's plight and to obtain her freedom, in 2002 I presented a solo exhibition entitled *Free Alba!*[14] at the Julia Fried-man Gallery in Chicago (May 3–June 15, 2002). *Free Alba!* included a large body of new work comprised of large-scale color photographs, drawings, prints, Alba flags, and Alba T-shirts. Seen together for the first time were the posters from my public inter-ventions in Paris (2000), an Alba flag flying outside the gallery (2001), photographs that reclaim green bunny narratives circulated by global media (2001–2002), drawings that reflect on our closeness to the "animal other" (2001–2002) and Alba T-shirts that extend Alba's cause beyond gallery walls (2002). Through the leitmotif of the green bunny, this exhibition explored the poetics of life and evolution. The story of *GFP Bunny* was adapted and customized by news organizations worldwide, often generating new narratives that, both intentionally and unintentionally, reinstated or overlooked the facts. My *Free Alba!* exhibition featured photographs in which I re-appropriated and re-contextualized this vast coverage, exhibiting the productive tension that is generated when contemporary art enters the realm of daily news. The photographs in this series dramatize the fact that the reception of *GFP Bunny* was complex, taking place across cultures and in diverse locations. I will continue to develop new strategies to make Alba's case public and to pursue her liberation.

Parallel to this effort, transgenic art evolves. One new direction involves the cre-ation of nanoscale three-dimensional structures built of amino acids. This "proteic art," or "protein art," can be experienced in many forms, including in vivo, in vitro, and expanded into other settings, such as rapid-prototype models and online naviga-tional spaces. All of these forms, and many others, can be combined through new bio-interfaces. A prominent aspect of this path is the fact that these three-dimensional structures are assembled according to combinatory rules that follow strict biological principles (otherwise it is not possible to produce them), even if one invents and synthesizes a new protein. This constraint imposes a bio-morphology that offers a new and fascinating creative challenge. A second new direction involves complex interactive transgenic environments with multiple organisms and biobots (biological robots partially regulated by internal transgenic microorganisms). In what follows I offer a discussion of these developments, both of which I explored in 2001 (figure 4.3).

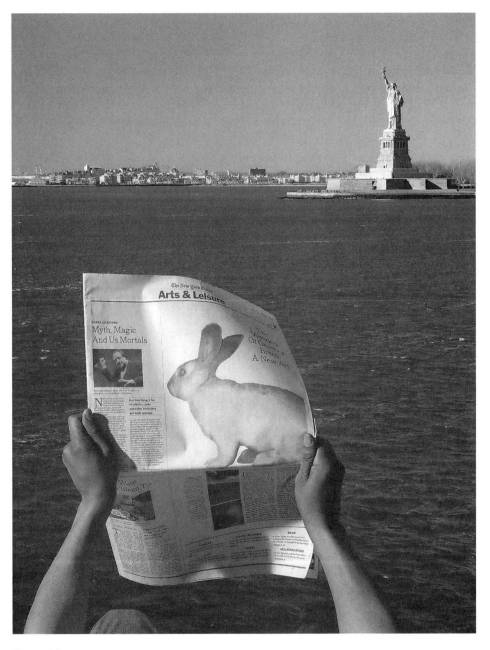

Figure 4.3
Eduardo Kac, *Free Alba! (The New York Times)*, 2002. Color photograph mounted on aluminum with Plexiglas. Edition of five. 36 × 46.5 inches. Collection Alfredo Herzog da Silva, São Paulo. © Eduardo Kac.

Sculpting New Proteins

While the first phase of *Genesis* focused on the creation and the mutation of a synthetic gene through Web participation, the second phase, carried out in 2000–2001, focused on the protein produced by the synthetic gene, the *Genesis* protein,[15] and on new works that examine the cultural implications of proteins as fetish objects. The *Genesis* protein is another step in the translation of the original biblical text, this time from the *Genesis* gene (itself encoding the English sentence) to a three-dimensional form made up of discrete parts (amino acids). The transmogrification of a verbal text into a sculptural form is laden with intersemiotic resonances that contribute to expand the historically rich intertextuality between word, image, and spatial form. The process of biological mutation extends it into time.

A critical stance is manifested throughout the *Genesis* project by following scientifically accurate methods in the real production and visualization of a gene and a protein that I have invented and which have absolutely no function or value in biology. Rather than explicating or illustrating scientific principles, the *Genesis* project complicates and obfuscates the extreme simplification and reduction of standard molecular biology descriptions of life processes, reinstating social and historical contextualization at the core of the debate. I appropriate the techniques of biotechnology to critique the language of science and its inherent ideologies, while developing transgenic art as an alternative means for individual expression. In its genomic and proteomic manifestations, the *Genesis* project continues to reveal new readings and possibilities.

Protein production is a fundamental aspect of life. Multiple research centers around the world are currently focusing their initiatives on sequencing, organizing, and analyzing the genomes of both simple and complex organisms, from bacteria to human beings. After genomics (the study of genes and their function) comes proteomics (the study of proteins and their function). Proteomics, the dominant research agenda in molecular biology in the postgenomic world, focuses on the visualization of the three-dimensional structure of proteins produced by sequenced genes.[16] It is also concerned with the study of the structure and functionality of these proteins, among many other important aspects, such as similarity among proteins found in different organisms. The second phase of *Genesis* critically investigates the logic, the methods, and the symbolism of proteomics, as well as its potential as a domain of artmaking.

To arrive at the visualization of the *Genesis* protein, I first explored aspects of its two-dimensional structure.[17] The next step was to compare the predicted folding pattern of the *Genesis* protein to another known protein to which it is similar: Chorion. With the goal of producing a tangible rendition of the nanostructure of the *Genesis* protein, I researched protein fold homology using the Protein Data Bank, operated by the Research Collaboratory for Structural Bioinformatics (RCSB). I then produced a digital visualization of the *Genesis* protein's three-dimensional structure.[18] This three-dimensional dataset was used to produce both digital and physical versions of

the protein. The digital version is a fully navigable web object rendered both as VRML (Virtual Reality Modeling Language) and PDB (Protein Data Bank) formats, to enable up-close inspection of its complex volumetric structure. The physical rendition is a small solid object produced via rapid-prototyping, to convey in tangible form the fragility of this molecular object.[19] This object was used as a mold for casting the final form of the protein used in the creation of the *Transcription Jewels*.

Transcription Jewels is a set of two objects encased in a custom-made round wooden box. The word "transcription" is the term used in biology to name the process during which the genetic information is "transcribed" from DNA into RNA.[20] One "jewel" is a 2-inch genie bottle in clear glass with gold ornaments and 65 mg of purified *Genesis* DNA inside. "Purified DNA" means that countless copies of the DNA have been isolated from the bacteria in which they were produced, then accumulated and filtrated in a vial. The gene is seen here out of the context of the body, its meaning intentionally reduced to a formal entity to reveal that without acknowledgment of the vital roles played by organism and environment, the "priceless" gene can become "worthless." The other "jewel" is an equally small gold cast of the three-dimensional structure of the *Genesis* protein. By displaying the emblematic elements of the biotech revolution (the gene and the protein) as coveted valuables, *Transcription Jewels* makes an ironic commentary on the commodification of the most minute aspects of life. Neither the purified gene in *Transcription Jewels* nor its protein is derived from a natural organism; each was created specifically for the artwork *Genesis*. Instead of a "genie" inside the bottle one finds the new panacea, the gene. No wishes of immortality, beauty, or intelligence are granted by the inert and isolated gene sealed inside the miniature bottle. As a result, the irony gains a critical and humorous twist by the fact that the "precious commodity" is devoid of any real, practical application in biology.

All pieces described and discussed above were presented together in my solo exhibition *Genesis*, realized at Julia Friedman Gallery, in Chicago, from May 4 to June 2, 2001. The multiple mutations experienced biologically by the bacteria and graphically by the images, texts, and systems that compose the exhibition reveal that the alleged supremacy of the so-called master molecule must be questioned. The *Genesis* series (including the living transgenic work, *Transcription Jewels*, and other works) challenges the genetic hype and opposes the dominant biodeterministic interpretation, stating that we must continue to consider life as a complex system at the crossroads between belief systems, economic principles, legal parameters, political directives, scientific laws, and cultural constructs.

The Eighth Day

The Eighth Day is a transgenic artwork that investigates the new ecology of fluorescent creatures that is evolving worldwide. It was shown from October 25 to November 2, 2001, at the Institute for Studies in the Arts, Arizona State University, Tempe.[21] While

fluorescent creatures are being developed in isolation in laboratories, seen collectively in this work for the first time they form the nucleus of a new and emerging synthetic bioluminescent ecosystem. The piece brings together living transgenic life forms and a biological robot (biobot) in an environment enclosed under a clear Plexiglas dome, thus making visible what it would be like if these creatures would in fact coexist in the world at large.

As the viewer walks into the gallery, she first sees a blue-glowing semisphere against a dark background. This semisphere is the four-foot dome, aglow with its internal blue light. She also hears the recurring sounds of water washing ashore. This evokes the image of the Earth as seen from space. The water sounds both function as a metaphor for life on Earth (reinforced by the spherical blue image) and resonate with the video of moving water projected on the floor. In order to see *The Eighth Day* the viewer is invited to "walk on water."

In the gallery, visitors are able to see the terrarium with transgenic creatures from both inside and outside the dome. As they stand outside the dome looking in, someone online sees the space from the perspective of the biobot looking out, perceiving the transgenic environment as well as faces or bodies of local viewers. An online computer in the gallery also gives local visitors an exact sense of what the experience is like remotely on the Internet.

Local viewers may temporarily believe that their gaze is the only human gaze contemplating the organisms in the dome. However, once they navigate the Web interface they realize that remote viewers can also experience the environment from a bird's eye point of view, looking down through a camera mounted above the dome. They can pan, tilt, and zoom, seeing humans, mice, plants, fish, and the biobot up close. Thus, from the point of view of the online participant, local viewers become part of the ecology of living creatures featured in the work, as if enclosed in a Websphere.

The Eighth Day presents an expansion of biodiversity beyond wildtype life forms. As a self-contained artificial ecology it resonates with the words in the title, which add one day to the period of creation of the world as narrated in Judeo-Christian scripture. All of the transgenic creatures in *The Eighth Day* are created with the same gene I used previously in *GFP Bunny* to create *Alba*, a gene that allows all creatures to glow green under harmless blue light. The transgenic creatures in *The Eighth Day* are GFP plants, GFP amoeba, GFP fish, and GFP mice. Selective breeding and mutation are two key evolutionary forces. *The Eighth Day* literally plays a role in transgenic evolution, since all organisms in the piece are mutations of their respective wildtype species and all were selected and bred for their GFP mutations.

The Eighth Day also includes a biological robot. A biobot is a robot with an active biological element within its body that is responsible for aspects of its behavior. The biobot created for *The Eighth Day* has a colony of GFP amoeba called *Dyctiostelium*

discoideum as its "brain cells." These "brain cells" form a network within a bioreactor that constitutes the "brain structure" of the biobot. When amoebas divide, the biobot exhibits dynamic behavior inside the enclosed environment. Changes in the amoebal colony (the "brain cells") of the biobot are monitored by it, and cause it to move about, throughout the exhibition. The biobot also functions as the avatar of Web participants inside the environment. Independent of the ascent and descent of the biobot, Web participants are able to control its audiovisual system with a pan-tilt actuator. The autonomous motion, which often causes the biobot to lean forward in different directions, provides Web participants with new perspectives of the environment.

The biobot's "amoebal brain" is visible through the transparent bioreactor body. In the gallery, visitors are able to see the terrarium with transgenic creatures from outside and inside the dome, as a computer in the gallery gives local visitors an exact sense of what the experience is like on the Internet. By enabling participants to experience the environment inside the dome from the point of view of the biobot, *The Eighth Day* creates a context in which participants can reflect on the meaning of a transgenic ecology from a first-person perspective (figure 4.4, plate 9).

Move 36

Move 36 makes reference to the dramatic move made by the computer Deep Blue against world-champion chess master Gary Kasparov in 1997.[22] This competition can be characterized as a match between the greatest chess player who ever lived and the greatest chess player who never lived. The work—presented for the first time at the Exploratorium, in San Francisco, from February 26 to May 31, 2004—sheds light on the limits of the human mind and the increasing capabilities developed by computers and robots, inanimate beings whose actions often acquire a force comparable to subjective human agency.

According to Kasparov, Deep Blue's quintessential moment in Game 2 came at move 36. Rather than making a move that was expected by viewers and commentators alike—a sound move that would have afforded immediate gratification—it made a move that was subtle and conceptual and, in the long run, better. Kasparov could not believe that a machine had made such a keen move. The game, in his mind, was lost.

The work presents a chessboard made of earth (dark squares) and white sand (light squares) in the middle of the room. There are no chess pieces on the board. Positioned exactly where Deep Blue made its move 36 is a plant whose genome incorporates a new gene that I created specifically for this work. The gene uses ASCII (the universal computer code for representing binary numbers as Roman characters, on- and off-line) to translate to the four bases of genetics Descartes's statement: "Cogito ergo sum" (I think, therefore I am).

Figure 4.4
Eduardo Kac, *The Eighth Day*, 2001. Transgenic work with live video, blue lights, sound, biological robot, water, GFP organisms (plants, mice, fish, amoeba), website. Dimensions variable. © Eduardo Kac. See plate 9.

Through genetic modification, the leaves of the plants grow multiple plantlets. In the wild these leaves would be smooth. The "Cartesian gene" was coupled with a gene for the expression of the plantlets, so that the public can easily see with the naked eye that the "Cartesian gene" is expressed precisely where the plantlets grow.

The "Cartesian gene" was produced according to a new code I created especially for the work. In 8-bit ASCII, the letter C, for example, is 01000011. Thus, the gene is created by the following association between genetic bases and binary digits:

A = 00

C = 01

G = 10

T = 11

The result is the following gene with 52 bases:

CAATCATTCACTCAGCCCCACATTCACCCCAGCACTCATTCCATCCCCCATC

The creation of this gene is a critical and ironic gesture, since Descartes considered the human mind a "ghost in the machine" (for him the body was a "machine"). His rationalist philosophy gave new impetus both to the mind–body split (Cartesian dualism) and to the mathematical foundations of current computer technology.

The presence of this "Cartesian gene" in the plant, rooted precisely where the human lost to the machine, reveals the tenuous border between humanity, inanimate objects endowed with lifelike qualities, and living organisms that encode digital information. A single, focused light shines in a delicate luminous cone over the plant. Silent video projections on two opposing walls contextualize the work, evoking two chess opponents in absentia. Each video projection is composed of a grid of small squares, resembling a chess board. Each square shows short animated loops cycling at different intervals, thus creating a complex and carefully choreographed thread of movements. The cognitive engagement of the viewer with the multiple visual possibilities presented on both projected boards subtly emulates the mapping of multiple paths on the board involved in a chess match.

A game for phantasmic players, a philosophical statement uttered by a plant, a sculptural process that explores the poetics of real life and evolution: This work gives continuity to my ongoing interventions at the boundaries between the living (human, nonhuman animals) and the nonliving (machines, networks). Checkmating traditional notions, nature is revealed as an arena for the production of ideological conflict, and the physical sciences as a locus for the creation of science fictions.

Specimen of Secrecy about Marvelous Discoveries

Specimen of Secrecy about Marvelous Discoveries is a series of works comprised of what I call "biotopes," that is, living pieces that change during the exhibition in response to internal metabolism and environmental conditions, including temperature, relative humidity, airflow, and light levels in the exhibition space.[23] Each of my biotopes is a genuine ecology made up of thousands of microscopic living beings in a medium of earth, water, and other materials. I orchestrate the metabolism of this diverse microbial life in order to produce the constantly evolving living works.

My biotopes expand on ecological and evolutionary issues I previously explored in transgenic works such as *The Eighth Day*. At the same time, the biotopes further develop dialogical principles that have been central to my work for over two decades.

The biotopes are a discrete ecology because within their world the microorganisms interact with and support each other (that is, the activities of one organism enable another to grow, and vice versa). However, they are not entirely secluded from the outside world: The aerobic organisms within the biotope absorb oxygen from outside (while the anaerobic ones comfortably migrate to regions where air cannot reach).

A complex set of relationships emerges as the work unfolds, bringing together the internal dialogical interactions among the microorganisms in the biotope and the interaction of the biotope as a discrete unit with the external world.

The biotope is what I call a "nomad ecology," that is, an ecological system that interacts with its surroundings as it travels around the world. Every time a biotope migrates from one location to another, the very act of transporting it causes an unpredictable redistribution of the microorganisms inside it (because of the constant physical agitation inherent in the course of a trip). Once in place, the biotope self-regulates with internal migrations, metabolic exchanges, and material settling. Extended presence in a single location might yield a different behavior, possibly resulting in regions of settlement and color concentration.

The biotope is affected by several factors, including the very presence of viewers, which can increase the temperature in the room (warm bodies) and release other microorganisms in the air (breathing, sneezing).

I consider the exhibition's opening as the birth of a given biotope. Once an exhibition begins, I allow the microorganisms in suspended animation to become active again. From that point on I no longer intervene. The work becomes progressively different, changing every day, every week, every month.

When the viewer looks at a biotope, she sees what could be described as an image. However, since this image is always evolving into its next transformative state, the perceived stillness is more a consequence of the conditions of observation (limits of the human perception, ephemeral presence of the viewer in the gallery) than an internal material property of the biotope. Viewers looking at the biotope another day

will see a different image. Given the cyclical nature of this image, each image seen at a given time is but a moment in the evolution of the work, an ephemeral snapshot of the biotope metabolic state, a scopic interface for human intimacy.

Each of my "biotopes" explores what I call "biological time," which is time manifested throughout the life cycle of a being itself, in vivo (contrary to, say, the frozen time of painting or photography, the montaged time of film or video, or the real time of a telecommunications event).

This open process continuously transforms the image and may, depending on factors such as lighting conditions and exhibition length, result in its effacement—until the cycle begins again.

The biotope has a cycle that starts when I produce the self-contained body by integrating microorganisms and nutrient-rich media. In the next step, I control the amount of energy the microorganisms receive in order to keep some of them active and others in suspended animation. This results in what the viewer may momentarily perceive as a still image. However, even if the image seems still, the work is constantly evolving and is never physically the same. Only time-lapse video can reveal the transformation undergone by a given biotope in the course of its slow change and evolution.

To think of a biotope only in terms of microscopic living beings is extremely limiting. Although it is also possible to describe a human being in terms of cells, a person is much more than an agglomerate of cells. A person is a whole, not merely the sum of parts. We shall not confuse our ability to describe a living entity in a given manner (e.g., as an object composed of discrete parts) with the phenomenological consideration of what it is like to be that entity, for that entity. The biotope is a whole. Its presence and overall behavior is that of a new entity that is at once an artwork and a new living being. It is with this bioambiguity that it manifests itself. It is as a whole that the biotope behaves and seeks to satisfy its needs. The biotope asks for light and, occasionally, water. In this sense, it is an artwork that asks for the participation of the viewer in the form of personal care. Like a pet, it will provide companionship and produce more colors in response to the care it receives. Like a plant, it will respond to light. Like a machine, it is programmed to function according to a specific feedback principle (e.g., expose it to the proper amount of heat and it will grow). Like an object, it can be boxed and transported. Like an animal with an exoskeleton, it is multicellular, has a fixed bodily structure, and is singular. What is the biotope? It is its plural ontological condition that makes it unique.

Natural History of the Enigma

The central work in the *Natural History of the Enigma* series is a plantimal, a new life form I created and that I call "Edunia," a genetically engineered flower that is a

hybrid of the petunia and myself. The Edunia expresses my DNA exclusively in its red veins.

Developed between 2003 and 2008, and first exhibited from April 17 to June 21, 2009, at the Weisman Art Museum[24] in Minneapolis, *Natural History of the Enigma* also encompasses a large-scale public sculpture, a print suite, photographs, and other works.

The new flower is a petunia strain that I invented and produced through molecular biology. It is not found in nature. The Edunia has red veins on light pink petals and a gene of mine is expressed on every cell of its red veins; that is, my gene produces a protein in the veins only.[25] The gene was isolated and sequenced from my blood. The petal pink background, against which the red veins are seen, is evocative of my own pinkish-white skin tone. The result of this molecular manipulation is a bloom that creates the living image of human blood rushing through the veins of a flower.

The gene I selected is responsible for the identification of foreign bodies. In this work, it is precisely that which identifies and rejects the other that I integrate into the other, thus creating a new kind of self that is partially flower and partially human.

Natural History of the Enigma is a reflection on the contiguity of life between different species. It uses the redness of blood and the redness of the plant's veins as a marker of our shared heritage in the wider spectrum of life. By combining human and plant DNA in a new flower, in a visually dramatic way (red expression of human DNA in the flower's veins), I bring forth the realization of the contiguity of life between different species.

This work seeks to instill in the public a sense of wonder about this most amazing of phenomena we call "life." The general public may have no difficulty in considering how close we truly are to apes and other nonhuman animals, particularly those with which it is possible to communicate directly, such as cats and dogs. However, the thought that we are also close to other life forms, including flora, will strike most as surprising.

While in the history of art one finds imaginative associations between anthropomorphic and botanical forms (as in the work of Archimboldo, for example), this parallel (between humans and plants) also belongs to the history of philosophy and to contemporary science. Advancing notions first articulated by Descartes, Julien Offray de La Mettrie (1709–1751) already proposed in his book *L'homme plante* [Man a Plant] (1748) that "the singular analogy between the plant and animal kingdoms has led me to the discovery that the principal parts of men and plants are the same." The preliminary sequencing of the human genome and that of a plant from the mustard family (*Arabidopsis thaliana*, in the journal *Nature*, December 14, 2000) have extended the artist's and the philosopher's analogies beyond their wildest dreams, into the

deepest recesses of the human and plant cells. Both have revealed homologies between human and plant genetic sequences.

Thus, the key gesture of *Natural History of the Enigma* takes place at the molecular level. It is at once a physical realization (i.e., a new life created by an artist, *tout court*) and a symbolic gesture (i.e., ideas and emotions are evoked by the very existence of the flower).

I had a sample of my blood drawn, and subsequently isolated a genetic sequence that is part of my immune system—the system that distinguishes self from nonself, that is, protects against foreign molecules, disease, invaders—anything that is not me. To be more precise, I isolated a protein-coding sequence of my DNA from my immunoglobulin (IgG) light chain (variable region).[26]

To create a petunia with red veins in which my blood gene is expressed I made a chimeric gene composed of my own DNA and a promoter to guide the red expression only in the flower vascular system. To make my blood-derived DNA express only in the red veins of the petunia, I used Professor Neil Olszewski's CoYMV (Commelina Yellow Mottle Virus) Promoter, which drives gene expression only in plant veins. Professor Olszewski is in the Department of Plant Biology at the University of Minnesota, St. Paul.[27]

My IgG DNA is integrated into the chromosome of the Edunia. This means that every time that the Edunia is propagated through seeds my gene is present in the new flowers.

The sculpture that is part of *Natural History of the Enigma*, entitled *Singularis*, is a three-dimensional fiberglass and metal form measuring 14′4″ (height) × 20′4″ (length) × 8′5″ (width). It contrasts the minute scale of the molecular procedure with the larger-than-life structure. Likewise, the work pairs the ephemeral quality of the living organism with the permanence of the large sculpture. The sculpture is directly connected to the flower because its form is an enlargement of unique forms found inside this invented flower. In other words, the sculpture is derived from the molecular procedure employed to create the flower.[28] In its hybridity, the sculpture reveals the proximity of our next of kin in the kingdom *Plantae*.

I used 3D imaging and rapid-prototyping to visualize this fusion protein as a tangible form. I created the visual choreography of the sculpture based on the flower's molecular uniqueness. The sculpture was created with a vocabulary of organic twists and turns, helices, sheets, and other three-dimensional features common to all life. The sculpture is blood red, in connection with the starting point of the work (my blood) and the veinal coloration of the Edunia.

In anticipation of a future in which Edunias can be distributed and planted everywhere, I created a set of six lithographs entitled *Edunia Seed Pack Studies*. Visually resonant as they are with the flower and the work's theme, these images are meant to be

used in the actual seed packs to be produced in the future. In my exhibition at the Weisman Art Museum, I exhibited a limited edition of Edunia seed packs containing actual Edunia seeds. All works mentioned above (*Singularis*, *Edunia Seed Pack Studies*, and *Edunia Seed Packs*) are in the permanent collection of the Weisman Art Museum. This means that the new organism itself, in its germinal state, is in the collection (figure 4.5).

Conclusion

Quite clearly, genetic engineering will continue to have profound consequences in art as well as in the social, medical, political, and economic spheres of life. As an artist I am interested in reflecting on the multiple social implications of genetics— from unacceptable abuse to its hopeful promises, from the notion of "code" to the question of translation, from the synthesis of genes to the process of mutation, from the metaphors used by biotechnology to the fetishization of genes and proteins, from simple reductive narratives to complex views that account for environmental influences. The urgent task is to unpack the implicit meanings of the biotechnology revolution and contribute to the creation of alternative views, thus changing genetics into a critically aware new art medium.

The tangible and symbolic coexistence of the human and the transgenic, which I have developed in several of my works discussed above, shows that humans and other species are evolving in new ways. It dramatizes the urgent need to develop new models with which to understand this change, and calls for the interrogation of difference, taking into account clones, transgenics, and chimeras.

The Human Genome Project (HGP) has made it clear that all humans have acquired, through a long evolutionary history, genetic sequences that came from viruses.[29] This shows that we have in our bodies DNA from nonhuman organisms. Ultimately, this means that we too are transgenic. Before deciding that all transgenics are "monstrous," humans must look within and come to terms with our own "monstrosity," that is, with our own transgenic condition.

The common perception that transgenics are not "natural" is incorrect. It is important to understand that the process of moving genes from one species to another is part of wild life (without human participation). The most common example is the bacterium called "agrobacterium," which enters the root of plants and communicates its genes to it. Agrobacterium has the ability to transfer DNA into plant cells and integrate the DNA into the plant chromosome.[30]

Transgenic art suggests that romantic notions of what is "natural" have to be questioned and the human role in the evolutionary history of other species (and vice versa) has to be acknowledged, while at the same time respectfully and humbly marveling at this amazing phenomenon we call "life."

Figure 4.5
Eduardo Kac, *Natural History of the Enigma*, 2003/2008. Transgenic flower with artist's own DNA expressed in the red veins of the petals. Dimensions variable. Collection Weisman Art Museum, Minneapolis. © Eduardo Kac.

Notes

1. See Eduardo Kac, *Luz & Letra: Ensaios de arte, literatura e comunicação* (Light & Letter: Essays in art, literature, and communication) (Rio de Janeiro: Editora Contra Capa, 2004); Eduardo Kac, *Telepresence and Bio Art—Networking Humans, Rabbits, and Robots* (Ann Arbor: University of Michigan Press, 2005). See also <http://www.ekac.org>.

2. Robert Atkins, "State of the (On-Line) Art," *Art in America* (April 1999): 89–95; Mario Cesar Carvalho, "Artista implanta hoje chip no corpo," *Folha de São Paulo, Cotidiano* (November 11, 1997): 3; Michel Cohen, "The Artificial Horizon: Notes Towards a Digital Aesthetics," in *Luna's Flow: The Second International Media Art Biennale*, ed. Wonil Rhee (media_city seoul 2002, Seoul Museum of Art, Seoul, Korea, 2002), 20, 32–33; Patricia Decia, "Bioarte: Eduardo Kac tem obra polêmica vetada no ICI," *Folha de São Paulo*, Ilustrada (October 10, 1997): 13; Steve Dietz, "Memory_Archive_Database," *Switch* 5, no. 3 (2000), <http://switch.sjsu.edu>; Steve Dietz, "Hotlist," *Artforum* (October 2000): 41; Luis Esnal, "Un hombre llamado 026109532," *La Nacion* (December 15, 1997), Section 5, 8; Eduardo Kac, "*Time Capsule*," *InterCommunication* 26 (autumn 1998): 13–15; "*Time Capsule*," in *Database Aesthetics*, ed.Victoria Vesna, Karamjit S. Gill, and David Smith, vol. 14, no. 2 (special issue of *AI & Society*, 2000), 243–249; "Art at the Biological Frontier," in *Reframing Consciousness: Art, Mind, and Technology*, ed. Roy Ascott (Exeter: Intellect, 1999), 90–94; "Capsule Temporelle," in *L'Archivage Comme Activité Artistique/Archiving as Art*, ed. Karen O'Rourke (Paris: University of Paris, 2000), n.p.; Arlindo Machado, "A Microchip inside the Body," *Performance Research* 4, no. 2 ("Online" special issue, London, 1999): 8–12; Christiane Paul, "*Time Capsule*," *Intelligent Agent* 2, no. 2 (1998): 4–13; Julia Scheeres, "New Body Art: Chip Implants," *Wired News*, March 11, 2002; Maureen P. Sherlock, "Either/Or/Neither/Nor," in *Future Perspectives*, exhibition by Marina Grzinic, Gallery (Dante) Marino Cettina (Umag, Croatia: Marino Cettina Gallery, 2001), 130–135; Kristine Stiles, "*Time Capsule*," in *Uncorrupted Joy: Art Actions, Art History, and Social Value* (Berkeley: University of California Press, 2003); Stephanie Strickland, "Dalí Clocks: Time Dimensions of Hypermedia," *Electronic Book Review*, no. 11, 2000; Steve Tomasula, "*Time Capsule*: Self-Capsule," *CIRCA* 89 (autumn 1999): 23–25.

3. Gisele Beiguelman, "Artista discute o pós-humano," *Folha de São Paulo*, October 10, 1997; Patricia Decia, "Artista põe a vida em risco" e "Bioarte," *Folha de São Paulo*, October 10, 1997; James Geary, *The Body Electric: An Anatomy of the New Bionic Senses* (New Brunswick, NJ: Rutgers University Press, 2002), 181–185; Eduardo Kac, "A-positive," in *ISEA '97—The Eighth International Symposium on Electronic Art*, September 22–27, 1997 (Chicago: The School of the Art Institute of Chicago, 1997), 62; Eduardo Kac, "A-positive: Art at the Biobotic Frontier," Flyer distributed on the occasion of ISEA '97; Eduardo Kac, "Art at the Biologic Frontier," in *Reframing Consciousness*, ed. Roy Ascott (Exeter: Intellect, 1999), 90–94; Arlindo Machado, "Expanded Bodies and Minds," in *Eduardo Kac: Teleporting An Unknown State*, ed. Peter Tomaz Dobrila and Aleksandra Kostic (Maribor, Slovenia: KIBLA, 1998), 39–63; Matthew Mirapaul, "An Electronic Artist and His Body of Work," *New York Times*, October 2, 1997; Simome Osthoff, "From Stable Object to Participating Subject: Content, Meaning, and Social Context at ISEA97," *New Art Examiner* (February 1998):, 18–23.

4. Eduardo Kac, *"Transgenic Art,"* *Leonardo Electronic Almanac* 6, no. 11 (1998). See also <http://www.ekac.org/transgenic.html>. Republished in *Ars Electronica '99—Life Science*, ed. Gerfried Stocker and Christine Schopf (Vienna: Springer, 1999), 289–296.

5. In 1998, canine reproductive technology was not developed enough to enable the creation of a transgenic or cloned dog. However, research was already underway to both map the dog genome and to develop canine in-vitro fertilization. In 2005, scientists successfully cloned a dog at Seoul National University, Korea. Although the lead researcher (Woo Suk Hwang) was proven guilty of falsifying data in the field of stem cell research, the dog-cloning research was proven successful and has become internationally accepted. The research is not very practical and cannot be easily adapted, but further streamlining led to a budding dog-cloning business. This unique research stands to demonstrate that "GFP K-9" is possible.

6. Eduardo Kac, *"Genesis,"* *Ars Electronica '99—Life Science*, 310–313. See also: <http://www.ekac.org/geninfo.html>. *Genesis* was carried out with the assistance of Dr. Charles Strom, formerly Director of Medical Genetics, Illinois Masonic Medical Center, Chicago. Dr. Strom is now Medical Director, Biochemical and Molecular Genetics Laboratories Nichols Institute/Quest Diagnostics, San Juan Capistrano, California. Original DNA music for *Genesis* was composed by Peter Gena.

7. Charles Mudede, "The End of Art," *The Stranger* 9, no. 15 (Dec. 30, 1999–Jan. 5, 2000).

8. Eduardo Kac, *"GFP Bunny,"* in Eduardo Kac, *Telepresence, Biotelematics, and Transgenic Art*, ed. Peter Tomaz Dobrila and Aleksandra Kostic (Maribor, Slovenia: KIBLA, 2000), 101–131. See also <http://www.ekac.org/gfpbunny.html>.

9. I had proposed to live for one week with Alba in the Grenier à Sel, in Avignon, where Louis Bec directed the art festival "Avignon Numérique." In an email broadcast in Europe on June 16, 2000, Bec wrote: "Contre notre volonté, le programme concernant «Artransgénique», qui devait se dérouler du 19 au 25 juin, se trouve modifié. Une décision injustifiable nous prive de la présence de Bunny GFP, le lapin transgénique fluorescent que nous comptions présenter aux Avignonnais et à l'ensemble des personnes intéressées par les évolutions actuelles des pratiques artistiques. Malgré cette censure déguisée, l'artiste Eduardo Kac, auteur de ce projet, sera parmi nous et présentera sa démarche ainsi que l'ensemble de ses travaux. Un débat public permettra d'ouvrir une large réflexion sur les transformations du vivant opérées par les biotechnologies, tant dans les domaines artistiques et juridiques, qu'éthiques et économiques. Nous élevons de toute évidence contre le fait qu'il soit interdit aux citoyens d avoir accès aux développements scientifiques et culturels qui les concernent si directement." ["Against our will, the transgenic art program, originally scheduled for June 19–20, has been changed. An unjustifiable decision prevents us from enjoying the presence of *GFP Bunny*, the transgenic florescent rabbit we intended to present to the people of Avignon and the general public interested in the evolution of contemporary art. In spite of this disguised censorship, the artist Eduardo Kac, author of this project, will be among us and will present this work, as well as his larger body of work. A public debate will allow us to reflect on the ongoing transformations of life operated by biotechnology in the artistic, legal, ethical, and economic domains. We firmly oppose that citizens are being prevented from gaining access to these cultural and scientific developments that are so relevant to them."]

10. Gareth Cross. "Cross Hare: Hop and Glow," *Boston Globe*, September 17, 2000, A01. The article states: "Kac and Alba remain apart while Kac tries to persuade the French government laboratory, called the National Institute of Agronomic Research, to grant him custody of the bunny. The scientist who created her for Kac, Louis-Marie Houdebine, said he doesn't know when, or if, Alba will be allowed to join Kac, but said that she is healthy, and even noted that she has a 'particularly mellow and sweet disposition.'"

11. For a bibliography on transgenic art, see <http://www.ekac.org/transartbiblio.html>.

12. The guestbook is at <http://www.ekac.org/bunnybook.2000_2004.html>.

13. These posters have also been shown in gallery exhibitions: "Dystopia + Identity in the Age of Global Communications," curated by Cristine Wang, Tribes Gallery, New York (2000); "Under the Skin," curated by Söke Dinkla, Renate Heidt Heller, and Cornelia Brueninghaus-Knubel, Wilhelm Lehmbruck Museum, Duisburg (2001); "International Container Art Festival," Kaohsiung Museum of Fine Arts, Taiwan (Dec. 8, 2001–January 6, 2002); "Portão 2," Galeria Nara Roesler, São Paulo, Brazil (March 21–April 27, 2002); "Free Alba!," Julia Friedman Gallery, Chicago (May 3–June 15, 2002); "Eurovision—I Biennale d'Arte: DNArt; Transiti: Metamorfosi: Permanenze," Kunsthaus Merano Arte, Merano, Italy (June 15–August 15, 2002); "Gene(sis): Contemporary Art Explores Human Genomics," Henry Art Gallery, Seattle (April 6–August 25, 2002; "Face/off—Body Fantasies," Kunst und Kunstgewerbeverein, Pforzheim, Germany (February–May 2004); "Gene(sis): Contemporary Art Explores Human Genomics," Frederick Weisman Museum of Art, Minneapolis (January 25–May 2, 2004).

 See also the following catalogs: *Under the Skin* (Ostfilden-Ruit, Germany: Hatje Cantz Verlag, 2001), 60–63; *Eurovision—I Biennale d'Arte: DNArt; Transiti: Metamorfosi: Permanenze* (Milan: Rizzoli, 2002), 104–105; *International Container Art Festival* (Kaohsiung: Kaohsiung Museum of Fine Arts, 2002), 86–87.

14. Lisa Stein, "New Kac Show Takes a Look at Ethics, Rabbit," *Chicago Tribune*, May 10, 2002, 21.

15. In actuality, genes do not "produce" proteins. As Richard Lewontin clearly explains: "A DNA sequence does not specify protein, but only the amino acid sequence. The protein is one of a number of minimum free-energy foldings of the same amino acid chain, and the cellular milieu together with the translation process influences which of these foldings occurs." See: R. C. Lewontin, "In the Beginning Was the Word," *Science* 291, no. 16 (February 2001): 1264.

16. In 1985 I purchased an issue of a magazine entitled *High Technology* whose cover headline read "Protein Engineering: Molecular Creations for Industry and Medicine." Clearly, the desire to "design" new molecular forms has been evolving for approximately two decades. See Jonathan B. Tucker, "Proteins to Order: Computer Graphics and Gene Splicing Are Helping Researchers Create New Molecules for Industry and Medicine," *High Technology* 5, no. 12 (December 1985): 26–34. A few months before, I had published an article in which I discussed an art of the future, which would "develop a new form of expression in a space minimized to the highest degree." See "A Arte eletrônica em espaço microscópico (Electronic art in microscopic space)," *Módulo* 87 (September 1985): 49.

17. Special thanks to Dr. Murray Robinson, Head of Cancer Program, Amgen, Thousand Oaks, California.

18. Protein visualization was carried out with the assistance of Charles Kazilek and Laura Eggink, BioImaging Laboratory, Arizona State University, Tempe.

19. Rapid prototyping was developed with the assistance of Dan Collins and James Stewart, Prism Lab, Arizona State University, Tempe.

20. Terms like "transcription," as well as "code," "translation," and many others commonly employed in molecular biology, betray an ideological stance, a conflation of linguistic metaphors and biological entities, whose rhetorical goal is to instrumentalize processes of life. In the words of Lily E. Kay, this merger integrates "the notion of the genetic code as relation with that of a DNA code as thing." See Lily E. Kay, *Who Wrote the Book of Life: A History of the Genetic Code* (Stanford, CA: Stanford University Press, 2000), 309. For a thorough critique of the rhetorical strategies of molecular biology, see Richard Doyle, *On Beyond Living: Rhetorical Transformations of the Life Sciences* (Stanford, CA: Stanford University Press, 1997).

21. I developed *The Eighth Day* through a two-year residency at the Institute of Studies in the Arts, Arizona State University, Tempe. The exhibition ran from October 25 to November 2, 2001, at the Computer Commons Gallery, Arizona State University, Tempe (with the support of the Institute of Studies in the Arts). Documentation can be found at <http://www.ekac.org/8thday.html>. See *The Eighth Day: The Transgenic Art of Eduardo Kac*, ed. Sheilah Britton and Dan Collins (New York: Arizona State University Press/distributed by DAP, 2003).

22. See Elena Giulia Rossi, *Eduardo Kac: Move 36* (Paris: Filigranes Éditions, 2005).

23. "Specimen of Secrecy about Marvelous Discoveries" premiered at the Singapore Biennale (September 4–November 12, 2006).

24. The exhibition was comprised of the actual Edunias, the complete *Edunia Seed Pack* set of six lithographs, and a limited edition of Edunia seed packs with actual Edunia seeds.

25. The gene of mine I used is an IgG fragment. Immunoglobulin G (IgG) is a kind of protein that functions as an antibody. IgG is found in blood and other bodily fluids, and is used by the immune system to identify and neutralize foreign antigens. An antigen is a toxin or other foreign substance that provokes an immune response in the body, such as viruses, bacteria, and allergens. More precisely, my DNA fragment is from my immunoglobulin kappa light chain (IGK). In *Natural History of the Enigma*, the fusion protein, produced exclusively in the red veins, is a fusion of my IgG fragment with GUS (an enzyme that allowed me to confirm the vascular expression of the gene).

26. For her assistance in drawing my blood, isolating my IgG and cloning it, I owe a debt of gratitude to Bonita L. Baskin, who was, at the time I carried out this work, the CEO of Apptec Laboratory Services, St. Paul, Minnesota. The blood was drawn for *Natural History of the Enigma* on May 13, 2004, at Apptec Laboratory Services.

27. With the assistance of Professor Neil Olszewski, I obtained positive confirmation that my IgG protein was produced only in the Edunia veins by detecting the activity of the enzyme GUS (beta glucuronidase), which is fused to the IgG sequence. The detection was achieved through a staining technique.

28. The sculpture's form is an invented protein composed of human and plant parts. The human part is a fragment of my IgG light chain (variable region); the plant component is from the petunia's ANTHOCYANIN1 (AN1), responsible for red pigmentation in the flower. More precisely, AN1 is a transcription factor that controls genes encoding the enzymes that produce the red pigments.

29. See T. A. Brown, *Genomes* (Oxford: Bios Scientific Publishers, 1999), 138; and David Baltimore, "Our Genome Unveiled," *Nature* 409, no. 15 (February 2001), 814–816. In private email correspondence (January 28, 2002), and as a follow-up to our previous conversation on the topic, Dr. Jens Reich, Division of Genomic Informatics of the Max Delbruck Center in Berlin-Buch, stated: "The explanation for these massive [viral] inserts into our genome (which, incidentally, looks like a garbage bin anyway) is usually that these elements were acquired into germ cells by retrovirus infection and subsequent dispersion over the genome some 10 to 40 millions ago (as we still were early apes)." The HGP also suggests that humans have hundreds of bacterial genes in the genome. See "Initial Sequencing and Analysis of the Human Genome," *International Human Genome Sequencing Consortium* 409, no. 6822 (February 15, 2001): 860. Of the 223 genes coding for proteins that are also present in bacteria and in vertebrates, 113 cases are believed to be confirmed. See p. 903 of the same issue. In the same correspondence mentioned above, Dr. Reich concluded: "It appears that it is not man, but all vertebrates who are transgenic in the sense that they acquired a gene from a microorganism."

30. This natural ability has made a genetically engineered version of the agrobacterium a favorite tool of molecular biology. See L. Herrera-Estrella, "Transfer and Expression of Foreign Genes in Plants," Ph.D. thesis (Laboratory of Genetics, Gent University, Belgium, 1983); P. J. J. Hooykaas and R. A. Shilperoort, "Agrobacterium and Plant Genetic Engineering," *Plant Molecular Biology* 19 (1992), 15–38; J. R. Zupan and P. C. Zambryski, "Transfer of T-DNA from Agrobacterium to the Plant Cell," *Plant Physiology* 107 (1995): 1041–1047.

5 Machinima: On the Invention and Innovation of a New Visual Media Technology

Thomas Veigl

The machinima genre is a worldwide phenomenon that in recent years has penetrated further and further into the media mainstream, where it is fast becoming known as the most popular form of digital game art of our times. Machinima[1] technology is used to create computer-animated films within a virtual real-time 3D environment—in short, to produce films in computer games. The game's modified virtual environment, the objects, and avatars are used to develop scenarios that are then recorded and edited.

It is invading diverse areas of our society and is found today in large-scale archiving projects and distribution channels,[2] established festivals of film[3] and media art,[4] as well as specialist film festivals dedicated to machinima.[5] Its influence on cinema and television testifies to the increasing acceptance of this art form that is increasingly entering popular culture.[6] Well-known cultural institutions like the New York Museum of the Moving Image, the Science Museum in London, and the Center for Art and Media (ZKM) in Karlsruhe have all engaged with and devoted events to this subject.

Although this is a success story, a serious barrier to experiments and financial success with machinima is the legal uncertainty surrounding the issue that 3D game engines are the intellectual property of their producers. Critically examining the evolution of machinima and its status in the new media economy, I posit that we are now at a point where this restriction can be overcome. Combining film techniques, computer animation, and using real-time 3D game engines signals a process of change of the digital image that has far-reaching consequences for production and copyright.

This essay provides an optimistic view on machinima as an emancipatory movement, which arose out of unintended user interaction with computer games and led to social and cultural changes in the computer-animation and game industries. I will show that machinima, as a new production technique, allowed the establishment of economically exploitable forms, which will lead to further cultural acceptance in the form of legal adjustments to the new production technique.

First, according to the new technology, as a legal framework is constructed that overcomes the limitations of the exploitation of machinima, new viable applications of existing prototypes will appear. This demonstrates machinima as an example of media technology that engenders social and cultural change.

The approach used here follows the main features of Joseph Schumpeter's model of economic development[7] by locating traces of the invention of machinima beginning in the mid-1990s and describing its innovation, which appears at the moment to be completed.

The invention phase comprises the period until the first complete problem-solving version appeared, a prototype whose ultimate use is not yet clear. It is not possible to pinpoint the beginning of this phase precisely, unlike its end, because every invention has a series of predecessors. To explore the invention of machinima I shall examine the immediate technological and cultural preconditions, including the intentions of the protagonists involved that led to the realization of the first prototype.

As the invention alone is not decisive for the form of its application or for whether a new media technology will continue to exist, the next section examines the prototype's innovation and its actual application.

The innovation's completion is articulated by three indicators. These are: finding an accepted name for the new medium; the emergence of a commercial market for it; and the development of specific legislation. Commercially viable forms reflect the social demand for a new product and determine its continued existence and further development. If a new technology achieves sufficient relevance, one consequence of the social formatting of the new medium[8] and the increasing necessity for legal control will be the emergence of new legal provisions that are better attuned to the logic of the new technology. I will provide some selected examples of the machinima invention and innovation phases as illustrations; obviously, these are by no means exhaustive.

Invention

"In the game world, it was the modifiable first-person shooter, not the lavishly prerendered puzzle game, that created the means for machinima to become a new narrative medium."[9]

The origins of machinima are closely connected with the first-person shooter (FPS) games of the early 1990s in which the developers of id Software, John Carmack and John Romero, were significantly involved. Essential elements, which later proved to be prerequisites for machinima production, are *real-time game engines, modifiability* of game content, *multiplayer mode,* and *in-game recording*. These elements were present in isolated instances in 1980s computer games, but id Software consciously combined them in their FPSs to achieve an enhanced immersive experience. The developers'

goal, which was facilitated by the rapidly improving performance of PC hardware, was to create evermore exciting, lifelike games.[10]

Real-Time Animation

"These games were created from the first-person point of view. The whole idea was to make the player feel as if he were inside the game."[11]

To draw the player into the game as much as possible, it was necessary that the player should enter the virtual space from his or her own personal perspective. Because the screen has to be rerendered continuously according to the player's actions, prerendered animations are not suitable for realizing the action shooter's first-person perspective. For the games Hover Tank 3D, Wolfenstein 3D, and Doom, John Carmack programmed 3D-simulating, and later for Quake entirely real-time 3D game engines.

Modification

"The Doom mod tools immersed programmers as creators, as ones who could take this incredible world and sculpt it to their own divine desires."[12]

John Carmack and John Romero, who were both influenced by the game hacker culture of the early 1980s, published shortly after the release of Wolfenstein 3D the players' mod Barneystein 3D, with music from the children's TV show of the same name and the purple dinosaur Barney as "endboss." In keeping with their vision of open and free fun-hacking, id Software programmed their next game Doom in such a way that the image and audio files could be saved and loaded separate from the game in so-called WAD files, which allowed players to insert their own objects and sounds without altering the program's code. In addition, id Software published Doom's source code, enabling players to create their own mods. The WAD videos that were created documented game sequences with changed opponents and sounds, such as Super Mario Doom, Alien Doom, Pòkemon, and Simpsons Doom. In this way id Software consciously changed the status of authorship of computer games by facilitating access to mod possibilities.

Multiplayer Mode and In-game Recording

"It [Doom] immersed competitors in an arena of deathmatching where they could hunt each other down."[13]

The multiplayer gaming mode allowed competition outside of the predetermined game plan. So-called deathmatches rapidly developed from being an additional function to representing the factor that determined success, and established the social game world of the 1990s: "LAN parties."

Driven by deathmatch and speedrun[14] modes, the demands made on players increased and "high-performance play"[15] became a mass phenomenon. With the possibility of recording game sequences, deathmatch and speedrun demo videos were produced to document game success and generate rankings like the "Doom Honorific Titles" (DHT). These videos demonstrated the vast potential of game play, and thus served as examples and teaching materials for other players. A Finnish survey[16] supported the proposition that multiplayer games and in-game recordings vastly increase the level of immersion. The illusion of the player's spatial presence in the virtual world is much stronger when competing against other players instead of a computer-controlled opponent. This effect is further enhanced when players know each other, and increases even more when they are friends. While engaged in deathmatching, players experience increased subjective feelings of excitement, threat, and self-referentiality through the avatar they control. The feeling of being watched, as in multiplayer modes, speedrun, and high-performance recordings, increases the player's efforts and motivation to deliver the best performance.

A player's excitement heightens his or her degree of concentration on the game and makes him or her devote less attention to the medium itself and the artificial game world. Following the principle of immersion, the apparatus of the illusionist medium evades the player's perception and maximizes the intensity of the transmitted message.[17] Hence, recording modes provide essential contributions for increasing the subjectively perceived illusion of spatial presence and immersion.

In 1996 the Quake movie, *Diary of a Camper* (figure 5.1), was released by the Ranger Clan. In principle it was a recording of a Quake deathmatch with a short amusing narration referring to the game with text-based dialogues. The Ranger Clan splits into two groups and explores the area. Two clan members are shot by a camper, a player who waits for enemies in a good strategic position. Recognizing this, the other Rangers overpower the camper, who turns out to be John Romero himself, the inventor of

Figure 5.1
Diary of a Camper. © Ranger Clan. By kind permission of the artist.

deathmatches. Here, the camera work was no longer from a first-person perspective but already independent of the avatar.[18] Although the filmic quality of *Diary of a Camper* can be challenged, it is widely recognized as the first machinima production. It is the first narrative produced with a real-time 3D game engine: one small step for deathmatch movies, one giant leap for machinima. Also in 1996, *Torn Apart 2: Ranger Down!*, the first Quake movie with narrators instead of text dialogues, was produced. Inspired by the United Rangers films, 1997 saw the release of *Operation Bayshield* from Clan Undead, with added skins and lip movements, and the next highlight *Eschaton—Darkening Twilight* from the Strange Company, the first narration that did not refer to the game but had completely independent content.

The Nature of Invention

Was machinima, then, invented by the gaming community, first and foremost the Ranger Clan? What defines an invention? Henry Lowood's apposite question, "Was machinima an invention or innovative use of existing technology?"[19] must be answered in the affirmative: Both are correct. Machinima is an innovative use of games: Since the days of Doom, the players' influence on game design is increasing. Deathmatching was only the beginning of operating outside of predetermined game plans. In a "new cultural economy of game design,"[20] producers now provide their games with far-reaching mod possibilities. Computer games evolve continuously, and machinima has contributed its part. Game titles such as The Movies or Little Big Planet are representative of a game design where user-generated content takes center stage.

And yes: Machinima is an invention. As we shall see, a commercially and legally independent medium is developing.

One consequence of the goal to increase the FPS's immersive power was that the technology was diverted from its intended use—the production of computer-animated films. The invention of machinima consists in the recombination of already existing elements to build a fully functional prototype and not in the development of technology itself.[21]

The cultural anthropologist Robert L. Carneiro defines an invention as follows:

An invention—which in fact is generally a synthesis of preexisting cultural elements—will be made first by the person best prepared to do so. By "best prepared" I mean the one endowed with the highest native ability and in the best position to absorb from his culture the elements that must be pieced together for the invention to occur.[22]

Who is better qualified to do this than the players themselves? The technology resulted from the development of FPSs, but the required skills and knowledge of media use is contributed by the players. Henry Lowood offers the comparison with the cultural historical concept of "found art." Found objects are not created to be used in an

artwork; they are goods or items removed from nature or society, which an artist diverts from their intended use (for example, Marcel Duchamp's *Fountain* or *Bicycle Wheel*).

In this sense machinima is "found technology."[23] The game engine is not modified, but diverted into a new context as an animation engine. Through recording, exhibiting, and distributing proper skills in demo movies, the player, who knows that he is being watched, changes into an actor.[24] Besides the player's increased efforts and the intended increase of immersion, the situation of being watched leads to the activation of an older media experience: the cinema—and the game world becomes a film set.

Innovation

In the phase of innovation, the invention encounters its proper application. I call this society's differentiation of and function assignment to the new technology. As mentioned above, the phase's completion is marked by three indicators: (1) the accepted denomination of the new medium, (2) a nascent economic market, and (3) the formulation of specific legislation.[25]

Denomination

In 1999, after John Romero left id Software, the company impeded access to the Quake III engine's code under penalty of legal steps. This fact plus the release of further games with mod possibilities like the FPS Unreal (1998) from Epic Games, or Half-Life (1998) from Valve Software, ended the sole reign of the Quake engine. The difficult production conditions for Quake movies and the proliferation of accessible game engines led to the emancipation from id Software products and a generally broader perspective on the phenomenon of game movies. A milestone was the movie *Quad God* in 2000, which for the first time was not only distributed in a demo file format, but also in a conventional video file format that could be viewed without the game engine. Moreover, in the same year the naming of the technology, machinima, occurred under the auspices of Hugh Hancock, cofounder of the Strange Company and the online platform, <http://www.machinima.com>. Machinima is a made-up word from "machine" + "cinema" + "animation." *Quad God* was one of the very first contributions on <http://www.machinima.com>.

Commercial Uses

In recent years new areas for commercial applications of machinima have emerged.

The game and film industries use the popularity of machinima for advertising purposes, image building, and image cultivation, and organize product-specific competitions on a regular basis. With a total of US$ 1 million in prize money, one of the

highest-paying is the "Make something unreal contest,"[26] organized by Epic Games and Intel.

Major film and media art festivals that offer a platform for machinima productions include: since 2003, the Ars Electronica Animation Festival in the category Computer Animation/Film/VFX; also since 2003, the Bitfilm Festival with its own category for machinima; since 2004, the Ottawa International Animation Festival with its own category, the Sundance Film Festival; since 2008, the Next Gen Machinima Contest included in NVISION; and since 2002, the exclusive annual Machinima Film Festival by the Academy of Machinima Arts and Sciences.

Producers of machinima who emerged out of the game community have found commercial applications for their art. In addition to independent machinimas like *Eschaton* and *Ozymandias*, one of the longest existing machinima groups, the Strange Company from Edinburgh, produced in 2003 *Tum Raider* (figure 5.2) for the BBC. It is a short parody of Tomb Raider, in which Lara Croft is replaced by a male obese counterpart. It can be seen as funny critique of Tomb Raider or as a contribution to the discourse about idealizations of the female body in contrast to the fast food culture. Further projects were produced from BAFTA, Scottish Television, and Electronic Arts.

The ILL Clan from New York, who has also produced machinimas for many years, works for MTV, Universal, Warner Brothers, NBC, and IBM. The group creates videos, commercials, and presentations for Web and television, including a spot for the TV series *Two and a Half Men* (figure 5.3, plate 10) and machinima material for the TV series *CSI: New York*. ILL Clan founding member Paul Marino is of the opinion that

Figure 5.2
Tum Raider. © Strange Company. By kind permission of the artist.

Figure 5.3
Two and a Half Men. © ILL Clan. By kind permission of the artist. See plate 10.

the time- and cost-saving technology of machinima will one day even dominate the film industry.[27]

Rooster Teeth Productions successfully sell DVD compilations of their machinima series *Red vs. Blue. Red vs. Blue* (figure 5.4) is a machinima comedy series produced with Microsoft game studio's Halo from 2003 to 2007. The story line refers ironically and critically to the game itself. The Red and the Blue Team are at war with each other, and even though both teams' existence is only legitimized by being the opponent of the other, they simultaneously avoid fighting. Though the soldiers are often mired in endless, almost philosophical discussions about the meaning of their lives; they appear to be less clever than their robots, or even tanks, when practical decisions are demanded. The absurdity of the situation reflects the genre of FPS, and it is a good example of machinima as an instrument for critiquing game culture. As well as DVDs, Roster Teeth Productions sold merchandising articles and produced machinimas via the games Sims2 and F.E.A.R. for Electronic Arts. In 2007 Rooster Teeth produced a broadcast commercial for Electronic Arts featuring the Madden NFL 07 computer game.

Thus, machinima has grown far beyond the context in which it emerged and is today an economic factor in film and television productions and commercials.

The French Duran Animation Studio has so far produced two films that utilize mainly machinima technology: *Ugly Duckling* and *Me and Immortel*. For this the studio

Figure 5.4
Red vs. Blue. © Rooster Teeth Productions. By kind permission of the artist.

used its in-house software Storymaker, which integrates a 3D game engine to develop 3D storyboards for visualizing and modifying each sequence in real-time. For final rendering, conventional 3D software is used. The advantages of cost-efficiency in terms of working time and infrastructure are evident. Real-time rendering of 3D animations allows immediate feedback using a standard consumer product. Compared to a conventionally made computer-animated film like Pixar's *Finding Nemo*, which took four years to produce and cost around US$ 94 million, the advantages of machinima are obvious.

Steven Spielberg also discovered the advantages of machinima as a way to save time and costs in creating computer-animated contents. He used the Unreal Tournament engine for preproduction of *A.I.*[28]

Visualizing computer-animated films used to require 3D storyboard artists who delivered the desired results to the director with a considerable time lag of up to several weeks. Machinima is faster, more direct, and allows more spontaneity. However, it should be mentioned that previsualizing (previs) using computer game engines has a longer history than machinima. Already in 1989 James Cameron used the computer game The Colony[29] to prepare visual effects for his film *The Abyss*—more than a decade before *A.I.*, the first visual walkabouts on the set were simulated with games. However, it was only the improved performance of computer hard- and software during the 1990s that provided a truly viable solution.

George Lucas also used the Unreal Tournament engine as a previs tool to plan sequences of his *Star Wars* films.[30] To improve ease of operation the Lucasfilm Ltd. visual effects company, Industrial Light & Magic, developed the previs software Zviz.[31] Similar to the principle of machinima, Zviz offers three modes for set building, animation, shooting, and editing. Comparable software tools at the frontier of previs and machinima are iClone, Moviestorm, and MovieCube.

And the advertising industry also discovered machinima. In 2004 Volvo produced the commercial Game:on with the Unreal Tournament engine, and the manufacturer of lighting systems, OSRAM, used the Second Life engine for their Off-Grid project's spot.

A variety of music videos are produced with machinima technology; for example, the Zero7 video "In the Waiting Line" broadcast on MTV using the Quake engine, "Suffer Well" by Depeche Mode with Sims2, and Ken Thain's production "Rebel vs. Thug" by the Fine Arts Militia with Chuck D, again produced with Quake.

Several TV formats integrate machinima. MTV2 produces the series Video Mods, which presents machinima music videos using The Sims 2, Blood Rayne, and Tribes. For Time Commander the BBC History Channel uses the Rome: Total War engine to reconstruct historic battles of the ancient Romans. Since 2003 the Canadian broadcaster YTV has produced the children's TV series *Zixx* as a mixture of live action and machinima with the Lithtech engine from Monolith Productions.

Molotov Alva and His Search for the Creator: A Second Life Odyssey (figure 5.5, plate 11) is a example of using machinima techniques for documenting life in virtual online worlds. The documentary by Douglas Gayeton is about a man who leaves his real life in California for a new existence in Second Life. The film is shot entirely in the virtual world using its real-time 3D graphic engines. The Dutch television broadcaster VPRO commissioned the production in 2006, and parts of it were then shown successfully at various festivals. In 2008 Home Box Office, a subsidiary of Time Warner, bought the broadcasting rights for North America, although it had already premiered on YouTube.

Since the beginning of 2009 the German ZDF channel broadcasts *Mo und Ma erklären die Welt* with machinima, a morning magazine program of news headlines.

In view of the exponentially increasing performance of graphic processors, serious competition is bound to arise between real-time game engines and conventional computer animation.

As in the early days of cinematography, the major improvements to machinima currently consist in technological aspects, whereby the commercially successful projects focus on established linear concepts from film and TV. In this regard we must note the continuing discussion about the uniqueness of machinima as a new art form. Despite the fact that some projects are experimenting with the potential of machinima for creating new interactive image worlds,[32] most productions do not fully exploit this

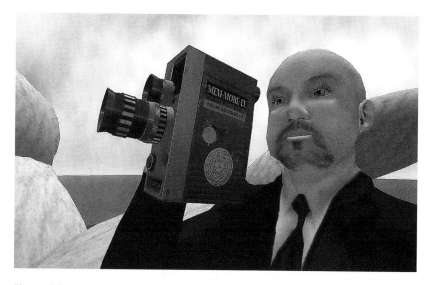

Figure 5.5
Molotov Alva. © Submarine. By kind permission of the artist. See plate 11.

possibility. In fact, it is mostly the case that highly interactive features of real-time 3D computer games are used for the production of conventional linear narratives, which reprocess concepts from film and TV. In this case the attribute of a new art form strictly refers to the process of production and not reception.

A serious barrier to experiments and financial success with machinima is the legal uncertainty surrounding the issue that 3D game engines are the intellectual property of their producer. Thus the reference to older media forms is an important stage in machinima's innovation and essential for achieving a professional level. In the following we will see how economic relevance causes change in legal structures.

Legal Issues

In a legal sense, machinimas are derivative works of copyrighted graphics, characters, sounds, and music from computer games. Under the fair use rule of the Copyright Act, the use of material for criticism, comment, reporting, teaching, and research does not infringe copyright.[33] The vague phrasing of fair use is problematic because legal disputes have to be resolved on a case-by-case basis.

Computer games, like software in general, often contain end user license agreements (EULA), which one has to accept before using the product. EULAs mostly allow noncommercial modification of game contents, but reserve the right of game producers to prohibit any modification that might harm the brand. EULAs can undermine the fair use rule by prohibiting actions that are deemed harmful to the product. For

example, Valve, producer of Half-Life, refused to grant permission to broadcast *Fake Science*, an experimental machinima short movie that took a critical look at the relationship between humankind, technology, and science.[34] In 2002, *Fake Science* won a prize at the Machinima Film Festival in the category of Best Visual Design.

In 2007, two game producers reacted with special licenses for machinima. Blizzard Entertainment's "Letter to the Machinimators of the World"[35] licensed the limited use of World of Warcraft, and Microsoft Corporation published "Microsoft's Game Content Usage Rules,"[36] a unilateral license, which did not undermine fair use, for limited use of the games to produce new derivative works. For commercial use, game producers provided the possibility of concluding individual agreements.

The reason that producers allow noncommercial derivative works is the realization that with machinima, customer ties can be strengthened at no cost and negative publicity can be avoided. Furthermore, infringements of copyright by anonymous, globally operating, and noncommercial offenders on the Internet are virtually impossible to track down. Such licenses protect the producers against having to tolerate copyright infringements over a longer period of time and avoiding legal discussions.

Licenses and a clear delineation of what is allowed likely benefit the development of user-generated content and derivative works. Not having to rely on the fair use rule—although it may offer more rights—prevents incurring costs and time-intensive examinations in each case. This ensures the legal position of machinima producers who may fear legal actions for injunction. Also, festival organizers will present more machinima productions if the legal aspects are not in dispute.

For Chistina Hayes[37] these licenses are inadequate, but they nevertheless represent a partial solution to the problematic situation under the copyright act. The licenses' idiosyncratic character implies that in case of commercial use, legal aspects have to be clarified separately for each game. This limits the possibilities of machinima producers and binds them to one or a few games.

In the absence of a reform of copyright legislation and fair use, the existing licenses are the best way of supporting the production of user-generated content. The better solution would be an umbrella licensing agreement between machinima producers and the video games industry or a thorough reform of the Copyright Act and especially the provisions for fair use.

Yet this legal reaction to machinima in the form of special licenses can be seen as a forerunner to specific legislation. The granting of special licenses is the reaction of the producers to a diffuse legal situation that may cause harm. If the economic significance of machinima increases still further, the necessity to maintain market positions will lead to legal standardization and may result in dedicated legislation. Protection for conventional computer animation techniques is to be expected, because such a development would lead to far-reaching structural changes in the production of computer-animated films.

Conclusion

We have seen that efforts to increase illusion and immersion in computer games, especially in the FPS genre of the early 1990s, resulted in diverting its intended use and instead led to the production of computer-animated films. Machinima is the unintended result of user interaction within the developing computer game industry.

The first productions of the movie-making video-gamers were meant for the gamers themselves; however, over time this subculture grew, and today machinima represents a production technique for computer-animated films with a very promising future, which has found both commercial utilization and legal issues. The continuing development of high-performance computer graphics suggests that the machinima phenomenon will continue to offer strong competition to traditional computer animation.

My concluding hypothesis is that the further consolidation of machinima as a production technique in the computer-animation industries and as a marketing factor for computer games can give rise to a legal framework in which computer games are treated less as closed products, like a music title or a film, and recognized more openly as tools for producing computer-animated visualizations.

When this occurs the innovation process advances to a more professional level, testing economically viable, independent forms. This process does not only benefit machinima. Opening up the legal framework of copyright on computer game engines would empower computer game artists in general, who are currently often unable to exploit their work commercially and reach a professional level.

At the moment it is not clear which economically viable forms will emerge out of computer game art, so we shall have to continue to observe which new applications that already exist on an experimental level become more established.

Although it is true that, in most cases, highly interactive features of real-time 3D computer games are used to produce conventional linear narratives, we should not overlook the necessity of this step. Machinima shows clearly that media evolution is a process where reference to older media is not a constraint; rather, it is necessary for development because it enables changes to legal structures, which then allow new viable forms to emerge.

Further, I posit that in the case of computer game art only machinima has the possibility to change and adjust these cultural norms to the new technological possibilities. Machinima possesses the potential to become established in the computer-animation and game industries as an important economic factor by acting out the conventional media language. The destiny of machinima is not inevitably to serve these existing structures, but this is a necessary step for achieving social acceptance and opening up the legal framework to make economic experiments possible.

In the future, we will need to observe all the different past, current, and future forms of machinima use, experiments, and prototypes, and at the same time figure out the development of economically viable forms in order to draw a line of evolution that also considers the technology's dead ends. For future explanations of successful innovations of new image forms that arose out of machinima, at present, we must document and archive these artifacts under scientific criteria to avoid misinterpreting their evolution afterward as unilinear and perhaps predetermined. This will also contribute to a better understanding of the histories of media art and technologies in general.

Notes

1. See Paul Marino, *3D Game-Based Filmmaking: The Art of Machinima* (Phoenix, AZ: Paraglyph Press, 2004).

2. Machinima Archive: <http://www.machinima.com>.

3. For example, the Ivy Film Festival, the Sundance Film Festival.

4. For example, the Ars Electronica Festival, the Ottawa International Animation Festival.

5. For example, the Machinima Film Festival, the Next Gen Machinima Contest.

6. For clarity, the essay will not compare the aesthetics of computer-animated and live action images, but rather will discuss in which niches the special form of machinima prospers.

7. Joseph Alois Schumpeter, *Theorie der wirtschaftlichen Entwicklung* (Berlin: Duncker & Humblot, 1997).

8. Rudolf Stoeber, *Mediengeschichte: Die Evolution "neuer" Medien von Gutenberg bis Gates: Eine Einführung* (Wiesbaden: Westdeutscher Verlag, 2003).

9. Henry Lowood, "High-Performance Play: The Making of Machinima," in *Videogames and Art*, ed. Andy Clarke and Grethe Mitchell (Chicago: Intellect Books, 2007).

10. David Kushner, *Masters of Doom: How Two Guys Created an Empire and Transformed Pop Culture* (New York: Random House, 2004).

11. Ibid., 80.

12. Ibid., 169.

13. Ibid., 168–169.

14. This characterizes the phenomenon already known in the 1980s of playing computer game levels as fast as possible while ignoring the given story.

15. Henry Lowood, "High-Performance Play: The Making of Machinima," in *Videogames and Art*, ed. Andy Clarke and Grethe Mitchell (Chicago: Intellect Books, 2007).

16. Niklas Ravaja et al., "Spatial Presence and Emotions during Video Game Playing: Does It Matter with Whom You Play?" *Presence* 15, no. 4 (2006): 381–392.

17. Oliver Grau, *Virtual Art: From Illusion to Immersion* (Cambridge, MA: MIT Press, 2003), 348–349.

18. In 1994, the Little Movie Processing Centre (LMOC) by Uwe Gierlich was released. As a technological milestone for the development of machinima it enables changing of camera positions of Doom and later Quake demo files after recording.

19. Henry Lowood, "Found Technology: Players as Innovators in the Making of Machinima," in *Digital Youth, Innovation, and the Unexpected*, ed. Tara McPherson (Cambridge, MA: MIT Press, 2008), 165–196.

20. Lev Manovich, *The Language of New Media* (Cambridge, MA: MIT Press: 2001).

21. This is also true for other media technologies, for instance, printing with movable metal type. This invention by the goldsmith Johannes Gutenberg at the beginning of the fifteenth century consists in a combination of the preexisting elements of block printing, metal type, and a friction press. Gutenberg's only genuine invention was the casting instrument, which allowed him to produce type with exactly the same form.

22. Robert L. Carneiro, *Evolutionism in Cultural Anthropology* (Boulder, CO: Westview, 2003), 120.

23. Lowood, "Found Technology," 185.

24. Ibid., 177–178.

25. Rudolf Stoeber, *Mediengeschichte*, 39.

26. "Make something unreal" website: <http://www.makesomethingunreal.com>.

27. "Deus ex machinima?" *Economist*, September 16, 2004.

28. Ibid.

29. Michael Nitsche, "Little Hollywood," Freepixel blog entry, posted on July 24, 2007, <http://gtMachinimablog.lcc.gatech.edu/?p=41>.

30. Bill Thompson, "Machinima: Film without Cameras," *Filmnetwork*, published September 22, 2008, <http://www.bbc.co.uk/dna/filmnetwork/A41149875>.

31. Barbara Robertson, "Zviz: ILM Goes Interactive with Previs," *Animation World Network*, posted on August 25, 2006, <http://vfxworld.com/?atype=articles&id=2985>.

32. An example of such experimentation with the interactive possibilities is Friedrich Kirschner's "Ein kleines Puppenspiel" ("A little puppet show"). In this interactive live installation using the Unreal Tournament engine, the avatar is controlled by information gathered via sensors on key positions on the real actor's body in front of the screen: <http://www.vimeo.com/1150543>. Another example is "Interactive 3D Modelling in Outdoor Augmented Reality Worlds" by Wayne

Piekarski. Here computer-generated images produced with the Quake engine are projected over the user's view of the physical world: <http://www.tinmith.net/wayne/thesis/>.

33. Christina J. Hayes, "Changing the Rules of the Game: How Video Game Publishers Are Embracing User-generated Derivative Works," *Harvard Journal of Law & Technology* 21, no. 2 (2008).

34. Karin Wehn, "Machinima versus Urheberrecht," *Telepolis*, posted on September 28, 2004, <http://www.heise.de/tp/r4/artikel/18/18379/1.html>.

35. World of Warcraft.com, "Letter to the Machinimators of the World," <http://www.worldofwarcraft.com/community/Machinima/letter.html>.

36. Xbox.com, "Game Content Usage Rules," <http://www.xbox.com/en-US/community/developer/rules.htm>.

37. Hayes, "Changing the Rules."

6 Steps toward Collaborative Video: Time and Authorship

Stefan Heidenreich

Collaboration

Collaboration is nothing new to moving images. From the very beginning of cinema it played an important role. One can even describe the history of filmmaking as a progressing series of collaborative practices, or as Janet Staiger suggests, as a sequence of modes of production.[1] Different approaches to teamwork depend on the available technologies and their profitability. And they come with a corresponding cultural format and a specific aesthetics of their own. Thus the structure of collaboration can give crucial hints as to how visual production might take shape. In fact, the scope of possible collaborative practices is already present, creating a field of potential practices. So the main task of turning to gaze into the twenty-first century does not consist in guessing the future, but much more in analyzing our present situation and comparing it with the history of the moving image.

Time and Authorship; Workflows

Time and authorship are the two crucial parameters of collaboration. To interact with each other, a series of decisions by several participants must be dispersed over time. During the production, authorship is distributed among many active participants and may only later be assigned to a few or even one. Thus, every collaboration involves a "mash-up" of participation stretching over a certain period of time. If we want to know more about likely types of collaborative production we might best consider the possibilities of organizing authorship with reference to the dimension of time.

If time and authorship are the internal factors of collaboration, some outside parameters also exist. Externally, it is basically triggered by a demand, which makes a separation of streams of the workflow convenient or even necessary. For example, when the wider distribution of cinemas created too much demand for movies, the focus of film production turned to fiction, as not enough "real" events were available.

Soon we started to break up the production process further and to create organizational formats like the script in order to plan and coordinate different tasks. It became necessary to separate the workflow and to organize collaborative production as soon as the demand exceeded the capabilities of individualized practices.

Early Media

Our situation nowadays seems very different from any previous point in the history of film. But the opposite is the case. There are some striking similarities between early cinema and "early YouTube," using the company's name for now as placeholder for the whole area of online video. They share some of the patterns specific to any new medium in its early stages, more or less along the lines of the schema proposed by McLuhan, "that the 'content' of any medium is always another medium."[2] That certainly holds true for early films, which either imitated scenes of amateur photography or restaged scenes known from theater. The very same relation can be found in the content of online video. Older media like TV or cinema either try to push their images online or try to prevent others from doing it. In either case, the content seems unavoidably to spread to the new medium, be it with or against the purpose of its creators (figure 6.1).

A Generation Gap

The McLuhan hypothesis of the initial imitation can be extended to a second phase during which each medium starts to develop its own aesthetics. The variety of experiments gets limited to some few surviving formats with a restricted range of stylistic variations—in short, a dominant form. This must not be read as a cultural loss, as it usually carries with it heightened sophistication.

Between the initial experimental phase and the second phase of consolidation exists a gap that extends more or less over the span of a generation. Its duration is easily to explain. It seems to require a generation raised with the specificities of the new medium to unleash its potential, to render it productive, and to grasp its unique aesthetics.

That holds especially true for those media that operate in a market-driven manner, like the gramophone and the cinema, where the proper aesthetic form appeared first with jazz or respectively with the classical Hollywood style, only about 20 to 30 years after the invention of the medium.[3] According to this assumption the Internet-video will only see its dominant visual form rising within the next 15 to 20 years.

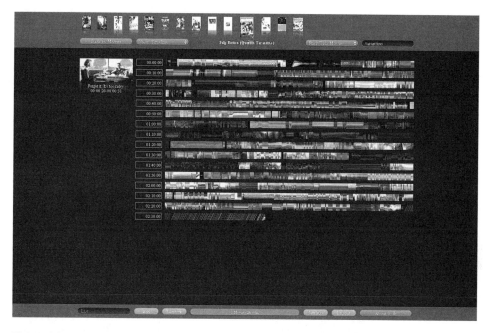

Figure 6.1
A timeline view of Quentin Tarantino's *Pulp Fiction*, from <http://www. 0xdb.org>, an experimental video interface that provides access to movies in new ways. See <http://0xdb .org/0110912?v=timeline>.

Dominant Form

Any type of organization or format that exceeds all others in quantity of produced content might be called a *dominant form*. Each epoch and each medium creates its own such form. The form's duration might vary; so the term does not serve primarily to explain a structure or a state, but more a time span of development.

As long as we speak of media, any dominant form requires a technical standard or leads to it. Sometimes such a new standard becomes powerful enough to spread even to the old media. The convergence of the old media within the Internet and its protocols offers a vivid example of such a process.

Besides technical reasons, there are also economic reasons that bring about a dominant form. As we live in a society where a huge part of production and activity is governed by the capitalist allocation of work through money, profitability remains responsible for the assignment of tasks. This creates a strong unifying pressure. In most cases this pressure can be regarded as the main reason for the growth of a dominant form.

The aesthetic implications remain secondary in comparison to these technical and economical factors. One could even state that in most cases a specific aesthetic is the effect of a dominant form rather than its reason. To keep with this image of a media ecology: The economic and technical constraints first create an environment in which several aesthetic solutions then compete for their survival.

There is no need to quantify the dominance of a form, even if it could be done along the lines of a media ecology, in a way comparable to the quantifiable populations of different species. Much more revealing than this limited quantified approach is the task to follow the changing settings of cultural distinctions that either stabilize or destabilize a form.

Making a guess as to which form is going to be dominant in the near future is as futile and unreliable as making a long-term weather forecast. The situation does not allow for trends to simply be followed, but for the analysis of a future that is already present, as we are witnessing the initial stages of a new medium during which numerous possible futures open up and several aesthetic solutions are being put to the test. There are two diverging options as we look ahead. One is to try to figure out a trend and consider where it leads. This perspective relies on time as a vector. The other option is to try to figure out possible situations that could occur with more or less probability. Both perspectives exclude each other, almost in the same way as simultaneously measuring a particle's position and its momentum is an impossible task, according to the uncertainty principle. The vector model constructs a chain of changes. The field model unfolds a set of possible positions. Once a dominant form is established, our present field of variety will look very different, as any experiment will in hindsight be valued as either an error or a predecessor. Therefore the main task consists in analyzing the present state as a field of possibilities.

Early YouTube, Early Cinema

Early film gave way to a dominant form of longer duration only after 1914, with the advent of the long feature. The invention of sound movies showed how a given dominant form can adapt to new technological developments. The present state of YouTube very much resembles the situation of early cinema before the rise of the next dominant form. We have a variety of formats, among which the most prevalent are still derived from an old medium. In sheer quantity, the music clip exceeds all the other genres, and its user-generated derivatives would be even more frequent if the music industry would not prosecute their producers (figure 6.2).

The history of visual media will not be able to reveal the direction of future developments. It only will be enable to draw some comparisons on the basis of a situation that shows some patterns similar to those of an earlier time. The most insightful

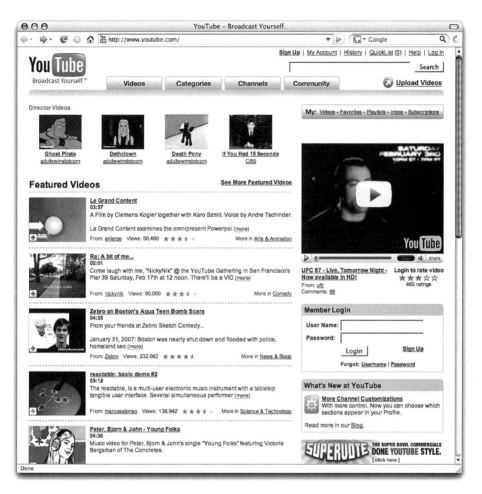

Figure 6.2
YouTube interface—screenshot from early 2007. At that time the website still offered a variety of categories (Videos/Categories/Channels/Communities/My:Video/My:Favourites/My:Playlists/My:Subscriptions).

parallel certainly can be found in the progress toward a dominant cinematic form. But the present situation also differs from the early stages of cinema in many aspects.

Digitalization

Digitalization brings some fundamental changes to pictures. But the mere fact that images are now encoded as numbers does not explain how the visual culture changed.

Contrary to the assumptions of many media theorists, the basic change in coding did not revolutionize the overall production of images. Generic complaints about the manipulation of images prove to be as misguided as the expectation that we are now entering an epoch of a 3D-rendered hyperreality. There is a simple explanation to such a miscalculation. Media-ontology seems to imply that a change in fundamentals must lead to a fundamental change on the surface. But in fact the revolution of the technical materiality left the structures of production and the dominant form almost unaffected. Instead the rise of the Internet took most of the early techno-ontological media-theorists by surprise.

The Net

The most influential changes occurred in cases in which the new techniques challenged the established model, including its formats, and the way it organized its distribution, and last but not least its commercial model. The possibility of sharing files puts an end to an economy that relies on the sales of storage media. The new scarcity, if there is one to be found, certainly does not lie in the restricted access to the data.

Now we find ourselves in a transitional stage, where the profiteers of the reproduction economy still fight for their old business models. Through legal restrictions they may manage to create a time lag of some years, which might allow them to adapt to the new situation. But in the long run, it would be absurd to create artificial scarcity and affective relations with reproduced data. Instead, we are going to have moments of a completely different scarcity, such as scarcity of unique bodily presence.

Avant-Garde or Break; Subject or Discourse

The idea of a dominant form is related to the view that history is a discursive movement, in which breaks occur when structures shift and not when heroes act. On the contrary, the hero might only appear when the break allows him to perform his task. An opposite approach would assume an avant-garde and their agents as the driving force. These two opposite methods to giving an account of history link very different events in order to picture a sequence in time, and they rely on very different ideas of actors and their possibilities. The avant-garde model assumes that the driving force of history is to be found in the decisions of the individual. The discursive model rejects that proposition in favor of the idea that possible actions are more or less determined by a given situation and will be performed by whomever. Both views may lead to a consistent narration of past events. But when it comes to the future, their claims are very different.

A history of the avant-garde usually tries to perpetuate a given momentum. For some years now, we have witnessed such an attempt in the terms used to describe a continuity of modernism with the help of various prefixes such as "post-," or more recently "alter-."[4] A discursive model sees each movement as a temporary realization of a possibility that left some unused options behind. It looks for parallel worlds with other options and waits for the break to occur.

An attempt to apply the avant-garde model to media and arts can be found in Lev Manovich's book *The Language of New Media*. Relying on the example of Russian formalism, his approach draws parallels between the experiments of Vertov and contemporary media arts.[5] On the other hand, Manovich is well aware that the situation of our contemporary media is not given by single actors but much more by the principles of programming, the logic of the database and new tools of navigation. No new Vertov has yet appeared. It would require some distortion of history to invent a parallel figure in the history of the Net, whose progress can be assigned to engineers, programmers, and founders rather than to artists. The recent history of new media does not lend itself to the vectorial approach to history and the rise of a new artistic avant-garde.

Parameters

Constructing the possibilities in the field of image-production requires figuring out the decisive parameters, some of them showing variables, others fixed states. One known factor, we can assume, is that the given technological environment will progress in a more or less linear way to higher bandwidth and smaller, more powerful machines, pretty much according to Moore's law. This will almost inevitably lead to a more and more time-dependent Internet, a more dynamic environment in contrast to the fixed and stable structures of today.

Among the variables there is the situation of the viewer, which has three possible arrangements. The old dominant form relies on the theatrical space of the cinema, with its controlled and passive viewing. Competing with it over last couple of decades is the home-based screen, well established by television, and recently enhanced by an internet connection. A third possibility arises from mobile devices.

Another important variable consists in the various platforms of production. As the slogan "Web 2.0" has made us believe—to a certain degree misleadingly—we enter a situation in which the users are fully entitled to deliver their own content. This achievement was not at all due to a specified interest on the user's side, but to a major change in the technical environment of the Web. Since more and more computer power is available on the side of the server, its actions were no longer restricted to simple data-transfer. Instead it could exploit the growing bandwidth to increase interaction with the user (e.g., AJAX) or interaction among servers (e.g., mash-ups). Thus,

the apparent empowerment of the client, that is, the user, is simply due to abundant computing power—not on the client's but on the server's side. The user itself acts as a dependent entity subjected to the frame of options offered by the server-side software. Here, we enter the field where future collaboration will take shape.

Time and Author

Whenever a video is made and seen, we are accustomed to having participants on two sides, the viewers and the producers. Even if the two sides start to melt into the figure of the "prosumer,"[6] most likely a considerable asymmetry will remain. Nevertheless, the border between production and reception might be blurred from now on. In the same way, the structure of time that was once fixed by the chain of production, post-production, and screening might break down. The time of viewing will be intrinsically linked to the procedure of production and also to the format, the narrative, and the aesthetics of the images.

Various configurations of the two parameters of authorship and time may show what might be possible. Until now, there were mainly text-oriented online platforms that created hitherto-unknown modes of authorship and time-relations.

The early Internet abolished the dimension of time almost entirely. For example, the search engine Google operates as an apparatus that widely ignores time. The reason for its blindness toward time stems from the simple fact that the links themselves bear no reference to time; files were regarded as items stored for eternity. These restrictions in the appearance of time might be superseded by a more dynamic architecture of the Web. But this change is only about to happen. It might eventually be regarded as a break from an early to a mature phase of the Net, much like the one from photography to moving images.

Possible Platforms

The wiki, a well-known platform for collaborative text, has not yet been widely used for video, as editing online remains difficult. Once that problem is solved, we might encounter more collaborative practices along the model of a Video-wiki.

In contrast to the wiki, the blog operates with a sequence of entries in the dimension of time. Instead of an assembled text aiming for long-term validity, it brings the author with his or her instantaneous thoughts back into relevance, taken to a dynamic extreme in micro-blogging sites like Twitter.

A third option is that of online games, which do not fully belong to this logic, because they are very dynamic and involve a large number of subjects. Games combine dynamism with authorship by joining together seeing and producing, turning every viewer into an actor and the whole system into a live environment with no archive.

Matrix of Author and Time

A matrix of possible forms unfolds along the dimensions of a time lag in production and authorship. The classical movie realizes the well-established combination in a format of production that has a time lag as well as a strong sense of authorship. Again, games position themselves at the opposite end of the spectrum, as they realize a live environment with no time lag, and with shared authorship among all participants.

There is more than one transitional form between these two opposite ends of the matrix. One of them is the so called machinima genre: movies that try to stage or restage cinematic scenes in a game environment, bringing back authorship and the time lag through the editing process.

Other possibilities explore the remaining two fields of the matrix. One solution consists of a practice that preserves authorship without time lag. Such a practice is well established in music. The DJ operates live, remixing foreign material under his or her authorship. When it comes to the field of the visual, the VJ steps in at various opportunities, seen not only in the clubbing scene. Other examples of such a practice can be found in any transmission of live events, be it sports or elections or concerts.

In contrast to the VJ-model (assigned authorship and no time lag), another combination is possible: with time lag but no authorship. The obvious model for such a practice is the wiki. What can be done with text should also be feasible with images, and indeed there are some projects in process (figures 6.3 and 6.4).[7]

For these types of works, the time of the product's release brings into question the relationship between producer and viewer. A wiki-video may never reach its final stage, like the famous movie *Birth of a Nation*, which was reedited several times by its director David W. Griffith after each of the first series of screenings. A wiki-like process of production would make creating a movie an ever-changing work in progress.

Aesthetics

The structure of Web-based platforms sets certain constraints on the flow of decisions and the assignment of authorship; in other words, they prefigure narration and aesthetics. Again, consider the cinema. The dominant form of movies brought a relatively strict type of narration, involving prominent actors supported by psychologically well-grounded roles and fully motivated chains of action with a beginning and an end.

But there were and are plenty of other forms of film available. The clip represents a smaller entity relying in its narrative on the limits of a musical form. It is no surprise that the format of the clip, with its limited duration, has proven most successful in the early era of YouTube.

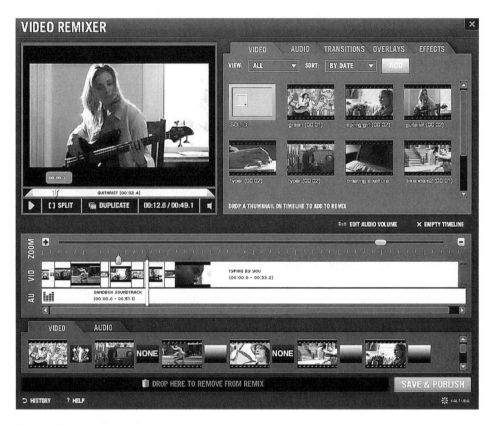

Figure 6.3
The online video-editing interface of the collaborative video-wiki, <http://www. Kaltura.com>.
See <http://corp.kaltura.com/blog/wp-content/uploads/2009/03/advanced_editor2.jpg>.

With regard to television, the format of the serial adapts the cinematic narration to a regular viewing situation. Cheap storage media and online streaming have helped to spread the serial beyond the scope of the actual broadcast.

Similarly, games realize a potentially endless flow of moving images. A mash-up of a game and a television series can be easily envisaged. It would either add the decisions of the viewer to the serial, or it would establish an asymmetrical distribution of viewers and actors within a game, turning it into a live-stage for the series.

Here we enter what Henry Jenkins called a "world."[8] In its degree of involvement and its universality of possible settings, combining many actors with a constant flow of events, the world as a known form in online gaming seems to be a likely possibility of future image production.

Figure 6.4
With over 50,000 participants from 101 countries, Mass Animation is one of the first large global animation collaborations. The platform is based on Facebook. From <http://apps.facebook.com/massanimation/AllShots.aspx?FilterId=RecentEntries>.

Parasitical Spectacle and Beyond

One could now imagine a variety of possible visual settings within the given coordinates, some of them already present or about to be realized, some of them still in the nascent stages. Certainly there will be VJ-like orchestrations of real-life events designed for mobile devices, or user-generated wiki-movies playing in a cinema, or a visual blog created by multiple authors delivered to a tag-based television-program.

Again, the task is not so much to permutate all the options, but first to construct them in a way that they match present, and not past, media environments, and then to observe their chances of attracting viewers and of having the appropriate allocation of the workforce. Another probably more exciting option remains the exploration of a form that could not only turn into a commercial success, but also become a visual art.

As for the commercial success, the most likely option remains the "best of all worlds" for consumers: a constant stream of narration, blended with advertising and created by a community of users.[9] This would prolong the dire situation of our contemporary television, which mainly operates as an advertising platform. Any other form that would want to compete with the mode of a parasitical spectacle nurtured by an exterior economy of consumption and advertisement would need to either establish a closed economic relationship with its participants, or rely on a technically inferior apparatus.

As the economy of reproduced goods cannot be revived given the free flow of data, the first option of a closed economy would have to consist in a model of restricted presence and participation, similar to that of online games. The second model of cheap production would need to be realized in user-generated visual forms that are then kept alive, nurtured, and exploited by the commercial visual worlds as explorative input. After all, the so-called cultural industry does not actively prevent the development of sophisticated inventions. It simply revalues them in terms of their profitability. Therefore, the coming parasitical spectacle of competing "better worlds" will leave a niche for artful works within its dominant form.

Notes

1. See Janet Staiger, "The Hollywood Mode of Production to 1930," in *The Classical Hollywood Cinema: Film Style and Mode of Production to 1960*, ed. David Bordwell, Janet Staiger, and Kristin Thompson (London: Routledge, 1985), 85–154.

2. Marshall McLuhan, *Understanding Media: The Extension of Man* (New York: McGraw-Hill, 1964).

3. See further Stefan Heidenreich, *Fliflop: Digitale Datenströme und die Kultur des 21. Jahrhunderts* (Munich: Hanser, 2004), 161–175.

4. Cf. Nicolas Bourriaud, *The Radicant* (Berlin: Sternberg Press, 2009), 22.

5. Lev Manovich, *The Language of New Media* (Cambridge, MA: MIT Press, 2001), 307.

6. Already in 1980 conceived by Alvin Toffler, *The Third Wave* (New York: William Morrow, 1980), 273.

7. For example, the open-source video platform, <http://www.kaltura.com>, or the mass animation platform based on Facebook, <http://www.Facebook.com/massanimation>.

8. Henry Jenkins, *Convergence Culture: Where Old and New Media Collide* (New York: New York University Press, 2006).

9. Maurizio Lazzarato, *Lavoro immateriale: Forme di vita e produzione die soggettività* (Verona: Ombre Corte, 1997), 85.

7 Imaging Science: The Pictorial Turn in Bio- and Neurosciences

Olaf Breidbach

The pictorial turn in sciences does not only mean a new extension in documentation.[1] The visualization of ideas entails referring to simulations and models that end up on a computer screen. We have to deal carefully with enhanced computation capacities that might allow us to give an artifact a lifelike appearance, but this appearance does not necessarily mean that the formula being depicted opens up a new dimension into our understanding of nature. We tend to emphasize the technical performance and might neglect the underlying analysis. Thus, eventually, we need some new way to form and judge visualizations. The difficulties involved might be demonstrated in the biosciences, in which models have become more and more important, especially in those cases where analysis is still in its early stages. The complexity is so great that it is very difficult to develop a mathematical approach to describe it.[2] The problem may also be demonstrated in the neurosciences, where although new imaging techniques are being used to understand brain functions, the performances of such have nevertheless been designed according to classical theory of brain anatomy.

What is a picture if not a documentation of something visual? A photograph seems to mirror nature. But that is true only in a superficial way. A photograph selects a perspective; it focuses on certain things, may enhance certain attributes important for the observer, and will point these out in particular.[3] Recently in the history of sciences, discussion has arisen on mechanical objectivity, dealing explicitly with this problem.[4] The outcome of this debate was that photography is not simply lending the pencil of chemistry to nature so that one can document it objectively. Apart from the notion that the photograph itself is an artifact that has been formed through a very complicated procedure that is optimized according to the particular needs of a photographer, there is a further simple fact: A photograph allows multiple reproductions. This can be seen in modern field guides for botanists or zoologists. The identification of a particular specimen is supported by illustrations. Formerly, these were line drawings that gave some of the essential characteristics of a certain species, generalized from the analysis of a whole series of individuals. Nowadays, these are photographs. The photographs give only one particular specimen of a species—interestingly in most cases

not the most typical, by which a taxonomist should classify the various forms, but an individual selected by aesthetic criteria. The photograph is not an abstraction showing the specific attributions that the taxonomist considered relevant for proper classification. Rather, the photograph is an individual that is reproduced hundreds or thousands of times and, thus, by its pure abundance, sets a new standard. Around 1800, Justus Christian Loder (1753–1832) published a widely used handbook of human anatomy, based in part on illustrations of dissections Loder had done himself.[5] In those, he pictured all the details of human muscle innervations. For example, he described side branches of the innervating nerve from the fifth to the sixth order. Colleagues who redid such preparations afterward, referring to these pictures, tried to reidentify the side-branches, but these are highly variable in human beings. Thus far, such details cannot be considered genuine anatomical characteristics, as they have only been shown in one individual.

When we receive a picture of something, we get an interpretation. The very selection of a certain object or a perspective under which this is presented already directs our associations. Thus, not everything that we associate with a convincing image should blindly be trusted as presenting us with the entity documented as it "really" is.[6] That might not be possible at all, if the take-home photography is just a reflection of something we had already understood according to our own point of view.[7] Furthermore, this photograph is also then reinterpreted by any second or third observer. As a photograph, it is interpreted as a picture, that is, according to the standards of our visual culture.

Around 1900, the prominent evolutionary biologist Ernst Haeckel (1834–1919) published a volume on the art forms of nature, presenting in much detail a series of zoological creatures.[8] He thought his pictures were an exact presentation of what the creatures really looked like, and that thus, in the book he was describing certain new species. Today, we consider that book a typical art nouveau production. In fact, we may treat these illustrations as artwork.

Our visual culture is very effective even in forming our representation of nature. The now extinct dodo was most fascinating for an ornithologist because of its obscure morphology.[9] Thus, there is a series of reconstructions and reports, based on some bones and some drawings from when the species was still alive at the start of eighteenth century. However, reconstructions differ considerably over time, in spite of the fact that the methods used in early nineteenth-century anatomy do not differ in principle from those used in the twenty-first century. What can be shown, however, is that the various reconstructions follow the principles of the conventions that were prevalent during the respective decades.

Thus, if we trust only pictures, we might find ourselves limited to our own cultural perspective. Another group of extinct animals—dinosaurs—may make this more

explicit by demonstrating the new dimensions of visual presentation and representation we now have to deal with.

Already in the late nineteenth century dinosaurs had become quite popular not simply as proof of evolution, but as some new type of exotic creature. They were exposed literarily in Sir Conan Doyle's (1859–1930) *Lost World*, written in 1912.[10] The ideas of their appearance were not just derived from the reconstructions of skeletons given by naturalists, but were prompted by illustrations. Édouard Riou (1833–1900) illustrated the 1864 *Journey to the Center of the Earth* written by Jules Verne (1828–1905).[11] One hundred years later, sketches of Neanderthal by Zdeněk Burian (1905–1981) had similar effects on the popular imagination.[12] Burian illustrated popular natural history, such as works by Karl May (1842–1912) and science fiction stories. The parallelism of the visual settings in these different types of literature made his illustrations most believable to the public, as he made use of common schemes and visual dispositions that were only enhanced by illustrations.

Illustrations of dinosaurs allowed us to understand something real, merely from preserved fragments. The picture gave the remnants new life, allowing our imaginations to set these models themselves into motion. Thus, the models themselves actually are endowed with a touch of reality, which allows us to understand that these virtualizations as a kind of nature film. The standard mid-European biologist at home is a trained TV watcher. Reality is set on a telescreen, giving an African lion more presence in workday life than the real-life sparrow sitting on the roof of his apartment. In such a media world, virtual realities come fairly close to filmed realities.

Thus, virtual realities have a meaning beyond the hypothetic exposure of ideas about former worlds and the objects within them. This is obvious in the BBC series *Walking with Dinosaurs*,[13] which describes the social behaviors of species like *Cynognathus*, behaviors that explain why such a group of vertebrates could have been successful in evolution. These *cynognathi* were primitive mammals; only a few of their bones have been discovered. The movie describes a scenario showing these *cynognathi* as a socially engaged species, despite the fact that any claim about such behavior is pure speculation. The film just puts forward the idea of an intellectually advanced type of species that, in the long run, outmaneuvered clumsier dinosaurs. In the additional material on the BBC disc, the filmmakers go on to make these visualizations real, explaining that visualization, and the challenge to make people believe that the virtual dinosaurs were behaving naturally, changed ideas about the functional morphology of these species. What no one could have understood just by looking at fossil bones could be fleshed out by a filmmaker. He had to combine the bones in such a way that a certain movement pattern became plausible. Thus, they proudly present a type of sea-monster whose pectoral fins were set into motion in such an impressive way, that—as the filmmaker argues—the scientists were overwhelmingly convinced by the

idea that the extinct species might actually have moved in such a way. The image thus places the lost species not only into a model but into real life. When in the last item of the series the virtual scenario changes from day to night, it goes from natural light to infrared representations, giving the illusion of an actual documentary. Thus it turns out that a dinosaur may even spit into the virtual lens of the virtual camera. And he did.[14]

Is this the future of visual representation in natural history? It seems that it is. In 2001, according to the virtual voyage back into natural history, when scientists tried to look forward into the future, they mixed together such schemes of virtual life from lost worlds.[15] They formed new combinations, made plausible by structural analogies to something that had already been seen on screen. But even in real studies of evolution, such fictions may be valid. For example, it is now possible to build new types of machinery through a construction that can be varied in some of its details. Such a machine is not described in every detail; rather, some of its parameters are varied and its resulting performance tested. The better performing variety is fixed, another parameter is varied and tested, and so on, resulting in a kind of evolution that allows us to optimize the machine's features. Such an evolution can be performed with real prototypes or in a virtual scenario, which is much faster and less expensive. Maciej Komosinski, for example, tries to optimize the automated movement of robots and uses visual modeling to test his ideas.[16] In his program Framesticks, he uses animated video-sequences to display various forms and test their movement patterns. The program selects some of these virtual forms by filtering out certain character patterns, describing the actual behavior of these machines using videos of animated movement patterns. There is no need to build a mechanical model that would allow actual testing of any particular form that might be developed in the various stages of optimization. Even better, the virtual conditions could be set in a way not safely obtainable in real life, and, thus, allow us to construct machines optimized for extreme situations.

However, as such surroundings are virtual, the machine can be implemented in the program only in regard to those parameters that are already known. Knowledge gained in the application of such a virtual device is reduced to the testing of new combinations. The virtual image that seems to outline something new only describes the details of a formula that is already known. It shows something that is understood in principle, so far, but that has to be tested in regard to specific parameter settings and their variations. So, the virtual world is not from afar; rather, it provides variations of something familiar. Such virtual worlds do not create new perspectives, but simply vary common characteristics. Thus, pictures do not create something new. To arrive at something new, our imaginations and hypotheses have to be tested in the real world. Only there can obstacles be found.

The virtual describes something already understood. The real-world scenario is different. In the virtual world, a moving robot is a machine that may function well in

its own world, but it has been set into a world that is not constructed down to its every detail.[17] The real-life robot is programmed, too, and it has to apply the rules using his mechanics in a surrounding that has been selected by its tester, but has not been defined by him. There are principal physical characteristics of real-world physics that we cannot vary but have to work with. These characteristics cannot be foreseen in all their details. There might be something we had not thought of, that might come into focus, that we have not foreseen. This is the test we are aiming at in a real-life scenario. This is the only way to see whether our construction can deal with the outer world. The image can document such a success: There might be a film that shows us to what extent our construction did what we thought it could do. But when such a film is set too far apart from real life, and claims that what we see in it is everything that could have happened, we may overestimate it. Such a film gives us no real perspective that would allow us to work with only those things we actually had known before, even if we can show any possible combinations within a predetermined set of data.

Fractals provide a good example of this situation.[18] There is just one formula, and all the various implementations of its variables, which result in a huge series of pictures, demonstrate that same formula. If we look at the pictures produced, according to a certain formula, we can describe very complex interactions. Therefore, we do not have to understand what the formula itself meant, but rather can just deal with its outcome. If the formula describes an ecological scenario, we can implement values like abundance, energy consumption, or different physico-chemical variables.[19] The result is a certain variation of the overall reaction of the system. Such overall reactions can be found in real life, too. One could even show whether the effect elicited by a change to one parameter in the model elicits something we know to be true from real life. If this is the case, and if the variation of another parameter might eventually also elicit responses similar to those in the model, we have a good indication that the model in fact reflects something from the real world. Thus, we test our formula with real-life data. In the end, when the model run comes pretty close to the data shown in the field experiment, that is a good indication that our model tells us something about what is actually happening. The question now is: Can we extend the model to constellations not yet seen in reality to approximate what might happen in the future? If so, we extend the situation tested, relying on the idea that some of the interactions that are effective in real life are actually depicted by our formula; and thus, by use of the model we can learn about what to do to control future risky situations. However, in doing so, we again stick to the factors already implemented. As we only combine things already registered, we follow a conservative modeling approach, taking for granted that there is a certain scale-invariance within a system. But what about long-term effects? How far can local components be abstracted from a huge system? If we change the variables in a preset framing, we will have preset a whole complex of

propositions. The complexity of the various interactions, all of them pictures so far, may show us such a large amount of variation that we might be tempted to just stick to the model—thus determining its figurative capacities rather than going to a more abstract level, where we would have to analytically question the applicability of such presumptions behind the situation, changing not the variables but the formula itself. The point here is that in doing so we lose the model reality we have been working toward; we might find some new images, or even continue with the old ones, but we would have to give them another meaning (because of the altered formula). That might prove difficult, especially if we used the former model to correlate various scientific disciplines, perhaps cooperating with colleagues who are explicitly interested not in the mathematics of the model but in its outcome.

The image that translates a formula into something that everyone understands implicitly has some dangerous aspects. You may look at a positron electron tomography (PET) scan or functional magnetic resonance imaging (fMRI) of brain tissue showing certain localizations of activity patterns, and you may get the feeling that indeed the brain is composed of such activation centers, whereas, in fact, we had to deal with a much more complicated network of interwoven neurons with very particular functional finely tuned patterns. Nevertheless, the presented images look like a performance of the essential activation pattern of such brain tissue, as you may effectively elicit comparable activation patterns by such noninvasive technologies in various individuals. Thus, again you may feel that, if such a system resembles the real world so closely, it must fit perfectly. However, it only describes one aspect of the complex of various functional activation patterns. These do exist, at least as the output of the machinery; how far they give us the essentials of the object under study is a second question. For us to accept them as useful, it might be sufficient that they look like a real-world performance. We will not have understood, however, how such analogies can be understood functionally. We cannot foresee to what extent we can trust the model. At this point, it should be used to make hypotheses about certain interactions and to test these hypotheses both analytically and experimentally. The picture, thereby, offers a tool to understand world situations, but it is not a world in itself, for the biological scientist. Thus, it might be profitable not to continue using certain images, but to form alternatives to describe further developments on a more abstract level.

When meteorological developments were programmed in Fortran in the 1980s, the data had to be compressed considerably, especially when working on a long-term perspective. For such purposes, in the beginning of the 1980s, the world was reduced to a nondimensional entity with a statistical distribution of seawater or a certain standard, a certain albedo, reducing biology to a percentage of forest patches in the zero-dimensional world. One could easily see that at that time such a model was based on describing certain aspects of an artifact of the methodology. That model was

designed in such a way that an early computer could handle it. The technical device predetermined the nature of the model. Today, calculation capacity has increased exponentially, but even the programming of the most complex systems has to make concessions to hardware and software design. Furthermore, the question remains: How much data does a system need to run reliably? Recent discussions about models that simulate climate development point to certain asymmetries in the data pool. Thus, whereas we had a high density of measuring devices in the northern hemisphere, we neglected offshore areas. Accordingly, we had to develop functions to correct the misrepresentations of certain world regions. Such functions, however, depend on the models applied. Thus far, the correction is redundant. The problem is that the only way to correct the misrepresentation is to rely on further models and simulations. As the amount of data is so great, and the interactions of the variables are so complex, we cannot work out a purely analytical scheme to deal with that problem. Parts of the models do allow for an analytical approach. Yet, to isolate them within the system, we have to commit to numerous assumptions that we can only test empirically.

This is the principal problem in handling very large data sets in dynamic systems. Complexity cannot be dealt with analytically now or in the near future.[20] We have to rely on models; and thus, we have to rely on images that demonstrate the performance of the model. We compare different models by referring to their respective performances. Thus, we have to think about how such performances are designed. How can we use them to make our ideas plausible? Can we use them as tools to put forward certain hypotheses, give them a certain heuristic value, and allow us to think in pictures, without taking them for the reality that we're using them to argue about? It might be necessary to develop a new way of visual thinking, using new types of pictures, models, and performances.

Mathematics describes complicated functions via the integration of various variables. If we combine two of these functions, we obtain coupled differential equations. If we add some more, the coupling features become more and more complicated. Thus, an analytical solution is impossible. Already, combining three equations results in the crash of analytical scopes. What we can do is estimate, by testing certain variables. As the calculating capacities of our computers have expanded, we can still do work on a continuously extending scale of data representations, allowing the modeling of more and more combinations to see what will result. The result is a picture, eventually a movie, in which certain combinations are performed for their effects. If we take them not as representations of something else but as their own reality, as some hypotheses about the world that is described by them, that would be a first step toward an extended use of imaginative sciences.[21]

We now have new developments not only in the design of model runs and the applications of simulations in the biosciences, but also in representation techniques.

Especially in the neurosciences, these can be studied in detail. The tool of choice in earlier neurophysiology was the electrode, which allowed neurologists to register cellular responses in the nervous system describing couplings and decouplings of different nerve cells, sensory neurons, and motor elements.[22] In the end, we were able to describe certain functional pathways in the brain, their ontogenesis, and their interactions. But such techniques were invasive and thus could not be used on healthy human beings. Furthermore, only a few electrodes could be set for one brain.[23] Thus, one was only able to describe quite small networks in the nervous system. That problem could be overcome by the analysis of more simple nervous systems, where, in fact, the neurons within one pathway could be described completely.[24] Even such simple nervous systems or subcompartments of nervous systems may form diversified tasks such as the control of chewing movements or leg movements. But the physiology of cellular interaction in the nervous system could only be targeted theoretically in such an experimental setting. In the 1980s, noninvasive techniques were developed that promised completely new insights into brain activity patterns. Before, there was the electroencephalogram recording, which already in the first half of the twentieth century allowed scientists to register mass activity.[25] The technique, however, was problematic in that its data could not be correlated directly with certain brain tissues, but was able to register only some summed-up brain activity patterns. Admittedly, in the last decades of twentieth century, pooled data sets of EEG activity recordings could be used to somehow present a topography of main activation regions in the brain, but the resolution was still too poor to correlate these regions with particular nerve cell types or tissue compartments.[26] New devices developed in the 1980s worked on changing rates of metabolism in the different brain areas over time. They tried to show how such rates were varied in certain regions in different situations: analysis of three-dimensional distribution of radioisotopes coupled to certain chemicals allowed reconstruction of blood flow in the brain and, thus, identified main activation regions on a reliable dimension to identify changes in activity in certain areas. Unfortunately, however, the temporal resolution of this technique was poor. Thus far, only quite general reaction patterns can be registered using this technique, positron electron tomography.[27]

Additionally, the description of magnetic resonance patterns allowed for an analysis of different tissue constitutions in the living brain without harming it. Thus, tissue constitutions of individual brains could be described parallel to PET scans, so that noninvasive histology could be combined with noninvasive physiology.[28] Similar techniques were able to register metabolic rates or to follow certain metabolic products within the brain. Thus, the human brain could be represented at work and brain-imaging entered a new dimension.[29]

This technique shows the complex network of instantaneous brain activations being employed in different behavioral contexts.[30] The purely descriptive access to

brain imaging thereby allows scientists to detect whether certain areas are prominent in certain behavioral settings. But this is only one part of the story. The data collected not only can allow the sorting out of certain areas of maximal metabolism, but can also show whether certain distinct areas in the brain are activated synchronously or in a characteristic and repetitive way.[31] As the PET machinery scans the whole brain, it registers the complete brain activity pattern. Thus data analysis now might allow us to analyze whether there are couplings in the extent of changes in the metabolic rate between any brain areas. As we know that the wiring pattern in the brain is highly complex and that any neuron is connected by fewer than 10 neurons to any other neuron, this may allow us to deal with the brain in a different way than the classical electro-physiological studies.[32] The data set could be analyzed not in the classical way, by recording certain brain areas with the most prominent activation pattern, but be described in its own characteristic way, by tracking a whole set of changes in coupling characteristics of the entire data set throughout one experiment. This would be theoretically interesting, as it would allow correlation of the analysis of pathway characteristics in neuron anatomy, and not be restricted to only classical neuron histology. Thus, we might develop a new way to look at integration in brain tissue.[33] However, the PET imaging did not allow this. As this tool is used in medical studies, its output has to be correlated with other classical data sets like histology, pathology, or the classical electrophysiological characterization of brain regions. According to the tradition that the brain forms a structure in which certain areas possess certain functions, one has to look for those particular regions that are used in certain functions. When designing the PET imaging technique in such a way, that is, to show local metabolic changes, one could extend former histology to a dynamic situation, showing not only lesions, but also functional defects. This would extend our knowledge about the effects of a stroke or other conditions that have an impact on brain tissue.[34] Such an analysis has direct medical significance. Accordingly, the data registered by PET machinery are presented in a form that can easily be compared to such classical registrations. The new data are not formed according to their own meaning, but are presented according to a visual tradition. This may easily allow interpretation of the new data according to old schemes, and thus, allow their direct use in medical research or applications. Thus far, the possibilities to form and test alternative concepts of functional brain representation have not been explored. These possibilities may, however, prove interesting in the long run. According to such alternatives in pictorial representation, we might even develop an alternative theory of brain function. Thus, the neuron network theory, as problematic as it was in its application in the neurosciences, at least presented a new way to visualize data transfer in a tissue of interwoven cellular elements. According to ideas following from these perspectives, one has to look at changes in the intensity waves of brain activation patterns and, thus, try to look for tools that allow such visualization of brain activation patterns. Ca^{++} sensitive dyes allow this,

even in real-life scenarios.[35] Using such techniques, activity patterns in whole brain areas can be tracked in minutes. The resolution was much better in time and space than that of the noninvasive brain imaging techniques. The only problem, however, is that these dyes prove to be poisonous, the brain surface has to be exposed, and the experiments are anything but simple in regard to the treatment and care of the animals. Nevertheless the data gained were spectacular. They demonstrate intensity changes in whole areas in real time, allowing parallel registration by classical electrophysiological recording techniques, and thus provide a much better view of brain activation patterns.

Tools that are being developed by molecular genetics, which allow the switching on and off of certain gene activators, provide additional means to understanding cellular interaction and the ontogenetic or postontogenetic changes in the wiring characteristics and basic functional architectures of brain tissue. Such studies have led to a new scenario in which the classical traditions of brain imaging could be replaced by new imaging techniques. These may allow for the study of brain dynamics at a new level of representation, and in the long run, may provide new ideas for how to visualize brain function and functional brain architecture.

Two aspects should be noted here: First, if the brain is a computational device, organized similarly in some ways to telecommunication systems, we are following a fairly old concept and reactivating some technical ideas that are only superficially represented in the neuronal wiring patterns of the brain. Second, there is no fixed pathway of brain activation; to the contrary. Activity is propagated through the brain by a more complicated arousal of entire networks of different cellular ensembles. We can show that, in effect, this device produces some concert of parallelized activation patterns. Interestingly, the model that is forming according to this idea is inconsistent with the idea of brain localization. Thus, a consequent representation might result in a different brain model, which would allow for the interpretation of regional specifications in brain organization but would not be reduced to that idea. Interestingly, a concept that dominated nineteenth-century functional brain morphology relied on just such an alternative idea, put forward in associative psychology. The prominent nineteenth-century author was James Mill (1773–1836).[36] He had the abstract idea that the brain is a kind of resonance organ, in which elements are set to resonate according to certain input characteristics: Certain brain regions are coupled to input areas that correspond to physical characteristics of the stimuli. The induced response of such a brain area would be registered by the surrounding tissues that may react in the same way. Thus, the reaction of such an area is predetermined by its structure. It can oscillate only in the way it is built to oscillate. Accordingly, an input is not represented in the same way it is presented in the outer world, but is formed according to the construction of the respective brain region. Mill postulated a hierarchy of such stimuli-

representing areas. The first level is formed by those areas that are coupled directly to a sensory organ. If these regions oscillate, they may cause an oscillation in the neighboring areas. Two only slightly different oscillations of the sensory input areas might result in some slightly different resonance of the brain tissue in the neighboring region. Accordingly, there is no real difference registered in that region. Two signals that elicit such a more or less identical response were described as being alike. In another case, the situation may be different, and, thus, two different signal inputs will be registered as distinct. Mill postulated a hierarchy of representations in which different oscillations in the lower level may be registered and be compared by the mechanism described; that is, two oscillations are considered to be equal if they elicit similar responses in the next hierarchy level of resonance areas.

In this way, Mill described sensory representation as a kind of distance functioning in the reaction capabilities of brain tissue. His idea was, in essence, a kind of simplified set theory.[37] Every stimulus is represented as an element of a set. Certain sets do not overlap, whereas other sets do. Enfolding a hierarchy of overlapping sets, and integrating the sets of the lower level as elements, allowed the development of the principles of the associative machinery. To understand this, we can postulated a simple mechanism: An overlap in stimulated areas could be detected in the next step of the association program, where, as in the case of logical calculus, some of the elements that were activated by the first set of sensory input areas will be activated only if there is such an overlap. That will cause a parallel response of different hidden units in this layer. The amount of coactivated elements and the intensity of their coactivations depend on the degree of overlap. This provides a measure of how similar two stimuli are. It is easy to construct the guidelines by which such a putative mechanism could be installed in the brain to do this. What we need are sets of neurons that react in the way described, showing different zones of overlap in a hierarchy of sets of integrating neurons. Thus, we may canalize the information flow, which may allow us to map out a mind-internal similarity-calculus.

The problem is that in the above-mentioned situation there is no predefined reaction and thus no predefined selection mode for a specific set of stimuli. In fact, the brain has to integrate something new, that is, something that has not been known so far. Something new cannot simply be compared with something already known. To understand it as being new, it must be perceived as something different from those things already known. The brain must provide a mechanism that allows it to identify such unknown stimuli and couple these to new trains of internal activation patterns. Given this situation, one has to realize that the naive attempt to describe the organization of the neuronal network as a set of interlaced information highways refers to anything but a simple structure.[38] If there is a defined property, this idea would tell us that there is a certain pathway organization in the brain that corresponds to a

delivery system. That organization may be optimized within certain limits; thus, it provides a certain preformation of putative and fruitful internal coupling characteristics. These characteristics, however, require much further elaboration.

Given the high degree of putative coupling characteristics in the brain, we essentially know that a signal will not be transferred from here to there, but rather from here to everywhere that the neuron is connected to.[39] According to Braitenberg, that indeed is no simplification. As an examination of the rat brain shows, each neuron is coupled with any other neuron via only four interlaced neurons.[40] As has already been mentioned, this demonstrates that each neuron has an immense ability to disperse information. In fact, one neuron sends its arousal characteristics through its axon and collaterals to any other neuron to which it is connected. If one of these second-order neurons has a low activation threshold, this input may be sufficient to cause a reaction of the neuron. Otherwise, its reaction capability will depend to a great extent on the state of internal activation of this neuron, which is itself dependent on former activations. The new input will overlay the already existing activation patterns of the neuronal network. Its effectiveness, thus, directly corresponds to the preexisting overall activation of the network in which it is implemented. In a low activation mode, higher input intensities are needed to change the overall system response characteristics. In a situation where there is a massive preexisting activation, even a slight change in the input area may elicit a long-lasting change in the characteristics of the activation pattern of local brain regions.[41]

Abstracting from the specific pathway characteristics of such a neuron architecture, we may regard connectivity as the expression of a space of activation patterns and describe space as a mathematical entity that allows the description of space-time characteristics in one formula.[42] This most basic approach requires simple calculus to describe the dynamics that were coupled in a neuronal network model. The calculus allows for a distinction between different signal inputs by describing the overlay in its internal stimuli characteristics. We can do that in a more sophisticated way. Therefore, we do not have to work with the idea of an explicit overlap of fixed grids with elements that are coupled in a fixed way to defined input elements.[43] What we can do is describe a series of elements that show various varying coupling characteristics. In such an array of elements, a signal is implemented. Now, one could describe the conditions under which this may or may not result in a certain response. Accordingly, one could get an idea about size and variation in a connectivity pattern that show corresponding responses and so far prove to be functionally equivalent, and so on. Thus far, we could describe various functional equivalent connectivity patterns. Such a group of functional coupling characteristics we call a *distance matrix*. The latter is not a particular neuron-anatomical structure, but a more abstract description of a functional type of tissue, neglecting specifications in the space-time characteristics of the elements of such a matrix.

Thus, we can identify a relative-distance matrix, which describes the relation of each element to any other. Now we can extend the analysis by asking how far a certain variation in stimulus characteristics will elicit a certain response. And we also have to show whether the matrix is the same for different input characteristics, or whether we can define different groups of connections that can be described as parts of various matrices to understand a bit more of the enormous variation in functional connectivity patterns of brain tissue. Having done this properly, we can define those groups of coupling characteristics that are functionally equivalent regarding a specific input and those that are functionally equivalent regarding different inputs. Correlating the two the types of matrices will tell us a bit about the functionality of neuronal connectivity patterns.[44] Such a description allows us to unfold homologous singularities in stimulus-response characteristics, depending on the actual hardware implementation of the neuronal connectivity in such a network.

Now, this is a straightforward task, as the system will just look for differences from anything that is implemented within itself. Yet, already this description shows that this categorization of signals may not work in reference to a fixed grid of network stimulations, but rather makes it necessary to use a more complex method. Thus, the idea of a fixed grid with fixed entry position is extended to the idea of a matrix in which every element is described by its putative contacts to any other element of the map. A certain stimulus presentation may be shifted around the grid, showing different excitational characteristics of its elements that reflect the actual connectivity of the elements of the system. All these different activity patterns are seen as equivalent. Thus, for example, if a small input elicits a certain response that quickly dies down, and a second input elicits a different response that in the end will result in the same effect, both inputs are regarded as functionally equivalent. However, such different, functionally equivalent inputs will be overlaid on a network that shows a considerable amount of endogenous activity. Here, the initially different patterns of the formerly functionally equivalent inputs will eventually result in different alterations to the system. Such differences in comparison of the effects of implementations still need to be described.

Thus far, a certain pattern can be rotated or otherwise repositioned in the system without affecting the overall activation of the system. The activation is described by the same formula. All of these activity representations that are described by the same formula are seen as identical. A pattern that is not matched by this formula is regarded as something distinct, representing a stimulation that is different from the former patterns.[45]

When dealing with such a situation, we have to rely on modeling to describe the appropriate experiment to explore such dynamics. So far, mathematical analysis is not able to give a formal treatment that would allow us to describe a formula by which we could pinpoint the essentials of such a functional characteristic of brain tissue.

Thus the dynamics of brain functionality provide just one example of the study of complex systems, alongside ecosystems or evolving populations. To gain a better understanding and evaluation of the images we have in mind when studying mental activity or other system dynamics, we need new concepts to describe the patterns and morphologies. Thus, theoretically, some of these problems have been addressed by other communities, using similar tools and similar terminologies. How did they do this? The apparently simple idea of defining effects by describing adaptations and identifying the most effective reagent in a web of putative causation proves to be difficult.[46] In such a situation, it might be reasonable, for example, to ask whether the idea of a web of interaction already preselects certain formalisms and modeling strategies.[47]

In looking for new representations and forming new images of such dynamics, we are still at the beginning, searching for the right terminology, models, formalisms, and experimental settings. To couch these ideas in images might be crucial to the entire approach. To select the right kind of visualization is itself a kind of experimental approach toward the use of models; and simulations and images might give an idea of the right perspective to follow. Thus it would be wise to consider the cultural context of our imaging techniques and our methods of image evaluation. Interestingly, the sciences in this way relate back to the arts as described in the late Renaissance in the methodological framework of Jacopo Zabarella (1533–1589),[48] who differentiated between the sciences, as a philosophically reflective approach, and the arts, as a praxis of forming hypotheses and being guided by a search for new forms to represent in theory and image what we have found in the world, or at least have found so far.

Notes

1. W. J. Thomas Mitchell, *What Do Pictures Want? The Lives and Loves of Images* (Chicago: University of Chicago Press, 2005).

2. Olaf Breidbach, Jost Jürgen, and Peter Stadler, "Toward Theoretical Formalism," *Theory in Biosciences* 126 (2007): 1–2.

3. See Peter Geimer, ed., *Ordnungen der Sichtbarkeit* (Frankfurt: Suhrkamp, 2002).

4. Lorraine Daston and Peter Galison, "The Image of Objectivity," *Repräsentations* 40 (1992): 221–250; Lorraine Daston and Peter Galison, *Objectivität* (Frankfurt: Suhrkamp, 2007).

5. Katja Regenspurger and Patrick Heinstein, "Justus Christian Loders Tabulae anatomicae (1794–1803): Anatomische Illustrationen zwischen wissenschaftlichem, künstlerischem und merkantilem Anspruch," *Medizinhistorisches Journal* 38, 3/4 (2003): 245–284.

6. See Olaf Breidbach, "Naturbilder und Bildmodelle" Zur Bildwelt der Wissenschaften," in *The Picture's Image: Wissenschaftliche Visualisierung als Komposit*, ed. Inge Hinterwaldner and Markus Buschhaus (Munich: Fink, 2006), 23–43.

7. Olaf Breidbach, "Representation of the Microcosm—The Claim for Objectivity in 19th-Century Scientific Microphotography," *Journal of the History of Biology* 35 (2002): 221–250.

8. Olaf Breidbach, *Visions of Nature: Arts and Sciences of Ernst Haeckel* (New York: Prestel, 2006).

9. Vincent Zisweiler, *Der Dodo: Fantasien und Fakten zu einem verschwundenen Vogel* (Zürich: Universität Zürich, 1996); Errol Fuller, *Dodo: From Extinction to Icon* (London: Collins, 2002).

10. Arthur Conan Doyle, *Lost World* (London: Hodder and Stoughton, 1912).

11. Jules Verne, *Voyage au center de la terre* (Paris: Hetzel, 1864).

12. E.g., Borivoj Záruba, *Cesta Do Praveku. Dávný svet v obrazech Zdenka Buriana* (Prague: Granit, 2003).

13. *Walking with Dinosaurs*, <http://www.bbc.co.uk/sn/prehistoric_life/tv_radio/wwdinosaurs>.

14. Cf. W. J. T. Mitchell, *The Last Dinosaur Book* (Chicago: Chicago University Press, 1998).

15. Claire Pye, *The Future Is Wild* (London: Firefly Books, 2002).

16. Maciej Komosinski, G. Koczyk, and M. Kubiak, "On Estimating Similarity of Artificial and Real Organisms," *Theory in Biosciences* 120 (2001): 271–286; Maciej Komosinski, "The Framesticks System: Versatile Simulator of 3D Agents and Their Evolution," *Kybernetes: The International Journal of Systems & Cybernetics* 32 (2003): 156–173.

17. Rolf Pfeifer and Christian Scheier, *Understanding Intelligence* (Cambridge, MA: MIT Press, 2001).

18. Kenneth Falconer, *Fractal Geometry: Mathematical Foundations and Applications* (San Francisco: Wiley, 2003).

19. For an introduction to this idea, see Karline Soetaert and Peter M. J. Herman, *Ecological Modeling: A Practical Guide to Ecological Modeling* (Dordrecht: Springer, 2008).

20. See Jürgen Jost, *Dynamical Systems* (Berlin: Springer, 2005).

21. See, e.g., Marie-Lusie Angerer, Kathrin Peters, and Zoe Sofoulis, eds., *Future-Bodies* (Vienna: Springer, 2002).

22. Gordon M. Shepard, *Neurobiology* (Oxford: Oxford University Press, 1994).

23. Francis H. C. Crick, "Gedanken über das Gehirn," *Spektrum der Wissenschaft* 11 (1979): 146–150.

24. See, e.g., Hans-Georg Heinzel, J. M. Weimann, and E. Marder, "The Behavioral Repertoire of the Gastric Mill in the Crab, Cancer pagurus: An in situ Endoscopic and Electrophysiological Examination," *Journal of Neuroscience* 13 (1993): 1793–1803.

25. See Herbert Witte et al., "News and Vies in Signal Analysis of the Electroencephalogram (EEG)," *Theory in Biosciences* 118 (1999): 284–299.

26. Cf. H. J. Herrmann, D. E. Wolff, and E. Pöppel, eds., *Supercomputing in Brain Research: From Tomography to Neural Networks* (Singapore: Science Press, 1994).

27. Klaus Wienhard, D. Wagner, and W. D. Heiss, *PET: Grundlagen und Anwendungen der Positronen-emissions-tomographie* (Berlin: Springer, 1989).

28. Functional magnetic resonance imaging, fMRI: see N. K. Logothetis, "Neurophysiological Investigation of the Basis of the fMRI Signal," *Nature* 412 (2201): 150.

29. Michael S. Gazzaniga, *The Cognitive Neurosciences III* (Cambridge, MA: MIT Press, 2004).

30. For an introduction, see Richard B. Buxton, *Introduction to Functional Magnetic Resonance Imaging: Principles and Techniques* (New York: Cambridge University Press, 2002).

31. *NeuroImage*, recently edited by Paul C. Fletcher, is a whole journal devoted to imaging and mapping strategies for studying brain structure and function. The former editor, Karl Friston, is concerned with advanced mathematical techniques that allow researchers to characterize brain organization and creating models of how the brain is wired and how it responds in different situations. These models are used to interpret measured brain responses using brain imaging and electromagnetic brain signals. Central for these tools are Bayesian estimation and inference in causal models. Bayesian interpretation is also used in the context of models describing cortical hierarchies (see Karl J. Friston et al., "A Critique of Functional Localisers," *NeuroImage* 30 [2006]: 1077–1087). As described by Karl J. Friston, such "models can be quite diverse, ranging from conceptual models of functional anatomy to nonlinear mathematical models of hemodynamics. However, they all have to be internally consistent because they model the same thing. This consistency encompasses many levels of description and places constraints on the statistical models, adopted for data analysis, and the experimental designs they embody." Karl J. Friston, "Models of Brain Function in Neuroimaging," *Annual Review of Psychology* 56 (2005): 57.

32. Patricia S. Churchland and Terrence J. Sejnowski, *The Computational Brain* (Cambridge, MA: MIT Press, 1992).

33. Georg Rusch, S. J. Schmidt, and Olaf Breidbach, eds., *Interne Repräsentationen—Neue Konzepte der Hirnforschung* (Frankfurt: Suhrkamp, 1996).

34. E. E. Kim et al., eds., *Clinical Pet: Principles and Applications* (New York: Springer, 2004).

35. See, e.g., N. V. Swindale et al., "Visual Cortex Maps Are Optimized for Uniform Coverage," *Nature Neuroscience* 3 (2000), 822–826; M. Müller et al., "An Analysis of Orientation and Ocular Dominance Patterns in the Visual Cortex of Cats and Ferrets," *Neural Computation* 12 (2000): 2574–2595.

36. James Mill, *Analysis of the Phenomena of the Human Mind* (London: Baldwin and Cradock, 1829), Olaf Breidbach, "Vernetzungen und Verortungen—Bemerkungen zur Geschichte des Konzepts neuronaler Repräsentation," in *Repräsentationismus—Was sonst?* ed. Axel Ziemke and Olaf Breidbach (Braunschweig: Vieweg, 1996), 35–62.

37. See Olaf Breidbach, "Neurosemantics, Neurons, and System Theory," *Theory in Biosciences* 126 (2007): 23–33.

38. R. M. Gaze, *Formation of Nerve Connections* (New York: Academic Press, 1970).

39. Valentin Braitenberg, *Gehirngespinste: Neuronanatomie für kybernetisch Interessierte* (Berlin: Springer, 1973).

40. Valentin Braitenberg and Almut Schüz, *Anatomy of the Cortex* (Berlin: Springer, 1991).

41. Moshe Abeles, *Corticonics: Neural Circuits of the Cerebral Cortex* (Cambridge: Cambridge University Press, 1991); Andreas K. Engel et al., "Binding and Response Selection in the Temporal Domain—A New Paradigm for Neurobiological Research," *Theory in Biosciences* 116 (1997): 241–266; Andreas K. Engel and Wolf Singer, "Temporal Binding and the Neural Correlates of Sensory Awareness," *Trends in Cognitive Sci*ence 5 (2001): 16–25; E. Rodriguez et al., "Perception's Shadow: Long-distance Synchronization in the Human Brain," *Nature* 397 (1999): 340–343.

42. Jürgen Jost and Olaf Breidbach, "On the Gestalt Concept," *Theory in Biosciences* 125 (2006): 19–36.

43. Olaf Breidbach, "Zur Materialisierung des Geistes oder: Du, Dein Hirn und was es zeigt," in *7 Hügel—Bilder und Zeichen des 21. Jahrhunderts 1 Kern*, ed. Gereon Sievernich and Peter Bexte (Berlin: Henschel Verlag, 2000), 113–121.

44. See, e.g., Klaus Holthausen and Olaf Breidbach, "Analytical Description of the Evolution of Neural Networks: Learning Rules and Complexity," *Biological Cybernetics* 81(1999): 169–175; Olaf Breidbach and Klaus Holthausen, "Self-organized Feature Maps and Information Theory," *Network: Computation in Neural Systems* 8 (1997): 215–227.

45. See M. Bongard, *Pattern Recognition* (New York: Spartan Books, 1970); W. J. Freeman, "Nonlinear Neural Dynamics in Olfaction as a Model for Cognition," in *Springer Series in Brain Dynamics 1*, ed. E. Bacar (Berlin and New York: Springer, 1988), 19–29; A. J. Bell and T. J. Sejnowski, "An Information Maximisation Approach to Blind Separation and Blind Deconvolution," *Neural Computation* 7 (1995): 1129–1159. See also M. Gell-Mann and S. Lloyd, "Information Measures, Effective Complexity, and Total Information," *Complexity* 2 (1996): 44–52.

46. Frank Pasemann and T. Wennekers, "Complete Synchronization in Coupled Neuromodules of Different Types," *Theory in Biosciences* 118 (1999): 267–283; Frank Pasemann and T. Wennekers, "Generalized and Partial Synchronization of Coupled Neural Networks," *Network: Computation in Neural Systems* (2000): 41–61.

47. Olaf Breidbach, "Vernetzungen," *Trajekte* 16 (2008): 29–33.

48. Jacopo Zabarella, *De Methodis libri quatuor: Liber de regressu* (1578) (Bologna: CLUEB, 1985).

8 Toward New Conventions for Visualizing Blood Flow in the Era of Fascination with Visibility and Imagery

Dolores Steinman and David Steinman

Biomedical images, like scientific images in general, are seen and used by the specialist as tools for interpreting, predicting, or understanding situations or phenomena; they are not generated as end-goals or objects for their own sake. However, in recent times, medical images have been permitted to penetrate the cultural realm at large, in which case they do require their own interpretation. In current communications, from expert to expert, and from such to public, the information is passed, found, and looked for through images that are accepted more readily than the written word;[1] thus a biomedical image requires special skill and knowledge to interpret. As suggested by a study conducted by Enquist[2]—among patients with different diagnoses and degrees of illness—both the clinical meaning as desired by their "creator" as well as the interpretative response of the "reader" (particularly the patient) carries an incredible emotional and psychological load. Visual literacy—so greatly needed in this era of fascination with the visual—requires great perceptual skill, conceptual knowledge, and interpretative comprehension in generating as much as in understanding and using images.[3] In this chapter we will try to address the issues and challenges encountered by the medical imager in the search for an appropriate visual vocabulary that would unequivocally represent and explain physiological phenomena (particularly blood flow, the focus of our own biomedical research) to experts and lay public alike.

Medical Gaze and Visual Paradigms

Medical illustrations have never been meant to replace the direct, actual perception of either the medical student or the clinician; however, computer-generated images, now pervasive in the biomedical sciences, reflect a reality that escapes our direct perception, and therefore are loaded with hidden information as well as the responsibility of accuracy and actuality. Science and its visual representations, just like art and everyday life, are influenced, supported, and promoted by technology (and as such also support, promote and influence technology). Medical images are in a pivotal position, being placed, from the outset, at the juncture of science, medicine, visual

representations, and society. Therefore, they merge ways of expression and interests from such apparently unrelated fields and move continuously and seamlessly from macro to micro, from body to tissue imaging, from outside to inside, from the seen to the unseen. The images are technical, certainly, but they also carry a huge emotional burden and can quickly become iconographic; thus they influence visual culture and leave an indelible imprint on culture at large.

Over the centuries medical images (drawings, woodcuts, engravings) have played an educational role for organizing and transmitting gathered information about the human body. Hence, medical images have provided both a cultural corollary and mnemonic aid. One can surely extrapolate and note that the role of nonartistic images has changed over the millennia without, however, being fundamentally altered.[4] Particularly from Andreas Vesalius' *De humani corporis fabrica* onward, anatomical representations have become more accurate through direct confrontation with the dissected body, and with the presence of a consistent iconography. The publication of such a well-illustrated and detailed atlas made great steps forward in correcting mistakes that had been propagated for centuries (as was the case of the *rete mirabile*—the vascular network formed by division of the artery into arterioles that reunite into a single vessel, at the base of the brain of ruminants; through extrapolation Galen postulated it to be part of the human anatomy as well; that theory was refuted by Vesalius, based on his direct observation and detailed description of the dissected body[5]). Undeniably, the publication in 1543 of such coherently ordered and rigorously rendered medical knowledge, Vesalius' *Fabrica* was one of the major turning points in medical visual representations. Another was brought about by accidental discovery of X-rays by Dr. Wilhelm Roentgen in 1896, which gave the ability to access the unseen living body. Both were, at their time, very useful tools in the hands of the anatomist/clinician, and both were dependent on the technological progress of their times. Meanwhile, if Vesalius' illustrations were outstanding, and his illustrator Jan van Calcar definitely obeyed the conventions of visual representations as culturally impressed, Roentgen's discovery was the one that really opened a new world of visual exploration in the scientific (medical) as well as the artistic world. These are just two examples of the strong association between the appearance of medical illustrations, the information contained, and the existing cultural and technological trends.

Keeping with the latter example of the penetrating gaze, it is important to point to the fact that although X-rays unveiled the unseen living body, it was initially the use of the microscope (first entering the biology laboratory in 1674 through Leeuwenhoek), and later the electron microscope (1931), that allowed the examination beyond the visible-to-the-naked-eye structures. This made it possible for the scientist's gaze to zoom into hidden structures, which revealed tissue configurations and functions previously inaccessible.

In addition to the role held by technology, that of artistic trends on the evolution of medical visual representations is undeniable. Medical atlas illustrations were deeply influenced by current cultural and artistic trends as was apparent from Berengario da Capri's background landscapes[6] and Charles Estienne's display of characters, clearly copied from Caraglio's work,[7] to Dr. Samuel Pozzi's *Treatise of Gynecology*[8] and its beautiful botanical-looking arrangements of the specimens. At the microscopic level, one can observe a similar phenomenon in the depiction of the plates, which are also illustrated according to the style of the time, and are beautifully exemplified by Ledermuller's microscopy handbook.[9] At the same time, technological advancements are obvious in the quality of the illustrations, the detail and nuance of the rendering of the anatomical structure as the technology shifted from drawings/woodcuts, to copper plates, to photographs. Technology also supplies an element of metaphor and analogy in the medical narrative to explain the functioning of the body (e.g., Kendall[10] or Kahn[11]) and later that of the cell (e.g., Myers[12]) as a kind of factory procedure.

Artisans and artists have been drawn to representations of the body for millennia, but never has the fascination appeared to have been so strong as within the last century. Possibly this stems from incredible technological progress, different levels of exploration and current investigation and examination, as well as deeper understanding of both the visceral and the virtual body. Contemporary artists approach and address the clinical aspect of the human body from different perspectives, according to their own perceptions, preoccupations, and sensibilities. The body of work to which the public is exposed is vast. In their work, artists may conjure the illusion of either a laboratory or a museum of natural sciences (e.g., Ionat Zurr and Oron Catts,[13] Suzanne Anker,[14] Jennifer Willet,[15] Cindy Stelmackowich[16]), or that of another self, through their search for redefining identity by way of quasi-clinical self-examination (Stelarc,[17] Mona Hatoum,[18] Gary Schneider,[19] Julie Rrap,[20] Kira O'Reilly[21]). This continuum of scientific and artistic research and use of medical imagery raises the public awareness from an ethical as well as an aesthetic point of view. Particularly of interest to us as researchers is the work of artists who place themselves at the intersection of magnetic resonance imaging (MRI) aesthetics and meanings, making the artistic practice of Justine Cooper,[22] Annie Cattrell,[23] Gerard Beaulieu,[24] Marc Didou,[25] Kevin Todd,[26] Linda Duvall,[27] and Marilene Oliver[28]—to name just a few—relevant to our own work, where MRI is both a research and a communication tool. Ethical and social implications of medical research are brought to the forefront of the public discourse by the introspective, artistic gaze. This provides for further mental reflection on medical imagery for scientists and researchers.

Medical images and imagery have also found nonartistic uses in as diverse professional specialties as forensics and the legal system, as well as in terms of commercial

promotion, advertisement, and lately, branding. Definitely all bring a different light and weight to the image. Of all these uses, branding seems to be the most unregulated and potentially deceitful, since branding represents a collection of symbols, experiences, and associations connected with a product, a service, or a person. Such may use as diverse a medical iconography as simple electrocardiogram (ECG) lines, to more complex computer tomography (CT) or MRI images. The use of medical images in branding is quite treacherous, because of its cultural impact (branding being an increasingly important component of the culture and the economy) and significantly, all used images (actual or virtual) are loaded with meaning of personalities, consciousness, lifestyle, cultural experience, and patients'/users' expectations, as well as their implicit use as seal of approval and symbols of scientific/medical authority—all of which adds to our responsibility before releasing them.

Technology and the Change in Medical Representations

Traditionally—from Andreas Vesalius, who used the skill of Jan van Calcar, trained by Titian, to Juan Valverde de Hamusco, who worked with the illustrator Gaspar Becerra, trained by Michelangelo—artists were directly involved in creating medical images of the body following the aesthetic style of the time. This is not to say that technology didn't play a very important part if only in the ability to improve the quality of the image. And it is interesting to note that the engraver of Govert Bidloo's atlas was Abraham Blotling, who invented the rocker tool used in mezzotinting. This technical advance positioned Bidloo's work at the intersection of technology, medical illustration, art, and cultural trends. It helped to improve the accumulation of multidisciplinary knowledge and to contribute to the "one of the finest anatomical atlases ever printed."[29]

The current areas of medical investigation and the accompanying technical developments make for an interesting mix and clash of cultures, as engineers and computer scientists are involved directly in generating new visual representations of the body and its components, blurring the lines between the real and the digital body. At one level, as with modern photography, digital acquisitions have replaced film in most X-ray imaging, a move that opens up powerful new opportunities like 3D and even 4D (time-resolved 3D) imaging, but which also necessitates computerized interpolations and visualizations that further distance the image from the real. This is even more the case for MRI and ultrasound (US) imaging, which at their technological cores have never been as "visual" as X-ray imaging, in that they rely on sophisticated computer processing to turn the underlying electromagnetic signals into something that can be interpreted as a visual representation. At another level, however, computer simulation technologies are being co-opted into the medical imaging world, as we shall discuss below.

The claim that "these images . . . try to measure intangible things by measuring temperature, blood flow or tissue density"[30] best encapsulates the heavy load of information that medical images carry under deceivingly familiar guises. As previously alluded to, their usage in the scientific milieu is manifold: They play a large role in assisting clinicians in establishing diagnoses and deciding on the right treatment, as well as in educating new generations of physicians and training future medical technologists. Specifics of these uses and their relevance will be discussed later in connection to experiences from our own research practice. For now we simply note that the flow of information between the engineers and computer scientists developing the technologies and those using it—namely, students and clinicians and, by extension, their patients—requires updated visual vocabularies, because "when we become literate in a language, we learn to write as well as to read."[31]

Blood Flow Imaging

The search for the best way of understanding, explaining, and representing motion in general, and blood flow in particular, has preoccupied both artists and scientists for centuries. As mentioned before, anatomical representations were, traditionally, the fief of the physician who granted the artist the artistic power in the area of visual representation only, an approach that started to shift with the advent of technology becoming mainstream in medical research. In our own area of angiology (vascular medicine), for example, focus has shifted from depicting and mapping the shape and location of blood vessels in the human body to exploiting advanced computer and imaging technology to understand and visualize, with the help of engineers, physicists, and computer scientists, the biomechanical forces underlying many vascular diseases. We are not going to insist on the artistry of these representations, but will point to a few interesting aspects from the perspective of this review, namely, the mapping aspect (within the body); the red-versus-blue color conventions in rendering arteries versus veins (still in use today); and the understanding of the effect that the shape has on the function of the vessels and on the blood flowing through.

In terms of understanding the phenomenon of blood flow and the changes undergone by flow depending on local geometry of the blood vessel and other local anatomical conditions, for about a century representations were literally illustrations of the mathematical models of Poiseuille's law—which "simplifies reality" by ignoring the fact that the blood actually follows a pulsatile motion according to the heartbeat, and according to which we represent the blood velocity profile across an artery as having a parabolic shape.[32]. Later, the mathematician Womersley extended Poiseuille's law to pulsating arteries, and as a result the simple parabolic shape gave way to much more complex flow when the heartbeat is taken into account. This notion was accompanied by corresponding visual illustrations (again, situated more on the technical

than the aesthetic side). Womersley's equations are too complex to write here, but were shown to be the same as those governing electrical circuits, which led to a popularization of electrical analog models of the circulatory system, at which point the visual representations of blood vessels became analogous to electrical circuits.[33]. This allowed investigators to elucidate how arterial diseases might affect the nature of the pressure pulse, and it was hoped that such models could be used to infer the nature of vascular diseases simply from pressure measurement.

By the late 1960s, however, Caro and others had shown that the well-known localization of vascular diseases to arterial branches and bends could be explained by the presence of complex blood-flow patterns at these sites.[34] This opened up a whole new line of investigation into local rather than global blood flow. Engineers brought to the table their know-how in visualizing flow experimentally using physical models, and through the 1970s and the 1980s, transparent glass and plastic models were routinely used to visualize flow according to various engineering conventions.

The 1990s were a turning point as the result of the parallel paths followed by scientists in collaboration with engineers and clinicians, all having the ultimate goal of a blood-flow representation that would be the most accurate, but also easily accessible to the main user, namely the physician, the medical student, and the medical technologist. This was the decade when it became possible to carry out computational fluid dynamics (CFD) simulations of blood flow on desktop computers. A natural first step was to use the same geometries as the physical models, for ease of defining them on the computer software available at the time, but also to compare the CFD results against the experiments (as these were symmetric models, it was also easy to slice through the velocity field using a single plane, and often using a conventional engineering rainbow color scheme, again, largely dictated by the software available at the time). By this time, Doppler ultrasound (DUS) had emerged as a frontline tool for imaging blood flow *in vivo*. Just as arteries are shown in red and veins in blue in anatomical texts, DUS employed the convention of red/warm colors for velocities toward the Doppler probe, and blue/cool colors away from the probe.

As in the past and as with the advent of X-ray imaging, the opening of these new windows into our bodies was accompanied by a false sense of transparency and visibility. What is important to remember is that even when rendered transparent by X-rays the body still holds unseen secrets and hidden pieces of information (much like the actual images themselves), which is why in order to study the phenomena in detail and with scientific precision, in addition to direct observation, in vitro experiments needed to be designed and conducted with great care. Currently, both detailed local physiological information and "realistic" anatomic information are available as digital representations. This "virtual patient," as it were, is in fact a simulacrum of the real patient in terms of the phenomena depicted but also by presuming/ignoring the potential individual physiological characteristics.

In this context, our daily research requires the translation of patient data into numerical data followed by the generation of visual representations of blood flow, which serves two purposes: (a) that of a model for a phenomenon or disease, and/or (b) that of a model for an experiment (a noninvasive way of determining the best treatment option). Thus our work falls under the umbrella of one of two paradigms. The first paradigm involves the clinician's exposure to conventional visualization drawn from a "direct" medical image of the patient, while the second adjusts reality through exposing the clinician to a virtual image, drawn from a virtual patient.

Our clinical collaborators are the main users of the images we are generating; however, these images may find their way into medical school classrooms or training sessions for radiology technologists. Either way, one can look at them as research tools in the hands of the scientists, or clinical investigation tools in the hands of the physician as well as resources for studying. As in the past, when the bioscientist working in a "wet lab" was trying to fix the apparatus or to measure some condition more exactly,[35] we continuously develop our tools (i.e., computer programs generated through the collaborations of bioscientist, computer scientist, and engineer) to simulate the experiments whose 4D refined results will be presented to the physician for further clinical investigation. If viewed as tools, the need for structured comprehensive information regarding both generating the images as well as their meaning and use could be comparable to a compendium of instruments, which historically proved to be a very useful reference, such as the first surgical atlas from 1465[36] or, later, Woodall's *The Surgions Mate*.[37]

Case Studies: Choices Made in Visual Representations/Digital Simulations of Patients' Reality

A. Adapted Traditional Color-Code Conventions

In the context of this chapter, an instructive case is that of the first anatomically realistic CFD studies we carried out. As noted earlier, engineering models of blood-flow patterns tended to focus on symmetric, idealized geometries, for which plastic phantoms could be easily manufactured for physical flow studies or drafted on the computer.[38]

Shown in figure 8.1 (plate 12) are the various stages that we went through in search for the best way of visually representing the flow through the human carotid artery. Our aim was to generate clear images that both contained all the information needed and were easy to interpret. Panel A shows a frame from particle imaging velocimetry (PIV) of flow in a plastic phantom of an idealized carotid artery. This common engineering technique visualizes flow by pumping a fluid containing reflective particles through the transparent model illuminated by a thin sheet of laser light. Digitally photographed at a fixed shutter speed and frame rate, the relative speeds of the

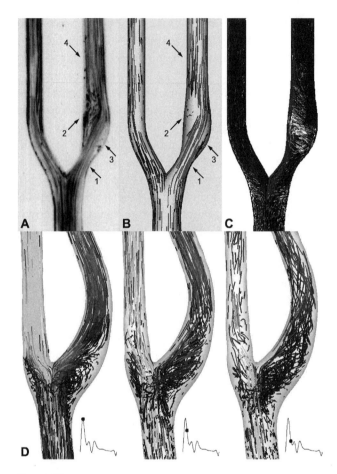

Figure 8.1
Real and virtual particle imaging, highlighting various conventions used to elucidate aspects of carotid bifurcation flow. See plate 12. Panels A–C adapted from David Steinman et al., "Flow Patterns at the Stenosed Carotid Bifurcation: Effect of Concentric vs. Eccentric Stenosis," *Annals of Biomedical Engineering* 28 (2000); panel D adapted from David Steinman, "Simulated Pathline Visualization of Computed Periodic Blood Flow Patterns," *Journal of Biomechanics* 33 (2000). © David Steinman.

particles can also be inferred from their streak lengths. In panel B we show a CFD simulation of flow in the same artery geometry, visualized in a way that precisely mimics the PIV acquisition,[39] allowing for a direct "reality check" against the flow features measured experimentally (hence the identically-labeled flow features in panels A vs. B). Panel C shows the same CFD simulation visualized by particles filling the entire artery volume rather than a thin sheet, and color is now used to highlight the flow patterns. Shades of red identify the predominantly forward flow, whereas blue, conventionally denoting venous flow, is used here to highlight pockets of flow reversal. The slowest particles are shown saturated by white, fortuitously highlighting the communication between the two regions of recirculation.

Finally, a sequence of three frames from a virtual PIV visualization of CFD-computed flow in a more anatomically realistic carotid artery bifurcation is shown panel D. In this case a red/blue convention is now used to highlight the mixing of blood streams destined to the brain (red) and face (blue). For somebody directly associating the blue and red directly to the direction of the blood flow as related to the heart, the use we gave the colors may appear misleading. However, for the clinician and medical students (it would also be fair to say, by now, for the public at large, as well) the blue and red color coding of the blood is the most intuitive one, and therefore the clearest (which is exactly what our aim was, for lack of a better convention). As a result of the use of clearly and obviously different colors for the two streams, the recorded sequence shows unmistakably and distinctly the presence of red particles (i.e., particles "headed" for the brain) within the opposite branch, during parts of the cardiac cycle shown. The medical significance of this phenomenon was initially unclear; however, we subsequently found reports in the medical literature suggesting that accidental injection of local anaesthetics into the external artery or its branches could cause adverse reactions via flow reversal of the blood back into the internal carotid artery.[40] Our visualization hinted at the pathway such refluxes might follow. So, despite a slightly "stretched" visual convention, the information obtained was plausible and valuable.

B. Visual Representations at the Crossroad of Engineering and Medical Visual Conventions

A second and more comprehensive example we chose in demonstrating the multistep process involved in generating a digital simulation and its challenges on both technical and visual levels is that of the clinical case of a 58-year-old female diagnosed with a giant internal carotid artery (ICA) aneurysm via X-ray angiography (in which the patient is X-rayed immediately after arterial injection of a radio-opaque contrast agent). This patient was treated using a technique in which flow to the aneurysm is blocked by inserting soft platinum coils, which are fed through an artery in the groin and up through the aorta, into the aneurismal artery. After six months, while

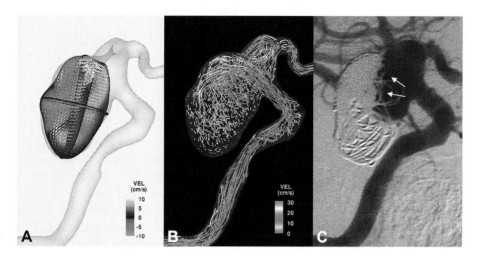

Figure 8.2

Evolution of engineering representations of flow in a simulated brain aneurysm, with corresponding angiogram suggesting the clinical consequence. See plate 13. Panel C adapted from David Steinman et al., "Image-based Computational Simulation of Flow Dynamics in a Giant Intracranial Aneurysm," *American Journal of Neuroradiology* 24 (2003). © David Steinman.

undergoing a routine check up procedure, X-ray angiography revealed that the coils had compacted, allowing the blood to get back into the aneurysm, thus risking its regrowth and possible rupture. To determine the reason for such an outcome we were asked to simulate the disturbed blood-flow patterns that may have been present.[41]

In figure 8.2 (plate 13), Panel A shows an engineering representation of simulated blood flow in this brain aneurysm. Following the usual engineering convention, the size and orientation of the arrows specifies the speed and direction of flow confined *within* the three respective planes. The colors indicate the speed and direction of flow *through* the respective planes, here using a medical (Doppler ultrasound) scheme of red/warm colors denoting flow toward the viewer, and blue/cool for flow moving away for the viewer. Although undeniably information-rich, for such a complex geometry this visualization approach resists an understanding of the big picture. Instead, and as shown in panel B, we again employed a virtual PIV visualization. Here the virtual particles were rendered used a rainbow color-coding convention for denoting speed more explicitly: The high-speed jet entering the aneurysm is shown in red (as velocity of the particles decreases their color changes to orange, yellow, green, etc.). This choice of representation was clearer, we thought, and did highlight the coincidence between the trajectory of the jet and the direction in which the coils used to treat this aneurysm were found to be compacted (panel C).

However, to present our data in a language not exclusive to engineers, we created an alternative visualization that also clearly captures the high-speed jet entering the aneurysm, while using a visual vocabulary already familiar to clinicians through the pioneering flow visualizations of Dr. Charles Kerber, a neurosurgeon with an aeronautics background.[42] As an insider in both camps, Kerber was able to get clinicians accustomed to his dye slipstream movies of flow through glass-casts of aneurysms, and it was this type of visual solution we used. By adopting this familiar visual paradigm, the same information was made clearer and more easily palatable. Fortunately for us, the slipstream movie proved not only to be an easier representation for clinical use, but also lent itself beautifully to the printed page, where the sequence of still frames made for a very compelling and clear image of the actual physiological phenomenon (figure 8.3, plate 14, panels A and B). For the virtual slipstreams the four colors were chosen for the practical reason of being more or less easily distinguishable from one another; there is no "meaning" to a specific color. The four frames, from left to right, each taken one half-second apart, clearly show the violent mixing of flow as it enters the aneurysm, but from different perspectives.

The viewpoint in panel B was chosen specifically to allow for comparison with the angiographic sequence (panel C), also acquired at half-second increments. It thus provided a reassuring "reality check," but in no way allowed us to quantify any errors in our simulations. Rather than inject four pinpoint dyes as are used in model studies, we elected to virtually inject and image an X-ray contrast agent into our models in a way that precisely mimics what happens in a real patient.[43] Figure 8.4 (plate 15) shows the individual still frames of the actual X-ray angiography (panel A) and virtual angiography (panel B), to demonstrate the agreement more compellingly.

To make this possible, we found we had to account for, in our virtual patient (i.e., CFD simulation), the fact that the contrast agent is injected at high pressure in order to completely displace the blood, albeit briefly, to maximize angiographic image quality. This served two purposes. The first was to visualize the flow in a way that obeyed a standard radiological convention. The second was to allow for a more direct comparison of simulated versus real blood. In panels C and D the comparison is highlighted through use of the rainbow color convention to show good agreement in color-coded residence time maps (blue denoting the shortest residence time) derived from the real and virtual angiographic sequences, respectively. Panel E shows the CFD simulation, unperturbed by the contrast agent injection, that is, the residence time map before we accounted for the blood-flow disturbances caused by the high pressure injection. In this way, one could argue that panel E is closer to the actual patient, despite it being virtual. We could have drawn such information solely from the color maps, yet it was obvious to us that the multiple readers of these technical images would need a deciphering step. In going through this process of trial and error we learned that medical imaging, nominally the most direct window into the patient,

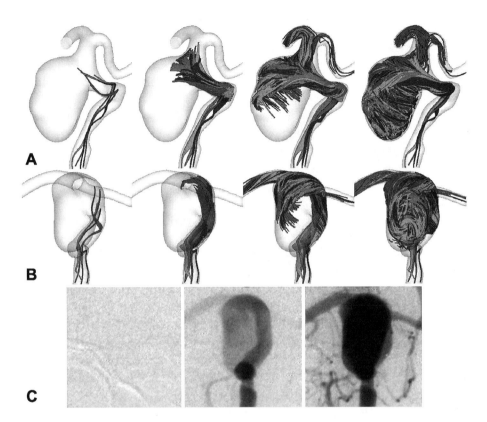

Figure 8.3
Virtual slipstreams entering the simulated aneurysm, shown in two different views, the latter being compared to an angiographic sequence from the same patient. See plate 14. Figure adapted from David Steinman et al., "Image-based Computational Simulation of Flow Dynamics in a Giant Intracranial Aneurysm," *American Journal of Neuroradiology* 24 (2003). © David Steinman.

comes with its own set of distortions and modifications. In our experience with various imaging modalities, these are often ignored or considered negligible unless specifically highlighted. For this reason we see as part of our job a responsibility to identify such potential misreadings. Finally, as an interesting digression, of all the visualizations of this aneurysm the only one that made the eyes of our clinical collaborator light up was the virtual angiogram. Sometimes simpler is better, but invariably a common language works best.

C. Clarifying Misconception through Visual Modeling and Clear Color Coding
As a computer-imaging twist on a clinical problem, the last example we give, from our most recent work, is that of a case in which information had to go through a

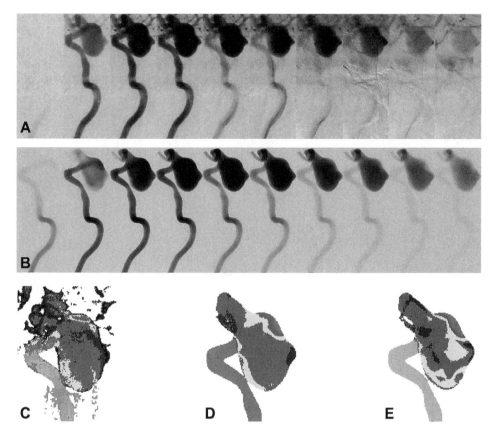

Figure 8.4
Real and virtual angiography, and derived residence time maps, highlighting the apparent truth of the virtual versus the real. See plate 15. Figure adapted from Matthew D. Ford et al., "Virtual Angiography: Visualization and Validation of Computational Fluid Dynamics Models of Aneurysm Hemodynamics," *IEEE Transactions on Medical Imaging* 24 (2005). © David Steinman.

sequence of visual representations for a better understanding of the phenomenon studied. As briefly alluded to in the introduction to this chapter, there is nothing new about propagating deeply ingrained misconceptions or about the power of the accurate image (as exemplified by the refute of Galen's *rete mirabile* by detailed and precise description of the human vasculature by Vesalius). In our case study, clinician and medical researcher alike were "blinded" by the widespread clinical assumption of the "fully developed flow" that must behave according to Poiseuille's law if the artery is relatively long and straight.

As part of a collaborative study we were provided with MRIs of velocity profiles at transverse sections through the common carotid arteries (which brings blood from

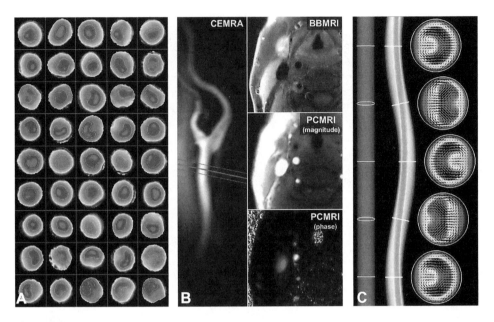

Figure 8.5
Compound images depicting the discovery of a surprising relationship between arterial shape and flow. See plate 16. Figure adapted from Matthew D. Ford et al., "Is Flow in the Common Carotid Artery Fully Developed?" *Physiological Measurement* 29 (2008). © David Steinman.

the aorta to the brain) of a large number of subjects.[44] Panel A of figure 8.5 (plate 16) shows 45 different common carotid artery cross-sectional images. Normally portrayed on the MRI scanner in grayscale, here we used a hot metal color scheme to highlight the fact that most of the velocity profiles are not symmetric (i.e., bull's-eye-shaped) as they should appear if behaving according to Poiseuille's law. This particular color convention was also preferred because it retains its information content when printed in grayscale, unlike the rainbow scale.

To the untrained eye, the presence of such perturbed flow might signify some unseen vascular pathology; however, further investigation of these subjects revealed that in most cases their arteries were healthy, but possessed seemingly innocuous curvatures or wiggles. Panel B shows the length of a typical carotid artery, demonstrating the curvature ahead of the location (denoted by the triple green line) where the cross-section images were acquired. A full complement of cross-section images acquired at this location is shown to the right in this panel. The top image revealed that there was, indeed, no significant disease present in the artery. At bottom is an original MRI velocity image, color-coded using a pseudo-Doppler scale.

In panel C an idealized engineering model of a tube possessing curvature in one direction but straight in another (i.e., a "wiggly" tube) is shown. Using the engineering rainbow and vector conventions, we highlight how a modest curvature can give rise to such complex flow patterns (including also vectors to depict the swirling in-plane velocities). These conventions were chosen because this particular image was presented primarily to an engineering audience. As we seek to educate both engineering and clinical communities about this surprising relationship between arterial shape and flow, we will strive to find visual representations that can speak to both.

In our search for better ways of expressing and representing the medical realities of the blood flow in the context of the living body, we were deeply touched by the parallels between our work and Nina Leo's representations of blood, in her installation *traces*,[45] in which blood is seen as a component of one's body (in this particular case, the artist's own), as a continuum, the basis of life, the critical component of the body's anatomy and physiology, and ultimately the imprint, the trace. What transcended the striking visual parallels between the glass slides of Leo's work and the MRI slides we are using and reinterpreting was the exploration in itself, the hunt for ways of distilling information and disseminating it. It was at that point that we understood our own limitation in visual rendering and the need for a close collaboration with an artist, in the quest for establishing an improved, common visual language.

From Laboratory to Popular Culture

The relationship between medical imagery, daily life, and culture is best and honestly encapsulated in Linda Duvall's artist's statement that declares "I felt very much that I was excluded from the potential offered by these images [because] I was not able to see the information contained within them, in the way that I felt I would approach most other photographic imagery."[46] Just like their artistic counterparts, "technical images . . . have different layers of meanings and fulfil manifold functions at the same time,"[47] but these meanings need be clear before the reader starts exploring the image. Even when used by artists in very personal ways—such as "genetic" or MRI self-portraits (e.g., Garry Schneider, Linda Duvall)—the messages get buried in the piles of information available to the viewer, with each image being so charged with meanings and information that it may become confusing or misleading.

Worthy of note, in the context of the use and meanings of the medical image, is the fact that in both scientific and nonscientific circles, the body synecdoche has been used with equal success, but, we think, for different reasons. In the current artistic practice as well as in the big pharmaceutical companies' advertisement campaigns (thus somehow connected with the bio/medical-scientific world), the visualized/represented part of the body becomes the person, so the "visual synecdoche" becomes

the "you" and the "me" in the common (visual) psyche. Today's fascination with new technologies, and with functional MRI (fMRI) in particular, has brought the brain to the forefront of the human/medical iconography; however, when we look into the visual past, starting with the era of religious references, the hand became a well-accepted synecdoche (as much as the heart or the eye). It was so very successfully used by Wilhelm Roentgen in releasing his new discovery to the public (e.g., the X-rayed hands of his wife or of the anatomist Albert von Koelliker), unintentionally (?) proving that in science, an important issue is following well-established (visual) conventions when trying to promote new ideas. This approach is very different from the artistic endeavor where one can revolutionize through themes, media, techniques, and style at the same time. In the scientific world, however, hypotheses and concepts have to be thoroughly and accurately understood in order to be accepted, and thus a familiar visual language is best suited to the purpose.

It is fair to say that the technological advances and developments have been fascinating scientists and artists equally and influencing their view and style.

As addressed in previous paragraphs, as various technologies and technological abilities captured the imagination of scientists, the representations of vascular blood flow followed suit. A similar process was present in the artistic world as well, where X-rays and the visual access they allowed into the living body were translated into visual innovations by Picasso, Braque, Duchamp, and Kupka, and enriched with mechanical representation of the "normalized" body structures by artists such as Hoerle and Kahlo. A fine example that summarizes the current interest in the various medical imaging techniques, translating them as an assemblage of representations and using not so much the technology as its visuals, is, in our view, the portrait of the Baroness Susan Greenfield by Tom Phillips: made from 169 drawings on paper, drawings onto computer screen, and short sections of video, the resulting 22,500 frames run on a loop on an Apple Macintosh G4 from its DVD drive.

These continuous changes in (re)presentations of the human body took place from cave drawings, to Egyptian temples' walls, to the Vitruvian man and all the way to the works of Giacometti and Botero, and have always been a reflection of skill and tools' evolution as well as cultural norms of the respective societies. The technologies' impact became dramatically obvious with the discovery of the X-ray that "inspired people's imagination of how the visible around them could be visualized in a different manner,"[48] but it continues with ongoing changes and developments in technology to lead to the current omnipresence of the medical image—see YouTube (as opposed to the more "scientific" one, "DNATube") where images are plucked from TV or other news media and broadcast, with ample use of image for the lay public to ingest and digest.

Interestingly enough, if one were to do a current Internet search for medical images and their various uses, it would often lead to links to art institutes' degrees in Web

design and interactive media, and even to a Second Life setting for medical training, which may lead to the question of how the new images and the new options of image-based medical training are superior to the "traditional" ways of training medical students; and, is this new way of addressing training and education bringing to the forefront the out-of-date (archaic) aspect of the "medical image"? Along the same lines of Internet resources "for surgical education," the not-so-ironically named <http://www.vesalius.com> offers "images, illustrations, photographs, animations, and multimedia resources in the Clinical Folios" for noncommercial, short-term educational use. Significantly, medical professionals are in charge and responsible for all narratives and discussions found on the site. However, the Internet is flooded with medical information and images, from specialized sites to popular sites, or TV programs like the Canadian comedy show *This Hour has 22 Minutes*, where one of the segments was the spoof "So you think you deserve an MRI." Either through scientifically oriented websites, or common-use ones, or even through websites that offer CT-/X-ray-like photoshop services such as Dunn's X-ray Photoshop Fun,[49] the dissemination of images happens, whether they are actual or digital. Whether they are there to solve scientific queries, for popularization of science purposes, or through appropriation, biomedical images ought to be created and released responsibly.

From Technological Progress and Visual Representation to Scientific Paradigm Shift

In the field of image dissemination, the images generated by artists or those appropriated by advertisement companies have almost equal footing. However, in terms of the importance of these images in influencing the medical images generated for scientific purposes, the artistic influence is essential and lately, we feel, imperative. This is not to say that artists and their views and use of images should be seen as the public-relations machine of the scientific world, as much as to acknowledge the fact that for the visual representations in medical sciences to acquire a deeper and more accurate meaning, they require the input of the artist, mostly as the expert found at the interface between the idea and its depiction. As previously indicated, in the scientific imagination, up until Newton and Kelvin, every (new) phenomenon was reduced to the mechanical metaphor (i.e., the mindset allowing all phenomena to be explained through the clockwork mechanism). We have also mentioned how in the seen and the unseen, the macro and the micro, visual representations are in tune with the existing cultural trends. In terms, however, of paradigm shifts, the barrier to progress has been shown to be the inability or refusal to see beyond the entrenched models of thinking, and it was through the use of new visual models of Galileo, Linus Pauling, or Watson and Crick, to choose a few well-known examples, that science moved forward.

All this is to say that because of fast technological progress, unprecedented abilities of explorations into the body, and fast-growing interest from the public, the need for better ways of representing these realities of the unseen body (in order to better explore and understand them in an increasingly virtual setting) requires a clear visual language that would also allow easier communication with the users of these images (be it specialists or the lay public). We strongly feel that our own efforts in creating such a language, as honest and laudable as they are, still need help from visual experts, which is why we do hope that, in the future, trained visual experts will lend a hand at creating new visual conventions in the field of medical representations.

Acknowledgments

We wish to thank F. Scott Taylor, cultural critic, technological watchdog, and dear friend, for his analysis of the text and suggestions. We are grateful to Drs. Roberta Buiani, Andrea Carlino, and Silvia Casini for providing timely, precise, and useful information.

Notes

1. Bettyann Kevles, *Naked to the Bone: Medical Imaging in the Twentieth Century* (New York: Basic Books, 1997), 261.

2. Henrik Enquist, "Emotional Images in Medicine," paper presented at the Fourth International Conference on Design and Emotion, Ankara, Turkey, July 12–14, 2004.

3. Roberts Braden and John Hortin, "Identifying the Theoretical Foundations of Visual Literacy," *Journal of Visual/Verbal Languaging* 2 (1982): 37.

4. James Elkins, *The Domain of Images* (Ithaca: Cornell University Press, 1999).

5. Andrea Carlino, *Books of the Body* (Chicago: University of Chicago Press, 1999), 201–202.

6. Philip Oldfield and Richard Landon, eds., *Ars medica: Medical Illustration through the Ages* (Toronto: University of Toronto Press, 2006), 27.

7. Ibid., 22.

8. Samuel Pozzi, *Traité de gynécologie clinique et opératoire* (Paris: G. Masson, 1890).

9. Martin Ledermuller, *Mikroskopische Gemüths und Augen-Ergötzung: Bestehend in Ein Hundert nach der Natur gezeichneten und mit Farben erleuchteten Kupfertafeln, sammt deren Erklärung* (Nürnberg, 1763).

10. Calvin N. Kendall, *Pictured Knowledge* (Chicago: Compton-Johnson Publishing, 1919).

11. Fritz Kahn, *Das Leben des Menschen: Eine volkstamliche Anatomie, Biologie, Physiologie und Entwick-lungs-geschichte des Menschen* (Stuttgart: Franckh, 1926).

12. Natasha Myers, "Conjuring Machinic Life," *Spontaneous Generations* 2 (2008): 112.

13. See <http://www.tca.uwa.edu.au>.

14. See <http://vcande.blogspot.com/2010/04/what-do-we-mean-by-visual-culture.html>.

15. See <http://fofagallery.concordia.ca/ehtml/2007/bioteknia.htm>.

16. See <http://virtualmuseum.ca/Exhibitions/Science/English/stelmackowich.html>.

17. See <http://www.youtube.com/watch?v=OKEfJRe4uys>.

18. See <http://www.youtube.com/watch?v=PQGnFbzszrg>.

19. See <http://www.garyschneider.net/Portfolio.cfm?nK=7856>.

20. See <http://www.ozarts.com.au/artists/julie_rrap>.

21. See <http://www.britishcouncil.org/arts-performanceinprofile-2009-british_council-kira_oreilly.htm>.

22. See <http://justinecooper.com>.

23. See <http://iaf2.bulletserve.net/artistpage.php?artist_id=83>.

24. See <http://www.cbc.ca/artspots/html/artists/gbeaulieu/notes.html>.

25. See <http://www.digicult.it/digimag/article.asp?id=1433>.

26. See <http://www.toddartist.com/exhibition/shifting-paradigms.html>.

27. See <http://www.lindaduvall.com/bigprojects/Visual%20Art%20Projects/bred.html>.

28. See <http://www.marileneoliver.com>.

29. Oldfield and Landon, *Ars medica*, 33.

30. Gerald Beaulieu, "X-ray Specs" (Artist's Statement, Charlottetown Confederation Centre Art Gallery and Museum, Charlottetown, Canada, 2004).

31. Jon Simons, "From Visual Literacy to Image Competence," in *Visual Literacy*, ed. James Elkins (Abingdon: Routledge, 2008), 87.

32. See, e.g., Adel M. Malek, Seth L. Alper, and Seigo Izumo, "Hemodynamic Shear Stress and Its Role in Atherosclerosis," *Journal of the American Medical Association* 282 (1999): 2035.

33. See, e.g., George J. Hademenos and Tarik F. Massoud, *The Physics of Cerebrovascular Diseases* (New York: AIP Press, 1998).

34. Colin G. Caro, "Discovery of the Role of Wall Shear in Atherosclerosis," *Arteriosclerosis, Thrombosis, and Vascular Biology* 29 (2009): 158.

35. George F. Kneller, "A Method of Enquiry," in *Science and Its Ways of Knowing*, ed. John Hatton and Paul B. Plouffe (Upper Saddle River, NJ: Prentice Hall, 1997), 11.

36. Serafeddin Sabuncuoglu, *Cerrahiyyetü'l Haniyye* (Imperial surgery), Turkish, 1465.

37. John Woodall, *The Surgions Mate, or, A Treatise Discovering faithfully and plainely the due Contents of the Surgions Chest, the Uses of the Instruments, the Vertues and Operations of the Medicines, the Cures of the most frequent Diseases at Sea* (London: Edward Griffin for Laurence Lisle, 1617).

38. David A. Steinman, Tamie L. Poepping, Mauro Tambasco, Richard N. Rankin, and David W. Holdsworth, "Flow Patterns at the Stenosed Carotid Bifurcation: Effect of Concentric vs. Eccentric Stenosis," *Annals of Biomedical Engineering* 28 (2000): 415.

39. David A. Steinman, "Simulated Pathline Visualization of Computed Periodic Blood Flow Patterns," *Journal of Biomechanics* 33 (2000): 623.

40. Jaques S. Milner, Jennifer A. Moore, Brian K. Rutt, and David A. Steinman, "Hemodynamics of Human Carotid Artery Bifurcations: Computational Studies with Models Reconstructed from Magnetic Resonance Imaging of Normal Subjects," *Journal of Vascular Surgery* 27 (1998): 143.

41. David A. Steinman, Jaques S. Milner, Chris J. Norley, Stephen P. Lownie, and David W. Holdsworth, "Image-based Computational Simulation of Flow Dynamics in a Giant Intracranial Aneurysm," *American Journal of Neuroradiology* 24 (2003): 559.

42. Charles M. Strother, "Charles Kerber, Immediate Past President of ASITN," *American Journal of Neuroradiology* 20 (1999): 1178.

43. Matthew D. Ford, Gordan R. Stuhne, Hristo N. Nikolov, Damiaan F. Habets, Stephen P. Lownie, David W. Holdsworth, and David A. Steinman, "Virtual Angiography: Visualization and Validation of Computational Fluid Dynamics Models of Aneurysm Hemodynamics," *IEEE Transactions on Medical Imaging* 24 (2005): 1586.

44. Matthew D. Ford, Yuanyaun Joyce Xie, Bruce A. Wasserman, and David A. Steinman, "Is Flow in the Common Carotid Artery Fully Developed?" *Physiological Measurement* 29 (2008): 1335.

45. See <http://www.ninaleo.com/traces.html>.

46. Linda Duvall, "Bred in the Bone" (Artist's statement, Winnipeg's Floating Gallery, 2002).

47. Matthias Bruhn and Vera Duenkel, "The Image as Cultural Technology," in *Visual Literacy*, ed. James Elkins (Abingdon: Routledge, 2008), 173.

48. Ibid., 170.

49. See <http://www.myinterestingfiles.com/2008/05/X-ray-photoshop-fun.html>.

9 Visual Practices across the University: A Report

James Elkins

What does the study of images look like beyond the familiar confines of fine art, and even beyond the broadening interests of the new field of visual studies? Outside of painting, sculpture, and architecture, and outside of television, advertising, film, and other mass media, what kinds of images do people care about? It turns out that images are being made and discussed in dozens of fields, throughout the university and well beyond the humanities. Some fields, such as biochemistry and astronomy, could be called image obsessed; others think and work through images. So far, the field of visual studies has mainly taken an interest in fine art and mass media, leaving these other images—which are really the vast majority of all images produced in universities—relatively unstudied.[1]

A great deal is at stake on this apparently unpromising ground. It is widely acknowledged that ours is an increasingly visual society, and yet the fields that want to provide the theory of that visuality—visual studies, art history, philosophy, sociology—continue to take their examples from the tiny minority of images that figure as art. At the same time, there is an increasingly reflective and complicated discourse on the nature of universities, which has as one of its tropes the notion that the university is "in ruins" or is otherwise fragmented. One way to bring it together, or at least to raise the possibility that the university is a coherent place, is to consider different disciplines through their visual practices. To begin a university-wide discussion of images, it is first necessary to stop worrying about what might count as art or science, and to think instead about how kinds of image making and image interpretation might fall into groups, and therefore be amenable to teaching and learning outside their disciplines. Above all, it is necessary to look carefully and in detail at the situation, and not flinch from technical language or even from the odd equation.

Five Themes

1 How Much of the World Can Be Pictured?

When the proposals for exhibits started coming in, I was struck by the fact that some departments that I would have thought were very visually oriented had not responded. We had no proposals from the departments of process and chemical engineering, electrical and electronic engineering, politics, or statistics. At the same time, we got a number of proposals from disciplines that are not especially known for their engagement with the visual. A member of the German department proposed an exhibit of concrete poetry in German, and a member of the French department proposed the cadavre exquis, the Surrealist game in which a figure is drawn by various players on sections of folded paper, so no one can see the full monster until the paper is unfolded. Both would have been interesting exhibits, but we decided not to develop them because they were not representative of what scholars in those departments ordinarily do. Concrete (shaped) poetry was also made in Latin and in most European languages. The cadavre exquis is a visual game played from the 1920s onward, but it does not have a direct relation to scholarship in the French language.

Comparing the list of departments that routinely use images with those that normally do not, I noticed a disparity: Most visual work in the university is done outside the humanities, but most of the claims to be doing visual work came from within the humanities. The large body of philosophical scholarship on relationships between the world and images can obscure the fact that visual images are normally peripheral to the concerns of people who work in languages, and the same is true of linguistics itself. On the other hand, the routines of image making and image interpretation in fields such as chemical engineering can make it seem as though nothing of pressing interest needs to be said about the images themselves, because all that matters is what the pictures represent and the science they make possible. The most interesting question that can be asked of this, I think, is the extent to which the world, as it is seen from the perspective of any given discipline, seems to be amenable to visualization. How much of the world—that part of it studied by a discipline—can be pictured?

For some disciplines, the answer would be that very nearly everything of interest can be represented by images; for others, such as French or German, the answer might be very different. This question, and several I will be asking later, can be nicely exemplified by a multivolume atlas of electrical engineering that I came across in a used book store. It's a thick, chunky book, intended as a handbook but too chunky to fit in a pocket. In exactly 2,100 thin pages and 3,773 tiny pictures it purports to illustrate every concept in electrical engineering.[2] A typical page on the different meanings of "zero" on analog meters shows how the book might be useful (figure 9.1).

Nullpunkt (m) 8 zero point, zero zéro (m) (d'une échelle graduée)		нулевая точка (f); нуль (m) zero (m) della scala cero (m)
Nullstellung (f) zero-position 9 position (f) de zéro (de l'aiguille d'un instrument de mesure)		нулевое положеніе (n); положеніе нуля; установка (f) на нуль posizione (f) zero posición (f) del cero
Nullpunktabweichung (f) zero error 10 déviation (f) du zéro, déplacement (m) du zéro		отклоненіе (n) отъ нуля deviazione (f) del zero desviación (f) del cero

Figure 9.1

Zero point. From *Die Elektrotechnik*, ed. Alfred Schlomann.

Morseschrift (f), Morsezeichen (n pl) Morse code *or* signals (pl) 6 caractères (m pl) *ou* signaux (m pl) [de l'alphabet] Morse		шрифтъ (m) (знаки (m pl) алфавита) Морзе segnali (m pl) dell'alfabeto di Morse signos (m pl) del alfabeto Morse
Morsealphabet (n) 7 Morse alphabet alphabet (m) Morse		азбука (f) (алфавитъ (m)) Морзе alfabeto (m) [di] Morse alfabeto (m) [de] Morse
Buchstabe (m) 8 letter lettre (f)		буква (f) lettera (f) letra (f)
Ziffer (f) 9 figure, cipher chiffre (m)		цифра (f) cifra (f) cifra (f)

Figure 9.2

Morse code. From *Die Elektrotechnik*, ed. Alfred Schlomann.

"Zero point," "zero position," and "zero error" are clearly distinguished in the pictures. But it is easy to overestimate what can be visualized. The page on Morse code, for example, is distinctly less useful (figure 9.2).

It exemplifies Morse code with some samples, and then omits the Morse alphabet entirely for lack of space, even though it would have been reasonable to expect it to be illustrated. "Letter" and "figure, cipher" are then illustrated with their Morse equivalents, for no clear reason. Elsewhere in the book, the editor gives up entirely when it comes to illustrating concepts related to ponderability (the capacity of an object to be weighed). There are no illustrations at all for the page including "ponderability," "ponderable," and several grammatical variants (figure 9.3).

1. Wägbarkeit (f) / ponderability / pondérabilité (f) — вѣсомость (f) / ponderabilità (f) / ponderabilidad (f)

2. wägbar (adj) / ponderable (adj) / pondérable (adj) — вѣсомый / ponderabile (agg) / ponderable (adj)

3. wägbare Substanz (f) / ponderable substance / substance (f) pondérable; pondérable (m) — вѣсомое вещество (n) / sostanza (f) ponderabile / substancia (f) ponderable

4. Unwägbarkeit (f) / imponderability / impondérabilité (f) — невѣсомость (f) / imponderabilità (f) / imponderabilidad (f)

5. unwägbar (adj) / imponderable (adj) / impondérable (adj) — невѣсомый / imponderabile (agg) / imponderable (adj)

6. unwägbare Substanz (f) / imponderable substance / substance (f) impondérable; impondérable (m) — невѣсомое вещество (n) / sostanza (f) imponderabile / substancia (f) imponderable

Figure 9.3
Ponderability. From *Die Elektrotechnik*, ed. Alfred Schlomann.

It is hard to judge how much of electrical engineering is amenable to being illustrated; my guess would be no more than a quarter of it.

This question, about how much of the interesting world can be pictured, is a difficult one. It would seem that disciplines like art history and studio art take visual objects as their principal subject of study, but it is also the case that both disciplines use visual objects that are more detailed than the disciplines can accommodate. All sorts of formal properties—light, color, texture, marks, traces—are left unremarked, because art-historical analyses concentrate on narrative, context, and the interpretive literature that surrounds artworks. The images' excess visuality is a remainder, left unnoted and typically untheorized.[3]

Other disciplines are both strongly visual and also maintain a closer correspondence between the content of images and the content that is understood to be significant. Here the preeminent field is probably the study of protein folding. The visualization of molecular movements began in the 1980s, when it became possible to calculate the static properties of molecules such as electron density surfaces. Some sophisticated versions of those early graphics, transformed into movies, are now routinely available.[4] The new movies reveal molecules as twitchy, shuddering things, not at all the way they had seemed in the many elegant and unmoving "ribbon diagrams" of older textbooks.[5] Protein folding animations preserve a closer correspondence between forms in the images and forms that are analyzed, simply because each "ball" or "stick"

or "ribbon" (each component of a molecule in the animations) is calculated. In these cases, virtually all of the interesting or pertinent visual world can be pictured; but scientific disciplines such as the study of protein folding differ radically from humanities disciplines such as art history because in science there is sometimes a nearly perfect correspondence between the content of the visual images and forms that are quantifiable, calculable, or otherwise articulated.

Within the question of how much of the world is understood to be visual, there are questions of the nonvisual nature of the humanities; the unthematized, excess visuality of disciplines like art history; the profligate visuality of fields such as molecular biology; and the interest in the limits of visuality in fields like atomic physics. Entire books are waiting to be written about each of those four subthemes.

2 Abuses of the Visual

Sometimes images accompany research papers, conferences, and textbooks, even though they are not used to support the science. In some fields images are customary; they are made habitually, and their absence would seem odd. As the exhibition developed, it became clear that a fairly high percentage of the production of images across the university was of this kind: Images were expected, but it wasn't always clear what function they fulfilled. I call these occurrences "abuses" just to give them a provocative label: I don't mean that images are being used wrongly, just that they are unexpectedly not used, or used for unexpected purposes given their initial research contexts. I will distinguish four kinds of abuses: visualization that is habitual, compulsive, forced, and useless.

Habitual visualization A scientist in Cork named Paul McSweeney proposed an exhibition of the electrophoresis gel analysis of the protein in Cheddar cheese. He sent me an elegant-looking blue-and-white image of casein, which looked like an abstract painting. He said, initially, that I could use it as it was, without much explanation. If I had, it might have become one of the "beautiful" images that are thought to communicate some of their content simply by their aesthetic appeal. We wrote back and forth about his image, and it emerged that his laboratory does not always make such images. Much less visually compelling versions of the image are good enough for research purposes, and in fact the gel tracks do not even need to be dyed blue. But every once in a while the lab needs a "beautiful" image to advertise itself. Gel electrophoretograms, as they are called, are a stock-in-trade of such laboratories; they are made for the posters scientists display at conferences, for teaching, for the covers of scientific journals, and for publicity inside and outside the university.[6] Labs that use gel electrophoresis are typically capable of producing these more "beautiful" versions of their ordinary images on demand.

Compulsive visualization My little encyclopedia of electrical technology is full of pictures that seem to have been made under a nearly incomprehensible compulsion to picture everything. One page offers vignettes of different kinds of "shops": machine shops, erecting shops, pattern shops, repair shops (figure 9.4).

I can't recognize anything in them except a few workbenches. I wonder for whom these could possibly be useful: If I had an intimate knowledge of German machine shops in the 1920s, then I might find it helpful to compare the pictures of different shops, but somehow I doubt it. My favorite section in the encyclopedia is the one on first aid, which includes pictures of a man who has fainted, together with instructions on how to extend and fold his arms in order to revive him, and even how to pull his tongue (figure 9.5).

I have no idea why it was considered helpful to pull an unconscious person's tongue, but the encyclopedia shows how to do it, and even labels the tongue and the

Figure 9.4

Shops. From *Die Elektrotechnik*, ed. Alfred Schlomann.

die Arme ausstrecken (v) und anpressen (v) — to extend and contract the arms — étendre (v) et replier (v) les bras — вытягивать и прижимать руки — stendere (v) e ripiegare le braccia — extender (v) y replegar los brazos — *1*

rhythmisches Ziehen (n) der Zunge — rhythmical pulling of the tongue — traction (f) rythmée de la langue — ритмическое вытягиваніе (n) языка — trazione (f) ritmica della lingua — tracción (f) rítmica de la lengua — *2*

Figure 9.5

First aid. From *Die Elektrotechnik*, ed. Alfred Schlomann.

man. The compulsive production of pictures is—one might argue, following, for example, Jean Baudrillard—a feature of late capitalism in general, but its disciplinary forms have not yet been studied.

Several displays in the exhibition gave evidence of compulsive visualization, and in some cases the disciplines also had a traditional debate about the necessity of visualization. In mathematics there is a long-standing discussion, dating back to the seventeenth century, about the place of the visual in proofs. In the exhibition, a mathematician showed diagrams that help solve a paradox by Lewis Carroll. His contribution touches on the question of mathematical truths: Are they always be susceptible to being visualized? Or is truth nonvisual, and images its ornament?

By forced visualization I mean the habit of making pictures of objects that are nonvisual because they are multidimensional or not susceptible to illumination. Quantum mechanics was the twentieth century's preeminent example. The objects it describes are famously outside of ordinary human experience and possibly outside of all spatial intuition. Paul Dirac, one of the most acute theorists of quantum mechanics, is often quoted for his mistrust of images and his injunction to physicists to just "follow the mathematics" no matter how strange it might seem.[7] But there are also specialists in quantum physics who do the opposite: They go on making pictures of quantum phenomena, despite the fact that they have to bend pictorial conventions to uses they've never had before.[8] Bernd Thaller is the best example I know; he has written books and computer programs, and has produced CDs of his visualizations. He makes pictures and movies of quantum effects, showing how particles exhibit wavelike behavior when they encounter objects (figure 9.6).

Thaller's images are colorful because he symbolizes the phase of the wave equation by hues assigned to the complex plane: A positive real component is red, decreasing

Figure 9.6
Bernd Thaller, Univeristät Graz, quantum effects, <http://vqm.uni-graz.at>. Reprinted by kind permission of Bernd Thaller.

in chroma in proportion to its distance form the origin, a positive imaginary compo-
nent is yellow-green, and so forth. I mention this for readers who may be interested;
the salient point is that the colors are only one of several properties of the particle's
wave equation. Other properties have to go unvisualized because it simply isn't pos-
sible to put them all into a picture or a movie. Most fundamentally, the wavelike
objects Thaller visualizes aren't waves, but probabilities, in accord with quantum
mechanics, and that basic difference is one of the reasons some quantum physicists
eschew pictorial representation altogether. Everything about such pictures, it could be
said, is a misleading analogy based on familiar, human-scale phenomena. Thaller is
an optimist about representation, a complement to Dirac's pessimism. He is very
inventive at bending the usual functions of pictures to make them express the
maximum amount of information about the unimaginable objects described by the
mathematics. He "forces" the conventions of pictures to express properties of objects
that can never be seen—much less seen as waves or as color.

Useless visualization In 1999, I visited a laboratory at the University of North Caro-
lina at Chapel Hill, where a scientist named Richard Superfine was investigating
carbon nanotubes. He had several atomic force microscopes set up in the lab, trained

on microscopic samples of the nanotubes. Sitting at a monitor, I saw a flat surface in perspective, with a wobbly form lying on it like a bent pipe. At my right, in front of the monitor, was a pen, attached by a series of bars and joints to the desktop. As I moved the pen, a cursor moved on the screen. The idea was that I could actually push the nanotube around on the substrate, and that when I made contact, the pen would push back, representing the force required to move the nanotube. The universal joint attached to the pen would provide force-feedback, giving me a kinetic sense of the object's tensile properties and the forces binding it to the substrate. Superfine's laboratory had several such microscopes, which they used to investigate the ways nanotubes bend, roll, and stack—the ultimate aim being to build structures with them, possibly even nanodevices such as nanobots. I asked for some scientific papers that set out discoveries made with the atomic force microscopes, and Superfine said there weren't any—that his results came from other experiments. That surprised me, and I asked what the force-feedback devices taught them. He said they kept a list of "aha!" moments, in which people in his lab had found unexpected properties of the nanotubes by pushing them around, but that none of those "aha!" moments had made it into a scientific publication. The microscopes were wonderful, he said, for getting a feel for the objects, and they were also popular with school tours. They helped publicize and promote the lab's activities, and they gave an intuitive grasp of the objects, but they did not produce science. The science came from more controlled experiments, in which properties such as tensile strength and compressibility could be quantitatively measured.

A "useless" image, in science, can be defined as an image that cannot be used to calculate, because it has nothing quantitative in it. Superfine's force-feedback setups are useless in that sense. There are also images that have quantitative information, but the experiments choose not to extract it. Instead the people who make the images are interested in them as visual examples of what their equations would look like. There are some spectacular examples in recent science. Consider, for example, Farid Abraham's simulation of the motion of 1 billion atoms in a block of copper.[9] It is a film made to show the effects of putting copper under stress without breaking it: The atoms shear against one another, producing dislocations throughout the block. The film includes several fly-throughs of the block, and viewers can watch as the dislocations spread like tendrils throughout the mass of copper (figure 9.7, plate 17).

(Atoms are only drawn if they are dislocated by the pressure: The film actually represents a solid block of a billion atoms, but the only ones shown are along shear lines.) Interesting as the film is, it only gives a qualitative idea of the tangle of dislocations; the science is elsewhere. It is useless, strictly speaking, because it serves more to capture viewers' imaginations than to disclose new properties of copper.

It might be said that the "abused" images in these four categories aren't "useless" at all, because they serve political ends. They help laboratories and scientists advertise

Figure 9.7
Farid Abraham, IBM Almaden Research, images of dislocation dynamics in a block of 1 billion copper atoms. See plate 17. Reprinted by kind permission of Farid Abraham.

themselves, and they spark conversations about the work that may lead in new directions. That is true; the images are only "useless" in the sense that they themselves are not the proof or evidence of whatever scientific claims the laboratory is making. They are, instead, ornaments on the more fundamental work of experiment or mathematics. I called this theme "abuses of the visual" rather than, say, "images that are only political" because the word "politics" flattens the images' different relations to scientific truth and utility. The politics of publicity, grants, careers, and publications certainly contributes to the production of "useless" and other "abused" images, but politics isn't the whole story. In the humanities, and especially in visual studies, the politics of an image is nominally its most fruitful and constitutive property. Politics is taken to go, as Nietzsche said, "all the way down," and analyses can begin and end with the politics of image making and image interpretation. In the sciences, politics plays a crucial role but it is not what the enterprise is all about. The idea of thinking about "abuses of the visual" is to shift the conversation a little so that these images cannot be so quickly explained as politically expedient.

A salient fact here is that the sciences, unlike the humanities, produce enormous numbers of images they do not directly use. To some degree these "useless" images are evidence that people associate truth with images, so that an image is a proof of veracity even when it is does not, strictly speaking, prove anything. It makes sense, I suppose, that such images are more common in the sciences than in the humanities, where veracity and truth are so much to the point. It might be fruitful to study these "abused" images from this perspective, as remnants of the idea that images are truth. (One could ask, for example, what about each image seems to capture something true, even though that truth cannot be quantified or linked to the mathematics or the experimental data.)

Images that are made and discarded, made but not used, made but not valued, are ubiquitous, and one of the cardinal dangers of any study that emphasizes images is not noticing when the objects of study aren't valued by the people who make them. The field of visual studies, in particular those scholars, centers, and departments interested in nonart images, is liable to make too much of what they study, and not to notice when the objects are eclipsed or forgotten. "Abused" images are also a reminder that it is easy to overvalue the objects of one's attention. Many of the pictures we're discussing here are simply not important to the fields that produce them.

3 What Counts as a Picture?

A common kind of image in astronomy is the velocity graph. Such images may look like ordinary astronomical images, and things higher in the image are "higher" in space, but things to the right in the picture are not to the right of things positioned more centrally. Instead, left–right relations map velocities. Hence, a star in the upper-right of a velocity graph is "higher" (i.e., in ascension, or in whatever coordinate

system the astronomer uses) than a star just below it in the image, but it is also moving more quickly (in relation to whatever coordinates are in use) than a star just to its left. (There are several examples of this in Visual Practices across the University.) Velocity graphs look like ordinary photographs of astronomical objects, but they aren't.

Normally such images are called graphs, diagrams, or—following the three-part division in Domain of Images—notations.[10] Sonograms are another example. Speech spectrograms and sonograms (such as recordings of birdsong) are more familiar examples of the same phenomenon, because the left–right relations indicate time, but up–down relations denote pitch: by analogy with the astronomical examples, they would be called pitch graphs (figure 9.8). A speech spectrogram or a sonogram is read as if it were a picture: It has color palettes and spatial options that derive from ordinary pictures. It can help, considering such images, to think of them at least provisionally as naturalistic pictures. Readers accustomed to music notation will be able to "read" (I can "read" pitch in this image of birdsong) and "see" (I can consider the image as a naturalistic picture, with spatial relations) information in these graphs. Here, as in velocity graphs, it often helps scientists to have images that behave a little like ordinary naturalistic photographs (figure 9.8).

That extraordinary fact opens a new way of talking about such images. They are picture-like, and the right language for interpreting them should probably not be too far removed from the language that is used to interpret naturalistic images. If they

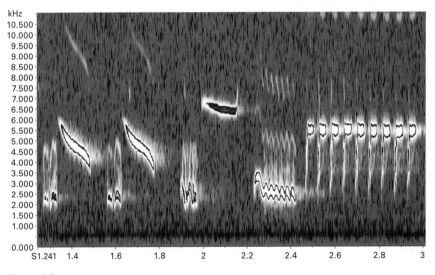

Figure 9.8
Pitch graph. © James Elkins.

were simply or purely graphs or notations they might well be arranged differently: without glowing colors, for example, and without higher tones being higher on the image. Those are pictorial conventions, borrowed from ordinary naturalistic picture making. All sorts of different conventions would be available to image makers who did not want to keep the residue, the hint, of ordinary pictures.

It is possible to distinguish several different kinds of images that are not quite pictures in this sense:

Picture-like graphs The examples I have given so far substitute things like pitch, time, and velocity for the usual dimension of space. (A photograph is a space–space representation, to put it abstractly. A sonogram is a pitch–time representation, and the images of the galactic center are velocity–velocity representations.)

Multidimensional images Aerial surveying is sometimes done with multispectral cameras, which gather images at different wavelengths—infrared, ultraviolet, monochromatic samples, and panchromatic reference images. When the images are processed and linked to map data, they can yield information about height, as well as data on specific crops or vegetation—multispectral aerial surveying has a large range of agricultural, geological, engineering, and city planning applications. Art the same time, such surveys yield high-resolution color images that look entirely normal—but what appears as a simple photograph is actually a cross-section of a large data set.

It rarely happens in the arts and humanities that an image is really just a sample from a more complex image or data set. The *Mona Lisa* is not an extract from some larger bank of images, except in the abstract sense that it has a history and a context, like any image. Artworks tend to display or contain the sum total of their information, but scientific images are sometimes just tiny portions of a larger invisible or unvisualized whole.

Frankenstein pictures Then there are images cobbled together from many different sources, not all of them visual. A curious example is a film of the binary star system named Wolf-Rayet 104 (the name identifies one of the two stars in the system). The system, WR104, has been widely reproduced as a short film loop because of the very unusual fact that it looks like a pinwheel (figure 9.9).

In the film, the spiral spins. The effect is caused by hot gases being thrown off of one of the stars in the pair. (Neither star is directly visible in the image.) The popularity of the film must be due in part to the surprise of discovering that somewhere in the constellation of Sagittarius there is a little pinwheel spinning.

Yet the film is really very distant from a movie of a pinwheel-shaped object. First, its "hot" red color is false.[11] Actually, it was imaged in the infrared, so this particular shape would be invisible to the naked eye. Second, this was never seen from a single telescope. It is an image constructed from three telescopes situated a small distance

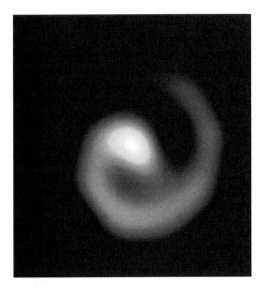

Figure 9.9
Charles Townes, the binary Wolf-Rayet 104. Reprinted by kind permission of Charles Townes.

from one another in a field. Third (and most counterintuitive), none of the three telescopes produced an image on its own. They each saw just one point of light at a time, and their signals were combined using interferometry. The combination of the signals of two of the three is shown in figure 9.10; this is a stage in the construction of the pinwheel image.

Fourth, the signals processed to make the image underwent a change known as heterodyne reduction: They were each combined with laser light, producing a single wave of a much longer frequency, which was then carried as a radio signal in wires. Fifth, the reduction was necessary because the signals have to reach the computer that analyzes them at the exact same time, and the telescope at one end of the field is actually a tiny bit farther from the star than one at the other end of the field. To compensate, the signal from the closer telescope is sent through a longer wire. It seems implausible, but in this way the three telescopes are effectively exactly the same distance from their object (figure 9.11).

The pinwheel image was therefore built out of the signals from three telescopes, by heterodyne reduction, signal delay, interferometry, and false color: hardly an ordinary way to make an image. Interferometry of this kind, which generates 2D images, is both counterintuitive and complicated, and although I have tried I do not understand it in full. The deceptively familiar-looking pinwheel is a Frankenstein creation, made of disparate parts.

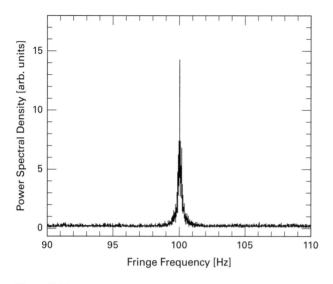

Figure 9.10

Charles Townes, diagram of the U.C. Berkeley Infrared Spatial Interferometer Array. Reprinted by kind permission of Charles Townes.

Picture-like graphs, multidimensional images, and Frankenstein pictures are examples of things that aren't really pictures or films in the conventional senses of those words. The Wolf-Rayet star, velocity graphs, and speech sonograms are picture mimics: They work, in part, because they mimic pictures.

4 The Thicket of Representation

"The thicket of representation" is a phrase coined by the biologist and philosopher William Wimsatt to describe the problem of making pictures of genes.[12] There are a half-dozen different conventions for making pictures of complex organic molecules, and no one of them is adequate by itself. Each gives a particular kind of information, and works at a certain level of detail. Ribbon diagrams of molecules, for example, do not quite reach to the level of atoms (figure 9.12), but ball-and-stick models do (figure 9.13, plate 18).

These two images cannot be combined into one image because they use different imaging conventions; it would be like trying to paste a picture of your house onto a map of your town. In scientific software these two conventional representations can be "toggled," but they can't be fused into one kind of picture.

This is another theme that is largely unknown in the humanities. A close parallel might be the existence of a painting and a drawing for the painting: The two can't be combined, but they have to be considered together in order to get the fullest idea of

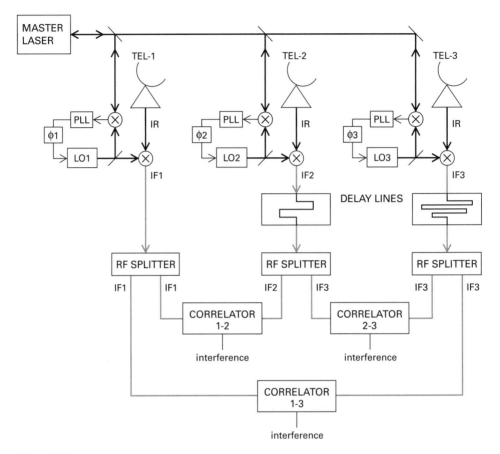

Figure 9.11
Charles Townes, pinwheel image. Reprinted by kind permission of Charles Townes.

the artist's conception. The flaw in that parallel is that in most cases, the painting was intended to be the self-sufficient and authoritative version of the object; in science, all the kinds of representation in the thicket need to be considered together. The authoritative version of the object is not any one visual representation, but a conceptualization that involves a number of different kinds of images.

Another example is the visualization of bacteriophages. On a rough count there are thirteen ways of looking at bacteriophages, although the number is arbitrary because most kinds subdivide into different types (these are discussed in Visual Practices across the University). A typical scientist might use a half-dozen in different combinations, toggling back and forth to compare them, and printing several side by side in scientific

Figure 9.12
Suzanne Witt, ribbon diagram of a cut-away overview and a close-up view of the 20S Rhodococcus proteasome: "The 20S Proteasome," Max Planck Institute of Biochemistry, Martinsread. Reprinted by kind permission of Suzanne Witt.

papers. The thicket cannot be cleared: It can only be negotiated. The thicket is the norm, and the isolated image of fine art is the rarity.

5 Image Quantification

If there is a general, underlying expectation of images in the sciences, it is that they contain what I call propositional content. It is expected that data can be extracted from them, that they contain measurable forms. A bar graph can be read immediately for its information, and so can the kind of supply–demand graph used in economics. Other images have to be measured before information can be extracted from them; an example is astronomical images, which are read pixel by pixel to extract quantitative information. The analogue in the humanities would be images that are also writing, so they can be read as well as seen. It is normal in the sciences to analyze an

Figure 9.13
Chandrajit Bajaj, ball-and-stick model of a molecule. See plate 18. Courtesy the Computational
Vision Center, University of Texas. Reprinted by kind permission of Chandrajit Bajaj.

image in order to extract information, and anything that is left over is considered
heuristic, decorative, aesthetic, or beautiful. A striking image can be a good thing, if
it helps the image attract attention, but what matters is the content, the stuff that can
be used to calculate. It is more or less the opposite in the humanities, where propo-
sitional content in an artwork—themes, ideas—would normally be seen as an interest-
ing part of the work, but by no means its central quality. The lack of interest in
propositional content explains why art historians (I was one of them) were impatient
with David Hockney's and Charles Falco's explanations of the perspective and geom-
etry of paintings: It wasn't that Hockney was wrong, exactly, but that his observations
were beside the point.[13] It is the supplement, what is taken as the visual contribution,
that matters in fine art.

It is interesting to study how scientists, lawyers, doctors, and engineers search for
propositional content. Often the tool is image-analysis software, which can outline

objects of specified shapes, sizes, or colors, count regions, and perform many other quantitative tasks. Figure 9.14 is an image of a cell, showing four common kinds of image analysis, including a Fourier transformation (lower left) and a counting algorithm (lower right).

In the humanities, there really isn't such a thing as quantitative image processing: Only in the sciences and allied fields is the quantification of images important.[14] Image-analysis software is a big and largely unstudied field; the major software packages, such as Exbem, NIH Image (used to make this image), and ImageJ, are virtually unknown outside the sciences. (Photoshop, the image-manipulation software of choice in the arts, has only very limited image-analysis capabilities.) Scientific image-analysis software packages are the equivalent of the exotic kinds of diggers that are used in large-scale strip mining: They are the most efficient way to strip away the "aesthetic" and get at the informational.

Figure 9.14
Cell image. © James Elkins.

It is fascinating that some image-making practices outside the arts continue to resist quantification. One example is mammography, which, despite all efforts to automate it, continues to require expertise and, as a necessary correlate, to be considered less than wholly reliable. In the mid-twentieth century the same was true of the diagnosis of chest X-rays for signs of tuberculosis. Having been tutored in how to read X-rays, I can say that it is definitely an art (a skill that cannot be wholly taught) to spot the small white smudges that are the first signs of tubercular infection. They are hard to see, and hard to distinguish from vessels seen end-on. Experts in chest X-rays and mammograms tend to be people who have practiced for years.

Image quantification, and the search for propositional content, is terra incognita for the humanities. A visual studies scholar, looking at these examples, might be interested in the human interactions involved in medical analyses, or in the reasons some scientists want to measure with such sweeping techniques and such obsessive precision. Visual studies might be good on the politics, the sociology, the psychology of image analysis; but it remains the case that image analysis itself is an enormous advance in the interpretation of images, made within the last twenty years, and it has been virtually ignored by scholars interested in the uses and meanings of the visual.[15]

Those five themes—deciding how much of the world can be pictured, cataloging abuses of the visual, wondering what counts as a picture, exploring the thicket of representation, and learning about image quantification—structure the book Visual Practices. They do not present the visual activities across the university as a unified enterprise of the production and interpretation of images, because that would play false with the diversity of imaging practices.

The Possibility of Teaching Nonart Images in the University

The widest context, and greatest challenge, for all studies of the visual beyond the confines of fine art and popular art is the possibility of a required, university-wide course that would introduce students to many different faculties and departments through their use of images. Such a course would make good on the common observation that ours is a visual culture. Philosophically, pedagogically, such a course is long overdue. In the book, I elaborate on the possibility of such a course. For it to make sense, there has to be an organizing schema of image-making communities: There can't be as many image-making practices as there are departments or technologies, because then such a course would only be sampling from a potentially endless field. I argue that image-making communities can be considered as languages, either in Wittgenstein's sense of toy languages (imaginary languages with just a few words) or in the ordinary sense. I do not mean anything especially profound by this analogy. In particular I am not implying anything about underlying structures, as in Chomsky

or Jerry Fodor. Nor do I mean to suggest that these languages have some relation to differing epistemologies of the world, as in Benjamin Whorf's work, or even to different kinds of intelligence, as Howard Gardner has argued. And I am not saying that these are languages in a philosophical sense, in Nelson Goodman's or Quine's sense.

I mean something more prosaic and practical: Like languages, these subjects can be learned to a reasonable degree of proficiency in a reasonable amount of time. The time required is keyed to the structure of university disciplines, so that it takes a year or two, sometimes three, to become adequately proficient at most of the visual practices described in Visual Practices. That time scale allows students to shift subjects, and add areas of expertise, within the frame provided by the university.

Like languages, visual practices come in families. For a person who understands phase contrast microscopy, interference contrast microscopy will already be partly intelligible. A person who knows interference contrast microscopy will know some of the fundamentals of polarized light microscopy. The same affinities occur in natural languages. A person who knows Danish will be able to understand Norwegian and parts of Swedish, but such a person will not be able to follow spoken Finnish or Estonian, because they belong to different language families. In the university, the language families of visual practices cluster in related departments.

Provisionally, then, the language families of the construction of images include the following: (a) optical microscopy, comprising about five languages; (b) image analysis software (NIH Image, ImageJ, Exbem, Photoshop); (c) digital video editing; (d) mapmaking and surveying in archaeology and civil engineering; (e) electron microscopy, including transmission, scanning, and atomic force microscopy, all of them represented in Visual Practices. There are perhaps a dozen others: My claim is that the number of "language families" is not the same as the number of disciplines or departments in a university, but is a significantly smaller number. That is crucial to this project, because it means that visual practices can be studied across the entire university. If there is a preeminent language family of image construction, analogous to Indo-European among natural languages in Europe, it is not fine art but scientific and technical image manipulation: another reason to say that the humanities are in the minority when it comes to images.

These "languages" can also be enumerated from the side of image interpretation, in which case I might list (a) X-rays and mammograms, (b) histology, (c) cognitive psychology and the neurobiology of vision, and (d) the history of art, which has about a dozen named languages in this sense including psychoanalytic art criticism, deconstruction, semiotics, and feminisms. Again there would be about a dozen more, all told. There is an often implicit claim among visual studies scholars that image interpretation is theorized mainly in the humanities, but if there is a preeminent language family here it would be medical semiotics. By contrast, the humanities own only a small number of ways of interpreting images.[16]

In outline, this is how I would defend the idea that visual practices can be studied all together, and that they can be learned to a workable degree of detail in, say, a year-long course. Such a course would have several advantages over existing introductions to the visual world. It would be specific, and need not rely on general observations about image production and dissemination. Existing introductory classes on visual studies or visual appreciation stay mainly within the fine arts, because the sciences, medicine, law, engineering, and other fields are out of reach unless students are introduced to their actual, day-to-day discourses, in detail and without undue generalization. (Students would have to learn some mathematics and physics, for example, in order to understand the images of carbon nanotubes I mentioned. That is impractical but not at all impossible, providing the instructors are available.) I think the existing first-year classes on visuality and visual culture are more rewarding for students who go on to study in the humanities than they are for students who study the sciences, because the level of detail of the art examples is so much higher than the detail accorded to the few nonart examples. A student majoring in chemistry, for example, will probably not think back on her first-year visual studies class when she is busy with molecular imaging; but she would if she had the experience of encountering molecular imaging in her first year in college, in the context of imaging done in other fields.

A second advantage of a year-long course on visual practices is that it does some justice to the commonplace that ours is a visual culture, where learning is increasingly done through images. There is a large literature arguing that visuality is the preeminent medium of our experience of the world, but universities continue to pursue text-based and mathematics-based education. This class would put visuality on the table in the first year of college as a subject and a central vehicle for understanding the world.

A final reason I am interested in using materials like the ones in *Visual Practices* for a university-wide course is that it could provide the beginnings—the first impetus—for university-wide conversations. The visual can be an informal lingua franca for the university, allowing people who would not normally stray outside of, say, inorganic chemistry to consider starting conversations with people in, say, Asian studies.

There is a tremendous weight of institutional inertia set against the university-wide study of visuality. It is directly pertinent that the theoretical and philosophic literature on the unity of the university is itself based in the humanities, and biased toward them.

(It is also a very nonvisual literature: Not a single book I have seen is illustrated.) Like Cardinal Henry Newman's *Idea of a University* (1852), Jaroslav Pelikan's (1992) book of the same name has next to nothing to say about the sciences. Henry Hutchins, one of the principal theorists of the University of Chicago, argued in *The University of Utopia* (1964) that nothing should be taught in the university except philosophy.

Other books, from Clark Kerr's *Uses of the University* (1963) and Kenneth Minogue's *Concept of a University* (1973) to Bill Readings's *University in Ruins* (1996) and Jacques Derrida's essays collected in *Eyes of the University* (2004), are similar in their emphasis on philosophical "rights" and philosophical analysis. Ultimately they all owe that emphasis to Kant, whose theorization stressed the importance of the faculty of philosophy over the "vocational" faculties of law, medicine, and theology. The fairly enormous literature on the idea of the university is strongly biased to the humanities, and exclusively nonvisual.

At the same time, the disciplines of art history, visual studies, and even visual communications remain focused on fine art, popular art, and unquantified images. Except for some minor strains in visual communications in which semiotics, computing, and marketing play a role, the study of the visual is carried on mainly by people who are uninterested in science and engineering, and that shows no signs of changing. But what reasons do we have, aside the many habits of art, our attachment to the humanities, and our lack of engagement with unpopularized science and mathematics, to keep our distance from so much of the visual world?

Notes

1. This chapter is a brief summary of a book called *Visual Practices across the University*, which was published in Germany in 2007 (*Visual Practices across the University*, ed. James Elkins [Munich: Wilhelm Fink Verlag, 2007]. The book is not known outside of German-speaking countries because the publisher, like many academic German presses, does not advertise or distribute internationally. That fact, and the reasons I chose to publish with Wilhelm Fink, are discussed in the afterword to the book. This chapter is a truncated and revised excerpt from the book's preface and introduction; and I have added a critique of the book and its dissemination at the end of this essay.) The book began with an exhibition of the same name, held in Cork, Ireland, in 2005. (The exhibition was originally intended to be published along with a conference called "Visual Literacy," in a single large book. In fact the conference will appear as two separate books. The main set of papers in the conference, with contributions by W. J. T. Mitchell, Barbara Stafford, Jonathan Crary, and others, has appeared as *Visual Literacy*, ed. James Elkins [New York: Routledge, 2007]; a second set of papers on the subject of the histories of individual nations and their attitudes to visuality and literacy is forthcoming in a volume entitled *Visual Cultures*.) For the exhibition, I sent an email inquiry to all the faculty in the sixty-odd departments at University College Cork, asking for proposals from anyone who used images in their work. The initial responses developed into thirty displays; each was accompanied by up to a thousand words of wall text. The exhibition represented all the faculties of the university, from arts to medicine, food science to law. Fine art was swamped, as I had hoped it would be, by the wide range of image-making throughout the university. The discussion that follows doesn't presuppose the book *Visual Practices across the University* or the related *Visual Literacy*, but it does presuppose the problematics set out in Elkins, *The Domain of Images* (Ithaca, NY: Cornell University Press, 1999); *How to Use Your Eyes* (New York: Routledge, 2000); *Visual Studies: A Skeptical Introduction* (New

York: Routledge, 2003), which expands the argument that visual studies do not pay attention to science; and *Six Stories from the End of Representation: Painting, Photography, Astrophysics, Microscopy, Particle Physics, Quantum Physics* (Stanford: Stanford University Press, 2008), which continues the theorization of the historical discussion of nonart images. Here I will briefly discuss five principal themes that emerged in the course of the exhibition, and the possibility that this kind of material might be used in a university-wide introductory course on visual practices.

2. *Die Elektrotchnik: Schlomann-Oldenburg Illustrierte Technische Wörterbücher*, vol. 2 ed. Alfred Schlomann (Munich: R. Oldenburg, n.d.).

3. This theme is expanded in *Visual Practices across the University*; for art history, see "What Are We Seeing, Exactly?" *Art Bulletin* 79, no. 2 (1997), 191–198; and *Visual Studies: A Skeptical Introduction*.

4. See the demonstration of different parameters by James Holton, at <http://ucxray.berkeley.edu/~jamesh>.

5. At the most sophisticated levels, distributed computing has made it possible to make animations of the folding of large molecules like t-RNA. Such molecules fold in thousands of similar ways, and by sharing the calculations across a number of computers, researchers have found the commonest path from unfolded to folded molecule. Two examples: Kay Hamacher's animation of protein-ligand docking at <http://www.kay-hamacher.de> (which is very suggestive, and would have delighted the Surrealists), and the high-speed snakelike folding of a 64-residue protein done by the Process Systems Engineering team at the University of California at Davis, <http://www.chms.ucdavis.edu/research/web/pse/research_areas/protein_folding_dynamics/protein_dynamics.php>. See also Eric Sorin et al., "Does Native State Topology Determine the RNA Folding Mechanism?" *Journal of Molecular Biology* 337 (2004), with online supplement.

6. Electrophoretograms are discussed in my *Domain of Images*, chapter 3, in reference to a study by Karin Knorr-Cetina and Klaus Amann, "Image Dissection in Natural Scientific Inquiry," *Science, Technology, and Human Values* 15, no. 3 (1990): 259–283.

7. Dirac: "one can tinker with one's physical or philosophical ideas to adapt them to fit the mathematics," he said, "but the mathematics cannot be tinkered with. It is subject to completely rigid rules and is harshly restricted by strict logic." Dirac, "The Mathematical Foundations of Quantum Theory," in *Mathematical Foundations of Quantum Theory*, ed. A. R. Marlow (New York: Academic Press, 1978), 2.

8. "On Some Useless Images [in Physics]," *Visual Resources* 17 (2001): 147–163; this is expanded in *Six Stories from the End of Representation*.

9. Farid Abraham of IBM Almaden Research, in collaboration with LLNL personnel Mark Duchaineau and Tomas Diaz De La Rubia; <http://www.llnl.gov/largevis/atoms/ductile-failure>.

10. See Elkins, *Domain of Images*. Michael Marrinan, *Culture of Diagram*, forthcoming, presents an extended argument about these and other image types, which he calls diagrams.

11. The following is from <http://isi.ssl.berkeley.edu/system_overview.htm#optics>.

12. This is discussed in my *Domain of Images*, which provides further references..

13. Hockney, Secret Knowledge. See the discussion in *Visual Studies*, and my review of the N.Y.U. conference in *Circa* 99 (spring 2002): 38–39, <http://recirca.com/backissues/c99/elkins.shtml>.

14. The contributions by Lev Manovich, Jeremy Douglass, and Martin Warnke in the present book are pioneer projects that address this challenge.

15. An interesting exception is Henrik Enquist's essay "Bridging the Gap between Clinical and Patient-Provided Images," in the book *Visual Literacy*. Enquist studies the effects of empowering patients to produce and interpret their own images.

16. This enumeration of language families, both in image construction and interpretation, may be compared to the much larger sample in *Bild und Erkenntnis: Formen und Funktionen des Bildes in Wissenschaft und Technik*, ed. A. Beyer and M. Lohoff (Munich: Deutscher Kunstverlag, 2006), 467–538.

II Critical Terms of the 21st Century

10 On Sourcery, or Code as Fetish

Wendy Hui Kyong Chun

Debates over new media often resonate with the story of the six blind men and the elephant.[1] Each man seizes a portion of the animal and offers a different analogy: the elephant is like a wall, a spear, a snake, a tree, a palm, a rope. Refusing to back down from their positions—based as they are on personal experiences—the wise men then engage in an unending dispute with each "in his own opinion / Exceeding stiff and strong / Though each was partly in the right, / And all were in the wrong!" The moral, according to John Godfrey Saxe's version of this tale, is: "So oft in theologic wars, / The disputants, I ween, / Rail on in utter ignorance / Of what each other mean, / And prate about an Elephant / Not one of them has seen!"[2] It is perhaps profane to compare a poem on the incomprehensibility of the divine to arguments over new media, but the invisibility, ubiquity, and alleged power of new media (and technology more generally) lend themselves nicely to this analogy. It seems impossible to know the extent, content, and effects of new media. Who knows the entire contents of the World Wide Web or the full extent of the Internet or of mobile networks? How can one see and know all time-based online interactions? Who can expertly move from analyzing social networking sites to Japanese cell phone novels to *World of Warcraft* to networking protocols to ephemeral art installations? Is a global picture of new media possible?

In response to these difficulties, an important strain of new media has moved away from content and from specific technologies to what seems to be common to all new media objects and moments: software. All new media allegedly rely on—or, most strongly, can be reduced to—software, a visibly invisible essence. To return to the parable, software seems to allow one to grasp the elephant as a whole precisely because it is the invisible whole that generates the sensuous parts. It is a magical source that promises to bring together the fractured field of new media studies.

But what is software? What does it mean to know software and, most importantly, what does positing software as the essence of new media do? This essay responds to these questions, arguing that software as source relies on a profound logic of sourcery, a fetishism that obfuscates the vicissitudes of execution and makes our machines

demonic. Further, this sourcery is the obverse rather than the opposite of the other dominant trend in new media studies: the valorization of the user as agent. These sourceries create a causal relationship between one's actions, one's code and one's interface. The relationship between code and interface, action and result, however, is always contingent and always to some extent imagined. The reduction of computer to source code, combined with the belief that users run our computers, makes us vulnerable to fantastic tales of the power of computing. To break free of this sourcery, we need to interrogate, rather than venerate or even accept, the grounding or logic of software. Crucially, though, closely engaging software will not let us escape fictions and arrive at a true understanding of our machines, but rather make our interfaces more productively spectral. As a fetish, source code can provide surprising "deviant" pleasures that do not end where they should. Framed as a re-source, it can help us think through the machinic and human rituals that help us imagine our technologies and their executions.

The Logos of Software

To exaggerate slightly, software has recently been posited as the essence of new media and knowing software a form of enlightenment. Software is allegedly the truth, the base layer, the logic of new media. No one has been more influential in making this claim than Lev Manovich in *The Language of New Media*. In it, he asserts, "new media may look like old media, but this is only the surface . . . to understand the logic of new media, we need to turn to computer science. It is there that we may expect to find the new terms, categories, and operations that characterize media that become programmable. *From media studies we move to something that can be called 'software studies'—from media theory to software theory.*"[3] This turn to software—to what lies beneath—has offered a solid grounding to new media studies, allowing it to engage presently existing technologies and to banish so-called "vapor theory" to the margins.[4] This grounding is welcome but troubling because it dismisses as irrelevant the vaporiness of new media (such as the ephemerality of software) and reifies knowing software as truth, an experience that is arguably impossible.[5] Regardless, from myths of all-powerful hackers who "speak the language of computers as one does a mother tongue"[6] or who produce abstractions that release the virtual[7] to perhaps more mundane claims made about the radicality of open source, knowing (or using) the right software has been made analogous to man's release from his self-incurred tutelage.[8] As advocates of free and open source software make clear, this critique aims at political, as well as epistemological, emancipation: as a form of enlightenment, it is a stance of how not to be governed like that.[9]

To be clear, I am not dismissing the political potential of free or open source software or the importance of studying or engaging software. Rather, I am arguing that

we need to interrogate how knowing (or using free or open source) software does not simply enable us to fight domination or rescue software from evildoers such as Microsoft, but rather is embedded in—mediates between, is part of—structures of knowledge-power. For instance, using free software does not mean escaping from power, but rather engaging it differently, for free and open source software profoundly privatizes the public domain: GNU copyleft does not seek to reform copyright, but rather to spread it everywhere.[10] It is thus symptomatic of the move in contemporary society away from the public/private dichotomy to that of open/closed.[11] More subtly, the free software movement, in insisting that freedom stems from free software—from freely accessible source code—amplifies the power of source code, erasing the vicissitudes of execution and the structures that ensure the coincidence of code and its execution. It buttresses the logic of software, that is, software as logos.

Software as we now know it (importantly, software was not always software) conflates word with result, logos with action. The goal of software is to conflate an event with a written command. Software blurs the difference between human readable code (readable because of another program), its machine-readable interpretation, and its execution by turning the word "program" from a verb to a noun, by turning process in time into process in space, by turning execution into inscription, or at least attempting to do so. An example I've used elsewhere, Edsger Dijkstra's famous condemnation of go to statements, encapsulates this nicely.[12] In "Go To Statement Considered Harmful," Dijkstra argues, "the quality of programmers is a decreasing function of the density of go to statements in the programs they produce" because go to statements work against the fundamental tenant of what Dijkstra considers to be good programming, namely, the necessity to "shorten the conceptual gap between static program and dynamic process, to make the correspondence between the program (spread out in text space) and the process (spread out in time) as trivial as possible."[13] This is important because, if a program suddenly halts because of a bug, go tos make it difficult to find the place in the program that corresponds to the buggy code. Go tos make difficult the conflation of instruction with its product—the reduction of process to command—which grounds the emergence of software as a concrete entity and commodity. That is, go tos make it difficult for the source program to act as a legible source.[14] As I've argued elsewhere, this conflation of instruction or command with its product is also linked to software's gendered, military history: in the military there is supposed be no difference between a command given and a command completed, especially to a "girl."[15] The implication here is: execution does not matter—like in conceptual art, execution is a perfunctory affair; what really matters is the source.[16]

This drive to forget or trivialize execution is not limited to programmers confounded with the task of debugging errant programs; it also extends to many critical

analyses of code. These theorizations, which importantly question the reduction of new media with screen, emphasize code as performative or executable. For instance, Alexander Galloway in *Protocol: How Control Exists After Decentralization* claims, "code draws a line between what is material and what is *active*, in essence saying that writing (hardware) cannot *do* anything, but must be transformed into code (software) to be effective. . . . Code is language, but a very special kind of language. *Code is the only language that is executable.*"[17] Drawing in part from Galloway, N. Katherine Hayles in *My Mother Was a Computer: Digital Subjects and Literary Texts* distinguishes between the linguistic performative and the machinic performative, arguing:

Code that runs on a machine is performative in a much stronger sense than that attributed to language. When language is said to be performative, the kinds of actions it "performs" happen in the minds of humans, as when someone says, "I declare this legislative session open" or "I pronounce you husband and wife." Granted, these changes in minds can and do reach in behavioral effects, but the performative force of language is nonetheless tied to external changes through complex chains of mediation. Code running in a digital computer causes changes in machine behavior and, through networked ports and other interfaces, may initiate other changes, all implemented through transmission and execution of code.[18]

The independence of machine action—this autonomy, or automatic executability of code—is, according to Galloway, its material essence: "the material substrate of code, which must always exist as an amalgam of electrical signals and logical operations in silicon, however large or small, demonstrates that code exists first and foremost as commands issued to a machine. Code essentially has no other reason for being than instructing some machine in how to act. One cannot say the same for the natural languages."[19] Galloway thus strongly states in "Language Wants to Be Overlooked: On Software and Ideology," "to see code as subjectively performative or enunciative is to anthropomorphize it, to project it onto the rubric of psychology, rather than to understand it through its own logic of 'calculation' or 'command.'"[20]

To what extent, however, can source code be understood outside of anthropomorphization? Does understanding voltages stored in memory as commands/code not already anthropomorphize the machine? (The inevitability of this anthropomorphization is arguably evident in the title of Galloway's article: "Language *Wants* to be Overlooked" [emphasis mine].) How is it that code "causes" changes in machine behavior? What mediations sustain the notion of code as inherently executable?

To make the argument that code is automatically executable, the process of execution itself must not only be erased; source code also must be conflated with its executable version. This is possible because, it is argued, the two "layers" of code can be reduced to each other. Indeed, in *Protocol*, Galloway argues, "uncompiled source code is *logically* equivalent to the same code compiled into assembly language and/or linked into machine code. For example, it is absurd to claim that a certain value expressed as a hexadecimal (base 16) number is more or less fundamental than that same value

expressed as binary (base 2) number. They are simply two expressions of the same value."[21] He later elaborates on this point by drawing an analogy between quadratic equations and logical layers:

One should never understand this "higher" symbolic machine as anything empirically different from the "lower" symbolic interactions of voltages through logic gates. They are complex aggregates yes, but it is foolish to think that writing an "if/then" control structure in eight lines of assembly code is any more or less machinic than doing it in one line of C, just as the same quadratic equation may swell with any number of multipliers and still remain balanced. The relationship between the two is *technical.*[22]

According to Galloway's quadratic equation analogy, the difference between a compact line of higher-level programming code and eight lines of assembler equals the difference between two equations, in which one contains coefficients that are multiples of the other. The solution to both equations is the same: one equation can be reduced to the other.

This reduction, however, does not capture the difference between the various instantiations of code, let alone the empirical difference between the higher symbolic machine and the lower interactions of voltages (the question here is: where does one make the empirical observation?). That is, to push Galloway's conception further, a technical relation is far more complex than a numerical one.

Significantly, a technical relation engages art or craft. According to the *Oxford English Dictionary* (OED), a technical person is one "skilled in or practically conversant with some particular art or subject." Code does not always nor automatically do what it says, but does so in a crafty manner. To state the obvious, one cannot run source code: it must be compiled or interpreted. This compilation or interpretation—this making executable of code—is not a trivial action; the compilation of code is not the same as translating a decimal number into a binary one. Rather, it involves instruction explosion and the translation of symbolic into real addresses. Consider, for example, the instructions needed for adding two numbers in PowerPC assembly language, which is one level higher than machine language:

```
li r3,1 *load the number 1 into register 3
li r4,2 *load the number 2 into register 4
add r5,r4,r3 *add r3 to r4 and store the result in r5
stw r5,sum(rtoc) *store the contents of r5 (i.e. 3)into the memory
    location
*called "sum"s (where sum is defined elsewhere)
blr *end of this snippet of code[23]
```

This explosion is not equivalent to multiplying both sides of a quadratic equation by the same coefficient or to the difference between E and 15. It is, rather, a breakdown of the steps needed to perform what seems a simple arithmetic calculation. It is the

difference between a mathematical identity and a logical equivalence, which depends on a leap of faith. This is most clear in the use of numerical methods to turn integration—a function performed fluidly in analog computers—into a series of simpler, repetitive arithmetical steps. This translation from source code to executable is arguably as involved as the execution of any command. More importantly, it depends on the action (human or otherwise) of compiling/interpreting and executing. Also, some programs may be executable, but not all compiled code within that program is executed; rather lines are read in as necessary. *So, source code thus only becomes source after the fact.* Source code is more accurately a *re-source*, rather than a source. Source code becomes a source when it becomes integrated with logic gates (and at an even lower level, transistors); when it expands to include software libraries, when it merges with code burned into silicon chips; and when all these signals are carefully monitored, timed and rectified.

Code is also not always the source because hardware does not need software to "do something." One can build algorithms using hardware, for all hardware cannot be reduced to stored program memory. Figure 10.1, for instance, is the following logical statement:

```
if notB and notA, do CMD1 (state P); if notB and notA and notZ OR B and
  A (state Q) then command 2.
```

To be clear, this is not a valorization of hardware over software, as though hardware necessarily escapes this drive to conflate space with time. Crucially, this schematic is itself an abstraction. Logic gates can only operate "logically" if they are carefully timed. As Philip Agre has emphasized, the digital abstraction erases the fact that gates have "directionality in both space (listening to its inputs, driving its outputs) and in time (always moving toward a logically consistent relation between these inputs and outputs)."[24] When a value suddenly changes, there is a brief period in which a gate will give a false value. In addition, because signals propagate in time over space, they produce a magnetic field that can corrupt other signals nearby ("crosstalk"). This schematic erases all these various time-based effects. Thus hardware schematics, rather than escaping from the logic of sourcery, are also embedded within this structure. Indeed, John von Neumann, the alleged architect of the stored-memory digital computer, drew from Warren McCulloch and Walter Pitts's conflation of neuronal activity with its inscription in order to conceptualize our modern computers. According to McCulloch and Pitts (who themselves drew from Alan Turing's work), "the response of any neuron [is] factually equivalent to a proposition which proposed its adequate stimulus."[25] That is, the response of a neuron can be reduced to the circumstances that make it possible: instruction can substitute for result. It is perhaps appropriate then that John von Neumann spent the last days of his life—dying from a cancer most probably stemming from his work at Los Alamos—reciting from memory *Faust Part*

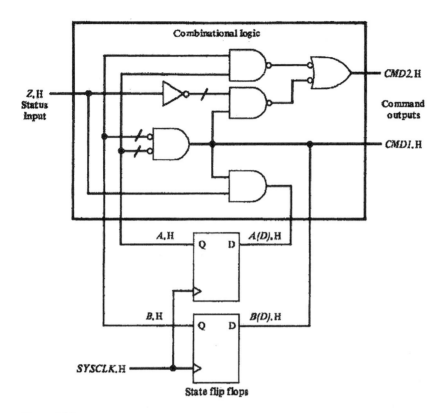

Figure 10.1
If notB and notA, do CMD1 (state P); if notB and notA and notZ OR B and A (state Q) then command. © Wendy Hui Kyong Chun.

1.[26] At the heart of stored program computing lies the Faustian substitution of word for action.

Not surprisingly, this notion of source code as source coincides with the introduction of alphanumeric languages. With them, human-written, non-executable code becomes source code and the compiled code, the object code. Source code thus is arguably symptomatic of human language's tendency to attribute a sovereign source to an action, a subject to a verb.[27] By converting action into language, source code emerges. Thus, Galloway's statement, "to see code as subjectively performative or enunciative is to anthropomorphize it, to project it onto the rubric of psychology, rather than to understand it through its own logic of 'calculation' or 'command,'" overlooks the fact that to use higher-level alphanumeric languages is already to anthropomorphize the machine, and to reduce all machinic actions to the commands that supposedly drive them. In other words, the fact that "code is law"—something

Lawrence Lessig pronounces with great aplomb—is hardly profound.[28] After all, code is, according to the OED, "a systematic collection or digest of the laws of a country, or of those relating to a particular subject." What is surprising is the fact that software is code; that code is—has been made to be—executable, and this executability makes code not law, but rather every lawyer's dream of what law should be: automatically enabling and disabling certain actions; functioning at the level of everyday practice.

Source Code as Fetish

Source code as source means that software functions as an axiom, as "a self-evident proposition requiring no formal demonstration to prove its truth, but received and assented to as soon as it is mentioned."[29] In other words, whether or not source code is only source code after the fact or whether or not software can be physically separated from hardware,[30] software is always posited as already existing, as the self-evident ground or source of our interfaces. Software is axiomatic. As a first principle, it fastens in place a certain logic of cause and effect, based on the erasure of execution and the privileging of programming that bleeds elsewhere and stems from elsewhere as well.[31] As an axiomatic, it, as Gilles Deleuze and Félix Guattari argue, artificially limits decodings.[32] It temporarily limits what can be decoded, put into motion, by setting up an artificial limit—the artificial limit of programmability—that seeks to separate information from entropy, by designating some entropy information and other "nonintentional" entropy noise. Programmability, discrete computation, depends on the disciplining of hardware, and the desire for a programmable axiomatic. Code is a medium in the full sense of the word. As a medium, it channels the ghost that we imagine runs the machine—that we see as we don't see—when we gaze at our screen's ghostly images.

Understood this way, source code is a fetish. According to the OED, a fetish was originally an ornament or charm worshipped by "primitive peoples . . . on account of its supposed inherent magical powers."[33] The term *fetisso* stemmed from the trade of small wares and magic charms between the Portuguese merchants and West Africans; Charles de Brosses coined the term fetishism to describe "primitive religions" in 1757. According to William Pietz, Enlightenment thinkers viewed fetishism as a "false causal reasoning about physical nature" that became "the definitive mistake of the pre-enlightened mind: it superstitiously attributed intentional purpose and desire to material entities of the natural world, while allowing social action to be determined by the . . . wills of contingently personified things, which were, in truth, merely the externalized material sites fixing people's own capricious libidinal imaginings."[34] That is, fetishism, as "primitive causal thinking," derived causality from desire rather than reason:

Failing to distinguish the intentionless natural world known to scientific reason and motivated by practical material concerns, the savage (so it was argued) superstitiously assumed the existence of a unified causal field for personal actions and physical events, thereby positing reality as subject to animate powers whose purposes could be divined and influenced. Specifically, humanity's belief in gods and supernatural powers (that is, humanity's unenlightenment) was theorized in terms of prescientific peoples' substitution of imaginary personifications for the unknown physical causes of future events over which people had no control and which they regarded with fear and anxiety.[35]

Fetishes thus allow the human mind both too much and not enough control by establishing a "unified causal field" that encompasses both personal actions and physical events. Fetishes enable a semblance of control over future events—a possibility of influence, if not an airtight programmability—that itself relies on distorting real social relations into material givens.

This notion of fetish as false causality has been most important to Karl Marx's diagnosis of capital as fetish. Marx famously argued:

the commodity-form . . . is nothing but the determined social relation between humans themselves which assumes here, for them, the phantasmagoric form of a relation between things. In order, therefore, to find an analogy we must take a flight into the misty realm of religion. There the products of the human head appear as autonomous figures endowed with a life of their own, which enter into relations both with each other and with the human race. So it is in the world of commodities with the products of men's hands. This I call . . . fetishism.[36]

The capitalist thus confuses social relations and the labor activities of real individuals with capital and its seeming magical ability to reproduce. For, "it is in interest-bearing capital . . . that capital finds its most objectified form, its pure fetish form. . . . Capital—as an entity—appears here as an independent source of value; a something that creates value in the same way as land [produces] rent, and labor wages."[37]

The parallel to source code seems obvious: we "primitive folk" worship source code as a magical entity—as a source of causality—when in truth the power lies elsewhere, most importantly in social and machinic relations. If code is performative, its effectiveness relies on human and machinic rituals. Intriguingly though, in this parallel, enlightenment thinking—a belief that knowing leads to control, a release from tutelage—is not the "solution" to the fetish, but rather what grounds it, for source code historically has been portrayed as the solution to wizards and other myths of programming. According to this popular narrative, machine code provokes mystery and submission; source code enables understanding and thus institutes rational thought and freedom.

John Backus, writing about programming in the 1950s, contends, "programming in the early 1950s was a black art, a private arcane matter."[38] These programmers formed a "priesthood guarding skills and mysteries far too complex for ordinary mortals."[39] Opposing even the use of decimal numbers, these machine programmers

were sometimes deliberate purveyors of their own fetishes or "snake oil," systems that allegedly had "mysterious, almost human abilities to understand the language and needs of the user; closer inspection was likely to reveal a complex, exception-ridden performer of tedious clerical tasks that substituted its own idiosyncracies for those of the computer."[40] Automatic programming languages such as FORTRAN, developed by Backus, allegedly exorcised the profession of the priesthood by making programs more readable and thus making it easier to discern the difference between snake oil and the real thing. Similarly, Richard Stallman in his critique of non-free software has argued that machine-executable programs create mystery rather than enlightenment. Stallman contends that an executable "is a mysterious bunch of numbers. What it does is secret."[41] As I argue later, this notion of executables and executing code as magic is buttressed by real-time operating systems that posit the user as the source. Against this magical execution, source code supposedly enables pure understanding and freedom—the ability to map and understand the workings of the machine, but again only through a magical erasure of the gap between source and execution, an erasure of execution itself. Tellingly, this move to source code has hardly deprived programmers of their priestlike/wizard status. If anything, the notion of programmers as superhuman has been disseminated ever more and the history of computing—from direct manipulation to hypertext—marked by various "liberations."

But clearly, source code can do things: it can be interpreted or compiled; it can be rendered into machine-readable commands that are then executed. Source code is also read by humans and is written by humans for humans: it is thus the source of some understanding. Although Ellen Ullman and many others have argued, "a computer program has only one meaning: what it does. It isn't a text for an academic to read. Its entire meaning is its function," source code must be able to function, even if it does not function—that is, even if it is never executed.[42] Source code's readability is not simply due to comments that are embedded in the source code, but also due to English-based commands and programming styles designed for comprehensibility. This readability is not just for "other programmers." When programming, one must be able to read one's own program—to follow its logic and to predict its outcome, whether or not this outcome coincides with one's prediction.

This notion of source code as readable—as creating some outcome regardless of its machinic execution—underlies "codework" and other creative projects. The Internet artist Mez, for instance, has created a language "mezangelle" that incorporates formal code and informal speech. Mez's poetry deliberately plays with programming syntax, producing language that cannot be executed, but nonetheless draws on the conventions of programming language to signify.[43] Codework, however, can also work entirely within an existing programming language. Graham Harwood's perl poem, for example, translates William Blake's nineteenth-century poem "London" into London.pl, a script that contains within it an algorithm to "find and calculate the gross lung-capacity of

Plate 1 The Conversation Prism, <http://www.theconversationprism.com>, Creative Commons.

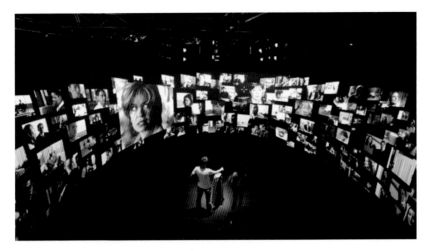

Plate 2 *T_visionarium*. By kind permission of Jeffrey Shaw, <http://www.icinema.unsw.edu.au/ projects/prj_tvis_II.html>.

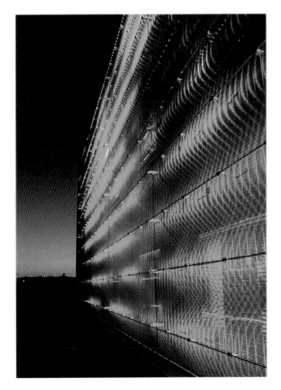

Plate 3 Atelier Torce 2007/2009—*Illumesh*, <http://www.medienfassade.com>.

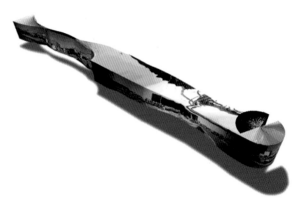

Plate 4 Traveling through time in 3D images. By kind permission of ART+COM, <http://www.artcom.de>.

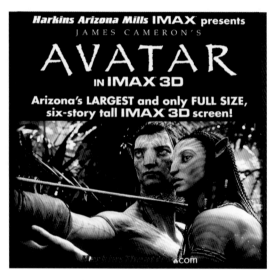

Plate 5 Promotion for *Avatar*, James Cameron (dir.), 2009.

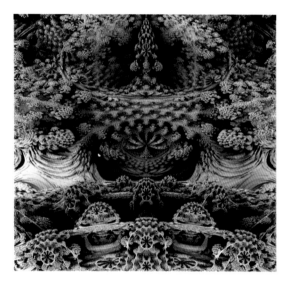

Plate 6 Daniel White, *Mandelbulb 3D*, 2009, <http://www.skytopia.com/project/fractal/mandelbulb.html>.

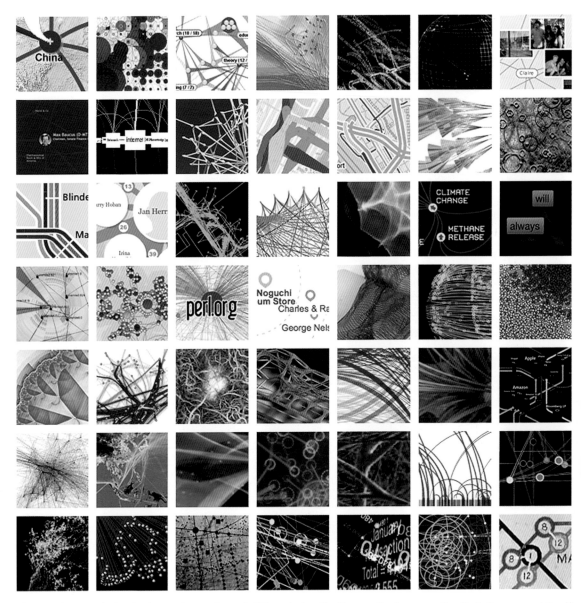

Plate 7 For insight in the increasing variety of different visualization methods across the disciplines, see <http://www.visualcomplexity.com>. By kind permission of Manuel Lima.

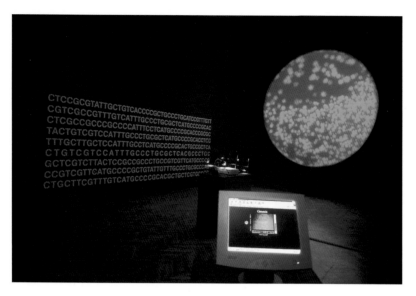

Plate 8 Eduardo Kac, *Genesis*, 1999. Transgenic work with live video, light box, microvideo camera, petri dish with Genesis gene, website. Edition of two. Dimensions variable. Collection Instituto Valenciano de Arte Moderno—IVAM, Valencia. © Eduardo Kac.

Plate 9 Eduardo Kac, *The Eighth Day*, 2001. Transgenic work with live video, blue lights, sound, biological robot, water, GFP organisms (plants, mice, fish, amoeba), website. Dimensions variable. © Eduardo Kac.

Plate 10 *Two and a Half Men.* © ILL Clan. By kind permission of the artist.

Plate 11 *Molotov Alva.* © Submarine. By kind permission of the artist.

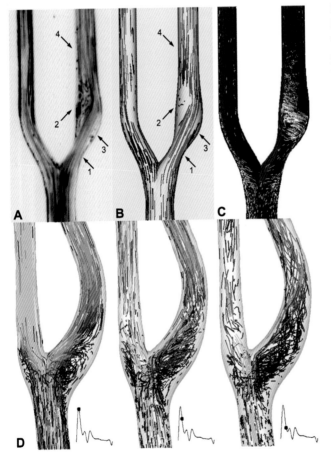

Plate 12 Real and virtual particle imaging, highlighting various conventions used to elucidate aspects of carotid bifurcation flow. Panels A–C adapted from David Steinman et al., "Flow Patterns at the Stenosed Carotid Bifurcation: Effect of Concentric vs. Eccentric Stenosis," *Annals of Biomedical Engineering* 28 (2000); panel D adapted from David Steinman, "Simulated Pathline Visualization of Computed Periodic Blood Flow Patterns," *Journal of Biomechanics* 33 (2000). © David Steinman.

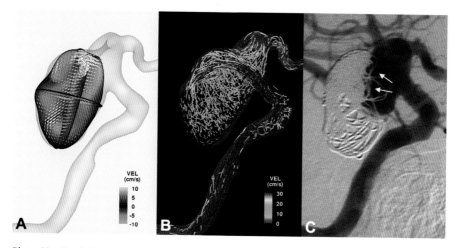

Plate 13 Evolution of engineering representations of flow in a simulated brain aneurysm, with corresponding angiogram suggesting the clinical consequence. Panel C adapted from David Steinman et al., "Image-based Computational Simulation of Flow Dynamics in a Giant Intracranial Aneurysm," *American Journal of Neuroradiology* 24 (2003). © David Steinman.

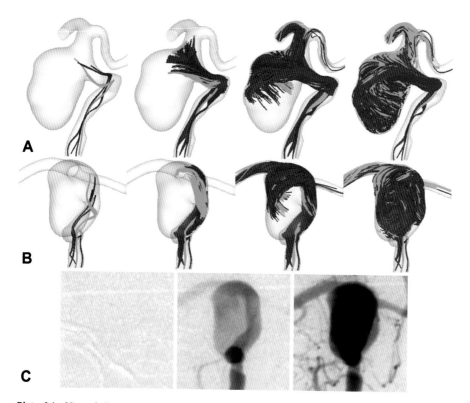

Plate 14 Virtual slipstreams entering the simulated aneurysm, shown in two different views, the latter being compared to an angiographic sequence from the same patient. Figure adapted from David Steinman et al., "Image-based Computational Simulation of Flow Dynamics in a Giant Intracranial Aneurysm," *American Journal of Neuroradiology* 24 (2003). © David Steinman.

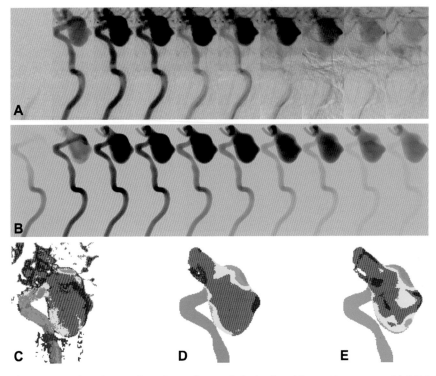

Plate 15 Real and virtual angiography, and derived residence time maps, highlighting the apparent truth of the virtual versus the real. Figure adapted from Matthew D. Ford et al., "Virtual Angiography: Visualization and Validation of Computational Fluid Dynamics Models of Aneurysm Hemodynamics," *IEEE Transactions on Medical Imaging* 24 (2005). © David Steinman.

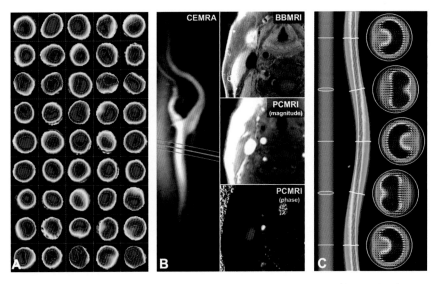

Plate 16 Compound images depicting the discovery of a surprising relationship between arterial shape and flow. Figure adapted from Matthew D. Ford et al., "Is Flow in the Common Carotid Artery Fully Developed?" *Physiological Measurement* 29 (2008). © David Steinman.

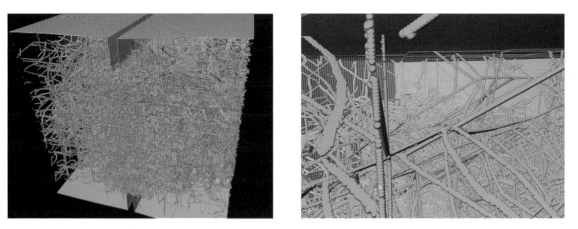

Plate 17 Farid Abraham, IBM Almaden Research, images of dislocation dynamics in a block of 1 billion copper atoms. Reprinted by kind permission of Farid Abraham.

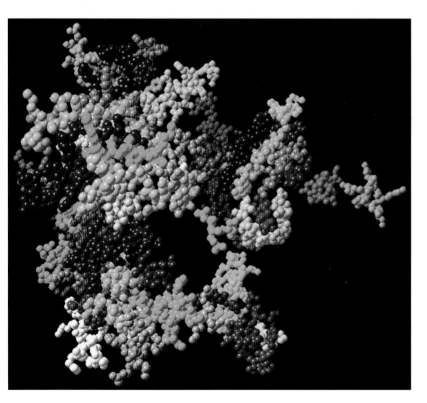

Plate 18 Chandrajit Bajaj, ball-and-stick model of a molecule. Courtesy the Computational Vision Center, University of Texas. Reprinted by kind permission of Chandrajit Bajaj.

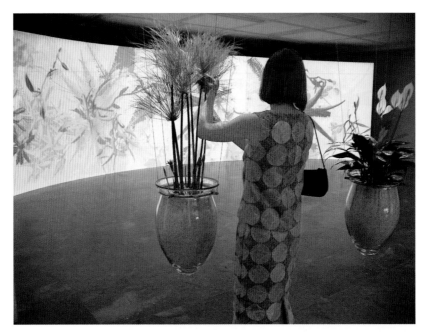

Plate 19 *Eau de Jardin,* an interactive art installation using living plants as interfaces, developed for the House-of-Shiseido, Japan, 2004. © Christa Sommerer and Laurent Mignonneau.

Plate 20 The *reacTable* is played by manipulating several tangible synthesizer modules on its round interactive table surface. Photo and artwork © Xavier Sivecas.

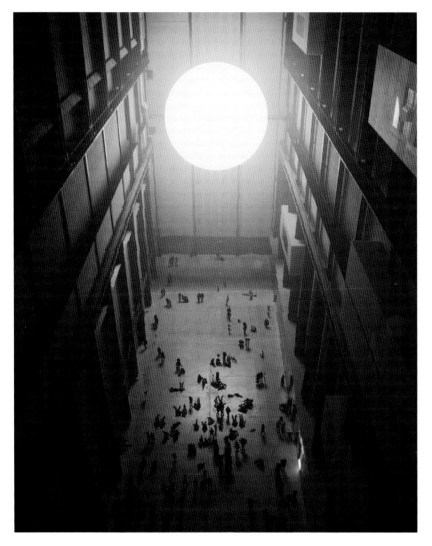

Plate 21 Olafur Eliasson, *The Weather Project*, 2003. © Olafur Eliasson. Reprinted by kind permission of the artist.

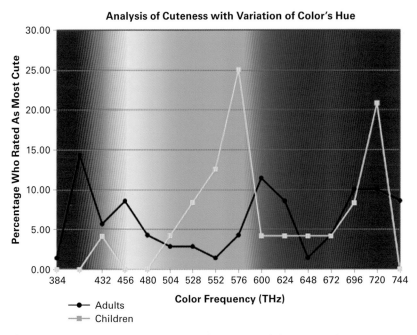

Plate 22 Chart showing the summary of selections of the cutest color.

Plate 23 *From Art and Civilisations: Africa, Asia, Oceania, and the Americas in the Louvre*, CD-ROM © Musée du Quai Branly, Réunion des Musées Nationaux, Carré Multimédia, Paris, 2000.

Plate 24 From *Verner Panton*, CD-ROM © Vitra Design Museum, Weil am Rhein; Panton Design, Hochschule für Gestaltung und Kunst Basel, Studienbereich Visuelle Kommunikation, Basel, 2000.

Plate 25 A set of 35 paintings by canonical modern artists discussed in chapter 17.

Plate 26 The Warburg argument, followed from within the HyperImage Reader, image detail.
© Martin Warnke.

© Dombois

Plate 27 Johanna and Florian Dombois, *Fidelio 21st Century*, interactive installation. Reprinted by permission of the artists.

Plate 28 Database of Virtual Art (screenshot).

Graphische Sammlung Stift Göttweig

Start | Suchen | Ausstellungen | Profil & Geschichte | Dienstleistungen | Projekt | Kontakt | Fine Art Prints | Impressum

Aktuell

Barocke Bilder-Eythelkeit Die Sammlung Dienstleistungen Benutzereinstellungen

Plate 29 Göttweig Print Collection Online (screenshot).

Plate 30 Christa Sommerer and Laurent Mignonneau, *The Living Web*, interactive installation. Reprinted by permission of the artists.

Plate 31 Rowan Drury, *Kempa Lisa*, 2004. Reprinted by kind permission of the artist.

the children screaming from 1792 to the present."[44] Regardless of whether or not it can execute, code can be, must be, worked into something meaningful. Source code, in other words, may be sources of things other than the machine execution it is "supposed" to engender.

Source code as fetish, understood psychoanalytically, embraces this nonteleological potential of source code, for the fetish is a genital substitute that gives the fetishist nonreproductive pleasure. It is a deviation that does not "end" where it should, a deviation taken on so that the child may combat castration for both himself and his mother, while at the same time accommodating to his world's larger Oedipal structure. It both represses and acknowledges paternal symbolic authority. According to Freud, "the fetish is a substitute for the woman's (mother's) phallus which the little boy once believed in and does not wish to forego,"[45] but the fetish, formed the moment the little boy sees his mother's genitals, also transforms the phallus:

It is not true that the child emerges from his experience of seeing the female parts with an unchanged belief in the woman having a phallus. He retains this belief but he also gives it up; during the conflict between the deadweight of the unwelcome perception and the force of the opposite wish, a compromise is constructed such as is only possible in the realm of unconscious thought—by the primary processes. In the world of psychical reality the woman still has a penis in spite of it all, but this penis is no longer the same as it once was. Something else has taken its place, has been appointed as its successor, so to speak, and now absorbs all the interest which formerly belonged to the penis.[46]

The fetish is a transformation of the mother's "phallus" whose magical power "remains a token of triumph over the threat of castration and a safeguard against it."[47] As such, it both fixes a singular event—turning time into space—and enables a logic of repetition that constantly enables this safeguarding. As Pietz argues, "the fetish is always a meaningful fixation of a singular event; it is above all a 'historical' object, the enduring material form and force of an unrepeatable event. This object is 'territorialized' in material space (an earthly matrix), whether in the form of a geographical locality, a marked site on the surface of the human body, or a medium of inscription or configuration defined by some portable or wearable thing."[48] Although it fixes a singular event, the fetish works only because it can be repeated, but again, what is repeated is both denial and acknowledgment, since the fetish can be "the vehicle both of denying and asseverating the fact of castration."[49] Slavoj Žižek draws on this insight to explain the persistence of the Marxist fetish:

When individuals use money, they know very well that there is nothing magical about it—that money, in its materiality, is simply an expression of social relations . . . on an everyday level, the individuals know very well that there are relations between people behind the relations between things. The problem is that in their social activity itself, in what they are *doing*, they are *acting* as if money, in its material reality is the immediate embodiment of wealth as such. They are fetishists in practice, not in theory. What they "do not know," what they misrecognize,

is the fact that in their social reality itself—in the act of commodity exchange—they are guided by the fetishistic illusion.[50]

Fetishists importantly know what they are doing—knowledge is not an answer to fetishism. The knowledge that source code offers is therefore no cure for source code fetishism: if anything, this knowledge sustains it.

To make explicit the parallels, source code, like the fetish, is a conversion of event into location—time into space—that does affect things, but not necessarily in the manner prescribed. Its effects can be both productive and non-executable. Also, in terms of denial and acknowledgment, we know very well that source code is not executable, yet we persist in treating it as so. And it is this glossing over that makes possible the ideological belief in programmability.

Code as fetish means that computer execution deviates from the so-called source, as source program does from programmer. Alan Turing, in response to the objection that computers cannot think because they merely follow human instructions, argued:

Machines take me by surprise with great frequency. . . . The view that machines cannot give rise to surprises is due, I believe, to a fallacy to which philosophers and mathematicians are particularly subject. This is the assumption that as soon as a fact is presented to a mind all consequences of that fact spring into the mind simultaneously with it. It is a very useful assumption under many circumstances, but one too easily forgets that it is false. A natural consequence of doing so is that one then assumes that there is no virtue in the mere working out of consequences from data and general principles.[51]

This erasure of the vicissitudes of execution coincides with the conflation of data with information, information with knowledge—the assumption that what's most difficult is the capture, rather than the analysis, of data. This erasure of execution through source code as source creates an intentional authorial subject: the computer, the program, or the user, and this source is treated as the source of meaning. The fact that there is an algorithm, a meaning intended by code (and thus in some way knowable), sometimes structures our experience with programs. When we play a game, we arguably try to reverse engineer its algorithm or at the very least link its actions to its programming, which is why all design books warn against coincidence or random mapping, since it can induce paranoia in its users. That is, because an interface is programmed, most users treat coincidence as meaningful. To the user, as with the paranoid schizophrenic, there is always meaning: whether or not the user knows the meaning, she knows that it regards her. Whether or not she cares, however, is another matter. Regardless, the fact that the code allegedly driving an interface can be revealed, the fact that source code exists means that the truth is out there. To know the code is to have a form of "X-ray" vision that makes the inside and outside coincide, and the act of revealing sources or connections becomes a critical act in and of itself.[52]

Real Time, This Time

This discussion of the user brings to light an intriguing fact: the notion of user as source, introduced though real-time operating systems, is the obverse rather than the antidote to code as source. According to the OED, real time is "the actual time during which a process or event occurs, especially one analyzed by a computer, in contrast to time subsequent to it when computer processing may be done, a recording replayed, or the like." Crucially, hard and soft real-time systems are subject to a "real-time constraint." That is, they need to respond, in a forced duration, to actions predefined as events. The measure of real time, in computer systems, is its reaction to the live, its liveness.

The notion of real time always points elsewhere—to "real-world" events, to user's actions—thereby introducing indexicality to this supposedly non-indexical medium. That is, whether or not digital images are supposed to be "real," real time posits the existence of a source—coded or not—that renders our computers transparent. Real-time operating systems create an "abstraction layer" that hides the hardware details of the processor from application software; real time images portray computers as unmediated connectivity. As Realplayer reveals, the notion of real time is bleeding into all electronic moving images, not because all recordings are live, but because grainy moving images have become a marker of the real.[53] What is authentic or real is what transpires in real time, but real time is real not only because of this indexicality—this pointing to elsewhere—but also because its quick reactions to users' inputs.

Dynamic changes to Web pages in real time, seemingly at the bequest of users' desires or inputs, create what Tara McPherson has called "volitional mobility." Creating "Tara's phenomenology of websurfing," McPherson argues:

When I explore the web, I follow the cursor, a tangible sign of presence: implying movement. This motion structures a sense of liveness, immediacy, of the now . . . yet this is not the old liveness of television: this is liveness with a difference. This liveness foregrounds volition and mobility, creating a liveness on demand. Thus, unlike television which parades its presence before us, the web structures *a sense of causality* in relation to liveness, a liveness we navigate and move through, often structuring a feeling that our own desire drives the movement. The web is about presence but an unstable presence: it's in process, in motion.[54]

This liveness, McPherson carefully notes, is more the illusion—the feel or sensation—of liveness, rather than the fact of liveness; the choice yoked to this liveness is similarly a sensation rather than the real thing (although one might ask: what is the difference between the feel of choice and choice? is choice itself not a limitation of agency?). The real-time moving cursor and the unfolding of an unstable present through our digital (finger) manipulations makes us crane our necks forward, rather than sit back on our couches, causing back and neck pain. The extent to which computers turn the

most boring activities into incredibly time-consuming and even enjoyable ones is remarkable: one of the most popular computer game to date, *The Sims*, focuses on the mundane; action and adventure games reduce adventure to formulaic motion-restricted activities. This volitional mobility, McPherson argues, reveals that the "hype" surrounding the Internet does have some phenomenological backing. This does not necessarily make the Internet an empowering medium, but at the very least means that it can provoke a desire for something better: true volitional mobility, true change.[55]

As noted earlier, however, the user is not the only source of change in real time. Real-time images, such as those provided by webcams, make our computer screen seem, for however brief a moment, alive. Refreshing on their own and pointing elsewhere, they make our networks seem transparent and thus fulfill the promise of fiber optic networks to connect us to the world, as do real-time stock quotes and running news banners.[56] As a whole, these moments of "interactivity" buttress the notion of transparency at a larger level. The source of a computer's actions always stems from elsewhere because real time makes it appear as though only outside events—user mouseclicks, streaming video—cause the computer actions. These real-time interactions, which were initially introduced to make computation more efficient, have almost erased computation altogether. Once again, the movements within the computer—the constant regeneration, the difference between the textual representation of a program, a compiled program, a program stored on the hard drive, and the program read-in instruction by instruction into the processor—are all erased. These movements create our spectral interface, without which our machines (we erroneously believe) could not work, and it is these spectral interfaces that allow us to include computers within the broader field of "visual culture" studies or screen media. Viewed as the alpha and omega of our computers, interfaces stand in, more often than not, for our computer itself, erasing the medium as it proliferates its specters, making our machines transparent producers of unreal visions—sometimes terrifying but usually banal imitations or hallucinations of elsewhere.

Demonic Media

Not accidentally, this spectrality of digital media makes our media demonic: that is, inhabited by invisible processes that, perhaps like Socrates' *daimonion*, help us in our time of need. They make executables magic. UNIX—that operating system seemingly behind our happy spectral Macs—runs daemons. Daemons run our email, our Web servers. Macs thus not only proudly display that symbol of Judeo-Christian man's seduction and fall from grace—that sanitized but nonetheless telling bitten apple; it also inhabits its operating systems with daemons that make it a veritable "Paradise

Figure 10.2
FreeBSD mascot <http://www.zer0.org/daemons/wc/standing_daemon.jpg>. © 1988 Marshall
Kirk McKusick. Reprinted with permission.

Lost." The mascot for FreeBSD, the robust operating system (used by Apple OSX) dis-
tributed via Berkeley Software Distribution and descended from AT&T's UNIX, nicely
features the daemon as its logo (see figure 10.2).

So what are these daemons called sendmail, if not Satan? Most simply, a daemon
is a process that runs in the background without intervention by the user (usually
initiated at boot time). They can run continuously, or in response to a particular event
or condition (for instance, network traffic) or a scheduled time (every five minutes or
at 5:00 every day). More technically, UNIX daemons are parentless—that is, orphaned—
processes that run in the root directory. You can create a UNIX daemon by forking a
child process and then having the parent process exit, so that INIT (the daemons of
daemons) takes over as the parent process.[57]

UNIX daemons supposedly stem from the Greek word *daemon* meaning, according
to the OED, "A supernatural being of a nature intermediate between that of gods and
men; an inferior divinity, spirit, genius (including the souls or ghosts of deceased
persons, esp. deified heroes)." A daemon is thus already a medium, an intermediate
value, albeit one that is not often seen. The most famous daemon is perhaps Socrates'
daimonion, mentioned above—that mystical inner voice that assisted Socrates in time

of crisis by forbidding him to do something rash. The other famous daemon, more directly related to those spawning UNIX processes, is Maxwell's demon. According to Fernando Corbato, one of the original members of the Project MAC group in 1963:

Our use of the word daemon was inspired by the Maxwell's daemon of physics and thermody-namics. (My background is Physics.) Maxwell's daemon was an imaginary agent which helped sort molecules of different speeds and worked tirelessly in the background. We fancifully began to use the word daemon to describe background processes which worked tirelessly to perform system chores.[58]

Daemonic processes are slaves that work tirelessly and, like all slaves, define and challenge the position of the master.

The introduction of multiuser command line processing—real-time operating sys-tems—necessitates the mystification of processes that seem to operate automatically without user input, breaking the interfaces' "diegesis." What is not seen, becomes daemonic, rather than what is normal, because the user is supposed to be the cause and end of any process. Real-time operating systems, such as UNIX, transform the computer from a machine run by human operators in batch-mode to "alive" personal machines, which respond to the user's commands. Real-time content, stock quotes, breaking news, and streaming video similarly transform personal computers into per-sonal media machines. These moments of "interactivity" buttress the notion of our computers as transparent. Real-time processes, in other words, make the user the "source" of the action, but only by orphaning those processes without which there could be no user. By making the interface "transparent" or "rational," one creates demons.

It is not perhaps surprising then that Nietzsche condemned Socrates so roundly for his daemon (and similarly language for its attribution of subject to verb). According to Nietzsche, Socrates was himself a daemon because he insisted on the transparency of knowledge, because he insisted that what is most beautiful is also most sensible. Crucially, Socrates' divine inner voice only spoke to dissuade. Socrates introduced order and reified conscious perception, making instinct the critic, and consciousness the creator. Perhaps as a sign of the desire for the transparency of knowledge—the reigning of rationality—daemon is also an acronym. Since the first daemon was appar-ently a program that automatically made tape backups of the file system, it has been assumed that daemon stands for "Disk And Executive MONitor." This first daemon is appropriately about memory: an automated process, stored in memory that transfers data between secondary and tertiary forms of memory, and which stores the code so it can be viewed as source. Memory is what makes possible daemons, makes our media daemonic.[59] The questions that remain are: how to deal with these daemons and their alleged source codes? Should these daemons be exorcised, or is this spectral relation-ship not central to the very ghostly concept of information and the commodity itself?[60]

Code as Re-Source

To answer these questions, let me return to code as re-source, for code as re-source enables us to think in terms of the gap between source and execution, and makes an interface a process rather than a stable thing. This gap complicates any analysis of user determination by software: as Matthew Fuller points out, the "gap between a model of a function and its actualities . . . in some cases describes a degree of freedom, and . . . in others puts into place a paralyzing incapacity to act."[61] Reading Microsoft Word's mammoth feature mountain, Fuller compellingly argues that the more features offered in an anxious attempt to program the user—the more codes provided—the more ways the user can go astray.[62] Thinking in terms of this gap also means thinking of how information is undead; that is, how it returns over and over again.[63] Second, code as re-source allows us to the take seriously the entropy, noise, decay that code as source renders invisible. By taking decay seriously, we can move away from the conflation of storage with memory that grounds current understandings of digital media. Lastly, understanding code as re-source links its effectiveness to history and context. If code is performative, it is because of the community (human and otherwise) that enables such utterances to be repeated and executed, that one joins through such citation.

This larger view of the performative has been developed by Judith Butler, who argues that the felicity of a performative utterance does not depend on the sovereign subject who speaks it. Instead, she argues that what is crucial to a performative utterance's success or failure is its iterability, where iterability is *"the operation of that metalepsis by which the subject who 'cites' the performative is temporarily produced as the belated and fictive origin of the performative."*[64] In other words, when a speaker executes a performative utterance, she or he cites an utterance that makes "linguistic community with a history of speakers."[65] What is crucial here is: one, code that succeeds must be citations—and extremely exact citations at that. There is no room for syntax errors; two, this iterability precedes the so-called subject (or machine) that is supposedly the source of the code; three, and most importantly, an entire structure must be in place in order for a command to be executed. This structure is as institutional and political as it is machinic.

To make this point, I'll conclude by directly addressing an example that has "haunted" this article: the current struggle between free software and open source. At a material level, this disagreement makes no sense, for what is the difference between free software and open source software, between Linux and GNU Linux? Nothing and everything: an imagined, yet crucial difference. According to Richard Stallman, the difference lies in their values:

The fundamental difference between the two movements is in their values, their ways of looking at the world. For the Open Source movement, the issue of whether software should be open

source is a practical question, not an ethical one. As one person put it, "Open source is a development methodology; free software is a social movement." For the Open Source movement, non-free software is a suboptimal solution. For the Free Software movement, non-free software is a social problem and free software is the solution.[66]

The fact that code automatically does what it says is hardly central. The difference between open source and free software lies in the network that is imagined when one codes, releases, and uses software, the type of community one joins and builds when one codes. The community being cited here, worked through, is one committed to this notion of freedom, to coding as a form of free speech. Open source and free software movements are aligned, however, in their validation of "open": freedom is open access.[67]

This emphasis on imagined networks I hope makes it clear that I'm not interested in simply exorcising the spectral or the visual, but rather trying to understand how its spectrality lies elsewhere and how what we see may not be all there is to see and know. Capturing ghosts often entails looking beyond what we "really" see to what we see without seeing, and arguably, digital media's biggest impact on our lives is not through its interface but its algorithmic procedures. Agre has emphasized its mode of capture, rather than surveillance, that is, the ways in which computers capture our routine tasks as data to be analyzed and optimized: from shopping to driving a car.[68] Capture reworks the notion and importance of access: one does not need a "personal computer" in order to be captured—all one needs is a RFID tag, or to work in a factory, or to simply be in debt. Capture also emphasizes tactility and the mundane rather than the spectacular—but also the political and theoretical importance of imagining these invisible networks and technologies that envelop us in their dense thicket of passive and active signals, that can only be imagined. This necessary imagining, this visually spectral other, underscores the fact that we do not experience technology directly, although to what extent human sensory experience or affect is the end-all and be-all of computation remains to be seen, for emphasizing human perception can be a way of clinging to a retrograde humanism. What remains to be seen may not be what remains, however fleetingly, on our interfaces.

Notes

1. This essay was originally published as Wendy Hui Kyong Chun, "'On Sourcery': Code as Fetish," *Configurations* 16:3 (2008), 299–324. Copyright © 2008 The Johns Hopkins University Press and the Society for Literature and Science. Reprinted with permission of The Johns Hopkins University Press.

2. John Godfrey Saxe, "Blind Men and the Elephant," <http://www.wordinfo.info/words/index/info/view_unit/1/?letter=B&spage=3>.

3. Lev Manovich, *The Language of New Media* (Cambridge, MA: MIT Press, 2001), 48.

4. Vapor theory is a term coined by Peter Lunenfeld and used by Geert Lovink to designate theory so removed from actual engagement with digital media that it treats fiction as fact. This term, however, can take on a more positive resonance, if one takes the non-materiality of software seriously. (Geert Lovink, "Enemy of Nostalgia, Victim of the Present, Critic of the Future Interview with Peter Lunenfeld," July 31, 2000, <http://www.nettime.org/Lists-Archives/nettime-l-0008/msg00008.html>.

5. We all know some software, some languages, but does anyone really "know" software? What could that even mean?

6. Alexander Galloway, *Protocol: How Power Exists after Decentralization* (Cambridge, MA: MIT Press, 2004), 164.

7. McKenzie Wark, "A Hacker Manifesto, version 4.0," <http://subsol.c3.hu/subsol_2/contributors0/warktext.html>.

8. See Richard Stallman, "The Free Software Movement and the Future of Freedom; March 9th 2006," <http://www.fsfe.org/freesoftware/transcripts/rms-fs-2006-03-09.en.html>.

9. For more on enlightenment as a stance of how not to be governed like that, see Michel Foucault, "What Is Critique?" in *What Is Enlightenment?*, ed. James Schmidt (Berkeley: University of California Press, 1996), 382–398.

10. As Niva Elkin-Koren notes, the Creative Commons strategy "does not aim at creating a public domain, at least not in the strict legal sense of a regime that is free of any exclusive proprietary rights. The strategy is entirely dependent upon a proprietary regime and drives its legal force from its existence. The normative framework assumes that it is possible to replace existing practices of producing and distributing informational works by relying on the existing proprietary regime. The underlying assumption is that if intellectual property rights remain the same, but rights are exercised differently by their owners, free culture would emerge." Elkin-Koren, "Creative Commons: A Skeptical View of a Worthy Project," in *The Future of the Public Domain*, ed. P. Bernt Hugenholtz and Lucie Guibault (Kluwer Law International, 2006) <http://ssrn.com/abstract=885466>. Although Elkin-Koren is writing about Creative Commons in this passage, she makes it clear that this strategy of extending and revising intellectual property rights is drawn from the Free Software Movement's GPL.

11. For more on this, see Wendy Hui Kyong Chun, *Control and Freedom: Power and Paranoia in the Age of Fiber Optics* (Cambridge, MA: MIT Press, 2006).

12. See Wendy Hui Kyong Chun, "On Software, or the Persistence of Visual Knowledge," *gray room* 18 (winter 2005): 27–52.

13. Edsger Dijkstra, "Go To Statement Considered Harmful," in *Software Pioneers: Contributions to Software Engineering*, ed. Manfred Broy and Ernst Denert (Berlin: Springer, 2002), 342.

14. Structured programming was introduced as a way to make programs, rather than programmer priest, the source, although the term programmer priest complicates the notion of source: is the source the programmer or some mythic power she mediates?

15. See Chun, "On Software."

16. For more on software art as conceptual art, see Florian Cramer, "Concepts, Notations, Software, Art," <http://www.netzliteratur.net/cramer/concepts_notations_software_art.html>.

17. Galloway, *Protocol*, 165.

18. N. Katherine Hayles, *My Mother Was a Computer: Digital Subjects and Literary Texts* (Chicago: University of Chicago, 2005), 50. Hayles's argument immediately poses the question: What counts as internal versus external to the machine, especially given that, in John von Neumann's foundational description of stored program computing, the input and output (the outside world to the machine) taken together were a form of memory?

19. Alexander Galloway, "Language Wants to Be Overlooked: Software and Ideology," *Journal of Visual Culture* 5:3 (2005), 328.

20. Ibid., 321.

21. Galloway, *Protocol*, 167.

22. Galloway, "Language Wants," 321.

23. This example draws from the *PowerPC Assembly Language Beginners Guide*, <http://www .lightsoft.co.uk/Fantasm/Beginners/Chapt1.html>.

24. Philip E. Agre, *Computation and Human Experience* (Cambridge: Cambridge University Press, 1997), 92.

25. Warren McCulloch and Walter Pitts, "A Logical Calculus of the Ideas Immanent in Nervous Activity," in *Embodiments of Mind* (Cambridge, MA: MIT Press, 1965), 21.

26. Norman McRae, *John von Neumann* (New York: Pantheon, 1992), 378.

27. According to Friedrich Nietzsche in *The Genealogy of Morals*, "there is no 'being' behind the doing, effecting, becoming: 'the doer' is merely a fiction added to the deed—the deed is every-thing." (*The Birth of Tragedy & Genealogy of Morals*, trans. Francis Golffing, New York: Doubleday, 1956, 178–179.)

28. Lawrence Lessig, *Code and Other Laws of Cyberspace* (New York: Basic Books, 1999).

29. Oxford English Dictionary Online, <http://www.oed.com>.

30. See Friedrich Kittler, "There Is No Software," *Ctheory*, <http://www.ctheory.net/articles .aspx?id=74>.

31. Namely, twentieth-century genetics, but this is the topic of another article.

32. Felix Guattari and Gilles Deleuze, "Capitalism: A Very Special Delirium," <http://www .generation-online.org/p/fpdeleuze7.htm>.

33. Oxford English Dictionary Online.

34. William Pietz, "Fetishism and Materialism," in *Fetishism as Cultural Discourse*, ed. Emily Apter and William Pietz (Ithaca, NY: Cornell University Press, 1993), 138, 139.

35. Ibid., 137.

36. Karl Marx, *Capital: A Critique of Political Economy*, vol. 1. Trans. Ben Foskes. New York: Penguin, 1976), 165.

37. Marx as quoted by William Pietz, "Fetishism and Materialism," 149.

38. John Backus, "Programming in America in the 1950s—Some Personal Impressions," in *A History of Computing in the Twentieth Century*, ed. N. Metropolis et al. (New York: Academic Press, Harcourt Brace Jovanovich, 1980), 126.

39. Ibid., 127.

40. Ibid.

41. Richard Stallman, "Copyright and Globalization in the Age of Computer Networks," <http://www.gnu.org/philosophy/copyright-and-globalization.html>.

42. Ellen Ullman interviewed by Scott Rosenberg, "21st: Elegance and Entropy," Salon.com, <http://dir.salon.com/story/tech/feature/1997/10/09/interview>.

43. See mez's site: <http://www.hotkey.net.au/~netwurker>.

44. See <http://www.scotoma.org/notes/index.cgi?LondonPL>.

45. Freud, "Fetishism," in *Sexuality and the Psychology of Love* (New York: Macmillan, 1963), 205.

46. Ibid., 206.

47. Ibid.

48. William Pietz, "The Problem of the Fetish," pt. 1., *Res* 9 (spring 1985): 12.

49. Freud, "Fetishism," 208.

50. Slavoj Žižek, *The Sublime Object of Ideology* (New York: Verso, 1989), 31.

51. Alan Turing, "Computing Machinery and Intelligence," *Mind* 59 (1950), <http://www.loebner.net/Prizef/TuringArticle.html>.

52. N. Katherine Hayles develops this theme of revealing codes in *My Mother Was a Computer*, 54–61. Importantly, some software art projects also complicate and frustrate code as X-ray vision and connection as meaning, such as Golan Levin's *Axis Applet*.

53. See Tom Levin, "Rhetoric of the Temporal Index: Surveillant Narration and the Cinema of 'Real Time,'" in *CTRL Space: Rhetorics of Surveillance from Bentham to Big Brother*, ed. Thomas Levin et al. (Cambridge, MA: MIT Press, 2002), 578–593.

54. Tara McPherson, "Reload: Liveness, Mobility and the Web," in *The Visual Culture Reader*, 2nd ed., ed. Nicholas Mirzoeff (New York: Routledge, 2002), 462.

55. Coming from film rather than television studies and focusing more on applications than phenomenology, Alexander Galloway in *Protocol* similarly argues that continuity makes websurfing "a compelling, intuitive experience for the user":

On the Web, the browser's movement is experienced as the user's movement. The mouse movement is substituted for the user's movement. The user looks through the screen into an imaginary world, and it makes sense. The act of "surfing the web," which, phenomenologically, should be an unnerving experience of radical dislocation—passing from a server in one city to a server in another city—could not be more pleasurable for the user. Legions of computer users live and play online with no sense of radical dislocation. (64)

56. For more see chapter 5 of Chun, *Control and Freedom*.

57. The following PERL program, for instance, says hello every five minutes:

```
use POSIX qw(setsid);
#turns the process into a session leader, group leader, and ensures that it
  doesn't #have a controlling terminal
chdir '/' or die "Can't chdir to /: $!";
umask 0;
open STDIN, '/dev/null' or die "Can't read /dev/null: $!";
#open STDOUT, '>/dev/null' or die "Can't write to /dev/null: $!";
open STDERR, '>/dev/null' or die "Can't write to /dev/null: $!";
defined(my $pid = fork) or die "Can't fork: $!";
exit if $pid;
setsid or die "Can't start a new session: $!";
while(1) {
sleep(5);
print "Hello...\n";
}
```

From <http://www.webreference.com/perl/tutorial/9/3.html>

58. "The Origin of the Word Daemon," <http://ei.cs.vt.edu/~history/Daemon.html>. This is why Neal Stephenson in *Snow Crash* (New York: Bantam, 1992) describes robots or servants in the *Metaverse* as daemons.

59. See Wendy Hui Kyong Chun, "The Enduring Ephemeral, or the Future Is a Memory," *Critical Inquiry* (fall 2008).

60. See Thomas Keenan, "The Point Is (Ex)Change It: Reading *Capital*, Rhetorically," in *Fetishism as Cultural Discourse*, ed. Emily Apter and William Pietz (Ithaca, NY: Cornell University Press, 1993), 152–185.

61. Matthew Fuller, *Behind the Blip* (New York: Autonomedia, 2003), 107.

62. See Matthew Fuller, "It Looks as though You're Writing a Letter," *Telepolis* 07.03.2001 <http://www.heise.de/tp/r4/artikel/7/7073/1.html>.

63. See Chun, "The Enduring Ephemeral."

64. Judith Butler, *Excitable Speech: A Politics of the Performative* (New York: Routledge, 1997), 51.

65. Ibid., 52.

66. Richard Stallman, "Why 'Free Software' Is Better than 'Open Source,'" <http://www.gnu.org/philosophy/free-software-for-freedom.html>.

67. The question that remains is the subject of another paper: but what does this say about the meaning of open close down?

68. Philip E. Agre, "Surveillance and Capture: Two Models of Privacy," *Information Society* 10:2 (1994): 101–127.

11 Cultural Interfaces: Interaction Revisited

Christa Sommerer and Laurent Mignonneau

1 "Interaction"—An Interdisciplinary Term

1.1 Cartography as the Earliest Form of Interface Study

Before we show some cultural interfaces in more detail, let us look at what the term "interaction" means and where it originally came from. In the book *The Art and Science of Interface and Interaction Design*, Peter Weibel, one of the pioneers of media and interactive art, traces the roots of the word "interface" back to "surface science."[1] To him there is an etymological and conceptual connection between "surface" and "interface." According to Weibel, surface science is the study of physical and chemical phenomena that occur at the interface of two phases, and they include such fields as surface chemistry and surface physics. Weibel goes even further and suggests that the term "interface" means more than the study of the interface of two phases and also includes the study of the representation of these two phases. He draws a connection to cartography as the study of the surface of the Earth and its representation. Weibel shows how the study of the surface of the Earth produces an interface that represents the Earth. Even current trends in cartography are moving from analog methods of mapmaking toward the creation of dynamic, interactive maps that are able to be manipulated digitally. This brings up the question of how the study of the interface is also connected to the study of representation and simulation. Weibel notes that already Borges and Baudrillard pointed out that maps have the tendency to devour the territory and can simulate reality or territory so perfectly that no difference can be perceived between representation and reality, a trend currently best illustrated with the media-mapping system Google Earth. According to Weibel cartography can thus be seen as the beginning of the use of interfaces, and the study of the surface (of the Earth) tends or turns toward a study of the interface.

1.2 The Term "Interaction" in Social Psychology

The term "interaction" has also been used in social psychology. Here interaction was seen as a form of social relationship between humans. In her essay "Interactivity—A

Word in Process," Katja Kwastek[2] points out that the first use of the term interaction was Georg Simmel's use of the term "Wechselwirkung" (=interaction) to characterize interpersonal relationships.[3] According to Kwastek, George Herbert Mead and Edward Alsworth Ross were talking about "social interaction" or the "interaction of human beings,"[4] and Mead's student Herbert Blumer systematized his research under the term of "symbolic interactionism," comparing this in 1937 with the stimulus-response theory. Kwastek states that for the proponents of stimulus-response theory interpersonal interaction consisted in a complex process of causes and effects of the various sensory organs and muscle groups, and it was therefore primarily explained physiologically and investigated statistically. The symbolic interactionists, on the other hand, regarded "social interaction as primarily a communicative process in which people share experience, rather than a mere play back and forth of stimulation and response."[5] Whereas stimulus-response theorists principally investigated reactions, the symbolic interactionists were more interested in actions, according to Kwastek.

1.3 Human–Computer Interaction

The study of human–computer interaction goes back to the mid-1960s. In 1960, J. C. R. Licklider attempted to "foster the development of man-computer symbiosis by analyzing some problems of interaction between man and computing machines."[6] In 1963, computer pioneer Ivan Sutherland developed the "Sketchpad," a graphical interface that made it possible to manipulate graphics on a display using a light pen. In 1965, Douglas Engelbart[7] developed the "X-Y position indicator for a display system," now known as the computer mouse. Seymour Papert[8] and Alan Curtis Kay[9] also investigated how to design interfaces for better expressing human creativity; Kay was convinced that creative processes always include the use of sensorimotor and iconic forms of representations, especially in art and science. Kay's group in 1981 developed the famous first commercial workstation, the Xerox Star, which included the first graphical user interface that was easy and intuitive to use. This workstation had an enormous impact on how we use and interact with computers today and in fact popularized graphical user interfaces (GUIs) altogether. From then on, human–computer interaction was established as a highly specialized and interdisciplinary field within computer science.[10]

1.4 Interaction in Cybernetic Theories

Interaction is also an important topic in cybernetic theories. In 1947, Norbert Wiener[11] coined the term "cybernetics" and established it as the study of control and communication in the animal and the machine. Cybernetics focuses on how digital, mechanical, or biological systems process information and how they react to it. Principles such as learning, cognition, adaptation, social control, emergence, communication, efficiency, efficacy, and interconnectivity can be explained through cybernetic theories.

Cybernetics attempts to study feedback mechanisms and information processing in engineering and biology, by looking at how black boxes and derived concepts such as communication and control can lead to self-organization in living organisms, machines, and organizations.

1.5 Interaction Design

The area of interaction design has also seen steady growth in the last couple of years. From the 1930s, when pioneers such as Konrad Zuse[12] and Alan Turing[13] conceptualized computers as simple calculating machines, to today's multifunctional computers, designers have become more and more concerned about how to design the data exchanges between machines and humans. Based on an ever increasing flow of information in society, designers now need to look for tools to make these interactions more transparent, meaningful, and manageable. The area of interaction design is relatively new, and a theory on interaction design principles has been developed, for example, by Shneiderman in 1998.[14] The main focus here is on creating interactive products that are easy to use, efficient, and support people in their daily lives and work.[15] In her essay "Interaction Design: Definition and Tasks,"[16] Caroline Schubinger provides a good introduction to the definition and tasks of interaction design. She points out how interaction design specialists need to find ways to conceptualize, design, and implement these interfaces for creating user-friendly interactions in sustained and meaningful social environments. In his compendium *Total Interaction* G.M. Buurman[17] stresses the importance of interaction design in the creation of social meaning, as new technologies challenge designers to create new cultural experiences.

1.6 Interactive Art

When we look at when artists started to use interaction in artworks, it is necessary to distinguish interaction as a social form of participation and artworks that use interaction achieved through technological means. In the first category, artworks based on social participation and/or the execution of instructions were common in the participatory artworks of Dada (1916–1920),[18] Fluxus (about 1960s),[19] and conceptual art (1960s).[20] Already as early as 1913 Filippo Tommaso Marinetti proclaimed in his manifesto *Teatro di Variete* that the audience should get involved in a more physical manner instead of being passive, consuming, and nonacting;[21] this is in fact an extremely progressive suggestion for its time. The theory of an open accessible artwork was further developed during the 1960s and eventually defined by Umberto Eco in the 1962 book *The Open Work*[22] where he increased the importance of the audience for the artwork. According to Peter Bürger[23] the historical avant-garde made sure that the relationship between artwork and audience has changed and that the physically active viewer would take on a more decisive role, hereby becoming a deciding factor

for the work of art. In 2008 the San Francisco Museum of Modern Art put together an exhibition and catalog that traces the connection between early participatory art from the 1960s and today's interactive art movements. In this exhibition catalog, participatory and instruction-based artworks by John Cage, George Brecht, Jean Tinguely, Robert Rauschenberg, Wolf Vostell, Allan Kaprow, Joseph Beuys, Nam June Paik, Mieko Shiomi, Yoko Ono, Lygia Clark, Helio Oiticica, Valie Export, Vito Acconci, Marina Abramovic, and Ulay, among others, are introduced.[24] What is intriguing about these early forms of physical audience participations is that they broke down the barriers between the artist and the audience by using radical means of establishing new dialogues. This was done, for example, by introducing random and noise into the artwork (Cage[25]) or taking into account the audiences' interpretations of the artwork (Brecht[26]). The artist's body as an interface between the work of art and the audience is also a reoccurring theme from the 1960s on, and radical pieces such as the *Cut Piece* by Yoko Ono[27] or the *Tapp und Tastkino* by Valie Export[28] illustrate the breakdown of previous boundaries. Another radical idea of that time is the Beuysian concept of the *Social Sculpture*. During the 1960s Beuys formulated his central theoretical ideas concerning the social, cultural, and political function and potential of art. Motivated by a utopian belief in the power of universal human creativity, he was confident in the potential for art to bring about revolutionary change. In his concept of the *Social Sculpture*, society as a whole was to be regarded as one great work of art (the Wagnerian Gesamtkunstwerk) to which each person can contribute creatively.[29]

Some of the first artists to include technical devices in their audience participatory art works were Jean Tinguely[30] and Robert Rauschenberg,[30] Nam June Paik,[31] Nicolas Schoeffer, James Seawright, Edward Ihnatowicz, and Tony Martin. Here the artworks started to react to the environment and to viewers through the use of various sensor technologies. Several of these early pioneering works were exhibited in the exhibition *Cybernetic Serendipity* by Jasia Reichardt.[32] In 2007 Christiane Paul, Charlie Gere, and Jemima Rellie put together a comprehensive exhibition and catalog that deals with the connection of early instruction-based artworks and art responding to input and its environment.[33] From this compendium we can learn that artists, since the 1920s, have considered interaction and participation as a means of engaging in a social dialogue. The movement of *E.A.T Experiments in Art and Technology* around Billy Klüver and Robert Rauschenberg[34] and the *Pioneers of Electronic Art*[35] such as Woody and Steina Vasulka,[36] Nam June Paik and Jun Abe, Robert Moog, Don Buchla, Dan Sandin, Bill Etra and Steve Rutt, Stephen Beck, Eric Siegel, Bill Hearn, George Brown, and others, illustrate how artists and engineers started to explore and develop the creative potential of new technologies such as video and audio synthesizers, image processing, and electronic music devices. Peter Weibel wrote in the statement of the *Pioneers of*

Electronic Art: "The scandal of machine-supported art, from photography, video, to the computer, uncovers the fiction that art is a human place, a place for human creativity, unique individuality. Machine art mocks this bourgeois illusion in an unrelenting way."[37]

In 2004 Matthias Michalka curated an exhibition on the topic of expanded cinema, showing how artists in the 1960s and '70s have also experimented with the expansion of film. He showed how artists investigated the field of projection linked to the development of new forms of perception and participation, the interrogation of the film in terms of media analysis, as well as the exploration of the relationship between the media image and the physical space.[38] His selection introduced artworks by Peter Weibel, Valie Export, Hans Scheugl, Gottfried Schlemmer, Ernst Schmidt Jr., Paul Sharits, Wolf Vostell, Malcolm Le Grice, Annabel Nicolson, Joan Jonas, Michael Snow, Ken Jacobs, Anthony McCall, Carolee Schneemann, Birgit & Wilhelm Hein, William Raban, Dara Birnbaum, Dan Graham, the ONCE Group, Robert Whiteman, Claes Oldenburg, Andy Warhol, and Vito Acconci, among others. Many of these works presented new linkages between the visual, corporeal, and the social perception of film and often also included the involvement of the audience into these cinematic works. A good summary of this vibrant art form is provided by Liz Kotz.[39] As exemplary from this early times of interactivity, which was often achieved through the combination of film and performance, a work by Peter Weibel can be mentioned here: in 1968 he produced the *Action Lecture No. 2*, where he projected films of himself giving the same lecture projected on his own body on stage, while at the same time the audience could influence the operation of the film projector, the tape recorder, and a second tape recorder that played music.[40]

We can thus see that the idea of exchange between the artwork, the artist and the audience has a long and multifaceted tradition. It was, however, in the 1990s that the term "interactive art" became widely used. This was when the largest and oldest media art festival in the world, Ars Electronica Festival in Linz, Austria started to include "Interactive Art" as a new category in its international competition, the Prix Ars Electronica.[41] Myron Krueger[42] is often quoted as having originally coined the term and, not surprisingly, he was the main award winner in this category in 1990. An excellent overview of these different types of artistic interfaces and interactive systems is provided in the yearly Prix Ars Electronica catalogs[43] in the category of Interactive Art since 1990, as well as the Next Idea categories (from 2004 on) and the Hybrid Art category (from 2007 on). The interfaces and interactive systems presented in these categories range from artistic and designerly projects where users can influence images, sounds, or multimodal experiences to create novel art forms, to prototypes and research demonstrations that explore new interaction strategies and commercial applications for our daily media environment.

2 The Cultural Interface—Some Case Studies

In section 1 we have seen how historically relevant the term "interaction" has become. We saw that interface and interaction design cannot be analyzed only from an engineering point of view but must be viewed from a social, artistic, and conceptual angle as well. But what does this mean for today's artists and designers in an increasingly complex media world? Have we achieved what Lev Manovich and Stephen Johnson predicted, a new language of the interface[44] and the full bloom of the Interface Culture?[45]

We cannot answer this question in this chapter; however, we want to show case studies of interactive artworks and interactive prototypes that, in our opinion, hybridize and expand the areas of participatory art to interactive architecture, interactive fashion, communication, and design.

2.1 Tangible Interaction

2.1.1 *Interactive Plant Growing* In 1992, Laurent Mignonneau and Christa Sommerer developed an interactive art installation called *Interactive Plant Growing*.[46] It was one of the first interactive computer art installations to use a natural and tangible interface,[47] instead of the then-common devices such as joysticks, mouse, trackers, or other technical interfaces. In this installation, living plants function as the interface between the human user and the artwork. Users engage in a dialogue with the plants by touching or merely approaching them. The electrical potential differences (voltage) between the plant and the user's body are captured by the plant and interpreted as electrical signals that determine how the corresponding virtual 3D plants (which look similar to the real plants) grow on the projection screen. Through modifying the distance between the user's hands and the plant, the user can stop, continue, deform, and rotate the virtual plant, as well as develop new plants and plant combinations. The growth algorithms are programmed to allow maximum flexibility by taking every voltage value from the user's interaction into account. The virtual plants resulting on screen are always new and different, creating a complex combined image that depends on the user–plant interaction and the voltage values generated by this interaction. These voltage values increase the closer the hand of the user is to the plant. We use five different distance levels to control the rotation of the virtual plants, their color values, where they grow on screen, as well as the on/off growth value. The final result of the interaction is shown on the screen as a collective image of virtual plants grown by several users. A main artistic motivation for this project was to create generative images through linking the image algorithms directly to the user's input data. This guarantees always new and individual image results for each user and creates an open-ended artwork that is not predefined.

In 1992, using plants as interfaces to create awareness about the human-to-plant relationship by creating an artistic interpretation of this-minute dialogue was very unusual. In 2004, we created another version of this human–plant interaction, for an installation called *Eau de Jardin* for the House-of-Shiseido in Tokyo, Japan. Connecting living plants to the digital world has recently become popular in ubiquitous computing research,[48] and there are even products entering the market that use living plants as controllers. From this we can learn that an originally purely artistic idea of using plants as cultural interfaces now even influences the way we interact with technologies on a daily basis (figure 11.1, plate 19).

2.1.2 *reacTable*—A Tangible Musical Interface In 2003, a team of researchers of the Music Technology Group at the Pompeu Fabra University in Barcelona, Spain, developed a tangible musical interface that is situated between an instrument for musical improvisation and an interactive art installation. The system, called *reacTable*,[49] is a

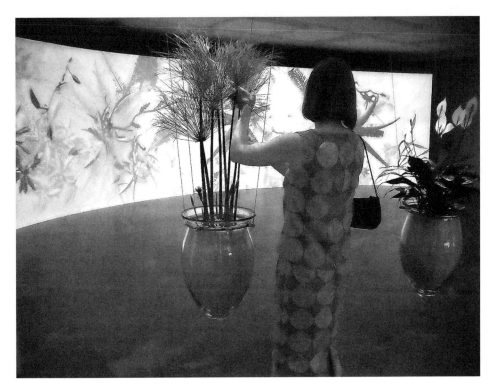

Figure 11.1
Eau de Jardin, an interactive art installation using living plants as interfaces, developed for the House-of-Shiseido, Japan, 2004. See plate 19. © Christa Sommerer and Laurent Mignonneau.

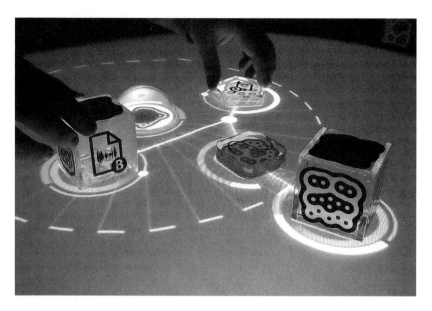

Figure 11.2
The *reacTable* is played by manipulating several tangible synthesizer modules on its round interactive table surface. See plate 20. Photo and artwork © Xavier Sivecas.

tangible modular synthesizer that combines acoustic, visual, and tactile feedback within a unified musical instrument design. The instrument consists of an interactive table where abstract yet tangible objects that contain markers can be placed and manipulated. Each of these objects has certain sound functions, such as sound generators, basic oscillators, digital synthesizers or sample players, sound effects or filters, controllers such as LFOs or step sequencers, as well as more global instruments parameters such as tonality and tempo controllers. A combination of sound effects and visual feedback provided on the table's surface entices the novice user into playing and experimenting with the system, while at the same time also providing enough complexity for compositions for expert musicians. *reacTable* is a good example of a cultural interface that not only provides a new interaction paradigm but also opens up new forms of future applications such as new musical instruments that are yet to come (figure 11.2, plate 20).

2.2 Ubiquitous Interaction

2.2.1 *Time_lapse*—Ubiquitous interaction in remote locations With the evolution of three-dimensional computing in the last decades, historic stereoscopic images can now be used for the creation of interactive virtual environments. Driven by the wish to

make historic stereo images interactively accessible, we (Christa Sommerer, Laurent Mignonneau, and Roberto Lopez-Gulliver) developed in 1999 an immersive virtual environment called *Time_lapse*.[50]

This system allows two remotely located users to interact with historic stereo images with full-body integration and immersion. The images were a selection of historic stereo images from the Tokyo Metropolitan Museum of Photography. As these images were originally captured in stereo, we could scan the image pairs and recalculate their perspective. To adapt the images for the construction of our three-dimensional virtual environment and to provide the user with an immersive interaction experience, various image preparation processes and depth extraction techniques were performed, as described in literature.[50]

In *Time_lapse* two remote users can meet in the same historic stereo images and interact there through their body gestures, but they can also have their images displayed simultaneously in several image environments. This brings up the concept of "ubiquity," an idea that has been explored by artists in telematic art since the 1970s (figure 11.3).

In 1980, Sherrie Rabinowitz and Kit Galloway were developing *Hole in Space*, a "public communication sculpture" in which citizens from New York and Los Angeles had a strange encounter with one another: They could see, hear, and speak to each other, live, through television.[51] Robert Adrian X.[52] and Roy Ascott[53] explored concepts of telematics and remote communication in the 1970s, and the cultural interfaces that they designed shaped how we interact through webcams on our office PCs today. Chatting live on the Internet is one of the most common aspects of social life nowadays, as digital communication now is everywhere and everyone can be part of it. As Virilio predicted, the distribution of images has prevailed and "images start to be everywhere, they start to be reality."[54]

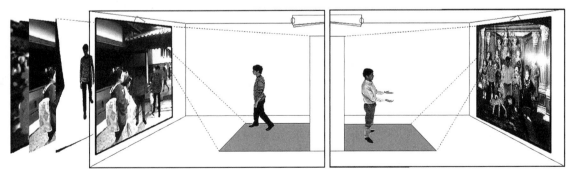

Figure 11.3
Two remotely located users interact together in several historic stereo images of *Time_lapse* through their gestures. © Christa Sommerer, Laurent Mignonneau, and Roberto Lopez Gulliver.

2.2.2 Ubiquitous interaction through wearable technologies The area of wearable technology has also seen a steady growth in the last couple of years. From the first wearables by Steve Mann, where "a wearable computer is a computer that is subsumed into the personal space of the user, controlled by the user, and has both operational and interactional constancy, i.e. is always on and always accessible,"[55] a lot has changed in terms of miniaturization and integration of the technology into garments. Books such as *Fashionable Technology*[56] by Sabine Seymour show how fashion designers and artists are now starting to work aesthetically with these technologies by combining the latest interfaces with fashion design.

For example, our Interface Cultures students, Mika Satomi and Hannah Perner Wilson, developed in 2007 a wearable interface that can be used as a game controller. The "Massage Me"[57] concept is a wearable massage interface that turns a video-game player's excess energy into a back massage for your partner or loved ones. Playing "Massage Me" requires two people, one who wears the jacket to receive the massage and one who massages the person wearing the jacket. Soft, flexible buttons are embedded in the jacket, and as the two users massage each other a fighting game can be played. An interesting artistic concept that deals with issues of control and being controlled, "Massage Me" also shows the potential of wearable interfaces to situate themselves between art, gaming, and fashion items (figure 11.4).

Figure 11.4
The "Massage Me" wearable interface by Mika Satomi and Hannah Perner Wilson. Users can massage each other through the wearable game-controlled jacket, while playing a violent fighting game. By kind permission of the artist.

2.3 Architectural Interfaces

Intelligent architecture and media facades are becoming more and more important areas where cultural interface will be seen in the future. Artists who are creating interactive systems have begun to look for new display formats for their interactive art systems. Modern architecture allows building facades to become membranes for the display of interactive digital content.

2.3.1 "Wissensgewächs"—An interactive facade In 2006 Laurent Mignonneau and Christa Sommerer were invited to develop an interactive facade for an exchange library in the center of Braunschweig, Germany. This was to form part of the "City of Science 2007" initiative that promoted Braunschweig's importance as city of research. To make this fact more widely known to the general public and to promote science and research in general, the city council decided to build a glass house in the city center, next to the cathedral. This glass house had a café and an open library where citizens could borrow books in exchange for their own books. The intention was to promote the concept of knowledge exchange. To encourage citizens to participate in this open book exchange library, we were asked to design a special interactive facade. We developed the concept of a visually growing facade that would reflect the visitors' attention and interest and entice them into the building. We called this interactive facade *Wissensgewächs*, or the growth of knowledge.[58] The intention was to arouse the passerby's attention and to get them to come physically closer. The reward was a series of increasingly complex images on the screens. Images of virtual plants would grow on the screens as visitors approached. Each time the participants moved, the images would change. Aluminum profiles and the integrated distance sensors were specially developed by Laurent Mignonneau. They were built into the framing of the glass elements of the building and housed beneath the 16 LCD screens that built a ribbon of screens around the building. Again, here the project was based on an artistic interest in creating public interfaces that test the users' involvement with art in public space. Recently there is also a trend in bringing interaction to the public space, and this trend has led to new research areas, such as media facades and public architectural interfaces, which surely will become more common in the future (figure 11.5).

2.3.2 *AtemRaum*—An interactive breathing wall In 2006, our Interface Cultures students Thomas Wagner, Andreas Zingerle, and Christina Heidegger developed a prototype system called *AtemRaum*,[59] an interactive wall that reacts to users' breathing rhythm and strength. When the user puts on a specially designed belt that hosts sensors, the strength and rhythm of the user's breath is measured and sent via wireless communication to an interactive wall that extends and retracts in synchronization with the user's breath. This creates an interesting sensation of an "intelligent wall" that can sense and react to the user, by displaying minute changes in his or her

Figure 11.5
The glass house exchange library with integrated interactive facade *Wissensgewächs*, 2007, City Center Braunschweig, adjacent the cathedral. © Christa Sommerer and Laurent Mignonneau.

breathing rhythm. While this is still a prototype interface, and intended as art project, it nevertheless opens up new forms of interactive architectural elements that give emotional feedback to their users (figure 11.6).

3 Summary

From the various descriptions of interactive projects we can see that there is a strong diversification of interactive art and interface design developing. While the examples shown above mostly come from the field of interactive art, they give us a glimpse on possible future areas where interaction will become more important. In his 1997 book *Interface Culture: How New Technology Transforms the Way We Create and Communicate*,[44] Stephen Johnson predicted that new types of interfaces would alter the style of our conversations, prose, and thoughts. He also predicted that interface designs would become strongly linked to artistic innovation as they reached out into applications in our daily lives. When we return to Lev Manovich's prediction,[45] that we will see a language of cultural interfaces developing just as the language of cinema developed 100 years ago, we are tempted to say that this is happing right now and our teaching and research activities at the Interface Cultures department at the University of Art and Design in Linz are part of this development.[60]

In 2008 an exhibition called "You_niverse" took place at the Biennale of Contemporary Art in Sevilla, Spain; it showed that interactive art has by now helped to prepare

Figure 11.6
AtemRaum, an interactive wall that reacts to the users' breathing rhythm and strength. © Thomas Wagner, Andreas Zingerle, and Christina Heidegger.

a participatory universe, where everyone can participate in creation. Peter Weibel, one of the curators of this exhibition, states that a certain democratization and personalization of technology has helped to empower users. In his catalog essay he writes: "Art, too, is included in this democratization. Painters no longer have a monopoly on creating images ever since photography made it possible for everyone to take pictures. Artists have lost their monopoly on creativity. In the global expansion of the Internet there is almost unlimited storage space in which the user can try out his or her creativity. Artists, in the age of Youtube.com, Flickr.com, MySpace.com, and Second Life, lose their monopoly on creativity. Using contemporary media everyone can be artistically creative."[61] Of course, we will need the work of media art historians and media critics[62,63,64] to look at these developments through the filter of time and judge whether and how these cultural interfaces will leave an impact on art and society at large, and how they can be related to the early participatory art forms of the 1960s and 1970s.

Notes

1. Peter Weibel, "Foreword," in *The Art and Science of Interface and Interaction Design*, Studies in Computational Intelligence, vol. 141, ed. Christa Sommerer, Lakhmi K. Jain, and Laurent Mignonneau (Heidelberg: Springer Verlag, 2008), v–x.

2. Katja Kwastek, "Interactivity—A Word in Process," in *The Art and Science of Interface and Interaction Design*, 15–26.

3. Heinz Abels, *Einführung in die Soziologie*, vol. 2: *Die Individuen in ihrer Gesellschaft*, 2nd ed. (Wiesbaden: VS Verlag für Sozialwissenschaften/GWV Fachverlage GmbH, 2004), 204–206.

4. George Herbert Mead, "Social Psychology as Counterpart to Physiological Psychology," in *Psychological Bulletin* 6, no. 12 (1909): 401–408; Edward Alsworth Ross, *Social Psychology: An Outline and Source Book* (New York: Macmillan, 1919), I.

5. Herbert Blumer, "Social Psychology," in *Man and Society: A Substantive Introduction to the Social Sciences*, ed. Emerson Peter Schmidt (New York: Prentice Hall, 1937), 144–198.

6. Joseph Carl Robnett Licklider, "Man-Computer Symbiosis," *IRE Transactions on Human Factors in Electronics* HFE-1 (1960) 4–11.

7. Douglas Engelbart, "Augmenting Human Intellect: Experiments, Concepts and Possibilities," in *Summary Report to the Airforce Office of Scientific Research* (Menlo Park, 1965).

8. Seymour Papert, *Mindstorms: Children, Computers, and Powerful Ideas*, (New York: Basic Books, 1980).

9. Alan Curtis Kay, "A Dynamic Medium for Creative Thought," in *Proceedings of the 1972 Minnesota NCTE Seminars in Research in English Education* (Minneapolis, 1972); Alan Curtis Kay, "User Interface: A Personal View," in *The Art of Human–Computer Interface Design*, ed. Brenda Laurel (Reading, MA: Addison-Wesley, 1990).

10. Marc Weiser, "The Computer for the 21st Century," *Scientific American* 265, no. 3 (1991): 94–104; Norbert Bolz, Friedrich Kittler, and Georg Christoph Tholen (eds.), *Computer als Medium* (Paderborn, München: Fink, 1994); Richard Coyne, *Designing Information Technology* (Cambridge, MA: MIT Press, 1995); Marc Weiser and John Seely Brown, "The Coming Age of Calm Technology" in *Beyond Calculation: The Next Fifty Years* (New York: Copernicus, 1996), 75–85; Nicolas Negroponte, *Being Digital* (New York: Alfred A. Knopf, 1995); Stephen Johnson, *Interface Culture: How New Technology Transforms the Way We Create and Communicate* (New York: Perseus Books, 1999); Jef Raskin, *The Human Interface: New Directions for Designing Interactive Systems* (Reading, MA: Addison-Wesley, 2000); John M. Carroll, *Human–Computer Interaction in the New Millennium*, (Reading, MA: Addison-Wesley, 2002); John M. Carroll, *HCI Models, Theories, and Frameworks* (New York: Morgan Kaufmann, 2003); William Lidwell, Kritina Holden, and Jill Butler, *Universal Principles of Design: 100 Ways to Enhance Usability, Influence Perception, Increase Appeal, Make Better Design Decisions, and Teach through Design* (Gloucester: Rockport Publishers, 2003); Chris Stary and Constantine Stephanidis (eds.), *User-Centered Interaction Paradigms for the Universal Access in the Information Society—8th ERCIM International Workshop on User Interfaces for All*, Vienna, Austria, June 2004 (Berlin: Springer Verlag, 2004); Ben Shneiderman and Catherine Plaisant, *Designing the User Interface: Strategies for Effective Human–Computer Interaction*, 4th ed. (Reading, MA: Addison-Wesley, 2004); Neville A. Stanton, Paul M. Salmon, Guy H. Walker, Chris Baber, and Daniel P. Jenkins, *Human Factors Methods: A Practical Guide for Engineering and Design* (Aldershot: Ashgate, 2005).

11. Norbert Wiener, *Cybernetics or Control and Communication in the Animal and the Machine* (Paris: Hermann & Cie Editeurs; Cambridge, MA: Technology Press; New York: John Wiley, 1948).

12. Konrad Zuse, 1936, *Rechenmaschine*, Patent: Z23624 (Z1), filed on December 21, 1936, available at: <http://www.zib.de/zuse>; Konrad Zuse, *The Computer—My Life* (Berlin: Springer Verlag, 1993) (translated from the original German edition, *Der Computer—Mein Lebenswerk*, Berlin: Springer Verlag, 1984).

13. Alan M. Turing, "On Computable Numbers, with an Application to the Entscheidungs problem," in *Proceedings of the London Mathematical Society, Second Series* 42 (1936): 230–265.

14. Ben Shneiderman, *Designing the User Interface: Strategies for Effective Human–Computer Interaction*, 3rd ed. (Menlo Park, CA: Addison-Wesley, 1998).

15. Jenny Preece, Yvonne Rogers, and Helen Sharp, *Interaction Design: Beyond Human–Computer Interaction* (New York: John Wiley, 2002).

16. Caroline Schubinger, "Interaction Design: Definition and Tasks," in *Total Interaction: Theory and Practice of a New Paradigm for the Design Disciplines*, ed. G.M. Buurman (Basel: Birkhäuser, 2005), 341–351.

17. Gerhard M. Buurman, "Introduction," in *Total Interaction*, 9–19.

18. Hans Richter, *Dada: Art and Anti-Art* (London: Thames & Hudson, 1997).

19. Gino di Maggio (ed.), *Ubi Fluxus Ibi Motus 1990–1962* (Milano: Nuove Edizione Gabriele Mazzotta La Biennale di Venezia, 1990).

20. Daniel Marzona and Uta Grosenick, *Conceptual Art* (Cologne: Taschen Verlag, 2005).

21. Filippo Tommaso Marinetti, *Teatro*, 2 vols., ed. Jeffrey T. Schnapp (Milan: Oscar Mondadori, 2004).

22. Umberto Eco, *Das offene Kunstwerk* (Frankfurt: Suhrkamp Verlag 1977).

23. Peter Bürger, *Theorie der Avantgarde* (Frankfurt: Suhrkamp Verlag, 1974).

24. *The Art of Participation 1950 to Now* (San Francisco: Museum of Modern Art, 2008).

25. John Cage, *Silence—Lectures and Writings* (Middletown, CT: Wesleyan University Press, 1961).

26. Georg Brecht, in *The Art of Participation 1950 to Now*, 86.

27. Yoko Ono, in *The Art of Participation 1950 to Now*, 86.

28. Agnes Husslein-Arco, Angelika Nollert and Stella Rollig (eds.), *VALIE EXPORT—Zeit und Gegenzeit, Time and Countertime* (Cologne: Verlag der Buchhandlung Walther König, 2010), 120.

29. Joseph Beuys, in *The Art of Participation 1950 to Now*, 95.

30. Museum Tinguely, *Robert Rauschenberg Jean Tinguely—Collaborations*, (Bielefeld: Kerber Verlag, 2009).

31. Nam June Paik, in *The Art of Participation 1950 to Now*, 98–100.

32. Jasia Reichardt (ed.), *Cybernetic Serendipity* (New York: Praeger, 1968)

33. Charlie Gere, "Art as Feedback," in *Feedback: Art Responsive to Instructions, Input, or Its Environment*, ed. Ana Botelle Diez del Corral (Gijon: LABoral Centro de Arte y Creacion Industrial, 2007), 62–78.

34. Billy Klüver, and Julie Martin, *E.A.T.—The Story of Experiments in Art and Technology 1960–2001* (Tokyo: NTT InterCommunication Center, 2003).

35. David Dunn, Peter Weibel, and Woody and Steina Vasulka, *Eigenwelt der Apparate—Pioneers of Electronic Art, Ars Electronica 1992* (Linz: Oberösterreichisches Landesmuseum, 1992).

36. San Francisco Museum of Modern Art, *Steina and Woody Vasulka, Machine Media* (1996).

37. Peter Weibel, "The Apparatus World—World unto Itself," in *Eigenwelt der Apparate—Pioneers of Electronic Art, Ars Electronica 1992*, 11–19.

38. Matthias Michalka (ed.), *X-Screen Film Installations and Actions in the 1960s and 1970s*, Museum Moderner Kunst Stiftung Ludwig Wien (Cologne: Verlag der Buchhandlung Walther König, 2004).

39. Liz Kotz, "Disciplining Expanded Cinema," in *X-Screen Film Installations and Actions in the 1960s and 1970s*, 44–57.

40. Peter Weibel, "Action Lecture: Intermedium," in *Protokolle* 2 (1982): 88.

41. Hannes Leopoldseder (ed.), *Der Prix Ars Electronica 90—International Compendium of the Computer Arts* (Linz: Veritas Verlag, 1990), 152–224.

42. Myron Krueger, *Artificial Reality* (Reading, MA: Addison-Wesley, 1983).

43. Hannes Leopoldseder (ed.), *Der Prix Ars Electronica 91—International Compendium of the Computer Arts* (Linz: Veritas Verlag, 1991), 118–156; Hannes Leopoldseder (ed.), *Der Prix Ars Electronica 92—International Compendium of the Computer Arts* (Linz: Veritas Verlag, 1992); Hannes Leopoldseder (ed.), *Der Prix Ars Electronica 93—International Compendium of the Computer Arts* (Linz: Veritas Verlag, 1993), 90–136; Hannes Leopoldseder (ed.), *Prix Ars Electronica 94—International Compendium of the Computer Arts* (Linz: Veritas Verlag, 1994), 100–134; Hannes Leopoldseder and Christine Schöpf (eds.), *Prix Ars Electronica 95—International Compendium of the Computer Arts* (Linz: Österreichischer Rundfunk ORF Landesstudio Oberösterreich, 1995), 94–134; Hannes Leopoldseder and Christine Schöpf (eds.), *Prix Ars Electronica 96—International Compendium for the Computer Arts* (Vienna: Springer Verlag, 1996), 118–156; Hannes Leopoldseder and Christine Schöpf (eds.), *Cyber Arts 97—International Compendium Prix Ars Electronica* (Vienna/New York: Springer Verlag, 1997), 106–150; Hannes Leopoldseder and Christine Schöpf (eds.), *Cyber Arts 98—International Compendium Prix Ars Electronica* (Vienna: Springer Verlag, 1998), 66–106; Hannes Leopoldseder and Christine Schöpf (eds.), *Cyber Arts 99—International Compendium Prix Ars Electronica* (Vienna: Springer Verlag, 1999), 58–92; Hannes Leopoldseder and Christine Schöpf (eds.), *Cyber Arts 2000—International Compendium Prix Ars Electronica* (Vienna: Springer Verlag, 2000), 66–92; Hannes Leopoldseder and Christine Schöpf (eds.), *Cyber Arts 2001—International Compendium Prix Ars Electronica 2001* (Vienna: Springer Verlag, 2001), 80–118; Hannes Leopoldseder and Christine Schöpf (eds.), *Cyber Arts 2002—International Compendium—Prix Ars Electronica* (Ostfildern-Ruit:

Hantje Cantz Verlag, 2002), 70–122; Hannes Leopoldseder, Christine Schöpf, and Gerfried Stocker (eds.), *Cyber Arts 2003—International Compendium—Prix Ars Electronica 2003* (Ostfildern-Ruit: Hantje Cantz Verlag, 2003), 82–122; Hannes Leopoldseder, Christine Schöpf, and Gerfried Stocker (eds.), *Ars Electronica—1979–2004* (Ostfildern-Ruit: Hantje Cantz Verlag, 2004); Hannes Leopoldseder, Christine Schöpf, and Gerfried Stocker (eds.), *Cyber Arts 2004—International Compendium—Prix Ars Electronica 2004* (Ostfildern-Ruit: Hantje Cantz Verlag, 2004), 102–148; Hannes Leopoldseder, Christine Schöpf, and Gerfried Stocker (eds.), *Cyber Arts 2005—International Compendium—Prix Ars Electronica 2005* (Ostfildern-Ruit: Hantje Cantz Verlag, 2005), 92–138; Hannes Leopoldseder, Christine Schöpf, and Gerfried Stocker (eds.), *Cyber Arts 2006—International Compendium—Prix Ars Electronica 2006* (Ostfildern-Ruit: Hantje Cantz Verlag, 2006), 102–142; Hannes Leopoldseder, Christine Schöpf, and Gerfried Stocker (eds.), *Cyber Arts 2007—International Compendium—Prix Ars Electronica 2007* (Ostfildern-Ruit: Hantje Cantz Verlag, 2007), 152–188; Hannes Leopoldseder, Christine Schöpf, and Gerfried Stocker (eds.), *Cyber Arts 2008—International Compendium—Prix Ars Electronica 2008* (Ostfildern-Ruit: Hantje Cantz Verlag, 2008), 144–191; Hannes Leopoldseder, Christine Schöpf, and Gerfried Stocker (eds.), *Cyber Arts 2009—International Compendium—Prix Ars Electronica 2009* (Ostfildern-Ruit: Hantje Cantz Verlag, 2009), 144–181; Hannes Leopoldseder, Christine Schöpf, and Gerfried Stocker (eds.), *Cyber Arts 2010—International Compendium—Prix Ars Electronica 2010* (Ostfildern-Ruit: Hantje Cantz Verlag, 2010), 158–207.

44. Lev Manovich, *The Language of New Media* (Cambridge, MA: MIT Press, 2001), 93.

45. Stephen Johnson, *Interface Culture: How New Technology Transforms the Way We Create and Communicate* (New York: HarperOne, 1997).

46. Christa Sommerer and Laurent Mignonneau, "Interactive Plant Growing," in *Ars Electronica 93—Genetic Art, Artificial Life*, ed. Karl Gerbel and Peter Weibel (Vienna: PVS Verleger, 1993), 408–414.

47. Hiroshi Ishii and Brygg Ullmer, "Tangible Bits: Towards Seamless Interfaces between People, Bits, and Atoms," in *Proceedings of the SIGCHI Conference on Human Factors in Computing Systems* (Atlanta, GA, 1997).

48. Satoshi Kuribayashi, Yusuka Sakamoto, and Hiroya Tanaka, "I/O plant: A Tool Kit for Designing Augmented Human–Plant Interactions," in *CHI'07: Conference on Human Factors in Computing Systems* (San Jose, CA, 2007), 2537–2542.

49. Martin Kaltenbrunner, Günter Geiger, and Sergi Jordà, "Dynamic Patches for Live Musical Performance," in *Proceedings of the 2004 Conference on New Interfaces for Musical Expression* (Hamamatsu, Shizuoka, Japan, 2004).

50. Christa Sommerer, Laurent Mignonneau, and Roberto Lopez-Gulliver, "*Time_lapse*: Immersive Interaction with historic 3D Stereo Images," in *5th International Conference on Virtual Systems and MultiMedia (VSMM'99) Conference Proceedings* (Dundee, Scotland, 1999), 295–307.

51. Sherry Rabinowitz and Kit Galloway's work is described in, e.g., Christiane Paul, *Digital Art* (New York: Thames & Hudson, 2003), 21–22.

52. Robert Adrian X., "Art and Telecommunications, 1979–1986: The Pioneer Years [1995]," in *Art and Electronic Media*, ed. Edward A. Shanken (New York: Phaidon Press, 2009), 239–240.

53. Roy Ascott, "Art and Telematics: Towards a Network Consciousness [1984]," in *Art and Electronic Media*, 232; Roy Ascott, *Telematic Embrace: Visionary Theories of Art, Technology, and Consciousness*, ed. Edward A. Shanken (Berkeley: University of California Press).

54. Paul Virilio, "The Work of Art in the Electronic Age," Special Issue of *Block*, no. 14 (Middlesex Polytechnic, Hertfordshire, 1988), 7.

55. Steve Mann, "Definition of Wearable Computer," Toronto, University of Toronto: 1998, <http://wearcomp.org/wearcompdef.html>.

56. Sabine Seymour, *Fashionable Technology—The Intersection of Design, Fashion, Science, and Technology* (Vienna: Springer Verlag, 2008).

57. Hannah Perner-Wilson and Mika Satomi, "Massage Me," in "Physical Computing and Hybrid Interfaces at Interface Cultures 2007," in *Goodbye Privacy—Ars Electronica 2007*, ed. G. Stocker and C. Schöpf (Ostfildern: Hatje Cantz Verlag), 386.

58. Laurent Mignonneau and Christa Sommerer, "Media Facades as Architectural Interfaces," in *The Art and Science of Interface and Interaction Design*, 93–104.

59. Thomas Wagner, Andreas Zingerle, and Christina Heidegger, *AtemRaum,* in *Simplicity—the Art of Complexity, Ars Electronica 2006*, ed. G. Stocker and C. Schöpf (Ostfildern: Hatje Cantz Verlag), 241.

60. Christa Sommerer, Laurent Mignonneau, and Dorothée King (eds.), *Interface Cultures—Artistic Aspects of Interaction* (Bielefeld: Transcript Verlag, 2008).

61. Peter Weibel, Foreword, *Youniverse—Bienal de Arte Contemporaneo de Sevilla* (Sevilla, Spain: Fundacion BIACS, 2008), 16–26.

62. Oliver Grau, *MediaArtHistories* (Cambridge, MA: MIT Press, 2007).

63. Siegfried Zielinski, *Deep Time of the Media* (Cambridge, MA: MIT Press, 2006).

64. Erkki Huhtamo, "Sieben Mißverständnisse über Interaktive Kunst," in *InterAct! Schlüsselwerke interaktiver Kunst*, ed. C. Brüninghaus-Knubel und S. Dinkla (Ostfildern: Hatje Cantz Verlag, 1997).

12 Feeling the Image: Some Critical Notes on Affect

Marie-Luise Angerer

Translated from the German by Nicholas Grindell

Many recent theoretical approaches in art and media studies underpin a development that distances itself from critiques of representation and orients itself toward an affective reading or interpretation of affects and emotions in reception. If we see it not as a passing fashion but as a complex shift, how is this rejection of critiques of representation to be understood? In my book *Vom Begehren nach dem Affekt*,[1] I refer to this shift as a *symptom* in order to arrive at the generally formulated theory that this process may reflect the beginning of a fundamental shift in modes of "theorizing the human."

In this context, a symptom has a dual character: It is something that conceals its deeper meaning while being enjoyed by the subject in the form in which its appears. The task of this symptom is to forbid something while, in an unconscious twist, offering it to the subject to enjoy. Consequently, in the current focus on the affective, this renaissance of feelings and emotions we are now witnessing, we can identify a great fear (on the part of the subject), a fear of losing the idealized composure (of its ego) to become nothing more than a reactive organism—on the same level as animals and self-modifying computers. The new enthusiasm for the affective, then, conceals an actual fear of affect, the fear of having (and being) nothing more than the need to dissolve oneself (one's ego).

1 The Body as Recipient

The recipient unquestionably submits to change via the media, but for the subject as the ultimate basis of insight and knowledge, this means not closure but opening up via the media. Consequently, the *locus* of video installations is to be sought not in the space they occupy or in the projections, but in the visitor him-/herself. It is the visitor who feels affected, while his/her consciousness (in the sense of experience) is crucial to his/her sense of being the subject of his/her reactions and behavior. As such, the installations are also the locus of an ego that feels strengthened in its subjectivity.[2]

Reaching this position in her art-theoretical dissertation *Emotionality and Aesthetic Reception*, Anne Hamker joins a line of argument that names sometimes the body,

other times the ego, and other times still the visitor's responsibility as crucial in the reception of video works and—and this is especially important here—as the sole relevant factor. In her study, Hamker examines the recipient's emotional behavior in its constructive, interactive, and intra-active function. She understands emotions as reception guides for reactions and regulations, as the basis for higher cognitive processes, and thus as indispensable to aesthetic experience. For Hamker, Bill Viola's work *Buried Secrets* is a perfect example of this. The overwhelming and immediate experience, brought about by image scale, color, motion, and sound, makes it impossible for the recipient to adopt any kind of intellectual distance. According to Hamker, the recipient seeks balance and meaning, but the video installation refuses to comply. Instead, the work calls for self-experience as active, constructive emotionality.[3]

Art historian Ursula Frohne, on the other hand, speaks in the context of video art as the *responsibility of the viewer*, which she considers necessary for synthetic production of meaning because the dissolution of the images—no longer framed individual pictures as in traditional film production or panel painting—raises the issue of the "framing of the viewer" and prompts the description of a new, different way of looking:

The observer's position, which, to this point, had had a defined frame of reference in a museum, loses its certainty regarding the object of reception, because the observer's ability to synthesize information when viewing images is challenged by the time factor. This paradigmatic change is primarily characterized by the fundamental instability of the viewer—which is, by the way, increased by the freedom of the viewer to move around in front of and inside the video installation. In a museum setting, the concentration is upon the viewer's optical reception of the work. Under such changed circumstances as these, however, concentration is shifted with a focus upon the responsibility of the observer.[4]

What this responsibility consists in, what it leads to, and how this "new" viewer develops the capacity for such responsibility are all questions that Frohne leaves unanswered.

Mark B. N. Hansen is now trying to provide answers by transferring this position of ethical responsibility into a situation of existential experience. In his book *New Philosophy for New Media*, Hansen focuses on the body of the viewer, which compensates for the new frameless quality of the images by producing a *framing* of its own. The new pictures are framed "in and through our own bodies."[5] Using the life philosophy of Henri Bergson, Hansen analyzes material including the online projects *Osmose*[6] and *Ephémère*[7] by Char Davies. In these works, visitors are taken in and enveloped; they find themselves within an overwhelming natural spectacle in which their bodies become a perceptible portal. For Hansen, Davies' installations represent a radical shift from a visually dominated interface to a "bodily or affective interface."[8]

2 Affect as the Focus of Attention

The current increase in interest in affect is particularly striking in the field of media and cultural studies. There are many examples of writers who a few years ago were interested in gender, ethnicity, imagination, and the symbolic order, or the issue of the ideological, and whose work now focuses on themes such as shame, emotions, or postideological, affective politics.[9]

I want to discuss two currents within this conspicuous shift: first, the rediscovery of affect in film and media theory, and second, the implementation of the body as the bearer of affect in the context of digital media, art, and the corresponding body of theoretical work.

2.1 The "Misunderstanding of the Feminists"

Crucial to Anglo-American cultural studies was Eve Kosofsky Sedgwick's introduction of Silvan Tomkins' affect theory into cultural and media studies. The publication of *Shame and Its Sisters: A Silvan Tomkins Reader*, which she edited with Frank Adam,[10] marked the beginning of a new era: The brand of film and media theory that for decades had been shaped by (mainly Lacanian) psychoanalysis could now be dismissed as a thing of the past.

Tomkins bases his position on a system of affect pairs: Positive affects are interest and curiosity, joy and excitement, neutral affects are surprise and dismay, negative affects are stress and fear, terror and shock, anger and fury, disgust, and above all, shame.[11] This last is understood by Tomkins as the central affect.

What Tomkins lists as affects are referred to in other contexts as emotions or feelings. It is important to emphasize this distinction, as these terms are treated with great negligence in the literature, where cognitive psychologies of emotion and neurobiology propose very different classifications and models for affect, emotion, and feeling.

Tomkins developed his work in the 1950s and '60s at Yale and later at Princeton. He broke off his own psychoanalytical treatment and was familiar with the ideas of Jacques Lacan. Subsequently, Tomkins developed his affect theory as explicitly distinct from psychoanalysis because he considered (a) that its system of drives was too small to act as an all-encompassing model and (b) that it had ignored shame as the key affect. In his system, the affects constitute the primary system of motivation for the human being, with the Freudian system of drives as a subsystem. The central affect among the basic affects is shame, which structures the entire psychophysical organism and develops itself as the basic component via the suppression of interest and curiosity. Tomkins defines his affects by analogy with the then-increasingly popular systems theory. His affects stand in a dichotomous relationship to one another—depending on its intensity, neural stimulation causes the affective situation to swing into plus or

minus. Shame is strongly linked to visibility, especially in the face (and its expressive powers). As Tomkins writes: "Man is, of all animals, the most voyeuristic. He is more dependent on his visual sense than most animals, and his visual sense contributes more information than any of his senses."[12] At the same time, however, he notes a taboo across society on looking each other in the eyes: "The universal taboo on mutual looking is based not only on shame but on the entire spectrum of affects."[13] Important similarities here are initially apparent with Sigmund Freud's explanations of voyeurism and exhibition, as Freud also takes the deep cultural dimension of these drives for granted. According to Freud, too, the child's pleasure in looking and showing changes over the course of its development under the hindering influence of the feeling of shame.[14]

But Tomkins faults Freud for having understood the drive of self-preservation in purely biological terms, whereas he himself links feeding with the affects "joy/ excitement." It is not necessary to point out here that both Freud and Lacan repeatedly and unambiguously made clear that the oral drive, like the other drives, can only partly be understood as a biological need, and that demand and desire have a part to play from the outset.

Tomkins' affect theory combined with the psychoanalytical affect theory of André Green form the matrix for *Moral Spectatorship* by San Diego-based media theorist Lisa Cartwright.[15] This book contains a serious critique of feminist film theory, which the author accuses of political calculation in its focus on psychoanalysis and representation. Today, she demands, this historical error must be acknowledged, and theories that were ignored at the time, such as Melanie Klein's object relation theory or André Green's affect theory, must be accorded fresh attention. What happened in the 1970s and '80s? What did feminist theorists in particular "misunderstand"? And what is the reason for this radical change of direction now seen in exemplary form in a study like Cartwright's?

In the 1970s, feminist discourse in Europe was strongly oriented toward France; Luce Irigaray, Hélène Cixous and Monique Wittig were important representatives of a "feminine language and aesthetics." In Britain at the same time, Laura Mulvey and Mary Kelly were working on the question of the representation of the feminine. Women artists and theorists spoke of women in opposition to men. In the foreword to the catalog for the Valie EXPORT exhibition "MAGNA—Feminismus: Kunst und Kreativität," Lucy Lippard wrote: "Of course art has no gender, but artists do."[16] And Valie EXPORT put forward the following theory: "THE HISTORY OF WOMAN IS THE HISTORY OF MAN, since man has defined the image of woman for man and woman."[17] In 1975, Laura Mulvey published her essay on the gaze and the image with their linking of male and female position, "Visual Pleasure and Narrative Cinema."[18] At the same time, Luce Irigaray published *Speculum of the Other Woman*.[19] Whereas Mulvey

uses Freud and Lacan in her analysis of a cinema-specific coding of male and female via the gaze and being-in-the-picture, Irigaray directs her critique against the patriarchal order as a whole. For her, psychoanalysis is part of this order. Irigaray reads Freud against the grain and holds up to women the mirror of their history, a history of deletions and the eradication of traces, a history that must first be excavated before it can be passed on to future generations.

From this symbolic nonexistence of woman, women artists then logically deduced that there can be no images of woman/women. Whenever pictures of women circulate, they are pictures by men for men. If women as artists want a different representation of the feminine, then instead of producing pictures, the first step they must take is to develop a visual language of their own. Efforts during these years were focused on this. With a mix of psycho-Marxism and feminist critique, the terrain of a "feminine aesthetic" was sounded out: one's own body, one's own voice, one's own camerawork, one's own visual idiom.[20]

The above chronology is intended to enable a better understanding of the struggle toward a politics of representation and the sometimes violent rejection of essentializations of the body by which women theorists and artists during this period were motivated. In this view, the female body, especially the body of the mother, is the place where the battle over language versus affect is fought. But Irigaray's theoretical position, her exclusive focus on the female body, came under increasing criticism. From the mid-1980s, this distance was further increased by Irigaray's proclamation of a "goddess" (of transcendence). At the same time, projects like Judy Chicago's *Dinner Party*[21] caused a stir and helped to allow art by women to be stigmatized as body art. Since women had always been defined in terms of their bodies, and the female body had always been defined as more natural than its male counterpart, it is only too understandable that this construct (woman-body-nature) needed to be dismantled in analytical terms. A particularly suitable tool for this was offered by psychoanalysis, especially its Lacanian version, which formulates a radical nonexistence of Woman, defining her neither in terms of physicality nor in terms of a male or female mentality. Instead, the female and male positions are grasped as distinct, specific failures with regard to the symbolic order.[22]

Cartwright refers among others to Jacqueline Rose's *Sexuality in the Field of Vision*,[23] in which the author undertakes a complex reading of Lacan's interpretation of the theme of femininity and representation. In this book, Rose mentions the name André Green, always quoting him in connection with Lacan but finally preferring the latter's interpretation. In this way, Cartwright is able to demonstrate that Green was not unknown to the women film theorists, but that for them—because of his closeness to Luce Irigarary—he must have appeared too body- and affect-centered. Armed with Green and his affective psychoanalysis, and with Melanie Klein and

Donald Winnicott, Cartwright proposes a presymbolic, tactile, auditory, gestural, and mimetic interpretation of viewer and image, advocating the rejection of approaches based on critiques of psychoanalysis and representation.

For Cartwright, this creates the basis for understanding television as a moral agency. Against this background, she can show how the mother–child relationship of TV is organized, how pity is used as a link between TV broadcasters and viewers, and how shame and politics overstep their respective fields of competency and strengthen each other.

For all its merits, the pressing question remains as to what added value we gain from this reading. What do we understand or see differently if we join André Green and Silvan Tomkins in placing shame and affect at centerstage? The fact that television is very good at playing on the keyboard of our emotional ties? That television has always depended on an affective bond, and that in postideological times television has taken the place of political authority? But we could surely have worked this out for ourselves without the help of Green and Tomkins.

2.2 Feeling Images

According to current theories accompanying the shift in media and art theory, digital media are contributing to these changes in a range of ways. Digital media, the theories claim, are freshly questioning the status of the image, have fundamentally altered its production, reception, and propagation, as well as the relationship between viewer and image, thus calling for a different theory, a new philosophy of the media.

From the outset, a promise has been attached to digital images, crediting them with a special immediacy, tactility, and thus also affectivity. In other words, digital images are seen as the cause of sociopolitical changes that range from digital surveillance and online criminality through to new forms of image/sound usage and distribution.

But one can also look beyond the edge of the picture and ask oneself whether the great interest in emotions and affect is genuinely due to digitality, or whether it is not more a case of other (additional) powers pursuing an affective dimension by declaring it a new vital characteristic of human life. In place of psychoanalysis as an expensive and time-consuming cure, we now have fitness and wellness, which are addressed not to speech but to the body. Art and media environments contribute to the widely wished-for sense of well-being, and in the field of theory, the call for a refocusing on the senses has been audible for years now. Neurology with its "I feel therefore I am" (Antonio Damasio) did not have to do much persuading—dyed brain lobes are now readily accepted as guarantors of emotional self-situation.

This becomes especially clear in the second wave of the affective turn, in computer and Internet art. Especially the works of Henri Bergson, but also Gilles Deleuze's cinema books, are taken as the frame of reference here, focusing on the new frameless-ness of the digital image.

In *The Language of New Media*,[24] Lev Manovich names framing as one of the major changes wrought by digital image production. In his new philosophy, Mark Hansen refers to this work, but his expectations are disappointed. For, he writes, Manovich finally represents another humanist position, as images are only relevant to him in their relation to a viewer (*consumer*), added to which they are always film images that are perceived and interpreted. According to Hansen, Manovich thus fails to recognize the specific quality of digital images because he clings to the primacy of the cinematographic. Hansen points to the precinematographic phase, which offered technical options where perception and tactility were/are linked: the stereoscope, the panorama—here, the viewer's experience was always hands-on, requiring him or her to move, to position him- or herself to be able to see the images, requiring bodily involvement to maneuver into the necessary position for reception. He compares this with today's virtual realities, with computer games and simulation environments that call for a new philosophy, a philosophy that enthrones the body in its affective dimension as an active agent. In Hansen's view, Bergson's philosophy is suited to this task, since it understands the various picture registers always and only in connection with the affective body. For Bergson, perception without affect is not possible because we must consider "the fact that our body is not a mathematical point in space, that its virtual actions are complicated by and impregnated with real actions or, in other words, that there is no perception without affection. Affection is, then, that part or aspect of the inside of our body which we mix with the image of external bodies; it is what we must first of all subtract from perception to get the image in its purity."[25]

"*My body* is that which stands out as the centre of these perceptions," Bergson continues in *Matter and Memory*, "my *personality* is the being to which these actions must be referred."[26] It is this body that, according to Bergson, processes perception like a filter and subtracts the relevant aspects in any given case from the totality of perceptive possibilities. "My body, then, acts like an image which reflects others, and which, in so doing, analyses them along lines corresponding to the different actions which it can exercise upon them. . . . Conscious perception signifies choice, and consciousness mainly consists in this practical discernment."[27]

Hansen transposes this definition to the new situation brought about by digital media, allowing him to underline that the central role of the viewer's body in the perception of digital images is not only new, but also exclusive. "In a very material sense the body is the 'coprocessor' of digital information."[28]

The ways this affective body is conceived of, however, differ considerably. The neurologist Antonio Damasio understands affect as an agent of survival that ensures that the human being eats, drinks, and sleeps. For Bergson, affect is the potential for memory that supports the body in its unconsciously remembered activities. And for Deleuze, affect is a relay—between the Other and one's own body, between two moments in time, between the "no longer" and the "not yet."

3 Coming to Grips with Affect

Is affect in the body, in the image, or in between? Is it always there; is it produced, by the body, or by the image? Does it determine the subject's actions, or does the subject determine how it is managed? Apart from psychoanalysis, which postulates a specific relationship between subject, language, and affect, a special place within film and media theory has long been occupied by Gilles Deleuze's two cinema books, *The Movement-Image* and *The Time-Image*. In these books, Deleuze develops his definition of the affective in the media dimension of the cinema.

In his view, the affective becomes an intermediary zone, a relay, a kind of skin contact. For Bergson, rather than being separate from the visual, the auditory is included in his concept of the image. Inscribed in this concept are movement and interval. Following Bergson, Deleuze links affect to this interval but without filling the interval. Instead, he indicates a movement that is not yet action.

Affection is what occupies the interval, what occupies it without filling it in or filling it up. It suddenly appears in the centre of indetermination, that is to say in a subject. . . . There is therefore a relation between affection and movement in general. . . . But it is precisely in affection that the movement ceases.[29]

For Deleuze, affect is still firmly inscribed in the relationship between viewer and image, it is the parenthesis, the affective parenthesis, through which a space—"any-space-whatever"[30]—opens up, an emptied, detached space, neither geometric nor geographic nor social in any strict sense. This "any-space-whatever" is marked by optic or acoustic situations. These "*opsigns* and *sonsigns*," as Deleuze calls them, point to a "crisis of the action-image."[31] Mark Hansen takes this concept of the "any-space-whatever" and introduces it into digital art praxis. There—now outside any cinematographic framing—it combines with autonomous affect. This difference is important insofar as the autonomy of affect in Deleuze is one that goes beyond the subject before returning to it—from the outside. In Hansen's version, on the other hand, it combines with a neurobiological view that has generally abandoned the question of the subject (and its language).

Digitally generated space is no longer connected with any kind of human activity. Its singularity and its potential are autonomous, neither understandable nor occupiable in human terms. Whereas in the cinema, affect appears as a formal correlate, in the digital "any-space-whatever," affect means "a bodily *supplement*, a response to a digital stimulus that remains fundamentally heterogeneous to human perceptual (visual) capacities. In sum, affection becomes affectivity."[32]

In this light, tactility in the cinema (*haptic, tactile space*) means something entirely different from what it means in digitally produced space. This, as Hansen makes clear from the outset, is to the result of the new position of the affective body. Digital space

is only tactile "because it catalyzes a nonvisual mode of experience that *takes place* in the body of the spectator, and indeed, as the production of place within the body."[33]

4 The Hare and the Hedgehog

The positions discussed here are based on two premises: (a) the affective is a fundamental quality of media environments, which may not be new, but which now takes on a new form; and (b) affect has to date been criminally neglected and ignored, above all by theories such as psychoanalysis.

In my comments on Tomkins' affect theory, I referred to Freud and explained that he took for granted that affect and shame are central factors in the fabric of the individual and of society. But Freud (and later Lacan) adopted a very reserved position toward this affective dimension, as it was clear to him (and later to Lacan) that affect does not appear as itself (as one might put it in rather pathos-laden terms) but that it attaches itself, so to speak, concealing itself or slipping. This idea of slipping comes from a comment by Lacan, who once described affect as follows: "Anxiety is an affect. It is absurd to say that I am not interested in affects. All I say is that affects are not unmediated being, nor are they the subject in its raw form. They are by no means *protopathique*. Affect is not repressed—it has become displaced (like a ship's cargo), it is adrift, shifted, slipped, gone awry . . . but not repressed."[34] Here, Lacan follows Freud's definition, given in *Inhibitions, Symptoms, and Anxiety*: "Anxiety, then, is in the first place something that is felt. We call it an affective state although we are also ignorant of what an affect is."[35]

Among those who accused Lacan of understanding affect not as affect but as something beyond the grasp of the symbolic was André Green, whom we have already encountered above. In the 1970s, Green became an opponent of Lacan and allied himself increasingly with Melanie Klein and Donald Winnicott. He also accused Freud of not even having spoken of affect in connection with anxiety—an unfounded accusation, as the above quotation demonstrates.

But simply defending psychoanalysis against justified and unjustified accusations won't get us anywhere; it makes more sense to ask what drives representatives of art, culture, theory, neurology, and the life sciences today to zealously pursue a confrontation between affect and sexuality, dismissing the latter as unimportant or overrated.

Rosi Braidotti, for example, takes her lead from Deleuze and Guattari's *Nomadology* in understanding "life as subject" and advocates a line of argument that calls for a dynamic view of nature, life, and the individual. She rejects all psychoanalytical approaches, and those based on language or structure, as no longer adequate: "What if the subject is 'trans,' or in transit, that is to say no longer one, whole, unified and in control, but rather fluid, in process and hybrid? What are the ethical and political implications of a non-unitary vision of the human subject?"[36]

British cultural theorist Luciana Parisi translates Braidotti's demand into a radical model, developing a definition of sexuality (*abstract sex*) in which she connects Deleuze's terminology with an approach based on molecular biology (the endosymbiotic theory of Lynn Margulis). In this view, sex no longer has to do with *gender* or with bodies in the real sense, becoming instead a question of exchange, of combination and reshaping on various levels of life—inorganic, organic, climatic, geological, and so on.

But psychoanalysis, which both writers subject to a comprehensive critique, is also making first steps of its own toward neurobiology, to return to firm ground via the kind of anchoring of psychoanalytical theory in biology that Freud supposedly always wanted.

An especially interesting example of this for me, however, is Joan Copjec. Known as a fervent supporter of Lacan and sharp critic of Judith Butler (whom she accuses of having completely annulled the psychoanalytical concept of sexuality with her concept of gender), she, too, has discovered the affect of anxiety and shame.

Driven perhaps by a similar ambition to Slavoj Žižek, who tried to demonstrate Deleuze's unconscious closeness to Lacan[37] as a way of making sure that the field of theory and politics was not left to Deleuze's large following alone, Copjec is interested in pointing to early misjudgments and then—like the hedgehog's wife in Grimm's fairytale of *The Hare and the Hedgehog*—having got there first. As explained above, Lacan referred to affect as not repressed but as "displaced liked a ship's cargo." Copjec refers to this displacement, first as a way of showing that Deleuze's understanding of affect as a relay was very close to Lacan, and second in order to define affect as something that moves among the symbolic order. "The later Deleuze is more 'Sartrean' in the sense that he conceives affect as more disruptive, more murderous than murmuring; it is less a mantle surrounding perception than perception's inner division, its dislocation from itself."[38] And then Copjec raises the hedgehog's wife's cry of "I'm already here!" by conjuring up Freud's definition of affect as the phase of movement in which representation and affect slip out of phase with one another. In this reading, affect can be described as representation's own, distinctive, essential "out-of-phaseness."[39] According to this argument, subjective perception detaches itself from the individual for a moment, a moment that thus becomes the difference from affect; affect becomes a movement of thought, just as Freud and Lacan understood affect: "That Freud tried to theorize this movement of thought by insisting on affect's displacement is a truth nearly lost on his readers, mainly because he reserved the much-maligned word 'discharge' to describe the process."[40]

In her section on anxiety, entitled "Anxiety: Sister of Shame,"[41] Copjec recasts Freud's definition of anxiety as an affect insofar as it is not the repressed that returns and causes anxiety, but the yawning gap (between perception and displacement) that shows itself for a moment; anxiety occurs when the subject's shameful relationship

to its existence opens up, when anxiety loosens the cement for moments and stops the flight into being (the role attributed by Lacan to shame).[42] For Lacan, shame, so willingly adopted in the current reception of Tomkins, forms the fundamental link to existence by holding the subject back from becoming one with being, forcing it to maintain the distance to the world and others that is needed to survive. When the topic is shame, then, different writers are not necessarily talking about the same thing.

In the race between hare and hedgehog, have we lost sight of who is trying to catch up with whom? Have we simply got to where the others were waiting all along? Is the entire hysteria surrounding affect a pretext to make us believe that a shift in "thinking the human" toward the "posthuman" and "transhuman" means an over-coming or even a liberation of the subject? Or has the excitement over affect merely made it clear that the real, the unconscious, the body, the organism are empty signi-fiers that can be given a charge but are also subject to slippage and displacement?

Even if Freud and Lacan (as Mr. and Mrs. Hedgehog) have always already been where the hare of affect is now trying to overtake them, something is still going on here (even if it is only the hedgehog's progress that is currently visible on the surface). What can be diagnosed is a shift of sexuality toward its possible abolition in a com-prehensively psychoanalytical sense. As one of the master narratives of the nineteenth and twentieth centuries, the psychoanalytical notion of the sexual loses its frame of reference and dissolves into many competing models for practicing and defining sexu-ality. Queer, asexual, patchwork families, childlessness and hegemony of the old, the redefinition of family ties, *sex sells*, the organ trade, migratory movements, and the spiral of capitalist development are indications forming a grid of relations within which the genealogical power of sexuality displays clear traces of shifting.

If visual reading has always been located "in the field of vision,"[43] then affective reading has left behind both the field of vision and thus also the field of sexuality. The consequences of this shift may not yet be clearly identifiable, but speculations about a time thereafter are justified. If the dominant view today is not only that everything is allowed and possible, but also that everything must be shown and made visible, then in my view, this has less to do with the progress of liberalization than with an extension of the battle zone of what can be done to the body, how it can be manipulated. Neurobiology and plastic surgery in association with cognitive psychol-ogy are working on an optimized human being whose body is to be controllable via his or her affects. When the sexual has lost its uncanny power, because sexuality as sexual praxis (like drug-taking, fashion, cosmetic surgery, etc.) has become a question of style, of class, and of self-performance, then it becomes clear what the question of *the desire for affect*[44] is aiming at: at a possible postsubject that tries, having been abol-ished on the symbolic plane, to position itself in affective terms within "life as such," as an accumulation of cell nuclei and genetic data, as a conglomerate of organs, or as a biotope.

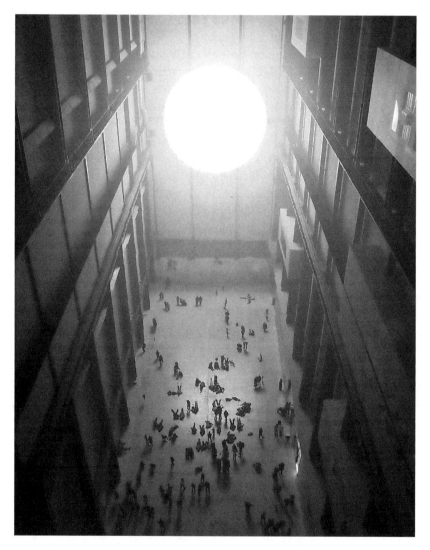

Figure 12.1
Olafur Eliasson, *The Weather Project*, 2003. See plate 21. © Olafur Eliasson. Reprinted by kind permission of the artist.

Notes

1. Marie-Luise Angerer, *Vom Begehren nach dem Affekt* (Berlin/Zurich: Diaphanes, 2007).

2. Anne Hamker, *Emotionalität und ästhetische Rezeption* (Münster: Waxmann, 2003), 160.

3. Ibid., 173.

4. Ursula Frohne, "That's the Only Now I Get—Immersion and Participation in Video-Installations by Dan Graham, Steve McQueen, Douglas Gordon, Doug Aitken, Eija-Liisa Ahtila, Sam Taylor-Wood," <http://www.medienkunstnetz.de>.

5. Mark B. N. Hansen, *New Philosophy for New Media* (Cambridge, MA: MIT Press, 2004), 76.

6. *Osmose*, 1995, is an immersive, interactive virtual reality installation with 3D computer graphics and 3D sound; visitors wear a head-mounted display, a real-time motion-tracking system based on breathing and balance.

7. The iconography of *Ephémère* is based on nature as metaphor. Archetypal elements such as rocks and rivers are combined with body organs, bones, and blood vessels. This connection is intended as a reference to the existence of a subterranean relationship, an exchange between the inside of the body, its materiality, and the inside of the Earth. The project is structured vertically in three levels: landscape, Earth, the inside of the body. Both *Osmose* and *Ephémère* can be seen at <http://www.immersence.com>.

8. Hansen, *New Philosophy*, 76.

9. For example: Sara Ahmed, *The Cultural Politics of Emotions* (London: Routledge, 2004); Elspeth Probyn, *Blush: Faces of Shame* (Minneapolis: University of Minnesota Press, 2005); Lisa Cartwright, *Moral Spectatorship, Technologies of Voice, and Affect in Postwar Representations of the Child* (Durham: Duke University Press, 2008).

10. *Shame and Its Sisters: A Silvan Tomkins Reader*, ed. Eve Kosofsky Sedgwick and Adam Frank (Durham: Duke University Press, 1995).

11. Silvan Tomkins: *Affect, Imagery, Consciousness* (2 vols., New York: Springer, 1962/1963).

12. Silvan Tomkins quoted in Kosofsky Sedgwick and Frank, *Shame and Its Sisters*, 144.

13. Ibid., 148.

14. Sigmund Freud, *Civilization and Its Discontents* (1930) (New York: Norton, 2005).

15. Cartwright, *Moral Spectatorship*.

16. Lucy Lippard, "Foreword," in Valie EXPORT, *MAGNA. Feminismus: Kunst und Kreativität* (Galerie Nächst St. Stephan, Vienna, 1975), 2–3.

17. Valie EXPORT, "Womans art," manifesto for the exhibition "MAGNA (arbeitstitel frauen-kunst) eine ausstellung, an der nur frauen teilnehmen," *neues forum* (1972) 228: 47.

18. Laura Mulvey, "Visual Pleasure and Narrative Cinema" (1975), in *The Feminism and Visual Culture Reader*, ed. Amelia Jones (London: Routledge, 2003), 44–53.

19. Luce Irigaray: *Speculum of the Other Woman* (1974) (Ithaca: Cornell University Press, 1985).

20. See Marie-Luise Angerer, "Expanded Thoughts: Zu Valie EXPORT," in *LAB, Jahrbuch für Künste und Apparate* (Cologne, 2006), 11–25.

21. Judy Chicago, *Dinner Party* (1974–1979), installation in various materials.

22. See Marie-Luise Angerer, *Body Options: Körper.Spuren.Medien.Bilder* (Vienna: Turia and Kant, 1999), especially 94–119.

23. Jacqueline Rose, *Sexuality in the Field of Vision* (London: Verso, 1986).

24. Lev Manovich, *The Language of New Media* (Cambridge, MA: MIT Press, 2001).

25. Henri Bergson, *Matter and Memory* (1896) (Minneola: Dover, 2004), 60.

26. Ibid., 44.

27. Ibid., 46.

28. Tim Lenoir, "Foreword," in Hansen, *New Philosophy*, 26.

29. Gilles Deleuze, *Cinema 1: The Movement-Image* (Minneapolis: University of Minnesota Press, 1986), 65–66.

30. Gilles Deleuze, *Cinema 2: The Time-Image* (Minneapolis: University of Minnesota Press, 1989), 5–6.

31. Ibid.

32. Hansen, *New Philosophy for New Media*, 209.

33. Ibid., 211.

34. Jacques Lacan, *L'Angoisse, Séminaire X* (Paris, 2004).

35. Sigmund Freud, *Inhibitions, Symptoms, and Anxiety* (1926 [1925]) (New York: W. W. Norton, 1977), 60.

36. Rosi Braidotti, *Transpositions: On Nomadic Ethics* (Cambridge: Blackwell, 2006), 9.

37. Slavoj Žižek, *Organs without Bodies* (New York: Routledge, 2004).

38. Joan Copjec, "May '68, The Emotional Month," in *Lacan: The Silent Partners*, ed. Slavoj Žižek (London: Verso, 2006), 90–114: 94.

39. Ibid.

40. Ibid., 95.

41. The allusion to the title of the Tomkins Reader edited by Eve Kosofsky Sedgwick and Frank Adam (*Shame and Its Sisters*) is unmistakable here—or is it pure coincidence?

42. "[F]light into being . . . which protects us from the ravage of anxiety." Copjec, "May '68," 111.

43. Rose, *Sexuality in the Field of Vision.*

44. Owing to the double meaning of "nach" in German, the title of my book *Vom Begehren nach dem Affekt* (see note 1), translates into English as both "On the desire for affect" (affect as the object of desire) and "On desire after affect" (in time, post-affect desire).

13 Web 2.0 and the Museum

Peter Weibel

The Noah's Ark Principle

The museum embodies something that I would like to call the *Noah's Ark principle*. The story of Noah's Ark is a parable of survival and of storage. As we recall, the story of the deluge and Noah's Ark is written in the first book of Moses (Genesis), chapters 6–9 in the Bible. God chose the patriarch Noah for his sense of justness and warned him of the flood. He told him to build an ark (Lat. *arca*) that could float and to bring in this ark eight people (himself, his wife, his three sons and their wives) and a great number of animals, two of every sort. According to the story in the Bible, this floating ark was extraordinarily large for its day, approximately 150 meters long, 25 meters wide, and 15 meters high, with three decks and a floor space of 9,000 square meters and a gross volume of nearly 14,000 cubic meters: almost as large as the *Titanic*. After it had rained for forty days and nights and the whole surface of the Earth was covered, the waters remained high for 150 days. All that was left of the living creatures on Earth were those in the ark. Everything else that had stirred upon the dry ground, whether human or beast, had been eradicated. In modern terms, Noah's Ark was a platform that saved lives, a storage room for people and animals, where they could survive.

But one thing is strange in this story: Not everything was stored and not everybody was saved, only a few. The majority was extinguished; only a tiny minority was selected for survival. In light of the general destruction, Noah's Ark doesn't really embody the principle of survival. The Noah's Ark principle seems to be the principle of selection. Is Noah's Ark a model of evolution, a picture of Darwin's natural selection, "the survival of the fittest?" Is Noah's Ark an aristocratic model, or a democratic one? Noah's Ark embodies evidently the following principle: Only a few are chosen— the happy few, not the masses—and only some will be saved. This is not a democratic principle.

Museums are floating crates like Noah's Ark: They are meant to store artworks in their "bellies." They are meant to assure that artworks do not disappear, but instead

are preserved, that artworks survive and do not perish. Museums are support systems, which should take care that artworks do not vanish, that artworks are conserved, preserved and restored. They function like Noah's Ark, unfortunately, because until now, museums have worked along precisely the lines of Noah's Ark, selecting a small number of works and saving only a few: the masterpieces. Not many artists or works have been able to enter these ships of wood and stone, the museums, these arks of the archives.

Museums are a kind of platforms where only some may be rescued. Contemporary art is produced nonstop all over the world, and it is the museum's duty to make sure that these artworks will not disappear. Hence the museum's mission statement mainly is to collect—to be Noah's Ark. However, if we inquire how many works have been preserved during the last century, the estimates vary between 1 percent and 7 percent of the whole production of art. Visualizing that, from Gothic altars to twentieth-century pneumatic artworks, just a maximum of 7 percent of the total production of art has been preserved shows that museums have not yet been very successful in their archiving work. Museums just work like Noah's Ark, following the principle of selection.

Museums have mercilessly followed the Darwinian model of selection: Only a few may be rescued, only a few may enter the ship. Culture has become therefore the embodiment of this selection, the expression of selection. Most artworks have disappeared, and only a small number are selected to be stored in a museum, to be collected. Museums have done a poor job. They have passed their judgments with the guillotine of history—separated out the majority of art, rejected it, and forgotten it.

The Web 2.0 Principle

On the other hand, today we have Web 2.0—the opposite of Noah's Ark. Web 2.0 is a platform where, in principle, everything can be stored, be saved, and survive, where everyone can search and find everything. Web 2.0 is virtually an endlessly expandable ark, an endlessly deep archive, a ship, a floating crate, wider than it is long, longer than it is high, higher than it is wide. All that we are experiencing today with sites like YouTube (<http://www.youtube.com>), Flickr (<http://www.flickr.com>), MySpace (<http://www.myspace.com>), and so on, is precisely the opposite of selection. Storage space is expanding into the infinite.

We have now a Noah's Ark that has room for everyone and is no longer a platform for the chosen ones. Until now, through the Noah's Ark principle, culture was a bottleneck through which only very few could pass. Just imagine: You are an unknown artist, more precisely, a photographer, at the beginning of your career, striving to be accepted as an artist and to depart from the ranks of amateur. You go from editors of magazines to galleries and museums, present your works, submit them, send them in,

and request attention. Most galleries, museums, and magazines will reject you. You will be cast back on your status as amateur. The Net platforms of the twenty-first century have expanded this bottleneck of culture, this censorship of connoisseurs. The ship is no longer a censor, but an open source, and open bottleneck, wide enough that almost everyone can get through. All amateurs of the world will unite on the Net platforms and can show all of their photos. Now finally the nineteenth-century avant-garde's demand that art should be made by all can be fulfilled. Lautreamont formulated in 1870 this avant-garde program in his famous maxim: "La poésie doit être faite par tous, non par un" (Poetry must be made by all and not by one). Feudal culture in the possession of the few could be turned into amateur culture in the possession of all. The urge to be creative, which a great many of society's members have, has now finally found its platform, its ark. The Net has become the ark of the creativity of everybody, the storage space, the distribution system for the products of everybody's creativity, the support system of the creativity of the masses. The museums could only claim to offer art for the masses, the art of the happy few experts to the excluded masses. With the Web, for the first time, civilization can offer art of the masses for the masses: Everybody is included in the production, distribution, and conservation of the products of creativity.

The Culture of the Recipient

Ever since the early nineteenth century, we have had what is known as recipient culture. The shift of attention from the producer of an artwork to the viewer of an artwork started in the nineteenth century. Art theory realized that the spectator is part of the production of the artwork through his or her participation in the construction of the meaning of the artwork. This recipient culture was developed by various theorists,[1] through to Michael Bakhtin.[2] This recipient culture is also formulated in Marcel Duchamp's famous statement, which he articulated in his speech "The Creative Act," namely, that the spectator contributes to the creative act: "All in all, the creative act is not performed by the artist alone; the spectator brings the work in contact with the external world by deciphering and interpreting its inner qualification and thus adds his contribution to the creative act."[3]

Modern art of the twentieth century has a tendency to place the beholder or spectator at the center of the work. In the practice of art, this recipient culture, that is, viewer and visitor participation, has taken hold since the 1950s. Ever since op art and kinetics, artworks have been observer dependent. The observer has to move to either evoke optical effects or set a work in motion. Happenings, Fluxus, and Events were dominated by instructions to the beholder for how to act: The beholder followed the written or spoken instructions of a game leader and thereby completed the artwork. Concept art, too, commonly addressed the beholder to carry out ideas. Already in

1968, Franz Erhard Walther published a series of works entitled *Objekte, benutzen*[4] (Objects, to use). Since 1980, after the art of participation, interactivity has played a central role in digital art, from virtual to immersive environments.

The word "user" has long been present in art. Art movements have consistently demanded the spectator's participation. Already in the 1950s, the op artists asked for the participation of the beholder. Only if the viewer would change his position in front of a picture could he experience the optical effects. From this participation of the observer in creating the special optical effects it was a small step to the observer's physical participation in the creation of the artwork. From the command "Move!" followed the command "Touch!" For example, the group GRAV (Groupe de recherche d' art visuelle) began making exhibitions in theirs studios in Paris in 1960 entitled "Touching is permitted." Normally in the museum one reads, "Touching is not permitted," or "Please do not touch," but here the opposite is called for.

The possibilities offered by the computer further developed spectator-relativity, which had not been a physical interaction up to this point. Artists used interfaces with which humans could communicate with machines and were able to give them instructions for how to act. Spectator-relativity thereby intensified to become human–machine interaction. But this interactivity consisted basically in the artist delivering an artwork and then this artwork having to be set in motion by the visitor, for example, through movements or by pressing a button, that is, through interface techniques. The content of the artwork comes from the artist; the beholder merely sets the artwork in motion.

With Web 2.0, we experience something called "user-generated content," which means that beholders also deliver the content. This means that MySpace, YouTube, and all of the other Internet platforms contain works that have been created by the users of these networks. That presents a colossal difference from previous ideas of interactivity.

We can thus see that with the Web 2.0 revolution, previous artistic activities can be carried much further, because here, for the first time, the content originates from users. In art up to this point, artworks were created by artists for the use of spectators. Now, the spectators have come so far that they can publish their own art online, which others can then behold. That means that we have now created a circle whereby the so-called amateurs, or in Greek, the "idiots" (i.e., not the specialists and professionals such as artists and gallerists, but the general public), are capable of circulating their own work for other "amateurs." This is an incredible attack on the principle of selection, the Noah's Ark principle. Now the question at hand is whether museums will enter into this cultural revolution or if they will continue to stick to the Noah's Ark principle and say: We have the power of definition, we can judge what is art, we make the selection of what is art, and you, the beholder/visitor, are allowed to enter the museum and kneel before the artworks that we have selected.

The new behavior that the younger generation is acquiring by using the Web (learning online, doing their own programming, not simply being programmed, putting together music programs, editing films and putting them online, etc.) is also crucial for museums. If museums continue to act traditionally—curating like TV and radio program directors and programming like curators, showing the audience works in a certain sequence and at a certain time, that is, precluding the beholder's opportunity to put together his or her own program—then the museum will become obsolete.

And if over the next decades we don't adapt to this newly acquired behavior that users/beholders have acquired by the Web, then at some point museums will have a relatively obsolete function, since beholders will say: I only go to the museum when I want to get a sense of what cultural behavior was like in the nineteenth and twentieth centuries. But when I want to experience contemporary cultural behavior, suitable for the twenty-first century, I can't go into the museum, because the museum makes me assume a behavior that is a throwback to the nineteenth and twentieth centuries. Thus, I believe that museums have no other choice but to embrace this new way of acting that beholders and users have acquired by the Web.

The Performative Museum

What does that mean for museums? When you go into a museum nowadays, you are always tied to time and space—first, you experience the museum as site-specific the moment that you stand in the building in front of an artwork. You can only experience the museum's works for the duration of your visit to the building, during its opening hours. When you leave the museum, all that you can take with you is an exhibition catalog in which, ideally, the works are depicted. Of course, nowadays you can also look at the museum's Web site, where you can generally see the works owned by the museum, arranged as in a catalog.

To do justice to the users' new behavior, we have to free the museum of time and place restrictions, which means that in the future, people should be able to come into contact with the museum and its works even when they're not in the museum; and this means something different than simply visiting a Web site. The museum must be available around the clock and everywhere. An asynchronicity of sorts is necessary, meaning that I am not bound to a museum's opening hours when I want to engage with a work. A nonlocality should be available so that I am not obliged to physically visit the museum. It is thus necessary for museums to go into Second Life's virtual world and open branches there. In Second Life, it is possible to visit a museum at any time and even to choose what one sees there. In addition—and this is the crux of the matter—beholders must have the opportunity to put their own artworks there. This means that the idea does not stop at simply transferring the existing museum structure online, but goes on to allow beholders to put their own artworks online and thus

become artists and curators. For example: When I create an exhibition, let's say on the theme of "Unfair Trade," I can select essays and put them online, select artworks and put pictures of them online, and put the artworks themselves in the museum. But the point is, through the Internet, I am able to give everyone the opportunity to put their own ideas, thoughts, and opinions, or even their own artworks online, in a setup similar to that of the Wikipedia structure or a blog. The idea is that these texts, opinions, and artworks are, at the same time, projected into the real museum. Beholders, who visit the real museum, have access to the online data in a sort of computer installation. The online data thus becomes part of the real exhibition through projections. The information available to museum visitors is thereby not limited to what is on site, provided by the curators and artists, but via the Internet, information is also available from people who were never in the museum and might not ever come to the museum. In reverse, people sitting at home in Malaysia or South America at their computers can participate from a distance as not only beholders of this exhibition, but also as users; they can bring in their own artworks and texts, and as already mentioned, these entries appear directly in the museum space. Virtual and real spheres permeate one another. Dispersed beholders participate in the exhibition online and also in the real exhibition space, since the online content is projected into the real exhibition space. Local beholders participate online and in the happenings in the real space.

Another example: From history and from painting we know that in the past only very few people were able to have their portraits painted. The skills and expertise of the portrait painters fetched a healthy payment. This led to painting's emergence as an "elite medium": When there were portraits, they were only of church and civic leaders, bishops, kings, rulers, aristocrats, and so on. Very few (experts) were able to paint portraits and only very few (elites) could pay for portraits. When you go into a museum today, then you see the depictions of these elite, this selection of nobility, church leaders, and wealthy citizens. With the advent of photography, for the first time it was possible to cash in on a democratic promise, namely, that everyone can take photos and also that everyone can have a portrait. Through the technical innovation of photography, everyone could photograph everyone, and also every object (theoretically, at least). Did the museum react to that? No. This hierarchy persists even today. In museums, the elite still encounters itself and the artists are still those experts that legitimate and immortalize the elite. In spite of photography's democratic promise, there is still a Noah's Ark, that platform of culture that has no room for you. You take a photograph, go to an agency, to a museum and they say: No, that is not art. We don't publish those kinds of photos, we don't exhibit such photos. Rejected from the Ark, condemned to extinction, excluded from culture, forced into anonymity, the masses have thus created a new medium, a new museum, a new ark where they can show and distribute their photos. The masses have now their own Noah's Ark, an

online technical platform called Flickr. That is how the author got the idea for "Flick_ Ka," a type of citizen's forum for photography. The aim of this art project is to cash in on photography's democratic promise by inviting everyone residing in the city of Karlsruhe, every visitor to the ZKM, to have a representative portrait in the museum. There is a photo vending machine in the foyer of ZKM where everyone who wants to participate can have their photo taken. The pictures are automatically digitized and sent to a huge databank and are projected in large format in the museum. They can also be seen online: <http://www.zkm.de/flick_ka>. Online there is also the possibility to upload one's pictures from home, which means that it isn't even necessary to come to the museum to participate in the project. Everyone, not just experts and elites, can place a representative artwork in the museum, a picture of himself, a picture that he can choose. Average people, every ordinary person, not only kings, but every consumer; not just the privileged few, but everyone can produce an artwork at the museum and be part of an artwork. The museum becomes a citizen's forum, in which everyone is equal. Everyone's photographs will be treated as a painting of a hero. Amateurs become experts, consumers become producers, visitors become the content of the museum. This is possible because the museum enters into an alliance with the Internet. Two things are achieved with this work: All visitors have their own artworks in the museum and all visitors can see themselves in the museum, as the subject of a portrait. Andy Warhol's silk screens work in the same way as classical painting, showing only the rich and the beautiful. They court the celebrity cult of the yellow press and tabloids. They profit from the masses, but don't serve the masses. When a museum exhibits Andy Warhol, it clearly states that it places itself at the service of a certain media aristocracy. After the political, ecclesiastical, and military aristocracies, the majority of today's art serves the media aristocracy, that "leisure class" of rich and famous who are made famous via the glossy photo magazines, *Illustrierte* in German (famous=illustrious). Today it is a media aristocracy for whom museums do the groundwork. Yet now, through the Internet, the democratic promise of photography can be redeemed by giving all citizens the opportunity to have their own artworks, their portraits, in the museum, and at the same time, to appear as artists and portrayed subjects. It is clear that the Internet has cultivated an ideology of participation, of so-called sharing. This culture of participation, where all beholders, all users, play their part, is the continuation of what I called participation. Recipient culture has risen to become a culture of participation, where fair exchange occurs not only symbolically, but in a material way.

The Participatory and Creative Visitor

That can be intensified even further, of course, when, as already mentioned, the museum enters into this three-dimensional virtual model that we know from Second

Life. What remains from Second Life is the model that we have of three-dimensional immersive virtual worlds that can be visited and played with by lots of people around the whole world all at the same time, so-called multiplayer worlds. In the past, one stood in front of an artwork—alone—and could simply press on a button. Interactivity was reduced to a singular or individual interactivity. Computer and online games then made it possible for several players to play together at the same time. The Internet is now also the dream of many artists because of its unique quality of being a multiplayer medium. Many beholders, many users, can simultaneously create an artwork together there. And in these new, virtual model worlds like Second Life, a lot of people enter into a space where there are already other people, and they can interact. Also in the real museum, it will be possible to enter into a virtual space as an avatar and communicate with other avatars. In the museum, visitors wouldn't speak to another directly; in the virtual museum they would. When people are at home and want to introduce something into the museum, they will see that other people have also introduced similar content, and then they'll communicate about it. In that way, the museum will no longer be a locally bound event in space and time for a lone individual who confronts an artwork as a lone individual; instead, this individual will participate in an act of sharing and communication. He or she will take part, will share something with others. The museum itself will, ideally, become a platform where people speak with one another and discuss the artworks, topics, and so on that interest them. Museums can become a medium for the masses by entering into an alliance with the Internet, whereby the museums and the Internet act as service providers, as distributors of messages, as providers for the audience's "content."[5]

Thus, on the one hand we have the possibility of a small cultural revolution that sets up a new culture of sharing in and with the museum. On the other hand, we have strong, organized powers that see the whole Web as an accumulation of their profits. If we are not able to clarify this issue in public, then it won't be possible to make full use of the opportunity for cultural renewal with and through the Internet. And what that amounts to is gambling away a chance for culture and education. Choose your world, choose a museum in the Internet era, choose a museum as a mass media, as multiplayer medium.

The museum is a support system so that artworks do not vanish. But it is also a support system so that artworks will be created. In the age of Web 2.0, the art system and the artists have lost the monopoly on creativity like painting has lost its monopoly on picture making 1840 at the arrival of photography. The Web is the museum for the creativity of everybody. If the museum will not have only a contract with dead artists and support their works, but also a contract with the generation of living artists and these living artists are everybody everywhere, then the classical museum, the museum of the few, must enter into an alliance with the Web, the museum of the many. The museum that takes care of the past and future works, of the collections

and construction of artworks, does not only take care of the past but also of the future of art. Even the old Noah's Ark, the old principle of the archive, was about the future. It was a ship built to conserve creatures, in fact built to guarantee the future of life. Now in the age of Web 2.0, the archive, Noah's Ark, the museum, is more than ever an agent of the future. "It is the future that is at issue here, and the archive as an irreducible experience of the future": Jacques Derrida.

Notes

1. See *Rezeptionsästhetik*, ed. Rainer Warning (Munich: Fink, 1988).

2. See Michael Bakhtin [Michail Bachtin], *Die Ästhetik des Wortes* (Frankfurt/Main Suhrkamp, 1979). See also Hans Robert Jauß, "Literaturgeschichte als Provokation der Literaturwissenschaft," in *Rezeptionsästhetik*, 126–162. (English translation: "Literary History as a Challenge to Literary Theory," in *Toward an Aesthetic of Reception*, trans. Timothy Bati [Minneapolis: University of Minnesota Press, 1982], 3–45.)

3. Marcel Duchamp, "The Creative Act," Robert Lebel, *Marcel Duchamp* (New York: Paragraphic Books, 1959), 77–78. See <http://www.iaaa.nl/cursusAA&AI/duchamp.html>.

4. Franz Erhard Walther, *Objekte benutzen* (Cologne: Buchhandlung Walther König, 1968).

5. See Harald Krämer, *Museumsinformatik und Digitale Sammlung* (Vienna: Facultas, 2001).

14 Kawaii: Cute Interactive Media

Adrian David Cheok

Introduction

The word "cute" is used to describe a number of things, usually related to adorable beauty and innocent attractiveness. The cute aesthetic is something that is not new and has been a component of art since the beginning. The contemporary world is still grappling with the aesthetics of cuteness and digital interactive systems are just beginning to find the strengths and weaknesses of cuteness. Cuteness in interactive systems is a relatively new development yet has its roots in the aesthetics of many historical and cultural elements. Symbols of cuteness abound in nature as in the creatures of neotenous proportions, drawing in the care and concern of the parent and the care from a protector.

In this chapter, I provide an in-depth look at the role of cuteness in interactive systems, beginning with the history of cuteness. Although the aim is for a general understanding and examples from different cultures, I focus on the Japanese culture of Kawaii, which has had a large impact around the world, especially in entertainment, fashion, and animation. I then take the approach of "cute engineering" and describe how to use cuteness (Kawaii) in technical and scientific way to solve problems in engineering applications. This knowledge provides for the possibility to create a "cute filter" that can transform inputs and automatically create cuter outputs. I also discuss the development of the cute social network and entertainment projects, providing an insight into the next generation of interactive systems that will bring happiness and comfort to users of all ages and cultures through the soft power of cute.

The Cute Aesthetic

Kawaii: Cute Culture History and Development in Japan

The Emptiness (kyomu), the Nothingness (mu) of Japan and of the Orient . . . is not the nothingness or emptiness of the West. It is rather the reverse, a universe of Spirit in which everything communicates freely with everything, transcending bounds, limitless.

—Yasunari Kawabata, 1968[1]

Japan is a country with a unique culture. Influenced by Chinese high culture from the early days, isolating itself deliberately from the outside world for centuries, Japan's cultural history is marked by absorption of and adaptation to Western cultural elements. The overwhelming disappointment in World War II, the nuclear bombing of Hiroshima-Nagasaki, and recently the ending of the cold war and subsequent political changes were decisive moments for Japan, which gradually altered its geopolitical attitude toward supremacy. Embracing the Western-oriented popular cultural ideologies is part of this metamorphosis. Kawaii is a subculture of the modern popular culture of Japan. We at first focus on the historical journey of Japanese Kawaii culture that is now shaping one of the most technologically affluent nations, its impact on a global scale, and its modern incarnation that is contributing to the Japan's universal image as a "soft power." This study in Kawaii is an attempt to lessen the gulf between cultures by understanding the aesthetics of Kawaii, and using such culture to increase the comfort and happiness in the design of interactive media systems. To understand the development and importance of Kawaii culture in Japan, let us take a brief look at some of the country's relevant history and culture.

Japan is a small island nation with a long history and a strong sense of cultural identity based on a homogeneous people. The first settlements in Japan were recorded during the Palaeolithic period circa 30,000 BCE. Primarily a hunter-gatherer culture, the Jomon culture[2] is characterized by the invention of earthenware and an aesthetic appreciation of the beauty of the natural world. This paved the way for the development of wet-rice farming, iron working, wheel-turned pottery, superior bronze ware, and Shinto religious practices. According to Jaroslav Kreje,[3] Shinto bestowed on Japanese a sense of unreserved allegiance, while Confucianism provided goodness and dignity and Buddhism contributed a tendency toward submission to inevitability.

The arrival of Zen Buddhism, which is simplicity and discipline, and the already well-established Shinto ceremonies influenced the development of distinctive arts of graceful gestures, elaborate rituals, composure and contemplation, gardens, architecture, and the tea ceremony. Haiku poetry and Noh theater followed by Bunraku and Kabuki marked the classical stage of culture. After almost two and a half centuries of a "closed country" policy by which Japan totally isolated herself from the outside world, the Meiji Restorations arrived, which essentially was a civil war between the Satsuma-Choshu Alliance and the Tokugawa Shogunate. During this period the absolute sovereignty of the emperor also developed. Japan materialized as a world power with colonial inclinations toward Asia. Following World War II, Japan surfaced to form a new nation, without the constitutional ability to build an army that could act globally; yet, this same setting has also pushed Japan toward an amiable culture and to became a nation of technological advancements with a drive toward business superiority.

The techno-cultural suppleness of today is the result of a difficult and temporary disruption that developed out of very long period of being culturally isolated. Today many cultural transformations in Japan are essentially obsessed with technology.[4] It has also been argued that the obsessive relationship that binds Japan with America after World War II initiated people to produce goods without having a sense of autonomy and to create new popular cultural identities, such as Kawaii.[5]

The first description of the meaning of Kawaii appeared during the Heian period in 794–1185 CE. A new manner of literature aided by the formation of two forms of simplified Japanese systems of writing using characters based on phonetics was created by the sophisticated aristocratic court society at Heian. *Makura no Shoshi* (The Pillow Book), written by Sei Shanogon,[6] one of the court ladies of the Heian court and an essayist, is a collection expressing the more urbane aspects of the contemporary society. The behavior of a chirping sparrow, the small leaf of a crest, and a lazuline jar were among her list of cute objects. Furthermore, kaiwase, the clam shell game played at the Heian court by aristocrats, involved competing to compose the most refined Waka (31-syllable Japanese poem) while moving 360 clamshells from left to right. Sei Shanogon had applied the word *utsulushi* to denote the meaning of Kawaii. The old mode of Kawaii, *kawayushi*, first appeared in *Konjakumonogatarishu* (Tales of times now past), which was the greatest collection of tales of Buddhism in Japan compiled at the end of the Heian period. In it the word *kawayushi* means "pity." *Vocabvlario da lingoa de Iapam* (*Vocabulno da Lngua do Japo* in modern Portuguese), a Japanese-to-Portuguese dictionary published by the Society of Jesuits in Nagasaki, Japan, in 1603, lists the word *Cauaij* and considers it the origin of the term *Kawaii*.[7] From the Taisho period until 1945 the word *Kawaii* was printed in dictionaries as *kawayushi*, followed by the change of *kawayushi* to *kawayui*.

History of Manga

A related historical effect to Kawaii culture is the development of "manga" (visual comic arts), as these directly project the Kawaii aesthetic. While being restored to its former glory in 1935, the Horyuji temple, the oldest wooden structure in Japan (which burned down in 670 CE), revealed caricatures of people and animals on the backs of planks in the ceiling. These caricatures are among the oldest surviving Japanese comic art.[8]

Cho-ju-giga, also known as Cho-ju-jinbutsu-giga, is a famous set of four picture scrolls belonging to Ko-zan-ji temple in Kyoto, which is considered to be the oldest work of Japanese manga. The first two scrolls, illustrating animals (frogs, rabbits, and monkeys) frolicking, are assumed to have been drawn in the mid-twelfth century, whereas the third and fourth scrolls date from the thirteenth century. The brush strokes are lively, portraying the actions and movements that are central to various episodes.

In the Edo period (1603–1867), woodblock techniques for the mass production of illustrated books and prints were developed. In the middle of the Edo period, in 1720, woodblock print publishing emerged in Osaka, and the first manga book to become a commercial success was published. Uncomplicated lines and exaggerated expressions are essential elements of manga, and the cinematic technique creates an even more expressive medium. The artists of long ago imaginatively combined these elements, laying the foundation for modern-day manga.[9]

The earliest usage of modern manga was recorded in 1770s. The growth of the urban middle class during this period resulted in the development of a popular consumption pattern in entertainment where mediums such as manga flourished. *Kibyoshi* were storybooks for adults, with the narrated story set creatively around ink-brushed illustrations. Most famous were the 1819 woodblock prints published by Katsushika Hokusai. The turn of the twentieth century marked the arrival of the physical form of modern manga. During the Sho-wa period (1926–1989), manga became part of the everyday life of the Japanese people. Amazingly, the first example of modern-day manga was for children, the comic strip *The Adventures of Little Sho* (Sho-Chan no Bo-ken), which is a story about a little boy and a squirrel. Even though Japan provides sufficient evidences to support manga's historical roots, the true ancestors of the modern manga are the European/American-style political cartoons of the later nineteenth century, in the form of the multipanel comic strips that flourished in American newspapers. The postwar years in Japan, in the midst of defeat, massive destructions, and Hiroshima-Nagasaki, initiated a new form of modern manga, in picture card shows and rental manga. A picture card show is a miniature theater with the story drawn on cards that are displayed in a theatrical style. And the destitute rural youths, who had entered the cities as migrant workers during this time, were the consumers who created a market for rental manga.

The 1960s witnessed the rapid expansion of the story-based manga, relating it to radical political and countercultural movements.[10] Commercial manga advanced and diversified during the 1970–1980s, its contents maturing to accommodate rapidly transforming tastes and attitudes. In 1990s manga encountered a challenge, in the form of computer games, personal computers, and the Internet. According to Sharon Kinsella,[11] modern Japanese manga is a synthesis: a long Japanese tradition of art that functions as entertainment. The physical appearance was an invention adapted from the West. Manga characters express cartoon tendencies with exaggerated emotional articulations. They convey human emotion in its basic form: swooning to visible excitement, unabashed embarrassment to hopping madness. These are personal characteristics that the cute generation associates with developing in their individual selves, to portray some of these cute qualities, if not all, in varying degree of appropriateness.

The artistic experience of manga gradually developed into cultural production: a collection of images with exaggerated vulnerable qualities and which are dreamily adorable, that set out to conquer the popular culture worldwide. These image-based culture products at face value seem little more than decorative characters. However, while manga is appealing the masses, these products also explore the technological landscape of Japan, giving the individual user a means of self-expression and individualization. Kawaii is the sentiment expressed in these aesthetics and products.

In the 1970s, Kawaii emerged as a new form of pop culture, which is an integral part of the Japanese culture. The popular obsession with Kawaii is a deeply unconscious one. To Takashi Murakami, Kawaii culture is an expression of Japan's postwar impotency and its childlike relationship to the United States.[12] The dynamics of manga and Kawaii are interrelated, each enhancing the existence of the other and both epitomizing Japan's susceptibility toward childish tastes and the shelter and safety those tastes offer.[13]

Kawaii Culture Development in Modern Japan

During the mid-1970s, Japanese teenage females developed a form of handwriting which became the rage,[14] writing in childlike fashion to communicate with one another. This new childish style of writing became such a phenomenon during the 1970s that a survey conducted in 1985 revealed that an estimated 5 million people were using this new form of writing. The new script was described by a variety of names such as *marui ji* (round writing), *koneko ji* (kitten writing), *manga ji* (comic writing), and *burikko ji* (fake-child writing).[15]

Romanization of Japanese text could be the birth of cute handwriting. Japanese writing is in vertical strokes, varying in thickness. The new style produced thin, even lines and stylized and rounded characters in a blend of English, *katakana*, and diminutive symbols in cartoon style, like stars, hearts, and adorable faces. The fixation on this style developed to such an extreme that schools across Japan banned its use in an effort to discipline school children.

By inventing this new form of handwriting the younger generation was aspiring to establish themselves as individuals, identifying themselves as a separate entity from adults and their traditional cultural values. Kawaii, in point of fact, is seen as a rebellion against the traditional cultural values and a belated reaction to the destruction of World War II and its aftermath. Their apparently babyish attitudes convey an unexpressed desire to be recognized as a new culture that will not be outmaneuvered or blindly led. This younger generation faithfully embraces the cuteness portrayed in Kawaii. The association of Kawaii with the technological landscape of Japan by customizing and humanizing[16] it gives the Kawaii-worshipping generation the inspiration to articulate themselves individually and yet as a group.

In 1971, the stationery company Sanrio established a Kawaii consumer market, targeting the cute-crazed teenagers by introducing cute-style fancy goods such as cuddly toys, pastel in color with frills and ribbons. Hello Kitty, a beribboned kitten with an inexpressive face and petite stature, in pink and white hues, is one of the most popular Sanrio cuties. She is now an adored trend enhancing the consumer appeal of over 22,000 products and services worldwide. Since 1983, Hello Kitty acts as the Ambassador of the children of United States for UNICEF. Sanrio has introduced a range of characters[17] for the Kawaii consumer market, including Chococat, Little Twin Stars, and My Melody.

The commercial aesthetic of Kawaii cute is that it should be modern and foreign in design, its shape and size must encourage cuddling, it must be adorably soft, and must be pastel in color, with frills and ribbons. According to Sharon Kinsella,[18] the essential anatomy of a cute cartoon character is small, soft, infantile, mammalian, round, without bodily appendages (arms), without bodily orifices (mouths), nonsexual, mute, insecure, helpless, or bewildered. A circle with the bottom half having three dots, two for eyes and one as a smiling mouth, is how Takashi Murakami describes the Kawaii scale.[19] Kawaii characters are a phenomenon manipulated primarily by consumer culture to exploit these cute elements for their cheerfulness and optimism.

When Takashi Murakami explored the aesthetic capabilities of pop culture, he introduced his famous theory of *superflat visual culture*, a theory that emerged from the cultural, political, and historical perspective of the interaction between high art and subculture, between Japan and the United states, and between history and the present day.[20] Arthur Lubow[21] mentions Murakami's argument that the flattening process liberated the contemporary Japanese from contemplating the contradictions of Japan's image during World War II with their postwar economic and political maneuverings.

"Becoming Kawaii," through infantile behavior, frivolous mannerisms, and a superficial attitude toward profundity and values, is the aspiration of most of young Japanese today. Following cute fashion and surrounding oneself with all things Kawaii is not enough to elevate oneself to the blissful stage of Kawaii. Living in a fantasy Kawaii world, where every available space is filled with cute things, the Japanese cute brigade deliberately disregards the harshness of the real world and refuses the maturity that comes with time. Kinsella[22] notices that in Kawaii culture, young people become popular according to their apparent weaknesses, dependence, and inability rather than their strengths and capabilities. According to Anne Allison,[23] these cute characters provide a sense of security, intimacy, or connection for people who, in this postindustrial age, lead busy, stressful lives often detached from the company of family or friends, and thus make these cute attachments their "shadow families."

Kawaii Globalization

Joseph Nye, Jr.,[24] who introduced the term "soft power" to highlight the importance of cultural factors in world politics, identifies Japan as a "one-dimensional" economic power marked by cultural insularity. Present-day Japanese culture is software and service-economy oriented, and with the globalization of Japanese soft culture, Japan is re-creating its national identity. As the Kawaii-craze is becoming the cultural vogue across the continent, mesmerizing the younger generation around the globe whose dream is to associate themselves with the values and lifestyle of Japan, a new Japanese identity is beginning to emerge. As Saya Shiraishi[25] notes, Japan may be developing what Nye calls a "co-optative" behavioral power.

Kawaii is, in fact, now a strong consumer culture. Japan is years ahead of many other countries in adopting strategies and modes for customization; and one especially dominant mode of customization is Kawaii culture.[26] It has spread all over the world as a universal trend with arrays of knock-offs and inventions. Even though they are not directly recognized as Kawaii, most countries are producing their own brands of cute subcultures, and not just as an impostor but as a culture legitimately their own with aspects that can be traced back for centuries.

In India, Kawaii elements in its culture are reflected in its various mythical literary masterpieces such as Ramayana,[27] an ancient Sanskrit epic dated from 500–100 BCE, in which a human/monkey character (Hanuman) coveys all cute attributes. Today, Indian artists are introducing a baby version of the monkey, appropriately named Baby Hanuman, as an animated figure. Some of the leading artists in Indian cinematic art have cultivated an image of cuteness that is immensely popular with Indian fans all over the world.

South Asian countries have their own cute characters and temperaments, and although they cannot be distinguished as Kawaii culture, the basic aspects are there. "Kolam," a folk dance of Sri Lanka that originated in India, in which the dancers wear intricately carved masks, is famous for its comic wit and hilariously made-up stories and cute characters. Though a strong tangible culture has not developed out of this ritualistic theater, it is still attached to the Sri Lankans' sense of innocence and mischief.

In the United States, Kawaii elements are found in the highly cultivated animation industry. Mickey Mouse, a character created in 1928 that has become an icon for the Walt Disney Company; Warner Bros. Bugs Bunny, a harebrained rabbit created in 1939; and Alvin and the Chipmunks, a singing trio of chipmunks created in 1958, are not only a major portion of present-day American culture but also a universal fascination. The European attachment to cute can be traced to the appearance of Moomin, a hippo-like round and furry character created originally by a Finnish writer, and Miffy, a female rabbit created in 1955.

The modern electronic era, beginning from 1980s, is also witnessing the Kawaii-inspired computerized electronic innovations that are now a global phenomenon. Hjorth states that the use of Kawaii features to familiarize new commodities or technologies has been a common practice in the material culture of postwar Japan.[28] The world, it seems, is adopting with the technological optimism expressed by Japan's popular cultural creations. Within the cyberspace and interactive games enjoyed the world over, subcultural Kawaii has lost its submissive nature. Instead, in the dramatic world of consumer culture where consumption is speedy and threshold of boredom is a thin line, each Kawaii character battles for supremacy and then survival. What is greeted today with a squeal of "Kawaii" will not receive the same rejoinder tomorrow. As a soft power, the surviving grace of Kawaii culture is its undeniable universal appeal, which has crossed cultural and political borders.

Contemporary Perceptions of Kawaii/Cute

Have you ever found yourself smiling when presented with a cute character in a Web site or video game? Perhaps you have noticed that the way a virtual character moves displays a personality of youth or excitement or a friendly demeanor. These are often carefully selected elements utilized by the designers to draw in the user, establish a micro-relationship, and impart positive feelings. In the Japanese culture, the cute aesthetic is widely used by many organizations and for many purposes, including mascots for the police, warning signs for dangerous areas, pedestrian detours in public places, company mascots, and video-game characters, among others.

On further examination, using cute to motivate and inform might seem a strange idea; however, there may be something about cute and what it can do that deserves more focus and research. We have noticed that the Japanese style of "Kawaii" embodies a special kind of cute design that could be used to show designers of interactive media how to engage users in a way that reduces fear and makes dull information more acceptable and appealing. An analogy could be a bitter pill with a flavored shell that makes taking the medicine more agreeable. The medicine itself is beneficial to the patient, but the process of swallowing a bitter pill detracts significantly from his or her happiness level. We can draw a parallel from the cold, digital, electronic, and unsettling components of a system to the bitter pill, as shown in figure 14.1. The "flavored coating" is the cute user interface that makes using the system more agreeable by establishing a relationship with the user and delivering the content of the system in a more friendly and attractive way.

This manipulated perception is not only a flavored coating that makes content easier to consume; it also brings the user to a desired frame of mind and attitude and then delivers content that might not otherwise be received. We can imagine this being

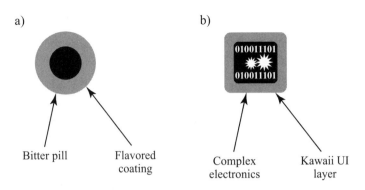

Figure 14.1
(a) Bitter pill with a flavored coating. (b) Cute interface layer.

used to improve educational materials by reducing the fear and apprehension of learning new concepts and therefore improve the speed of learning. Taking this concept further, it is conceivable to take an engineering approach to cute design and carefully customize interactions based on individual preferences, transforming various inputs into cuter outputs that appeal to the user by stimulating certain emotions. This automatic transformation could lead to new design possibilities, resulting in new sounds, smells, foods, and visual content in interactive systems. This represents a unique approach, aimed not at replacing the designer, but at providing tools to the designer in the preproduction phase, and then to the end user, enabling a new self-customization of products.

Cuteness in Interactive Systems

Aside from carefully designing toys to have a special appeal, cute interactive systems can draw in the user in a special way and motivate action in a way that is unique. In this section we describe the benefits of using cute in this way, for example, through the creation of educational games that help students learn challenging material; developing cute companions that help people get through painful rehabilitation sessions; enabling interesting ways for people to interact; and increasing the happiness level in general.

Studying Cuteness

Although we recognize that some design companies tightly guard their secrets of cute in order to maintain their market share, we also recognize the benefits of the power of cute and couldn't help but look deeper into the design of cute. At the "Designing

Interactive Systems" conference in Cape Town, South Africa, in 2008, we conducted a workshop, "Designing Cute Interactive Media," pulling together other researchers also interested in uncovering aspects of the cute aesthetic.

Among the presentations were scientific user-studies that focused on understanding the key elements of user perception of cute, including analysis of colors, shapes, proportions, and textures across users from all ages and genders. Some of the findings showed surprising differences in user preference among the ages and genders. We include the highlights of our results below and take a closer look at the concept and definition of cute from a design and engineering perspective.

Defining Cuteness

The first portion of the study was conducted via online questionnaire in which the respondents were asked to provide a definition of cuteness in their own words. Using word frequency analysis we developed a definition of cuteness as follows:

Cuteness includes the feelings and emotions that are caused by experiencing something that is charming, cheerful, happy, funny, or something that is very sweet, innocent, or pure. It can stimulate a feeling of adoration, sympathy, or the care response.

Responses to the questionnaire included mention of colors, sounds, motion, and feelings, among other aspects. We took the most commonly mentioned variables as input to the design of the subsequent portion of the study.

Using an interactive online survey, 72 respondents from 20 countries were polled, including representatives from Asia, Europe, and North and South America. Some interesting trends emerged, which showed some similar preferences among the groups, but also some key differences.

Color Selection

When respondents were given the freedom to choose colors from 16 hues in the visible spectrum, the respondents selected as shown in figure 14.2 (plate 22). This isolation of color values explored the limits of the trend toward bright and primary colors. The preferences focused on the primary and secondary hues of red, blue, and purple, with fewer respondents choosing green and yellow.

When the respondents were presented with just a few color samples from a limited number of hues, children showed a similar preference for brighter colors. When presented with hues that presented ranges of colors with less variance of the individual intensities, there was a tendency for selection toward the colors on the pure ends of the spectrum. In other words, the trend showed a stronger preference for primary hues and less preference for gray. Children showed a stronger preference than older respondents for the greenish-blue shade. They also shared a preference for the reddish shades, as shown in figure 14.3.

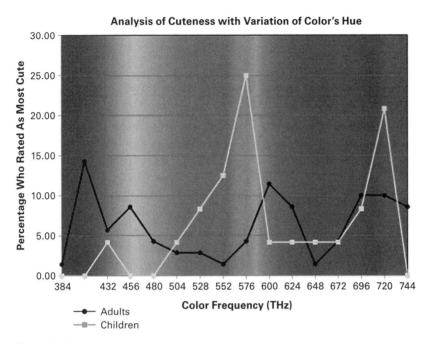

Figure 14.2

Chart showing the summary of selections of cutest color. See plate 22.

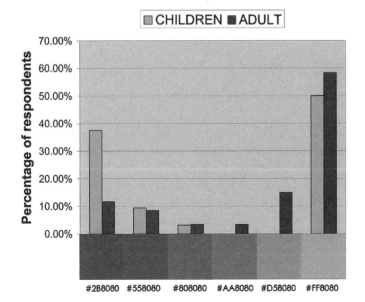

Figure 14.3

Chart showing the summary of selections of most Kawaii color, ranging from greenish to reddish hue.

Why These Colors?

These trends in the selection for pure hues and primary colors could originate in a complex mix between natural symbols that are instinctual, culturally conditioned symbols, and personal differences in preference and perception. From the natural world, warm colors, including red, orange, and yellow, are often seen as a symbol of youth and vitality. The flushed red cheeks of a baby and the bright red of roses and other flowers are examples. It could be that bright pure hue colors convey a sense of willful expression that is not muted as with darker shades (mysterious) or washed out as with the paleness of white (less confidence). From a cultural perspective, many cultures, especially Western cultures, use the bright primary hues for children and babies as a way to show innocence and purity. Regarding personal preferences, it is not always clear in which cases the selections for cute and colors would deviate from cultural and instinctual choices, but it could involve other influences from past experiences and or personal acceptance or rejection of contemporary trends. The influence of color is a complex and well-debated issue in the research and philosophy of aesthetics and psychology of perception, as noted by Rudolf Arnheim.[29]

Texture

The survey for cute ratings and texture was performed by presenting users with texture samples in such a way that they could not see the texture, but only make a judgment based on the sensation of feeling the texture sample as instructed by the survey facilitator. There was a noticeable trend in the softness and pile of the textile sample and the cuteness rating. The results showed that as the texture becomes softer and has a longer pile, the rating increases. A stronger association with cute was shown only to a certain point, beyond which the ratings show a decline. This showed us that there is a "sweet spot" in the isolated perception of textures and their affect on eliciting Kawaii feelings.

Texture Study Details

The user is presented with a texture number, and the test facilitator prepares the texture for the respondent to feel without looking at the color and shape of the sample. The respondent selects the Kawaii rating from the Likert five-position scale, ranging from "Very Cute," "Somewhat Cute," "Neutral," "Somewhat Not Cute," and finally "Not Cute at All." This is repeated until the respondent has experienced all 12 textures. The textures range from very soft to the touch, faux fur, to rough canvas. The textures used and their average ratings are shown in figure 14.4. The most highly rated Kawaii texture is shown in figure 14.5.

Why These Textures?

These trends in the selection for longer pile and softer textures is likely related to examples seen in nature. In the natural world, babies begin their lives as soft and

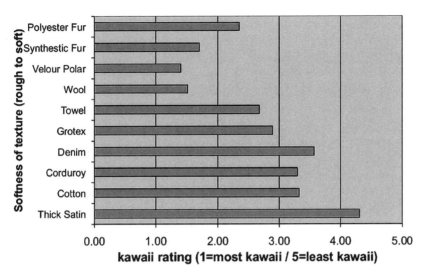

Figure 14.4
Chart showing that increase in softness and pile results in a stronger association with Kawaii.

Figure 14.5
The most highly rated Kawaii texture.

cuddly creatures. Respondents may make a connection with thoughts of kittens or puppies when they feel the texture samples. It may be this connection to nature that also leads to the lower scores for the unnaturally long pile samples. These declining scores for the obviously exaggerated samples might show the limits to the power of abstraction and manipulation from the real to the surreal.

Size and Proportion

In this test, users were presented with a paper survey and were asked to show their preferences for size, proportion, and association with "cuteness." For the first section, the respondents were presented with three different scenes containing several objects. Users were asked to select the scene showing the object that in its size was the most "cute." This same test was repeated for each of the other objects in the scene. During the test for each object, other objects in the scene remained their original size. The results of this test showed a preference for the size of the object to be small in relation to other objects (figure 14.6).

An additional type of proportion test was also presented involving various ratios of two parts of an object. Respondents were provided with characters including a human, a cowlike animal, and a mushroom. For each character, there were four proportions presented. Users were instructed to choose the picture of the figure that was the most "cute." The objects the respondents were presented with and the indication of the two sections noted as "head" and "body" sections are shown in figure 14.7.

The respondents selected proportions that were similar to the proportions of a baby, in which the head is disproportionately larger than is natural in relation to the size of the body. Our description of cuteness is consistent with the emotions of the nurture response, and the resulting selections by the respondents confirm the definition and agree with theories of the nurture response of Konrad Lorenz.[30] In our studies, we found some differences in user preference across older and younger respondents. For example, adults showed some tendency to select proportionately larger heads, as shown in figure 14.8; yet in the selection for proportions of the cow-like character, the adults selected for the smaller head (0.64 proportion of head/body) than the children respondents, as shown in figure 14.9. In the proportion selections for the mushroom, both age groups selected in a similar way, as shown in figure 14.10.

Why Are These Proportions Cute?

With most respondents selecting for the proportions that show a clearly larger head, the connection to the proportions of a baby comes naturally to mind. Regarding the difference in selection for the cow character in which the adults chose the smaller head, we may need to do more testing; but it might be that the adults prefer proportions that are more natural and less exaggerated for certain characters or animal

Figure 14.6
Diagram showing the difference in the preferences for flower size between adult and child respondents.

species. We will explore other animals in the future to determine if there are additional trends unique to mammals and other phyla.

Shapes and Form

We presented the respondents with simple shapes and instructed them to choose the shape that is the most cute. As shown in figure 14.11, the preference for roundness is consistent. There was an interesting result, shown in figure 14.12, in which the younger respondents selected for objects with sharper edges, possibly because of seeing the image as more like a star or another symbol.

Rudolf Arnheim's research focuses on the psychology of shapes and perceptual forces, and he describes the concept of the circle as conveying the infinite and purity.[31]

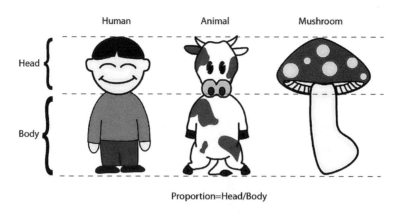

Figure 14.7
Diagram showing the head and body sections of the objects whose proportion the user manipulates.

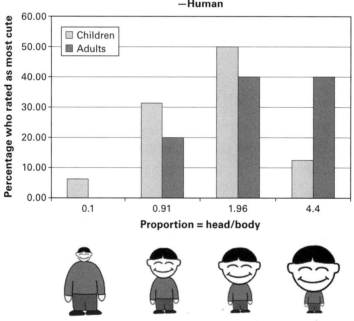

Figure 14.8
Diagram showing the ranges of proportion selected for the human character.

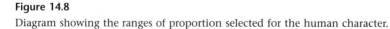

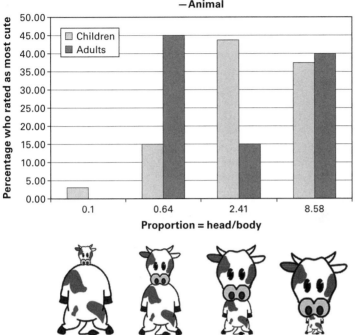

Figure 14.9
Diagram showing the ranges of proportion selected for the animal character.

This could give be why we associate cute and orderliness with the circle. On the other hand, too much order and sharp corners can lead to disinterest.

Cute Engineering

Engineering is the application of technical and scientific knowledge to solve problems. This is very closely related to design work, and in fact, design is one of the tasks of the engineer. Our focus is more closely related to testing and exploring the concept of cuteness as a means to activate cognitive structures, emotional responses, and user behavior, so we have chosen to call this vector of research "Cute Engineering" instead of using the simpler title of "Cute Design."

Research-Oriented Design

The next step to develop and refine the cute engineering approach is to create applications based on our cute engineering research, and, in a research-oriented design

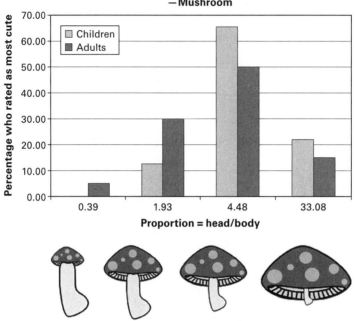

Analysis of Cuteness with Variation of Proportion — Mushroom

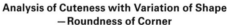

Figure 14.10
Diagram showing the ranges of proportion selected for the mushroom.

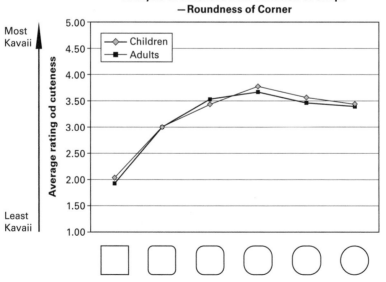

Analysis of Cuteness with Variation of Shape — Roundness of Corner

Figure 14.11
Diagram showing the shapes the user could choose.

Figure 14.12
Diagram showing the shapes the user could choose.

approach, to explore human interaction and experience issues. To conduct this research, two open platforms are being developed: a 3D virtual world for social networking and a small portable robotic interface to the virtual world. These systems will provide a platform to conduct user studies that will explore general user experience issues, and more importantly, the strengths of cuteness in the contemporary world. Research questions include large social issues, for example, "How can cuteness reduce aggression in online communication?" This and other research questions are being answered through ongoing user studies with the prototypes.

Qoot Systems: Petimo and Petimo World for Social Networking

The motivation behind this research is to provide a safe path for children to make friends in online social environments. "Petimo" is an interactive robotic toy that is fun to use and provides face-to-face interaction with friends, while protecting children from the dangers of online social networks. By adding a physical proximity requirement for adding friends, Petimo increases security and adds a new physical dimension to social computing.

Petimo's physical-touch-based friend identification exchange function uses close proximity radio frequency identification (RFID) technology. As shown in figure 14.13, children can add friends by activating the "Add Friend" option in the Petimo menu

Figure 14.13
Physical touch-based friend-adding feature of Petimo.

and physically touching their friends' Petimo. This internally results in exchanging of unique 80-bit identification keys between two Petimos and sending this event to the online user verification system for authentication, after which the relationship is created. In a case where Petimo is stolen, we can blacklist the desired ID from the central key database so that they cannot use the Petimo for any malicious actions. The user-input sensing features include a smooth scrolling-enabled resistive touch sensing pad, primarily for child-friendly menu navigation. Pressure-activated squeeze areas of the robot surface facilitate the exchange of special gifts and emoticons online. Users can experience a multimodal engagement, visually via the miniature organic light emitting diode (OLED) graphics display, audibly by an embedded sound module producing cute sounds, and haptically using a vibrotactile effects generator.

Petimo can be connected to any social network and provide safety and security for children. As proof of our concept, we have developed a 3D virtual world, "Petimo World," which demonstrates all of the basic features that can be realized with traditional online social networks and, in addition, provides interesting interactions such as visualization of your friends' spatial arrangement to understand closeness of friendship, personalized avatars, and sending special gifts/emoticons by physical squeezing.

Conclusion

In this chapter, we have taken a look at the cultural phenomena of cuteness, exploring its possible historical beginnings and its impact on popular design. With the cute engineering concept, we have presented an interactive and friendly soft robotic device, extending its capabilities to fundamentally change social networks. It provides a novel approach for children to make friends easily in a more protected and safe social networking environment. Petimo, together with Petimo World, encourages the development and use of real social networks through interaction, where the interaction is performed through squeezing and touching, and sending gifts/emoticons to their friends, family, and parents. This will dramatically change the younger generation's tendency of being disconnected from family and loved ones by bridging the gaps of existing social network security issues and acting as a powerful means to support a child's safe path toward a secure and personally enriching social networking experience.

Acknowledgments

Adrian David Cheok would like to deeply acknowledge and thank the hard work and efforts of the students and researchers in the Mixed Reality Lab, National University of Singapore who worked on the Cute Engineering and Petimo projects in the laboratory that led to this chapter.

Notes

1. From Yasunari Kawabata's Nobel lecture, "Japan, the Beautiful, and Myself," December 12, 1968: <http://nobelprize.org/nobel_prizes/literature/laureates/1968/kawabata-lecture-e.html>.

2. The first documented culture in the Japanese history. Horticultural and earthenware-related ceremonies of Jomon culture still part of Japanese culture.

3. J. Kreje, *The Path to Civilization: Understanding the Currents of History* (Basingstoke: Palgrave Macmillan, 2004).

4. William Gibson, "My Own Private Tokyo," *Wired* (2001), <http://www.wired.com/wired/archive/9.09/gibson.html>.

5. Midori Matsui, "Beyond the Pleasure Room to the Chaotic Street: Transformation of Cute Subculture in the Art of Japanese Nineties," in *Little Boy: The Arts of Japan's Exploding Subculture*, ed. Takashi Murakami (New Haven: Yale University Press, 2005).

6. Sei Shonagon, *The Pillow Book of Sei Shonagon*, ed. Irna Esme Morris (New York: Columbia University Press, 1991).

7. Inuhiko Yomota, *Kawaii Ron: Understanding Kawaii* (Tokyo: Chikuma Shoten, 2006).

8. Kinko Ito, "A History of Manga in the Context of Japanese Culture and Society," *Journal of Popular Culture* 38, no. 3 (2005): 456–457.

9. See Shimizu Isao, "Discovering the Origins of Anime in Ancient Japanese Art," *Nipponia* 27, December 2003, <http://web-japan.org/nipponia/nipponia27/en/feature/feature03.html>.

10. See Sharon Kinsella, *Adult Manga: Culture and Power in Contemporary Japanese Society* (London and Honolulu: Curzon Press and Hawaii University Press, 2000).

11. Sharon Kinsella, "Cuties in Japan" in *Women, Media and Consumption in Japan*, ed. Lise Skov and Brian Moeran (Honolulu: University of Hawaii Press, 1996), 220–254.

12. Arthur Lubow, "The Murakami Method," *New York Times Magazine*, April 3, 2005, <http://www.nytimes.com/2005/04/03/magazine/03MURAKAMI.html>.

13. See Murakami, *Little Boy*.

14. Diana Lee, "Inside Look at Japanese Cute Culture," 2005, <http://uniorb.com/ATREND/Japanwatch/cute.htm>.

15. Kinsella, "Cuties in Japan."

16. Larissa Hjorth, "Kawaii@keitai," in *Japanese Cyberculture*, ed. Nanette Gottlieb and Mark McLelland (New York: Routledge, 2003), 50–59.

17. Sanrio, "Home of Hello Kitty," 1976–2009, <http://www.sanrio.com/characters>.

18. Kinsella, "Cuties in Japan."

19. Lubow, "The Murakami Method."

20. See Dean Chan, "The Cultural Economy of Ludic Superflatness," 2007 <http://www.digra.org/dl/db/07311.51279.pdf>.

21. Lubow, "The Murakami Method."

22. Kinsella, "Cuties in Japan."

23. Anne Allison, "The Cultural Politics of Pokemon Capatalism," 2002, <http://web.mit.edu/cms/Events/mit2/Abstracts/AnneAllison.pdf>.

24. Joseph S. Nye, Jr., *Bound to Lead: The Changing Nature of American Power* (New York: Basic Books, 1990).

25. Saya S. Shiraishi, "Japan's Soft Power: Doraemon Goes Overseas," in *Network Power: Japan and Asia*, ed. Peter J. Katzenstein and Takashi Shiraishi (Ithaca: Cornell University Press, 1997), 237–273.

26. Hjorth, "Kawaii@keitai."

27. Ravi Prakash Arya, *Ramayana of Valmiki: Sanskrit Text and English Translation* (Delhi: Parimal Publications, 1998).

28. Hjorth, "Kawaii@keitai."

29. Rudolf Arnheim, *Art and Visual Perception: A Psychology of the Creative Eye* (Berkeley: University of California Press, 2004), 337.

30. Konrad Lorenz, "Part and Parcel in Animal and Human Societies," *Studies in Animal and Human Behavior* 2 (1971): 115–195.

31. Rudolf Arnheim, *Visual Thinking* (Berkeley: University of California Press, 2004).

15 Universal Synthesizer and Window: Cellular Automata as a New Kind of Cybernetic Image

Tim Otto Roth and Andreas Deutsch

Es hat doch gar keinen Sinn, die Welt, so wie sie ist, noch einmal zu simulieren. Uns ist doch schon schlecht von dieser Welt [It makes no sense to simulate the world as it is over again—we already feel lousy with this world].[1]

These critical remarks by Vilém Flusser on simulations could apply not only to the virtual worlds of computer games or Second Life, but to digital images in general. Are digital images really new, or are the contemporary imaging techniques just virtual plagiarisms, a kind of extended simulation of long-existing analog painting and photolab techniques?

It is evident that the new digital imaging techniques have changed the way we deal with images, not only in the sciences but also in our daily life. This has very much to do with new possibilities for distribution and storage. But: Do digital images really constitute a pictorial novelty in the sense of a new image logic or a new form of pictorial representation?

To approach this question, one first needs to distinguish the various imaging techniques, which are quite often inappropriately grouped together under the label "digital images" or especially "digital photography." It was Bernd Stiegler who pointed out an "eigentümliche Unschärfe"[2]—a peculiar haziness—of the latter term. In his *Theoriegeschichte der Fotografie* he gives an excellent overview of the discourse on "digital photography" and also reveals its morbid tendency to bury analog photography. Wolfgang Hagen's distinction of three technical processing steps might help to shed some light on that haziness. He distinguishes:

image processing (mathematical image feature analysis),
computer graphics (techniques of algorithmic image generation), and
electronic signal storage (semiconductor/CCD technique).[3]

Which of these three fields offer genuinely new computer-based pictures, in the sense of new forms of representation?

CCD chips, used for example in astronomy (e.g., in the Hubble Space Telescope), significantly extended the range of visibility and, thereby, revolutionized our

understanding of the universe. The application of semiconductors opened up new spectra of light (particularly in the far infrared), which could not be recorded before by photochemical means. But this technology first of all uses a silicon chip that produces an analog signal (similar to those we know from older video cameras). This continuous electrical signal is then converted by an analog–digital converter into a discrete digital value, allowing for mathematical processing thereafter. Accordingly, such light-sensitive semiconductors are not digital per se, but simply allow for the electronic enhancement of analog signals.[4]

Similarly, "image processing" at first glance doesn't offer any ground-breaking novelties. A camera picture, analyzed mathematically, is still subject to the pictorial laws of photography, especially to the central perspective imposed by optical laws. Complicated exposure and development techniques or retouch and collage applied to the final print are replaced here by just a couple of mouse clicks. In this way applications like Photoshop can be understood as simulation tools for analog lab practices that may in fact seriously change our habits of image production, especially by the simplicity and speed of the simulations. But they don't constitute a new kind of pictorial concept, a "post-photography."[5] Interestingly, in the field of "image processing" certain scientific applications do introduce a new type of picture. Examples include interferometric pictures as used in astrophysics or X-ray-diffraction patterns of crystallized proteins. Although these "pictures" are created by analog means—in fact, they are interference patterns with varying densities—the computer is required for any interpretation of their data.

Computer graphics is typically associated with technically elaborated simulations, which indeed offer new ways to interact with images in real time. But if we focus on the visual organization of, for instance, modern computer games, we find that the corresponding pictures are still structured according to central perspective, the dominant pictorial construction method since the Renaissance. But in principle, computer-based image-generation techniques also offer the possibility of structuring a planimetric surface in a purely formal way according to mathematical rules. Thus, a computer-based image isn't necessarily referential, that is, it doesn't need to represent an external object; it can just present the visual result of a mathematical operation in a planimetric model. Interesting examples of this type of image include self-similar patterns or cellular automaton simulations. Although self-similar patterns like Benoit Mandelbrot's "apple man" have become quite popular, cellular automata are still hardly known to the larger public. This essay introduces the concept of cellular automata with a particular focus on seeing them as a genuinely new kind of dynamic digital image. The novelty lies in the dynamical character of the model. Cellular automata are neither a static picture nor an animation. Furthermore, the model presented here breaks with the paradigm that computer-based images are just "artificial, algorithmic relations of data and their visualisation."[6] On the contrary, it will become clear that

cellular automata are not arbitrary visual appearances, but inherently precise spatial configurations.

Cellular Automata

The concept of cellular automata goes back to the late 1940s. At that time important discoveries were made in the field of biology involving the principles of the self-reproduction of living cells based on nucleic acids—a precondition for the discovery of the DNA structure in 1953. Inspired by the self-reproduction mechanisms of living organisms, the mathematician and inventor of game theory John von Neumann developed the idea of self-replicating automata. His "kinematic system" was rather complicated, composed of 29 different types of elements swimming in a pool of constructional parts. A kind of genetic tail contains the information how to create a new automaton from those parts.[7] The mathematician Stanislaw Ulam, who collaborated with von Neumann on the "Manhattan Project" in Los Alamos, suggested some crucial simplifications of the automaton concept. He proposed to discretize the system by imposing a regular grid. Instead of there being 29 different elements, all grid points—the so-called cells—follow the same simple transition rule that specifies how each point interacts with its neighborhood. In such a cellular automaton all cells change their state simultaneously in discrete moments of time. The subsequent state of a cell depends only on the states of its adjacent cells. This state is always discrete;[8] in the simplest case, it is binary, distinguishing between an active and a nonactive state. Accordingly, each cell functions like a little computer, repeating again and again the same rule defining how to react to its neighbors. This is why John Holland characterized this type of system as one of "iterative circuit computers."[9] Discussing the regular polygonal cell shape, Edward F. Moore speaks about "tessellation structures."[10] To describe vivid interaction of these picture tiles, or pixels, the notion of "pixelsex"[11] was introduced in a recent art and science project (figure 15.1). Today the notion of cellular automata is well established for this type of mathematical model.

La-Ola-Wave, Rugs, and Complexity

Cellular automata can demonstrate intuitively how complex systems work even without explicit knowledge of mathematical formulas. The simplest form of cellular automata is a one-dimensional automaton that can be imagined as a chain of pearls reacting to their neighbors on the right and left sides. For instance, a la-ola-wave in a stadium can be studied with a (linear, i.e. one-dimensional) chain of people forming a circle and reacting to their neighbors on either side. A clockwise circulating pattern is generated according to the rule: "get up if the right neighbor was standing, and sit down if the right neighbor was sitting, in the previous step." Such a one-dimensional

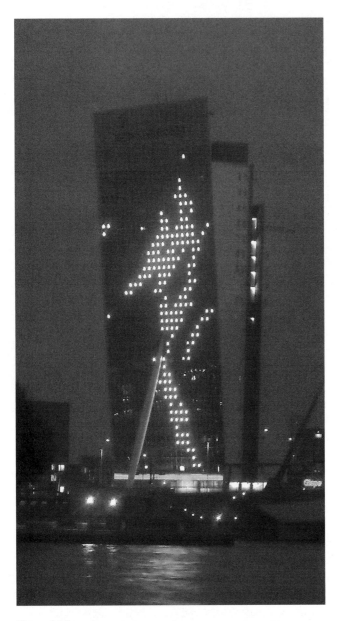

Figure 15.1
Pixelsex literally animated the 80-meter-high light wall at the KPN Telekom Tower in Rotterdam. This art and science collaboration by Tim Otto Roth and the biomodeling group of Andreas Deutsch at TU Dresden transmitted in near real time via the Internet a dynamic model of swarming myxobacteria to the building's facade in winter 2006. <http://www.pixelsex.org>. © Tim Otto Roth/imachination projects.

automaton can generate quite complex patterns just through slight modifications to these rules.[12]

Cellular automaton–like dynamics can be also demonstrated in rugs tied line by line with black and white knots on a rectangular grid. You start by tying white knots in the first line. Only the vertical thread in the middle gets a black knot. Suppose we follow the rule to tie a black knot in the next line of a vertical thread only if in the previous line there were one or two black neighbor knots; otherwise tie a white knot. An oscillating pattern will emerge, comparable to a Navaho rug.[13] Imagine now that we modify the rule so that we tie a black knot only if exactly one black knot existed in the neighborhood in the previous line. Then a fractal pattern will emerge that resembles Pascal's triangle, coloring the uneven numbers black and the even numbers white (figure 15.2).[14]

These simple examples show that cellular automata offer a paradigm for complex systems. The complexity is based on the local interaction of the cells and the iterative processing of subsequent configurations. To determine the configuration at a certain time, all the previous configurations of the systems need to be calculated step by

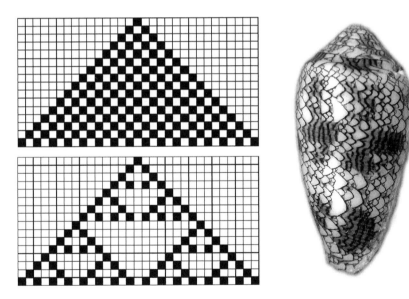

Figure 15.2
A simple one-dimensional automaton can be imagined simply by tying a rug line by line. Depending on the state of the knots in the previous line a white or black knot is tied. Slight changes in the rules can have a severe effect on the resulting pattern (see text). Such patterns can be found also in nature, for instance in the growth patterns of sea shells. Drawing by and © Tim Otto Roth and Andreas Deutsch.

step. A small change in the initial conditions may provoke a completely different development of the system. Stephen Wolfram has argued that depending on the initial situation and on the rule followed, four constellation classes can appear:[15] The system tends to a homogeneous state; the system remains in a static or periodic state (e.g., oscillation); the movement shows no regularity (chaos); or the system exhibits complex localized spatiotemporal patterns. Above all there is the "inverse problem"[16] of finding a microscopic rule underlying the development of given macroscopic properties.

The Iconic Turn: "Use Your Eyes"

Stanislaw Ulam was aware of the implications of the numerical difficulties involved in predicting the behavior of cellular automata:

Put in the simplest terms, unless one knows precisely what one is looking for, mere lists of numbers are essentially useless.[17]

Faced with this situation, he asked how to recognize "convergence" in a system. His simple answer is visualization:

We can only supply a partial answer to this question, but that answer has the advantage of simplicity, viz., "use your eyes."[18]

In the beginning of the 1960s, Stanislaw Ulam was one of the few privileged scientists who had access not only to computing power but also to corresponding visualization tools. The oscilloscope as a primitive vector screen and the Polaroid camera as a printing device made particular "morphologies"[19] demonstrable. These automatic plotting devices did "allow one to tell at a glance what is happening."[20] So a pictorial representation is indispensable in dealing with and evaluating the dynamics of cellular automata. Pictures and simulations become the workbench of the experiment and initiate a kind of "viscourse."[21] Finally, the history of cellular automata is tied not only to mathematics and computability, but also to the iconic turn,[22] handling the result not just as code but as a picture by means of rudimentary computer graphics.

A purely visual approach to cellular automata was also taken by Jim Crutchfield in the beginning of the 1980s. He used the video feedback of a color video camera filming its own image on a screen as an iterative system to simulate two-dimensional cellular automata. In contrast to the analog electronic feedback networks in use at that time, a video feedback system was able to process entire images rapidly according to the frame rate of the devices. To "program" the space-time dynamics of the video feedback, Crutchfield used as variables the orientation angle of the camera, the distance between camera and screen, and the luminance. Crutchfield considers a monochrome system especially useful to simulate binary cellular automata.[23]

Checkerboard as Visualization Tool

For simple automata, less technical visualization approaches also exist. Stanislaw Ulam used a checkerboard to experiment with a three-dimensional system. At the end of the 1960s the mathematician John Horton Conway developed a very popular two-dimensional automaton using an expanded checkerboard. With this simple tool he elaborated the "Game of Life," based on a simple but genius rule for how a cell interacts with its eight neighbors in a rectangular grid, which generates oscillating and meandering pixel amoebae. Announced as a "new solitaire game" in the mathematical games section of *Scientific American*, the game rapidly became widely known.[24] Its popularity might be related to the fact that the Game of Life doesn't appear mathematical in a classical sense, but rather more as a visual practice emancipated completely from the underlying linear calculus.

A Prime Example of Self-Organization

Models like the Game of Life demonstrate that cellular automata constitute a prime example of self-organization, according to which systems develop a macroscopic order without a central directing instance. How new macroscopic behavior (a behavior that is not present at the level of the "microscopic" system constituents) can emerge from the local interaction of simple constituents can be demonstrated with a simple scenario from the Game of Life: If you start with just three cells in a line, the line will rotate through 90 degrees in the next step (figure 15.3). The resulting macroscopic oscillation pattern isn't manifested at the level of the individual cells and their rules: An active or living cell survives only if it has two or three neighbors, and a nonactive cell is reanimated in the next time frame if it has exactly three neighbors.[25]

What makes automata like the Game of Life so interesting is the aspect of self-organization or emergence, which is related to the system's irreducibility and unpredictability:[26] It is difficult to deduce the simple local microscopic rules of the cells from the patterns appearing on the macrolevel. Above all, for systems like the Game of Life the behavior can't be predicted, although you can sometimes calculate a probability of where the system might tend to. Following Stanislaw Ulam, this aspect of self-organization changes a cellular automaton calculation into a kind of empirical experiment:

We are not attempting to "solve" some well-defined problem; instead we investigate via repeated trials the asymptotic properties of certain nonlinear transformations, usually without any advance knowledge of what we may find in a given case.[27]

This aspect distinguishes the self-organization rules of a cellular automaton from classical concepts of development based on preformation. The word "development" still

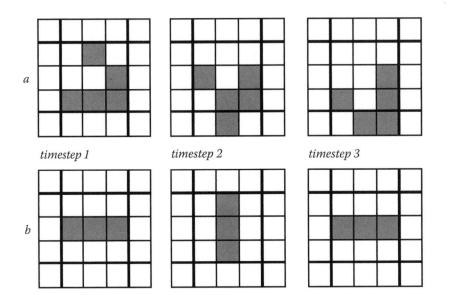

a timestep 1 timestep 2 timestep 3

b

Figure 15.3
A simple scenario for the Game of Life demonstrates the aspect of emergence in cellular automata. Some of the resulting figures can oscillate (b) or even move (a) in the grid. Drawing by and © Tim Otto Roth and Andreas Deutsch.

echoes this conventional Platonic concept of unveiling a preexisting pattern. The idea of a homunculus reflects this concept of development from a nucleus that contains the whole prefiguration for the later morphogenesis.[28]

Cybernetics

The idea of cellular automata first arose at about the same time that Warren McCulloch and Walter Pitts introduced their model of the central nervous system and Norbert Wiener developed his ideas on cybernetics.[29] John von Neumann's concept of a kinematic system was inspired by Alan Turing, who developed the concept of the Turing machine in the 1930s. One of von Neumann's ideas was to improve the concept of a Turing machine through replacing an external reproduction machine with a self-reproducing automaton concept. In 1952, Alan Turing published his paper "The Chemical Basis of Morphogenesis," describing a principle of self-organization based on local mechanisms.[30] These self-organization principles might have their own fascinating reality, but ultimately they are just models of real nature. John von Neumann was quite aware of the virtual character of his automata:

Natural organisms are, as a rule, more complicated and subtle, and therefore much less well understood in detail, than are artificial automata. Nevertheless, some regularities which we observe in the organization of the former may be quite instructive in our thinking and planning of the latter.[31]

Discrete Caricatures

Cellular automata constitute a purely digital model that "produces a variety of sets different from those defined by explicit algebraic or analytical expressions or by the solution of usual [continuous] differential equations."[32] This is why sometimes these automata are characterized as "caricature of classical physics"[33] or as discrete "caricatures"[34] of dynamical systems, especially of models based on differential equations. Cellular automata differ from continuous models by their discreteness. They are completely digital, based on a discrete lattice of cells, a discrete—typically small—set of states (often binary), and discrete steps of time.[35] In this sense, Tommaso Toffoli and Norman Margolus state, "cellular automata are the computer scientist's counterpart to the physicist's concept of a 'field.'"[36] To calculate fields in a computer by continuous models of space and time requires converting them into discrete values. This is not always possible without making compromises in the form of approximations. Cellular automata don't have these formalization or digitalization problems because of their discrete nature.[37]

Physics and Digital Particles

Tommaso Toffoli even goes a step further: "The importance of cellular automata lies in their connection with the physical world. In fact, they possess certain constructive properties that set them in a privileged position as models of physical computation and, at the same time, as computational models of physics."[38] So the question is whether the cellular automaton model is not merely a simulation tool, but could give also a description of a physical process.

In Germany in the 1960s, Konrad Zuse, one of the inventors of the modern computer, tried to transfer the principle of parallel computing to the physical world. He was inspired by his relay computers to speculate whether there were processes on the quantum level that might work according to cellular automaton principles—the world as "*Rechnender Raum*," a computing universe (figure 15.4).[39] According to this concept, information would be created by stabilizing certain meandering patterns of "Digitalteilchen"—digital particles within a self-reproducing system:

However, there is the interesting question about such structures propagating in space not as a wave front but as spatially limited structures, which bear a certain analogy to elementary particles. We want to call these formations digital particles.[40]

Figure 15.4
Ralf Baecker's *Rechnender Raum* is reminiscent of Konrad Zuse's ideas. The kinetic sculpture is a
translation of a circular one-dimensional automaton into a mechanical device. In the center of
the sculpture, a special display made of rubber threads shows the state of the automaton. Fest-
spielhaus Hellerau, CYNETart 2008, Dresden, Germany. Wood, metal, threads and electronics,
dimensions: ca. 2.5 by 2.5 meters. © Ralf Baecker.

Interestingly, Stanislaw Ulam linked these "subsystems" with biology and self-
reproduction, calling them "automata or organisms," "which are able to multiply, i.e.,
create in time other systems identical ('congruent') to themselves"[41] (figure 15.5).

Parallel Computers and Vision Chips

In the 1980s, concepts linking physics and cellular automata were discussed contro-
versially, while researchers developed new concepts for parallel computing architec-
tures such as the Connection Machine, a series of parallel super computers built
between 1983 and 1991 in the United States.

Today, there are several concepts for how to adopt cellular automata in parallel
computing architectures. Cellular automata play a crucial role, for instance, in the

Figure 15.5
Left: Photograph of a spiral wave resulting from the aggregation of the slime molds *Dictyostelium*. © dictyBase, Northwestern University. Right: Spiral pattern of excitable media in a simulation based on cellular automata. © Andreas Deutsch.

concepts for a magnetic quantum dot computer, or in the design for a quantum computer that uses a three-dimensional cellular automaton on a simple sodium chloride salt crystal.[42]

There are also functioning applications of cellular automata in enhanced vision chips fusing the image caption and its processing in one and the same device. In these CMOS chips (vMOS, SCAMP3), the processing unit is directly coupled with the light-sensing unit and also registers the measurements of neighboring units. In this way, edges can be detected in near real time after applying simple rules similar to the one in the Game of Life (about 200 frames/s).[43]

Cellular Automata as a New Kind of Digital Image

This fusion of image capturing and processing in the form of vision chips not only makes cellular automata interesting in the context of image studies, or *Bildwissenschaft*. As Stanislaw Ulam has suggested, the use of pictures is indispensable to cellular automata and differs fundamentally from their numerical component:

Very often the picture itself will suggest some change in the course of the investigation—for example, the variation of some hitherto neglected parameter.[44]

But images of cellular automata not only reveal an iconic difference from their calculus. As planar automata or a time plot of a linear automaton, the model in general constitutes a new kind of digital image. Some of its fundamental qualities include:

Composition A two-dimensional automaton constitutes a purely digital image consisting of a tessellated structure composed of cells, which can be interpreted as picture elements or pixels.[45] These cells have discrete (often binary) values.

Pixel morphology Pixels are more than a mathematical dot. They have a polygonal shape and function as morphological unit. The corresponding tessellation influences the pictorial output.

Iterative dynamics The image itself generates all future images. The imagery is not an arbitrary kinematographic succession, but is primarily a dynamically changing spatiotemporal pattern. Even a static pattern is the result of a preceding dynamic process.

Cybernetic picture By their construction as a network of iterative pixels, cellular automata are in fact cybernetic pictures.

Pictorial predictability The theory of cellular automata allows us to classify the dynamic behavior of the automata, which ranges from very predictable (e.g., an image remains static) to highly unpredictable (e.g., chaotic behavior). There are even "nonconstructible" pictures: The so-called Garden of Eden configurations are "unreachable" pixel constellations with no predecessors. They cannot appear after the first step independently from the initial configuration.[46]

Parallel Spatial Logic of Pictures

Consequently, cellular automata differ from the common concept of a digital picture. The dynamic pictorial logic of a cellular automaton is parallel, not serial. The a priori spatial structure is not only present in the visualization but also in the data structure represented by arrays. This becomes obvious by watching the connected surface of a vision chip or the cellular automata machine (CAM) by Tommaso Toffoli and Norman Margolus where each pixel is represented by an individual processor within an array. The parallel processing requires not a sequential but a spatial structure of the data.[47] Of course you can run cellular automata on a conventional serial computer, but ultimately you simulate a parallel system. So the classical distinction between data as serial notation in the form of textlike code and the image as its spatial translation is fundamentally undermined.

Virtual Reality

Cellular automata offer a special kind of virtual reality; to speak with Toffoli and Margolus: "They have their own kind of matter which whirls around in space and time of their own."[48] Such a virtual reality has nothing to do with the knock-offs à la Second Life. This new quality of virtuality does not converge with established concepts that connect picture and virtual reality. For instance, Oliver Grau claims that

virtual reality is essentially connected with immersion and tends to efface the distance between spectator and picture.[49] But cellular automata do not pretend at all to be an illusionary "as-if."

Lambert Wiesing introduces a new idea, that of comprehending virtual reality as an act of partial "adjustment of a picture to the imagination."[50] According to the philosopher, a picture consists of a flat structure that is purely visible.[51] He distinguishes in this context between the material surface of a picture and the pictorial object. He underlines the "artificial presence" inherent to pictures: What is ultimately represented in a picture, the pictorial object, is not bound to the presence of a real object. Generally, a pictorial object is situated between our imagination and a real object of our perception. You can transform a real object or play with a fantastic object in your imagination. But whether you can modify the pictorial object depends on the picture's medium. Wiesing distinguishes four classes of pictorial objects:

the fixed pictorial object of a panel;
the pictorial object of a movie that is in motion but determined;
the free-style manipulable pictorial object of an animation; and
the interactive pictorial object of the simulation.[52]

Neither the pictorial object of a panel nor the changes to the movie in time can be altered by the observer. Wiesing attributes the crucial difference of digital technologies to the fact that they now allow pictures that enable the spectator to manipulate a pictorial object. Consequently, digital imaging technology leads to an approximation of picture and imagination. Wiesing distinguishes here between animation and simulation. An animation is an "externalized object of fantasy"[53] and is modifiable without being bound by the constraints of physics. So you can freely create a surreal scenario in an animation. This implies that the spectator is able to anticipate the consequences of his interaction with the picture. However, a simulation is more restricted, and the pictorial object is bound to the laws of physics. Referring to Jean-Paul Sartre's concept of imagination, Wiesing underlines the difference between our own imagination and its externalization in a computer. Whereas we are never astonished by our own fantasies, a computer can surprise us, confronting us with an unexpected result. So a simulation obtains the character of a "Gedankenexperiment," a thought experiment, as virtual imaginary event.

Nonsymbolic Pictures

If Wiesing claims that simulations are the artificial presence of physics, what about cellular automata? And what is the pictorial object of a cellular automaton? A cellular automaton picture doesn't principally represent a real object. It can be used as a simulation and be projected on some phenomenon to provide a potential explanation. But

cellular automata present neither an object nor a physical law. They are not the product of fantasy but the visual result of a mathematical operation. As closed self-referential mathematical systems they are principally nonsymbolic[54]—just like self-resembling patterns. Finally, a cellular automaton represents the result of the iterative processes, that is, the previous steps of the pictorial computation. There is, in a way, an artificial presence in the macroscopic patterns being the expression of the inherent microscopic behavior. Cellular automata visualize a planimetric interaction that can't be understood on a numeric level but only as a picture. It was Stanislaw Ulam who started using pictures not to control or to interact with cellular automata, but just to get an initial idea of where these unpredictable systems might lead. So, in a way, pixelated automata can take over the imagination completely. Finally, a fifth class should be introduced in Wiesing's classification of pictorial objects: the mathematics-based cybernetic picture.[55]

Universal Synthesizer and Score

The crux of cellular automata is not only their spatial organization, which suggests their treatment as pictures, but also the related dynamics. Toffoli and Margolus point to the performative aspect inherent in this dynamics and introduce a further aspect by bringing cellular automata into the context of music:

A cellular automata machine is a universal synthesizer. Like an organ, it has keys and stops by which the resources of the instrument can be called into action, combined, and reconfigured. Its color screen is a window through which one can watch the universe that is being "played."[56]

The composite character of cellular automata as simultaneously musical and visual, synthesizer and window, expresses the dynamics of these "machines." The dynamics of music and a visual representation also come together in the concept of a score, the notation used to perform a music piece.[57] This scheme might be also translated to the use of digital images. In that sense the image data comprise the score to be interpreted on a visualization device like a screen. Cellular automata even go a radical step further: They are a self-performing score. Cellular automata don't denote an external object that is created by translating the notation. The pictorial appearance is always the immediate expression of the self-performing score. In fact, as spatial notation, cellular automata function as a score and an image at the same time.

Pictures without a History

Whether cellular automata really constitute "a new kind of science"—as claimed by Stephen Wolfram—is debatable. From an aesthetical point of view, seen as a cybernetic picture, they probably provide a new type of dynamically changing model with no

precedent in human culture.[58] It is remarkable that until today in the design tradition no visual pattern-generation technique based on that simple principle has been found.

In this sense, cellular automata differ in their ahistorical character from other techniques of creating images and visual structures—cellular automata seem to have no predecessor in the history of images. Pictures without a pictorial history are not a contradiction per se, as claimed by Horst Bredekamp.[59] For him, pictures necessarily refer to previous pictures in history. This might be true for paintings, but not for certain mathematical images like cellular automata, self-similar patterns or analog technical pictures like X-rays, crystallographies, or records from particle physics.

But sometimes previously unknown predecessors of mathematical models may turn up quite unexpectedly: For instance, the physicist Peter Lu discovered quasi-crystalline structures—so-called Penrose patterns—in medieval Girhi tilings in Islamic architecture. Persian architects created very complex tilings not by calculus but by a clever combination of several stencils.[60]

In conjunction with art, cellular automata are almost always mentioned in the context of "bio-art" and linked in theoretical writings with artificial life.[61] But it is remarkable that despite the intuitive understanding of the principles of cellular automata, only very few artists have focused on the formal qualities of cellular automata in their works. There is a large tradition in art on either how to create dynamics in a picture, including using accidental processes in the generation of the picture, or how to construct systematically formal relations between pictorial elements. For instance, Richard Paul Lohse developed a strict systematics on how to compose colors in tessellated matrices. This is a kind of Sudoku for colors, associating a color value with a number and combining it with other colors in the same horizontal and vertical line according to a certain distribution rule.[62] Consequently, an individual picture shifts to a series or a class of pictures. But it is inherent to the rules applied by Lohse to achieve a certain symmetry and harmony in the pictorial result. Above all, the artist is still the final control, choosing a basic setting or some other one to achieve a desired effect.

Cellular automata go a crucial step further: The picture elements literally take over the dynamic image-generation process. The action of the artist is reduced to choosing an initial setting and a rule; the rest is up to the interaction of the pixels. Thus, the philosophy of cellular automata differs radically from other generation techniques: The picture is not just a visualization of external nonlinear calculation processes; rather, the picture itself creates the pictorial dynamics out of its own elements.

Notes

1. Florian Rötzer and Peter Weibel, eds., *Cyberspace—Zum medialen Gesamtkunstwerk* (Munich: Boer, 1993), 70.

2. Bernd Stiegler, "Die digitale Fotografie," in *Theoriegeschichte der Fotografie*, ed. Bernd Stiegler (Munich: Fink, 2006), 403–422, here 409.

3. Hagen speaks about "image processing (mathematische Bildverarbeitungstechniken), Computergraphik (Techniken der algorithmischen Bild-Erzeugung) und elektronische Signalspeicherung (Halbleiter-/CCD-Technik)." Cf. Wolfgang Hagen, "Die Entropie der Fotografie—Skizzen zur Genealogie der digital-elektronischen Bildaufzeichnung," in *Paradigma der Fotografie—Fotokritik am Ende des fotografischen Zeitalters*, ed. Herta Wolf (Frankfurt: Suhrkamp, 2002), 195–235, here 195.

4. Tim Otto Roth, "Ars Photoelectronica—Astronomie als Königsdisziplin der Farbe," in *rot.grün. blau.—Experiment in Farbe & Licht*, ed. Konrad Scheurmann (Ilmenau: Technische Universität, 2008), 90–93.

5. In this context the concept of "post-photography" should be revised. See William J. Mitchell, *The Reconfigured Eye: Visual Truth in the Post-Photographic Era* (Cambridge, MA: MIT Press, 1992). Interestingly, Mitchell doesn't explain the notion "post-photographic" in the book. The postulated change brought about by digital image-recording techniques is not phenomenological, though it is at least hermeneutic. In fact, camera and lens construction were not changed by digital recording. An X-ray appears much more post-photographic, constituting a new concept of pictorial organization. Cf. Tim Otto Roth, "This Is Not a Photograph—Some Remarks on the Photogram as a Picture," in *Congress of Photography in Vienna*, ed. Anna Auer and Uwe Schögl (Salzburg: Edition Fotohof, 2008), 464–469.

6. "Computergrafik ist nie die notwendige Folge bestimmter Daten, sondern immer nur eine von vielen möglichen Formen ihres Erscheinens." Claus Pias, "Punkt und Linie zum Raster," in *Ornament und Abstraktion*, ed. Markus Brüderlin (Cologne: Dumont, 2001), 64–69.

7. For Arthur W. Burks, a "kinematic system" doesn't yet constitute a cellular automaton. See Arthur W. Burks, "Von Neumann's Self-Reproducing Automata," in *Essays on Cellular Automata*, ed. Arthur W. Burks (Urbana: University of Illinois Press, 1970), 3–83, here 51. See also Martin Gerhardt and Heike Schuster, *Das digitale Universum: zelluläre Automaten als Modelle der Natur* (Wiesbaden: Vieweg, 1995).

8. "Discrete" in mathematics means *noncontinuous*.

9. John H. Holland, "Iterative Circuit Computers," in *Essays on Cellular Automata*, 277–296.

10. Edward F. Moore, "Machine Models of Self-Reproduction," in *Essays on Cellular Automata*, 187–203, here 188.

11. *Pixelsex* was the name of an art and science collaboration between Tim Otto Roth and the biomodeling group of Andreas Deutsch at Technical University, Dresden, Germany, in 2006. See <http://www.pixelsex.org>.

12. This was demonstrated in the year 2008 with the "Music of Life" project, in which various cellular automaton rules were applied to the singers of a choir. See <http://imatters.de/pixelsex _org/musicoflife/index.htm>.

13. Richard H. Enns and George McGuire, *Computer Algebra Recipes* (Berlin: Springer, 2006), 408–410.

14. Heinz-Otto Peitgen, Hartmut Jürgen, and Dietmar Saupe, eds., *C_H_A_O_S—Bausteine der Ordnung* (Stuttgart: Klett-Cotta, 1994), 571. (English translation: *Fractals for the Classroom* [New York: Springer, 1992].)

15. Stephen Wolfram, "Universality and Complexity in Cellular Automata," *Physica D 10* (1984): 1–35.

16. Howard A. Gutowitz, introduction to *Cellular Automata—Theory and Experiment*, ed. Howard A. Gutowitz (Cambridge, MA: MIT Press, 1991), vi.

17. P. R. Stein and Stanislaw M. Ulam, "Nonlinear Transformation Studies on Electronic Computers," in Burks, *Essays on Cellular Automata*, 252.

18. Ibid., 254.

19. Stanislaw M. Ulam, "Mathematical Problems with Growth of Figures," in Burks, *Essays on Cellular Automata*, 219–231, 231.

20. Stein and Ulam, "Nonlinear Transformation Studies on Electronic Computers," 253.

21. Karin Knorr Cetina introduces the term "viscourse" in opposition to discourse to underline the experimental and communicative role of pictures in high-energy physics. Karin Knorr Cetina, "'Viskurse' der Physik—Konsensbildung und visuelle Darstellung," in *Mit dem Auge denken— Strategien der Sichtbarmachung in wissenschaftlichen und virtuellen Welten*, ed. Bettina Heintz and Jörg Huber (Zürich: Ed. Voldemeer, 2001), 305–320, here 308.

22. The concept of the "iconic turn," or the "pictorial turn," arose in the 1990s. The idea is to consider images as a source of knowledge equivalent to language. See Christa Maar (ed.), *Iconic Turn* (Cologne: Dumont, 2004).

23. Experimenting mainly with color feedback, Crutchfield also refers to other dynamic space-time models. For instance, he connects some "dapple patterns" with Turing's reaction-diffusion system. Jim P. Crutchfield, "Space-Time Dynamics in Video Feedback," *Physica 10D* (1984): 229–245.

24. Martin Gardner, "Mathematical Games—The Fantastic Combinations of John Conway's New Solitaire Game 'Life,'" *Scientific American* 223 (October 1970): 120–123.

25. See also the samples in Mitchel Resnick and Brian Silverman, *Exploring Emergence*, <http://llk.media.mit.edu/projects/emergence/life-intro.html>.

26. Klaus Brunner discusses cellular automata in the context of emerging computing. See Klaus Brunner, "What's Emergent in Emergent Computing?," in *Cybernetics and Systems*, ed. Robert Trappl (Vienna: Austrian Society for Cybernetic Studies, 2002), 189–192.

27. Stein and Ulam, "Nonlinear Transformation Studies on Electronic Computers," 254.

28. For a classification of organization principles, see Andreas Deutsch and Sabine Dormann, *Cellular Automaton Modeling of Biological Pattern Formation—Characterization, Applications, and Analysis* (Boston: Birkhäuser, 2005), 32. See also Andreas Deutsch, *Muster des Lebendigen: Faszination ihrer Entstehung und Simulation* (Wiesbaden: Vieweg, 1995).

29. Von Neumann referred to a "neuron analogy" when introducing his concept for a digital computer in 1945. He also took part in a discussion panel about the central nervous system at the Macey Conference in 1950. See "Some of the Problems Concerning Digital Notions in the Central Nervous System," in *Cybernetics—Kybernetik, The Macy Conferences 1946–1953*, ed. Claus Pias (Zurich: Diaphanes, 2003), 171–202.

30. Alan Turing, "The Chemical Basis of Morphogenesis," in *Philosophical Transactions of the Royal Society of London B* 237 (1952): 37–72. This reaction-diffusion model is based on the local interaction of two substances with different diffusion coefficients.

31. John von Neumann, "The General and Logical Theory of Automata," in *Collected Works*, vol. 5, ed. A. H. Taub (New York: Pergamon Press, 1963), 288–289. Cited in Helmut Schnelle, "Turing Naturalized—Von Neumann's Unfinished Project," in *The Universal Turing Machine: A Half-Century Survey*, ed. Rolf Herken (Hamburg: Kammerer & Unverzagt, 1988), 539–559, here 550.

32. Robert G. Schrandt and Stanislaw M. Ulam, "On Recursively Defined Geometrical Objects and Patterns of Growth," in Burks, *Essays on Cellular Automata*, 232–243, here 233.

33. Stefan Helmreich, *Silicon Second Nature—Culturing Artificial Life in a Digital World* (Berkeley, CA: University of California Press, 2000), 76.

34. H. Bossel, *Modeling and Simulation* (Wellesley, MA: Peters, 1994). See also Deutsch and Dormann, *Cellular Automaton Modeling of Biological Pattern Formation*, 60.

35. This discrete conception connects them mathematically to stochastic processes and coupled map lattices (CMLs).

36. Tommaso Toffoli and Norman Margolus, *Cellular Automata Machines: A New Environment for Modeling* (Cambridge, MA: MIT Press, 1987), 5.

37. There are also models that combine a differential equation with a discrete lattice, e.g., the Lattice Bolzmann model. Cf. Dieter A. Wolf-Gladrow, *Lattice-Gas Cellular Automata and Lattice Boltzmann Models* (Berlin: Springer, 2000).

38. Tommaso Toffoli, "Cellular Automata Mechanics" (Technical Report No. 208 at the University of Michigan, November 1977), 12.

39. Konrad Zuse, *Rechnender Raum* (Braunschweig: Vieweg, 1969); Konrad Zuse, "The Computing Universe," *International Journal of Theoretical Physics* 21, nos. 6–7 (1982): 589–600.

40. "Interessant ist jedoch die Frage nach solchen Strukturen, die sich nicht im Raum als Wellenfront, sondern in Form von räumlich begrenzten Strukturen fortpflanzen, die in eine gewisse Analogie zu Elementarteilchen gesetzt werden können. Wir wollen solche Gebilde Digitalteilchen

nennen." Konrad Zuse, "Der Rechnende Raum," *Elektronische Datenverarbeitung* 8 (1967): 336–344, here 339. Translation by the author.

41. Stanislaw Ulam, "Random Processes and Transformations," in *Proceedings of the International Congress of Mathematicians* 2 (1950): 264–275, here 274.

42. Daniel B. Miller and Edward Fredkin, "Two-state, Reversible, Universal Cellular Automata in Three Dimensions," 2005, arXiv:nlin/0501022v3 (nlin.CG). See <http://arxiv.org/abs/nlin/0501022>.

43. T. Asai, T. Sunayama, Y. Amemiya and M. Ikebe: "A vMOS Vision Chip Based on the Cellular-Automaton Processing," in *Japanese Journal of Applied Physics* 40, no. 4B (2001): 2585–2592; Piotr Dudek, "Vision Chips with Pixel-Parallel Cellular Processor Arrays," in *Gdansk University of Technology Faculty of ETI Annals*, No. 5, May 2007. The SIMD processor arrays used by Dudek for the SCAMP3 vision chip are computationally equivalent to cellular automata.

44. Stein and Ulam, "Nonlinear Transformation Studies on Electronic Computers," 253.

45. The pixel is not necessarily related to the computer; tessera in ancient mosaics are an example of an early version of discrete picture elements.

46. Edward F. Moore, "Machine Models of Self-Reproduction," in Burks, *Essays on Cellular Automata*, 187–203, here 195. The notion of the Garden of Eden was suggested by the American statistician John Wilder Tukey.

47. One of the properties of a parallel computer is that cyclic program procedures distribute a spatial representation cyclically on the processor grid.

48. Tommaso Toffoli and Norman Margolus, introduction to *Cellular Automata Machines*.

49. "Virtuelle Realitäten—historisch wie aktuell—sind essentiell immersiv," in Oliver Grau, *Virtuelle Kunst in der Geschichte und Gegenwart—Visuelle Strategien* (Berlin: Reimer, 2001), 22.

50. See Lambert Wiesing, "Virtuelle Realität—die Angleichung des Bildes an die Imagination," in Lambert Wiesing, *Artifizielle Präsenz* (Frankfurt: Suhrkamp, 2005), 107–124. Wiesing refers in that context to Edmund Husserl and Jean-Paul Sartre.

51. Lambert Wiesing, *Phänomene im Bild* (Munich: Fink, 2000), 10.

52. Wiesing, "Virtuelle Realität," 122.

53. Ibid., "Ein externalisiertes Phantasieobjekt," 119.

54. They interact syntactically but without any semantics. So they are pure discrete systems but not necessarily "digital systems." Nelson Goodman defined a "digital system" in his theory of symbols to be syntactically as well as semantically differentiated. See Nelson Goodman, *Languages of Art* (Indianapolis: Hackett, 1992), 161.

55. Wiesing concedes to mathematics the possibility of its own pictorial concepts. See the interview with the author: <http://www.imachination.net/next100/reactive/wiesing>.

56. Toffoli and Margolus, introduction to *Cellular Automata Machines*.

57. Interestingly, Nelson Goodman introduces the concept of the score in his theory of symbols, mainly dealing with visual representations. Goodman, *Languages of Art*, 177.

58. Compare Wolfram's example of oriental patterns in Stephen Wolfram, *A New Kind of Science* (Champaign, IL: Wolfram Media, 2002), 43. Laura Marks questions Wolfram's claim in her recent book: Laura U. Marks, *Enfoldment and Infinity: An Islamic Genealogy of New Media Art* (Cambridge, MA: MIT Press, 2010).

59. See "Schwarze Legenden, Horst Bredekamp im Gespräch mit Wolfgang Ullrich," *Neue Rundschau* 114 (2003): 9–25, here 10.

60. Peter J. Lu and Paul J. Steinhardt, "Decagonal and Quasi-crystalline Tilings in Medieval Islamic Architecture," *Science* 315 (2007): 1106–1110.

61. See, e.g., Ingeborg Reichle, *Kunst aus dem Labor—Zum Verhältnis von Kunst und Wissenschaft im Zeitalter der Technoscience* (Vienna: Springer, 2005), 158–219.

62. Richard Paul Lohse, *Zeichnungen—Dessins 1935–1985* (Baden: LIT, 1986). See also Paul Klee, *Kunst–Lehre* (Leipzig: Reclam, 1987). In recent years Tim Otto Roth has dynamized with "Colour-sex" the color notations as developed by Richard Paul Lohse and Paul Klee by the element of self-organization based on cellular automata. See Konrad Scheurmann (ed.), *Color continuo 1810 . . . 2010—System und Kunst der Farbe* (Dresden: Technische Universität, 2009), 116–117.

16 Interdependence and Consequence: En Route toward a Grammar of Hypermedia Communication Design

Harald Kraemer

This essay provides an insight into my current research project, "Hypermedia Communication Design & Museum." It focuses on why it is so difficult to describe and analyze hypermedia applications that feature cultural themes. Since multimedia "silver disc" classics tend to get lost, we must define criteria for analysis. Previous attempts to construct typologies have often failed because they have disregarded the complex grammar involved, the necessity to draw on methods from several disciplines, and the need to take into account the underlying philosophy. This essay explains how the functions, contents, and forms of hypermedia can be analyzed. Such analysis uses the instruments of systemic information design, audiovisual rhetoric, and the typology of hypermedia dramaturgy. Discussion also reveals that design, navigation, and user behavior are influenced by the principles of "Scientia potentia est," "Panta rhei," and "Festina lente." The complete results of this research project will be published in 2011–2012 in the shape of an analysis, a methodology, and an oeuvre catalog.

The Progressive Loss

For more than twenty years, online and off-line applications of hypermedia technology have combined text, image, video, animation, and sound into a "total work of art" (*Gesamtkunstwerk*).[1] Chiefly produced for museums, the digital masterworks of applied art are semaphores of our cultural heritage. They are important relics of the "Neolithic age" of multimedia. Hypermedia applications are insufficiently recorded with the traditional methods of documentation. In this respect, they are comparable with works of contemporary art.[2] Enlarged methods derived from the history of art, media sciences, filmmaking, and musicology are necessary to analyze the hyperlinked masterworks according to the criteria of narration, dramaturgy, navigation, and design. The challenge is to reinterpret our traditional understanding of information as well as our understanding of knowledge transfer.[3]

So, why it is so difficult to describe and analyze hypermedia applications? Hypermedia is open, transient, interdisciplinary, process-related, discursive, and dependent

on concept and context. Hypermedia is digital, multimedia-based, and related via interactive extension to its recipient, the user. Hypermedia is so diverse that it requires documentation, analysis, and methodology in a wider sense. Most CD-ROMs are currently still readable, but it is only a matter of time before one of the next computer generations denies access to the hypermedia classics.[4] Later generations will have no access to the "silver disc classics."

Information about hypermedia in museums is mostly published in the form of project-oriented articles in conference proceedings.[5] Some remarkable summaries were published in the 1990s.[6] Reference books as well as online brochures with annotated lists are produced for museum visitors, curators, docents, and producers.[7] Still, there are numerous books about digital cultural heritage, media art, new media, interactive dramaturgy, interface design, and virtual museums. Lev Manovich has shown that it is symptomatic that descriptions and visualizations of hypermedia works seldom present these in concrete and characteristic terms.[8] To this day, we lack stringent analyses of online and off-line hypermedia applications in museums, that is, methodologically grounded studies and oeuvre catalogs providing exemplary case studies.[9]

In what follows, I present my current research on "Hypermedia Communication Design & Museum."[10] It discusses the complexity of analyzing the different levels of hypermedia applications like dramaturgy, navigation, and design. Key questions include: Is there a correlation between the behavior of a museum visitor, that is, the user of hypermedia applications, and the application itself? How do the philosophical background and knowledge transfer strategies affect hypermedia applications?

The Provocation of Typologies

Hypermedia applications are hybrids. They are masterpieces of sampling information and cultural contents in different forms by combining different dramaturgic, navigational, and design strategies. The hypermedia presentation of a museum collection can create different solutions. The results can look like a database,[11] like the board game "Ludo" as a map for Quicktime VR spaces,[12] or like a jogging avatar in the Castle Woods of Wanås.[13] Previous efforts to construct a typology for such hypermedia applications have been condemned to failure because they have disregarded the variety of possible applications. A simple classification cannot follow all terms and conditions. The important questions are: How is content structured by dramaturgic strategies? Which categories exist for the analysis of content and navigation? How is the user guided by the system? How can the overall "hypermedia grammar" be documented? The present research project has partly resulted in creating different typologies to classify hypermedia applications.

Function

A typology structured by functions implies different categories: technical specifications, the format, and the field of application. Technical specifications like the minimal system requirements allow for a typology based on operating systems and required software. Most archives or museum libraries that have collected hypermedia formats like CD-ROM, CD-i, or Laserdisc no longer have computer systems running with the old specifications. They have therefore stopped collecting these formats. Meanwhile, the technical specifications of these relics are powerful signs of the powerlessness of the next computer generation, which will deny access to the hypermedia classics.

Andrea Prehn has classified hypermedia applications like CD-ROMs as follows: "image database," "lexical application," "games," "interactive schoolbook," "CD-ROM for a special exhibition," "book or catalog on CD-ROM," "project-oriented CD-ROM," "the presentation of a single work of art," "a work of media art," "museum on CD-ROM," "the multimedia application of the museum on CD-ROM," "museum tour guide on CD-ROM," and "general information about museums of other products."[14]

Prehn's typology confusingly blends functional categories with content-related terms. Moreover, the operational area is often multifunctional.[15] A hypermedia application can be produced as a kiosk system for an exhibition, sold as a CD-ROM, and nevertheless run on the Web, as the SFMOMA has shown in "Making Sense of Modern Art: The Anderson Collection."[16] Categorization, however, needs to include more aspects to become stringent.

Systemic, Scenic, or Scenographical Design

The synergy of different systemic levels influences the choice of a specific design solution. Jesse James Garrett termed these levels "strategy, scope, skeleton, structure, surface."[17] George Olsen subsequently extended Garrett's five levels with the terms "choreography, mise-en-scène, and sensory design," labeling the Web an "interactive multimedia."[18] In his 2005 account of systemic design, Cyrus D. Khazaeli pointed out the reciprocal influence of information architecture and design. If visual ideas are part of the whole dramaturgy from the very beginning, they facilitate access to information. According to Khazaeli, design was neither "fixed" nor "existent from the beginning." Instead, he argues that it "is present in its potential," and that "design is displaced from a mode of existence to a mode of possibility."[19] Khazaeli defines the design of interactive applications as "systemic information design." Whether systemic, scenic, or scenographical design, the discussion about these terms seems rather

theoretical, because they are interlinked. Niklas Luhmann used the term "systems theory" in 1984 to explain society as a process of closed-circuit communication.[20] The aspects of "autopoiesis" or "self-referentiality" (*Selbstreferenzialität*) are crucial to understanding the meaning of systemic design. Closed systems concentrate on their inner operations. They remain open to change if this forms part of the codes needed for communication. Just as in a "virtual museum,"[21] the interaction between the system itself and its environment is possible only by reducing the complexity of meaning. It is in this context that communication needs design as a hypermedia grammar, that is, as a language possessing syntactic and semantics properties.

Audiovisual Rhetoric

Richard Buchanan anticipated that design was a form of rhetorical communication and interaction when he observed, in 1985, that "Design is an art of thought directed to practical action through the persuasiveness of objects and therefore, design involves the vivid expression of competing ideas about life."[22] In 1965, Gui Bonsiepe had drafted the elements of "visual-verbal rhetoric" for graphic design.[23] Gesche Joost and Arne Scheuermann have shown in their book *Design als Rhetorik* that rhetoric is used as a model to describe the processes of design. Meanwhile, rhetoric[24] helps analyze advertisements,[25] commercials,[26] film,[27] and the Web,[28] as well as interactive multimedia.[29] "Audiovisual rhetoric"[30] thus seems to be predestined for the detailed analysis of hypermedia syntax (form) and semantics (contents and meaning). In what follows, I discuss an example using textual and rhetorical terms.[31]

Example: "Art and Civilizations: Africa, Asia, Oceania, and the Americas in the Louvre"

Starting from a global map as the main menu, users can decide which continents they would like to explore (figure 16.1, plate 23). Applying figures of speech introduces an additional quality into analytical description. What an "analogy," or rather a "metaphor," is this boundless conquest of the world by explorers.

A map of the chosen continent and a series of "colored" (!) artifacts appear at the bottom of the "white" (!) screen, and a second series below features the same artifacts as miniatures. Colored artifacts are aligned in a clean white space. This "accumulatio" functions as an overview, and symbolizes the museum as a storehouse. On the other hand, we also find another metaphor for conquest by colonial power.

Rolling over the image of the artifact provides basic information, and clicking it provides more visual details. When the subchapters "aesthetics," "use," and "society" are selected, text and audio information becomes available. Clicking "plan" selects the artifacts and groups them by continent. The ground floorplan shows the position of the artifacts in the Pavilion des Sessions in the Louvre. At the same time, a rollover

Figure 16.1
From *Art and Civilisations: Africa, Asia, Oceania, and the Americas in the Louvre*, CD-ROM © Musée du Quai Branly, Réunion des Musées Nationaux, Carré Multimédia, Paris, 2000. See plate 23.

function again provides basic information. This part is designed like an inventory. It combines "accumulatio" as "enumeration," and "repetition" with the "accentuation" of the single object.

Four thematic tours are offered in addition to this oeuvre catalog: "lifecycle," "rapport with the invisibles (gods, ghosts, ancestors)," "precious objects," and "forms and figures of power." Each tour explains the relationship of the artifacts by subject matter, irrespective of their origin. The tour is hyperlinked to the artifacts, so that the images are used like a "synecdoche," that is, a "pars pro toto." They as such refer to the whole. Finally, an "index" allows users to search all objects, images, audios, and videos.

This CD-ROM is well designed, but what message is hidden behind its visual grammar? Given that this CD-ROM has a powerful index of all kinds of information, it seems that enthusiastic colonialists and experts in ethnology are the main target groups. It is an oeuvre catalog of the ethnological collection of the Louvre while also serving as a historical document of the previous installation at the Pavilion des Sessions.

On the other hand, we have a design that exhibits cultic artifacts in a "white cube."[32] The meaning of these cultic artifacts is often unclear. It seems that every single object is a manifestation of the human ability to materialize the secrets of life. These ethnological artifacts were severed from their cultural background and environment. Often they were collected under dubious circumstances, and then shipped to France. Some of them (and by no means just a few) are victory signs of colonial power. Now the "white cube" of the CD-ROM transforms these cultic artifacts into works of art.

During the opening of the Musée du Quai Branly, an "aesthetics-versus-ethnology" debate was conducted. One commentator asked whether "religious, ceremonial and practical objects, never intended as art in the modern, Western sense, [will] be show-cased like baubles, with no context?"[33] The combination of a "white cube" with a letter case suggests democracy for all artifacts. It seems to be a pantheon of museum objects in the wide white space of museum architecture. Purified of the past history of colonialism, the new works of art have lost their meaning as semaphores, and have therefore also forsaken their semantic power. Now the audience can admire the arti-facts as works of art in a politically correct way. The "Art and Civilizations: Africa, Asia, Oceania, and the Americas in the Louvre" CD-ROM thus uses the colonialist philosophy of the Musée du Quai Branly before the construction of the new museum.[34] And so this CD-ROM appears as an "oxymoron," and thereby transforms the artifacts with a certain sarcasm into a symbol of a postcolonialist worldview.

A Grammar of Hypermedia

There is more to discover than purely rhetorical elements, namely, the complex meaning of the whole hypermedia application, or rather its overall "tone." Each application has its own visual, auditory, and interactive tone. As a sequence of differ-ent rhythms in the sense of a grammar, an application is designed by liquid informa-tion architecture and structured by a system of hyperlinks. Christian Leborg introduced the notion of visual grammar to describe the grammar of visual language. Visual grammar helps "define its basic elements, describe its patterns and processes, and to understand the relations between the individual elements in the system."[35] The grammar of hypermedia design is actually a "cognitive grammar"[36] or a "systemic grammar."[37] These terms have already been used in linguistics, so that Bonsiepe's "semiotic elasticity," "media specific metadiagrammar," or "audiovisualistic patterns"[38] are open to different meanings in hypermedia. Bonsiepe has taken the notion of "audiovisualistic patterns" from Christopher Alexander's "pattern language."[39] The challenge will be to expand both the static rhetoric of visual and verbal figures[40] and the linear audiovisual pattern language of film[41] to the multiperspectival, transmedia, and hyperlink-based grammar of hypermedia.

The Necessity of New Categories

Just as the rooms of an exhibition are part of a whole, the chapters of a hypermedia application are part of a homogeneous entirety. Often navigation just serves as a guid-ance system leading the user through database-structured contents. Therefore, drama-turgy, navigation, and interface-design drift apart. On the other hand, Janet H. Murray's

"digital environments"[42] include examples where content, dramaturgy, navigation, and design can form a successful symbiosis. One of the secrets of a successful hypermedia application is the balance of power.[43] The other is to know which users prefer which applications. A new typology must thus combine various elements: dramaturgy, information architecture, navigation, design, as well as the visitor's/user's impulses. It follows that the underlying motivation or philosophical background must also be part of the typology.

Alan Cooper has created the strategy of "personas,"[44] a user archetype designed "to help guide decisions about product features, navigation, interactions, and even visual design."[45] In response, Schweibenz has shown that "personas" is a helpful tool for design and communication in the museum world.[46] A good persona description is not a list of tasks or duties. It is a narrative that describes a person's daily routine as well as his or her skills, attitudes, environment, and goals. Thus visitors, as well as users, are divided into different groups. In discussing "the museum as Gestalt," Falk and Dierking have shown the complexity of personal, social, and physical contexts concerning the visitor experience.[47] They have defined the different phases of the visit and the three visitor groups. Based on Schuck-Wersig and Dreyer, another typology divides all museum visitors into the following four categories: type A, the "Museumsmensch" or the lifelong supporter of the museum; type B, the "Museumssammler" or the collector of events; type C, "Museumsbenutzer" or the consumer of museum attractions; and type D, the "Nicht-Museumsbesucher" or the nonvisitor of museums.[48]

Obviously, these categories are too simple. Something is missing; for example, the category of the learner is absent from Dreyer's typology. From the perspective of sociology, Kirchberg has shown that the group of those who are not interested in museums is inhomogeneous, just as the other categories are, too.[49] The reasons are manifold. A museum is untold in its wealth of collected experiences of life. Visitor preferences, their associations, and last but not least their own histories lead them through these contents. As a basic function of communication, a learning opportunity provides the greatest motivation to visit a museum. This applies to all categories. We all are mixed types, and we change our behavior in the museum from an event-hopper to a consumer. Sometimes, we become a lifelong supporter, and we would all like to be connoisseurs. And in all these groups, we are beginners, experts, and intermediates. Thus, the learner plays a role in all categories.

There are parallel categories and similar types if we compare the above visitor categories to the other user typologies of hypermedia applications, navigation, and information architecture. Based on the above typology, and omitting those ignorant of hypermedia applications (type D), the following reclassification has been developed.

Type A ("Knowledge Is Power")

Lifelong supporters of the museum have a distinct motivation to concentrate on ambitious topics of cultural significance for the sake of an encyclopedic education because it is part of their philosophy of life. Supporters are sometimes active members of the board of trustees. They are often experts and therefore part of the scientific community. Building constantly on their personal "musée imaginaire" ensures that all the artifacts in the collections are conducive to the purposes of their own objective research and high-value education. Supporters are thus hidden connoisseurs. Interested in all kinds of works of art, connoisseurs are also encyclopedists. They are hungry for knowledge as well as being "lovers and collectors of certain facts," just like Dostoevsky's Ivan Karamazov. The user behavior of encyclopedists is target oriented. They conduct controlled and methodical navigation, and prefer the hierarchy of a "hypertext-based system, allowing complex and independent enquiries."[50] Their favorite interface often resembles a typical museum collection management system, or indeed looks like a book with index, tables, lists, or a page in an oeuvre catalog.

No matter whether facts or things, the accumulation of knowledge is a powerful motif for developing hypermedia applications. Some CD-ROMs are useful spin-off products of the museum database management system, and they are also useful as data-storage devices for scientific researchers. It seems that academic museum researchers in particular prefer CD-ROMs with titles such as *Printed Portraits 1500–1618 from the Graphics Collection of the German National Museum*,[51] or *10,000 Masterworks of Painting from Antiquity until the Beginning of the Modern Era*.[52] Some of their teaching colleagues prefer the encyclopedic approach. They favor products like *Atlas of the Ancient World*,[53] or the multipiece set *History through Art*.[54] The former constitutes an experiment combining the overview maps of conventional schoolbooks with the functionality of the graphic user interface of the Apple Macintosh desktop or the Graphical Environment Manager of Digital Research. The result is a masterpiece of graphic disorder, as well as accidental. It helps show students that history is not a mere sequence of linear events, but an interactive network of intricate complexity. Reviewing the CD-ROM *History through Art: Ancient Greece*, Donald H. Sanders has remarked: "The lack of in-depth discussions and of opposing opinions on complex subjects make the CD of little use for scholars or advanced students but adequate for early students from 6th grade upward to high school. . . . Too much has been omitted, and what is presented is of mixed quality. The goal of teaching history through art has not been met."[55]

Often the attempt to create an encyclopedia with hypermedia fails because the storyboard is not reduced to one subject area. Contents are not suitable for hypermedia but usable for print. The authors of these hypermedia applications may have the "power," but in the majority of cases they have neither the "knowledge" of nor the

feeling for hypermedia. Curators and scientists have to become "E-Designers" to develop their "creativity, traditional art skills, and computer art skills."[56] Francis Bacon's original maxim of 1597, "(For) knowledge (itself) is power," assumes a new meaning.[57]

Type B ("Everything Is in a State of Flux")

Art events enhance prestige. Type B is an event-hopper, a kind of art-as-lifestyle addict who collects events, exhibitions, museums, and art fairs. Enjoyably stressed by permanent vernissages, previews, and other daily-changing must do's, these are first and foremost excellent multipliers in their own social communities. Following a subjective approach, these voyeuristic, predatory collectors perform "cultural window-shopping."[58] They will stroll through the museum halls and judge the quality of what they encounter, usually dwelling no more than a few seconds in front of a given artifact. The idea of browsing and discovering the treasures of the virtual world also inform this playful discoverer's motivation. The ludic explorer prefers a networked structure, which can be navigated associatively and meditatively. Their world is created by a liquid architecture containing flash-animated spaces replete with images and ambient sound. Guided by associations, their user behavior is more sensual than controlled. Here, the navigation and information architecture is characterized by "play-oriented edutainment applications with a high level of interaction."[59]

Only a few applications allow for ludic association and experimental access to their contents. Designed in the spirit of media art, these products often suffer from over-interactivity. Users are invited not to stay and obtain information, but instead to stroll around endlessly. Navigation can itself become content and thereby create a "reflexive liquid information architecture."[60] The sensual design stretches from floating images to equally sensual sound, generating a feeling of hypermedia happiness. The viewer is not intended to pause, not even for a moment. Everything flows: "Panta rhei," the dictum commonly attributed to Heraclitus, is the philosophy underpinning these applications.[61] CD-ROMs in this vein are *Sigmund Freud: Archaeology of the Unconscious*[62] and *Build in the Light: The Glass House by Bruno Taut*.[63] They illustrate that users frequently fail to follow stringent navigational logic. The playful discoverer jumps back and forth because of associations that occur to him or her while exploring. This approach is similar to a tentative search by remembering experiences and rediscovering them. The valence of each single item of information or fact is blurred into an entertaining monotony. This kind of CD-ROM is only useful to the serious sciences in a very limited way, but it offers an excellent approach to handling and conveying knowledge, perception, authenticity, and entertainment in our time.[64]

The CD-ROM *The Marguerite and Aimé Maeght Foundation, A Stroll in XXth Century Art*[65] offers visitors a voyeur's perspective. The approach resembles window-shopping,

and is designed to satisfy the visitor's curiosity. The user assumes the role of a discoverer armed with a video camera, strolling around the exhibits and discovering the artifacts displayed in the garden. In *Wanås: Contemporary Art in the Castle Woods of Wanås*,[66] this voyeuristic approach is visualized by the guiding assistance of a jogging avatar. The never-idle runner thus connects the works of art. The user can take pictures of his or her favorite items, and subsequently file them in an album like postcards. Compared to the Maeght voyeur, who is more of an onlooker, the Wanås voyeur is a kind of a paparazzi, documenting the favorite places seen. While Maeght and Wanås are nice excursions, *Place-Hampi*[67] is a masterpiece of panoramic or cycloramic voyeurism. Sarah Kenderdine and Jeffrey Shaw have realized a stereographic 3D trompe l'oeil view of the Vijayanagara (Hampi) in India.[68] Viewers explore a virtual landscape of archaeological, historical, and sacred locations enlivened by animated mythological gods like Ganesha. The rediscovery of these sacred locations by following these virtual gods allows the visitor to become an invisible observer and time traveler. Furthermore, even viewers who have no knowledge of Indian mythology, landscape, or architecture are drawn into an euphoric fever when facing the reality of *Place-Hampi*. This marvelous 3D application will serve as a blueprint for coming projects.

Compared to *Place-Hampi*, the journey through the CD-ROM *Museum Insel Hombroich*[69] is a piece of land art. This marvelous journey offers (silent) spaces in the best sense of the word: gaping vistas, open sites, and time spaces. The interplay between nature, architecture, and works of art creates a mantra of continuous repetition. As the visitor follows the path through the Museum Insel Hombroich, this rhythm seems to stand in the tradition of Ralph Waldo Emerson's famous words: "Philosophically considered, the universe is composed of Nature and the Soul. Strictly speaking, therefore, all that is separate from us, all which Philosophy distinguishes as the NOT ME, that is, both nature and art, all other men and my own body, must be ranked under this name, NATURE."[70]

Navigation and contents are a means to an end, and the path the user has to walk is the goal. This unusual concept corresponds to the nature of this charismatic place, the experience of discovering the twelve pavilions of Hombroich, and the works of art inside. Unfortunately, the experience ends with the experience. The user is deprived of obtaining more information about the works of art. And thus, the works of Hans Arp, Mark di Suvero, Gotthard Graubner, Constantin Brancusi, and the sculptures of the Khmer still "rest in peace." After leaving behind the state of flux, there remains a sense of having missed something essential, and thus, the visitor is left with a consequent incompleteness.

Type C ("Hurry Slowly")

Visiting a museum affords the listener-and-observer type an opportunity to meet likeminded people and to share experiences. Type C actively consumes all educational

possibilities offered by a museum. Listeners often take part in group tours, and they are also the typical users of infotainment tools like audio-guides or PDAs. For the duration of a tour, their attention span remains focused. Education, curiosity, and amusement permanently stimulate their behavior. Listeners are interested in all subject areas, no matter whether the subject is "Eroticism in ancient Egypt," "The funny world of Matthew Barney," or "The secret of the portrait of Rembrandt's mother." For a good story, listeners are open minded but also willing to be led. They prefer being offered a choice, making a decision, and following the narration in the shape of "a linear tree structure with only limited means of interaction."[71]

Over the past few years, a commitment to deceleration and simplicity has affected how we design applications. John Maeda observed this in his "laws of simplicity."[72] However, this is not a new idea; rather, this insight marks a return to old virtues. Its philosophical foundation is the theme of "Festina lente." Suetonius's *Life of Caesar* (De Vita Caesarum) contained this favorite proverb in his chronicle of the "Life of Augustus."[73] Erasmus of Rotterdam described it in his *Adagia* as a "royal proverb," because of its applicability to all life situations.[74] The oxymoron "Make haste slowly" or "Hurry slowly" combines the initial phase of careful deliberation (before a decision is made) with the efficiency of an action (after the decision has been taken). Those who wish to tell stories, however, will have to learn to listen first. Applied to the design of hypermedia applications, this principle involves the weaving of "moments of contemplation" into the narrative flow in order to create a varied dramaturgy of different narratives.[75] Janet H. Murray has defined this procedure as a "multiform story" and as the creation of "multicharacter environments."[76]

Storytelling strategies play a powerful role in knowledge transfer.[77] Using a face-to-face, subjective, and at least partly sentimental approach enables narrators to capture audience attention very effectively. Many applications use dramaturgies based on narrative concepts.[78] Narrators can be persons, artifacts, and events. Such personalization contributes to user identification with content and information.

The strategy of conducting a conversation is a brilliant tool for explaining complex topics. It guides interested listeners and observers onward by having them follow these conversations. The simple question-and-answer formula is used in such different applications as the shopping expedition of a daughter and her mother strolling in the streets of Edo (Tokyo) in *Kidai Shorân*,[79] or in the conversation between grandpa Vitalis and granddaughter Artula in *Augusta Treverorum Treveris: Discovering the Roman Trier*.[80] Both examples show how a conversation can convey further information through dialogue while at the same time guiding the listener through the story.

On the CD-ROM *Museum Schloss Kyburg*,[81] none other than the fictional moderator Dr. Gugel (Google) has invited the famous Swiss encyclopedist Johann Jakob Leu (1689–1768) to "Knowledge without Limits," a fictional TV talk show (figure 16.2). This is not a simple conversation like the previous examples. Leu and Gugel discuss the different methods of attaining knowledge in their respective centuries.[82] In the

Figure 16.2
"Knowledge without Limits. A Competition: Johann Jakob Leu versus Dr Gugel," *Museum Schloss Kyburg*, CD-ROM © Verein Museum Schloss Kyburg, Transfusionen, Zurich, 2004.

former workroom of the bailiff at Schloss Kyburg, the discussion takes up the following controversial question: "Do pupils still need a classical education considering the wealth of downloadable knowledge available on the Web?" In a special competition, Leu's knowledge-based lexicon competes against Dr. Gugel's search engine. During this competition, the hypermedia application simulates the search, analysis, and creation of knowledge in the context of three items: the Roman goddess Minerva, a potato, and a special kind of Swiss toad named *Geburtshelferkröte*. In the second part of the TV talk show, Leu and Dr Gugel discuss the pros and cons of the different methods:

Leu: Searching facts is just one side, but to generate new knowledge, you need a little bit more, Dr. Gugel. You can't solely administrate the knowledge, you also have to practice and live it.—
Dr Gugel: Quite true, my old friend, but in today's world it's not necessary to know everything. It suffices that you know where you can find the information you're looking for, as this is always available and searchable.

By following Leu and Dr. Gugel, the user learns that both systems of knowledge-based methods have their positive and negative aspects. Therefore, Genette's insight that a narration tells us less than it knows, but at the same time allows us to read between the lines and thus also communicates implied meaning, is also viable in interactive storytelling.[83] To separate the fiction from the correct historical facts and source material, the story has to be translated into the narrator's day and age, the narrated time, and the time of the narration. Otherwise, authenticity becomes problematic and so, too, does the correctness of content. Ever present is the danger of blurring the boundary between fact and fiction too much, thus compromising the original intent, namely, to allow for a better understanding of said facts.

The Balance of Power

The CD-ROM *Verner Panton* has been produced as a kiosk system for an exhibition at the Vitra Design Museum (figure 16.3, plate 24).[84] Following the timeline in a chapter entitled "Biography" introduces the user to the life and work of Panton. The second chapter, "Panton Chair," contains detailed information about the technical development and the differences in material (for example, fiberglass-reinforced polyester), mold, and the production of this famous single-piece chair. The third chapter, "Interior Design," shows four legendary interiors by Panton. All these projects, like "Visiona" (shown in 1970 on a Rhine cruiser), are presented in detail, including plans and photographs. Interactive floor plans allow the user to see the interior from different angles. This strategy of interactive voyeurism is like a voyage of discovery back into the 1970s. "Textile Design," the fourth chapter, introduces the user to the foremost creative instruments for the design of textiles, namely, colors and geometric patterns. The screen holds 76 textile patterns, which can be grouped according to thematic considerations like op art or 3D. The last chapter, "Pattern Game," is a clever supplement to "Textile Design." Four different patterns can be modified by numerous variations, and they can also be compared with Panton's own original textile design. Thus, the game teaches the user how to compose ornamental textiles. This five-part CD-ROM is addressed to all kinds of visitors and user groups. The encyclopedist or the expert will find information; the interested voyeur can make observations; the playful discoverer can play a game. On balance, the user will receive a mixture of basic documentation on Panton's philosophy and an incomplete oeuvre catalog of his design works dating from the 1960s and '70s. It also serves as a source book for creating new patterns. The CD-ROM on the Danish designer Verner Panton is an excellent example of how dramaturgy, navigation, and design can be successfully geared toward synergy. For these specific reasons, it is a rare example for the integration of all three user categories.

Table 16.1 interrelates dramaturgy, navigation, interface design, and user behavior with their underlying motivation and philosophical background.

Timeless Questions

In the courtroom of the *Museum Schloss Kyburg* CD-ROM, a kiosk system contains the interactive narration: "The inquisition of Johannes Grün of Kauffbüren. A historical criminal case" (figure 16.4).[85] The dramaturgy is divided into five parts:

1. The "Malefizbuch" with the historical court documents of 1725 and the delinquent's confession.
2. A commentary on the eighteenth-century Swiss judiciary system featuring descriptions of torture methods.

Figure 16.3
From *Verner Panton*, CD-ROM © Vitra Design Museum, Weil am Rhein; Panton Design, Hochschule für Gestaltung und Kunst Basel, Studienbereich Visuelle Kommunikation, Basel, 2000. See plate 24.

Figure 16.4
"The inquisition of Johannes Grün of Kauffbüren. A historic criminal case," *Museum Schloss Kyburg*, CD-ROM © Verein Museum Schloss Kyburg, Transfusionen, Zurich, 2004.

Table 16.1
A new categorization

	Type A	Type B	Type C
Interface Design	database, encyclopedia, index, tables	liquid architecture, spaces with images and sound	intra-active and linear forms of narratives (slide show)
Information Architecture	hierarchical structure	networked structure	linear structure with different levels
Navigation	controlled and methodical	associative and meditative	open-minded but willing to be led
Dramaturgy	information	ludic, explorative	narrative
User Behavior	target-oriented	sensual, curious	listening, observing
Motivation	controlling	strolling, exploring	reflecting
Motto	"Knowledge is power."	"Everything is in a state of flux."	"Hurry slowly."
Philosophical Background	"Scientia potentia est."	"Panta rhei."	"Festina lente."

3. A movie-like reconstruction of the inquisition with actors.

4. An analysis of the whole situation given by a present-day judge.

5. An introduction to the use of torture today, explaining and linking themes to the Universal Declaration of Human Rights and the UN Convention against Torture.

Taken all together, the five parts provide the visitor with an overview of the procedures surrounding the search for evidence and truth about the practice of torture. The 15-minute movie, was filmed on the original locations (the prison cell, the torture chamber, and the courtroom), is interrupted by questions like "Would you set him free?" or "What do you think? Is he guilty or not guilty?" This allows visitors to interact with the proceedings by trying to answer these questions themselves. These interludes in the process of finding the truth are absolutely necessary. They break the flow of the story, and the visitor is called onto the bench. Coming to these points of interaction, visitors often engage in a discussion precisely where this case was heard. They give their personal opinions. Combining different media and strategies transposes this historical subject into the present time of the museum as well as the classroom.

Authenticity and Credibility

If the most successful information transfer is the "creation of a confidential relation,"[86] then the primary objective has become to define strategies involving the visitor's own experiences, preferences, and curiosity.[87] To capture the visitor's "feeling of solidarity,"[88] empathy will be the key to creating polyperspectival readings and hyperlinked structures. The secret to gaining acceptance is to visualize the visitor's hidden needs in a sensitive and inspiring dramaturgy. If this is accepted by the user, viewer, or visitor, all hypermedia applications will become successful and epistomize the merit of education, as Parry and Arbach have shown in their study of online museum learning.[89]

Traditional narratives use a linear structure, pushing a single storyline, while hypermedia applications need a network of hyperlinked mini-stories, targeted at different user-groups and versatile enough to be used in different fields of application. Furthermore, the narratives in hypermedia applications use a type of language that combines verbal rhetoric with visual rhetoric to create a "cognitive design."[90] Unifying contents, navigation, and design requires the designer to possess a sort of visual intelligence, but it also demands the user's hypermedia competence. Interactivity, that is, the multiple choices of digital one-way streets, encompasses the intention to participate in both creativity and confrontation.[91] The first signifies a joyful collaboration, the second a clash with the system. Real interactivity thus grows out of the actuality of an action. It is productivity that leads to the creation of reality and the meaning of perception. The best navigation is itself content rather than merely its simplified

duplication. Information architecture should thus create different levels of context and animate the user to construct meaning autonomously. Readability is therefore directly dependent on the experiences and personal needs of users. Timeless questions need contemporary—in our case—hypermedia answers. Just telling interactive stories is not enough. In a film, each individual sequence is responsible for the rhythm of the story and the dynamics of the actions. The eye of the viewer easily ends up bored if there is no change of scene and no variety to the shots. To subdue the visual ennui, a diversified and eventful dramaturgy is necessary. The real challenge of such a dramaturgy will involve finding ways of designing motivating content modules with an overall visual and acoustic concept. How can we catch user attention? How can we decelerate the dynamics of user attitudes? How can we simplify information complexity? Film dramaturgy is the correct application of pacing and of rapid pulse beats, and then pausing for a moment. This means that the story is not only used as a narrative but also as a means of design, and furthermore that the story serves as a means for the recipient to identify with the content. To transfer this strategy into the liquid architecture of hypermedia is to understand the principle of simultaneity in nonsimultaneity. Larry Friedlander has shown us that the problems encountered when we try to communicate information about art are not specific to art but actually essential for the common transfer of knowledge. He raises three relevant questions in this context: "How can we analyze the structure of such a hybrid experience, and how can we better design this kind of complex space? How do we integrate media rich environments with people-rich ones and make them human, warm and conducive to learning? How do we organize these experiences for the user so they can make sense of them without robbing them of their inherently rich and spontaneous qualities?"[92]

Consequently, it is important to learn how to accelerate and decelerate the flow of information at the right moment, as well as learning how to guide users with a storyline and through a navigational design. It should be possible to create a work that is at the same time complex yet still intuitive. How far will the principles of "Scientia potentia est," "Panta rhei," and "Festina lente" influence the design of hypermedia applications? We shall see.

This essay has attempted to show some of the problems for a new grammar of hypermedia. A typology containing all possible categories has to document what has happened as well as what will follow. Documentation as yet remains retrospective. The numerous means of hypermedia design allow an imaginative, innovative, inventive information design, which is meant to be intuitive in its usage. Any new project still needs to define its own rules in accordance with the goals of the project in question. In this interplay of content and dramaturgy, navigation and design, lie the challenges for the codetermination of the hypermedia future and for the documentation. Carpite diem.

Notes

1. Hypermedia applications comprise online and off-line productions, including LaserDisc, Photo-CD, CD-i, CD-ROM, DVD-ROM, as well as kiosk systems or mobile technologies, such as handheld guides.

2. Harald Kraemer, "Art Is Redeemed, Mystery Is Gone: The Documentation of Contemporary Art," in *Theorizing Futures for the Past: Cultural Heritage and Digital Media*, ed. Sarah Kenderdine and Fiona Cameron (Cambridge, MA: MIT Press, 2007), 193–222.

3. Felicidad Romero-Tejedor, *Der denkende Designer: Von der Aesthetik zur Kognition: Ein Paradigmenwechsel* (Hildesheim: Georg Olms Verlag, 2007). See also Peter Samis, "The Exploded Museum," in *Digital Technologies and the Museum Experience: Handheld Guides and Other Media*, ed. Loïc Tallon and Kevin Walker (Lanham, MD: Altamira Press, 2008), 3–17.

4. To use old CD-ROMs on Apple Macintosh computers, the "Classic" environment (Mac OS 9) has to be installed. Since Apple Mac computers run on Intel processors (Mac OS X and later), the installation of Classic is technically infeasible in defiance of diverse experiments with emulator programs. See, among others, "How to Run Classic (pre OS X) Apps on Intel Macs," available at <http://www.macosxhints.com>.

5. *Computers and the History of Art* (CHArt), *Electronic and Imaging in the Visual Arts* (EVA), *International Cultural Heritage Informatics Meeting* (ICHIM), *Museums and the Internet* (MAI), *Museum Computer Network* (MCN), *Museums and the Web* (MW) and the *Meetings of the International Council of Museums* (ICOM), especially *International Committee for Audio-visual, Images and Sound New Technologies* (AVICOM), *Committee for Education and Cultural Action* (CECA), and *International Committee for Documentation* (CIDOC).

6. Stephanie Eva Koester, *Interactive Multimedia in American Museums*, Archives and Museum Informatics Technical Report, No. 16, 1993; Xavier Perrot, *Production des hypermédias et des interactifs multimédias pour les musées* (Diss. Paris 8, 1995); Pierre Jocelyn and Virginie Guilloux, *Les usages du multimédia interactif dans les lieux culturels: Bibliographie et synthèse documentaire* (Paris: Département des Études et de la Prospective, Direction de l'Administration Générale, Ministère de la Culture et des Communications, 1998); Petra Schuck-Wersig, Gernot Wersig and Andrea Prehn, *Multimedia-Anwendungen im Museen* (Berlin: Staatliche Museen zu Berlin Preußischer Kulturbesitz, Mitteilungen und Berichte aus dem Institut für Museumskunde, No. 13, Oct. 1998).

7. Compania Media, ed., *Neue Medien in Museen und Ausstellungen* (Bielefeld: Transcript Verlag, 1998); Andrea Prehn, "Das CD-ROM-Angebot deutscher Museen," in *Multimedia-Anwendungen in Museen*, ed. Petra Schuck-Wersig, Gernot Wersig, and Andrea Prehn (Staatliche Museen zu Berlin: Mitteilungen und Berichte aus dem Institut für Museumskunde, No. 13, October 1998), 173–194; catalog of CD-ROMs, <http://www.smb.museum/ifm/index.php?ls=10&topic=Bibliothek&subtopic=Cddvd&lang=de&te=ja&tf=ja>; Arthur E. Imhof, *Bestandskatalog von CDs und DVDs für Forschung und Lehre* (Berlin: Freie Universität Berlin, list of CDs and DVDs), on <http://userpage.fu-berlin.de/~history1/cdcoll.htm>.

8. Lev Manovich, *The Language of New Media* (Cambridge, MA: MIT Press, 2000).

9. Rihl surveys 24 hypermedia applications, mostly in German-speaking countries. Gerhard Rihl, *Science/Culture: Multimedia: Kreativstrategien der multimedialen Wissensvermittlung* (Vienna: facultas. wuv, 2007).

10. Launched in 2005, the research project "Hypermedia Communication Design & Museum" (formerly "Knowledge Hypermedia Design & Museum") has been supported by the Institute of Art History of the University of Berne, by the Department of Literature-Art-Media Sciences of the University of Constance, and by a grant from the Hofer-Wild-Stiftung, University of Berne. I am very grateful to the staff members of the archives and libraries of the Museum der Kulturen in Basel, Institut für Museumsforschung in Berlin, Kunst und Ausstellungshalle der BRD in Bonn, Center for Art and Media (ZKM) Karlsruhe, Academy of Media Arts (KHM) Cologne, Bildarchiv Foto Marburg, Bibliothèque Nationale de France in Paris, MAK—Austrian Museum of Applied Arts in Vienna, Zurich University of the Arts (ZHdK), the Universities of Basel, Berne, Constance, Lugano and Zurich, and the Staatsbibliothek Berlin for their support during the review of their hypermedia archives. In the last few years, around 600 online and off-line hypermedia applications have been analyzed to enter data into a database management system, develop a methodology for hypermedia documentation, and create an oeuvre catalog of case studies.

11. The Bildarchiv Foto Marbug founded DISKUS (Digitales Informationssystem für Kunst- und Sozialgeschichte) in 1993. Parts of digital collection management systems of museums have been published as several CD-ROMs by Saur-Verlag since 1995.

12. *100 Masterpieces from the Vitra Design Museum*, CD-ROM (Weil: Vitra Design Museum, Karlsruhe: ZKM, 1996).

13. *Wanås: Contemporary Art in the Castle Woods of Wanås*, CD-ROM (Knislinge: Wanås Foundation, Bremen: Bernd Fiedler, Bert Sender, 1998).

14. Andrea Prehn, "Das CD-ROM-Angebot deutscher Museen," in *Multimedia-Anwendungen in Museen*, 173–194.

15. Claudia Schulze, *Multimedia in Museen* (Wiesbaden: Deutscher Universitäts-Verlag, 2001); Anja Wohlfromm, *Museum als Medium—Neue Medien in Museen* (Cologne: Herbert von Halem Verlag, 2002); Geneviève Vidal, *Contribution à l'étude de l'interactivité: Les usages du multimédia de musée* (Pessac: Presses Universitaires de Bordeaux, 2006).

16. *Art as Experiment, Art as Experience: An Exploration of Fifteen Works from the Anderson Collection*, CD-ROM (San Francisco: San Francisco Museum of Modern Art, 2000), <http://www.sfmoma.org/multimedia/interactive_features/21>.

17. Jesse James Garrett, *The Elements of User Experience: User-Centered Design for the Web* (New York: American Institute of Graphic Arts, New Riders Publishing, 2003), <http://jjg.net/elements/pdf/elements.pdf>.

18. George Olsen, "Expanding the Approaches to User Experience," *boxes and arrows*, October 3, 2003, <http://www.boxesandarrows.com/view/expanding_the_approaches_to_user_experience>.

19. Cyrus D. Khazaeli, *Systemisches Design: Intelligente Oberflächen für Information und Interaktion* (Hamburg: Rowohlt, 2005), 245.

20. Niklas Luhmann, *Soziale Systeme—Grundriss einer allgemeinen Theorie* (Frankfurt: Suhrkamp Wissenschaft, 1984); Niklas Luhmann and Dirk Baecker (eds.), *Einführung in die Systemtheorie* (Heidelberg: Carl Auer Systeme Verlag, 2002).

21. Werner Schweibenz, *Vom traditionellen zum virtuellen Museum: Die Erweiterung des Museums in den digitalen Raum des Internets* (Frankfurt: Deutsche Gesellschaft für Informationswissenschaft und Informationspraxis, 2008).

22. Richard Buchanan, "Declaration by Design: Rhetoric, Argument, and Demonstration in Design Practice," *Design Issues* 2, no. 1 (1985): 4–23, here 7.

23. Gui Bonsiepe, "Visuell-Verbale Rhetorik: Über einige Techniken der persuasiven Kommunikation," *Ulm: Zeitschrift der Hochschule für Gestaltung* 14, 15, 16 (1965); reprinted in Gui Bonsiepe, *Interface: Design neu begreifen* (Mannheim: Bollmann, 1996), 85–103; reprinted in *Design als Rhetorik—Grundlagen, Positionen, Fallstudien*, ed. Gesche Joost and Arne Scheuermann, (Basel: Birkhäuser, 2008), 27–43.

24. For more on rhetoric, see Charles Kostelnick and Michael Hassett, *Shaping Information: The Rhetoric of Visual Conventions* (Carbondale, IL: Southern Illinois University Press, 2003).

25. Judith Williamson, *Decoding Advertisements* (London: Marion Boyars, 1978); for examples of visual-verbal figures, see Bonsiepe, *Interface*, 93–102.

26. Gui Bonsiepe, *Entwurfskultur und Gesellschaft: Gestaltung zwischen Zentrum und Peripherie* (Basel: Birkhäuser, 2009). See esp. the chapter entitled "Audiovisualistische Patterns," 129–146.

27. Arne Scheuermann, *Zur Theorie des Filmemachens: Flugzeugabstürze, Affekttechniken, Filme als rhetorisches Design* (München: edition text + kritik, 2009); Gesche Joost, *Bild-Sprache: Die audiovisuelle Rhetorik des Films* (Bielefeld: Transcript, 2008).

28. Nicholas C. Burbules, "The Web as a Rhetorical Place," in *Silicon Literacies: Communication Innovation and Education in the Electronic Age*, ed. Ilana Snyder (London: Routledge, 2002), 75–84.

29. Gesche Joost, "Audio-visuelle Rhetorik und Informationsdesign," in *Knowledge Media Design: Theorie, Methodik, Praxis*, ed. Maximilian Eibl, Harald Reiterer, Peter Friedrich Stephan, and Frank Thissen (Munich: Oldenbourg Verlag, 2006), 211–224.

30. Heike Sperling, "'Imaging Science': Integrative Audiovisualistik" (Ph.D. diss., Bergische Universität—GHS Wuppertal, 1998). See "PhD in Aesthetics" on <http://heikesperling.de/others.0.html>.

31. See *Art and Civilizations: Africa Asia, Oceania and the Americas in the Louvre*, CD-ROM (Paris: Réunion des Musées Nationaux, Carré multimédia 2000).

32. Brian O'Doherty, "Inside the White Cube," Part I, *Artforum* 14, no. 7 (1976): 24–29; Part II, *Artforum* 14, no. 8 (1976): 26–34; Part III, *Artforum* 14, no. 8 (1976): 38–44.

33. Michael Kimmelman, "ART; A Heart of Darkness in the City of Light," *New York Times*, July 2, 2006, <http://query.nytimes.com/gst/fullpage.html?res=9406E4D81730F931A35754C0A9609 C8B63&sec=travel&spon=&pagewanted=1>.

34. Sally Price, *Paris Primitive: Jacques Chirac's Museum on the Quai Branly* (Chicago: University of Chicago Press, 2007), 165–166.

35. Christian Leborg, *Visual Grammar* (New York: Princeton Architectural Press, 2006), 5.

36. Ronald W. Langacker, *Foundations of Cognitive Grammar*, vol. 1: *Theoretical Prerequisites* (Stanford, CA: Stanford University Press, 1987).

37. Michael A. K. Hallyday, *Explorations in the Functions of Language* (London: Edward Arnold, 1973).

38. Bonsiepe, *Entwurfskultur und Gesellschaft*, 129–146; see esp. the sections "Semiotische Elastizität" and "Audiovisualistische Patterns," 133.

39. Christopher Alexander, *Notes on the Synthesis of Form* (New York: Oxford University Press, 1970 [1964]); Christopher Alexander, Sara Ishikawa, and Murray Silverstein, *A Pattern Language: Towns, Buildings, Construction* (New York: Oxford University Press, 1977).

40. "List of Visual-Verbal figures," in Bonsiepe, *Interface*, 92–93; reprinted in *Design als Rhetorik*, 33.

41. "List of Audio-Visual Patterns in Film," in Gesche Joost, "Die rhetorische Pattern-Language des Films," in *Design als Rhetorik*, 229–245; see esp. 243–245.

42. Janet H. Murray, *Hamlet on the Holodeck: The Futures of Narrative in Cyberspace* (Cambridge, MA: MIT Press, 1997).

43. Harald Kraemer, "Simplicity, Slowness, and Good Old Stories as Strategic and Perspectives of Design in Hypermedia and Media," *ICHIM International Cultural Heritage Informatics Meeting*, Toronto (October 25, 2007), <http://www.archimuse.com/ichim07/abstracts/prg_335001550 .html>.

44. Alan Cooper, "The Origin of Personas" (August 1, 2003), <http://www.cooper.com/ journal/2003/08/the_origin_of_personas.html#more>.

45. Kim Goodwin, "Perfecting Your Personas" (August 1, 2002), <http://www.cooper.com/ journal/2001/08/perfecting_your_personas.html#more>; Kim Goodwin, *Designing for the Digital Age: How to Create Human-Centered Products and Services* (Indianapolis, IN: Wiley, 2009).

46. Werner Schweibenz, "Know Thy Visitors: Personas for Visitor-centered Museums," *International Journal for the Inclusive Museum* 1, no. 2 (2008): 103–109.

47. John H. Falk and Lynn D. Dierking, *Learning from Museums: Visitor Experiences and the Making of Meaning* (Walnut Creek, CA: AltaMira Press, 2000); John H. Falk and Lynn D. Dierking, *The Museum Experience* (Washington, D.C.: Whalesback Books, 1992).

48. Petra Schuck-Wersig, Gernot Wersig, and Andrea Prehn, *Multimedia-Anwendungen im Museen* (Berlin: Staatliche Museen zu Berlin Preußischer Kulturbesitz, Mitteilungen und Berichte aus dem Institut für Museumskunde, No. 13, Oct. 1998); Axel Dreyer, *Kulturtourismus* (Munich: Oldenbourg, 1996); Frank Winkler and Dietrich Holthoefer, "Wie langweilig dürfen Museen sein?" Deutsche Marketing Gesellschaft, <http://www.dmg-zentrale.de/de/kommunen/fachartikel/1>.

49. Volker Kirchberg, *Gesellschaftliche Funktionen von Museen: Makro-, meso- und mikrosoziologische Perspektiven* (Berliner Schriften zur Museumskunde, Wiesbaden: VS Verlag für Sozialwissenschaften, 2005).

50. Stephan Bode, "Multimedia in Museen—weder Königsweg noch Guillotine," in *Handbuch der museumspädagogischen Ansätze*, ed. Kirsten Fast (Opladen: Leske and Budrich, 1995), 340.

51. *Printed Portraits 1500–1618 from the Graphics Collection of the German National Museum*, CD-ROM, DISKUS No. 002 (Nuremberg: Germanisches Nationalmuseum, Munich: K. G. Saur Verlag, 1995).

52. *10,000 Masterworks of Painting from Antiquity until the Beginning of the Modern Era*, CD-ROM (Berlin: The Yorck Project, 2002).

53. *Atlas of the Ancient World*, CD-ROM (Richmond, Surrey, UK: Maris Multimedia, 1998).

54. *History through Art*: *Ancient Greece*, CD-ROM (Dallas, TX: Zane Publishing, 1995).

55. Donald H. Sanders, "*History through Art: Ancient Greece*—A CD Review," *CSA Newsletter* 9, no. 2 (August 1996), <http://csanet.org/newsletter/aug96/nl089610.html>.

56. Bruce Wands, "A Philosophical Approach and Educational Options for the E-Designer," in *The Education of an E-Designer*, ed. Steven Heller (New York: Allworth Press, 2001), 20.

57. Francis Bacon wrote in his *Meditations sacrae* of 1597: "Nam et ipsa scientia potestas est." The English version of this book appeared one year later with the words: "For knowledge itself is power," which has been paraphrased as "knowledge is power." Georg Büchmann, *Geflügelte Worte* (Berlin: Haude & Springer, 1972 [1864]), 436.

58. Heiner Treinen, "Das Museum als kultureller Vermittlungsort in der Erlebnisgesellschaft," in *Vom Elfenbeinturm zur Fußgängerzone*, ed. Landschaftsverband Rheinland (Opladen: Leske and Budrich, 1996), 118.

59. Stephan Bode, "Multimedia in Museen—weder Königsweg noch Guillotine," in *Handbuch der museumspädagogischen Ansätze*, 340.

60. Harald Kraemer, "Museums Are Storytellers! New Perspectives of Education and Hypermedia," in *Understanding the New Dynamic: Art, Technology, and the Mind*, ed. The New Media Consortium, CASE Western University, and Cleveland Museum of Art (Cleveland, OH, 2006), 165–172.

61. For Heraclitus, see *Fragments* 12 and 91 in *Die Fragmente der Vorsokratiker*, trans. Hermann Diels, ed. Walther Kranz (Hildesheim: Weidmann, 2005 [1903]). For "Pánta rhei kaì oudèn ménei," see also Plato, *Cratylos*, 402A=A6.

62. *Sigmund Freud: Archaeology of the Unconscious*, CD-ROM (Vienna: Sigmund Freud Museum, Nofrontiere, 1999).

63. *Build in the Light: The Glass House by Bruno Taut*, CD-ROM (Berlin: mib Gesellschaft für Multimediaproduktionen in Berlin, 1996).

64. Harald Kraemer, "Simplicity, Slowness, and Good Old Stories."

65. *The Marguerite and Aimé Maeght Foundation: A Stroll in XXth Century Art*, CD-ROM (St. Paul de Vence: Maeght Foundation, 1995).

66. *Wanås: Contemporary Art in the Castle Woods of Wanås*, CD-ROM.

67. *Place-Hampi*, <http://place-hampi.museum>.

68. Sarah Kenderdine, "Somatic Solidarity, Magical Realism, and Animating Popular Gods: Place-Hampi, Where Intensities Are Felt,'" in *Proceedings of the 11th European Information Visualization Conference IV07*, Zurich, July 3–7 (IEEE Computer Society, 2007), 402–408.

69. *Zwischenraum: Eine Reise durch das Museum Insel Hombroich*, CD-ROM (Düsseldorf: ilumi—interaktive erlebniswelten, 2002).

70. Ralph Waldo Emerson, "Nature," in *The American Transcendentalists*, ed. L. Buell (New York: The Modern Library Classics, 2006), 34. (Originally published Boston: James Munroe, 1836.)

71. Stephan Bode, "Multimedia in Museen—weder Königsweg noch Guillotine," 340.

72. John Maeda, *The Laws of Simplicity* (Cambridge, MA: MIT Press, 2006), <http://lawsofsimplicity.com>.

73. Gaius Suetonius Tranquillus, *Caesaris Augusti*, 25.

74. Desiderius Erasmus of Rotterdam, *Adagia*, 142.

75. Harald Kraemer, "Simplicity, Slowness, and Good Old Stories"

76. Murray, *Hamlet on the Holodeck*, 83–90.

77. Bart Marable, "Once Upon a Time: Using New Narratives in Educational Web Sites," *Museums and the Web* (1999), <http://www.archimuse.com/mw99/papers/marable/marable.html>; Mark Stephen Meadows, *Pause & Effect: The Art of Interactive Narrative* (Indianapolis: New Riders, 2002).

78. Eku Wand, "Interactive Storytelling: The Renaissance of Narration," in *New Screen Media: Cinema/Art/Narrative*, ed. Martin Rieser and Andrea Zapp (Cambridge, MA: MIT Press, 2006), 163–178.

79. *Kidai Shorân: Excellent View of Our Prosperous Age*, CD-ROM (Berlin: Museum für Ostasiatische Kunst, Staatliche Museen zu Berlin, Jeannot Simmen, 2000).

80. *Augusta Treverorum Treveris: Discovering the Roman Trier*, CD-ROM (Trier: Rheinisches Landesmuseum, 1998).

81. "Knowledge without Limits: A Competition: Johann Jakob Leu versus Dr Gugel," in *Museum Schloss Kyburg: Lustvolle, tragische und lehrreiche Geschichten*, CD-ROM (Zurich: Verein Museum Schloss Kyburg, Transfusionen, 2004).

82. Harald Kraemer, "Erlebnisse zwischen Vision und Realität: Virtueller Transfer Musée Suisse, Museum Schloss Kyburg," paper presented at M@I Museums and the Internet, Mai-Tagung Rheinisches Landesmuseum Bonn (May 13–14, 2004), <http://www.mai-tagung.de/maitagung+2004/beitraege+(download).htm>.

83. Gérard Genette, *Die Erzählung* (Munich: Fink/UTB, 1994).

84. *Verner Panton*, CD-ROM (Weil/Rhein: Vitra Design Museum; Basel: Hochschule für Gestaltung und Kunst der Fachhochschule beider Basel Nordwestschweiz, 2000).

85. "The Inquisition of Johannes Grün of Kauffbüren: A Historical Criminal Case," in *Museum Schloss Kyburg*, CD-ROM.

86. Heiner Treinen, "Das Museum als kultureller Vermittlungsort in der Erlebnisgesellschaft," in *Vom Elfenbeinturm zur Fußgängerzone*, 120.

87. Bart Marable, "Experience, Learning, and Research: Coordinating the Multiple Roles of On-Line Exhibitions," *Museums and the Web* (2004), <http://www.archimuse.com/mw2004/papers/marable/marable.html>; Hans W. Giessen and Werner Schweibenz, "Kommunikation und Vermittlung im Museum: Überlegungen zur Museumskommunikation, kognitiven Lerntheorie und zum digitalen Storytelling," in *Vom Betrachter zum Gestalter: Neue Medien in Museen—Strategien, Beispiele und Perspektiven für die Bildung*, ed. Michael Mangold, Peter Weibel, and Julie Woletz (Baden-Baden: Nomos Verlagsgesellschaft, 2007), 51–63.

88. Ulla Mothes, *Dramaturgie für Spielfilm, Hörspiel und Feature* (Konstanz: UVK, 2001), 78.

89. Ross Parry and Nadia Arbach, "Localized, Personalized, and Constructivist: A Space for Online Museum Learning," in *Theorizing Futures for the Past*, 281–298.

90. Cyrus D. Khazaeli, *Systemisches Design: Intelligente Oberflächen für Information und Interaktion* (Hamburg: Rowohlt, 2005).

91. Harald Kraemer, "CD ROM und digitaler Film—Interaktivität als Strategien der Wissensvermittlung," in *Euphorie digital? Aspekte der Wissensvermittlung in Kunst, Kultur und Technologie*, ed. Claudia Gemmeke, Hartmut John, and Harald Kraemer (Bielefeld: Transcript Verlag, 2001), 199–228.

92. Larry Friedlander, "Keeping the Virtual Social," *Museums and the Web 99*, Archives & Museum Informatics, Proceedings on CD-ROM, 1999, <http://www.archimuse.com/mw99/papers/friedlander/friedlander.html>.

III New Tools for Us: Strategies for Image Analysis

17 Visualizing Change: Computer Graphics as a Research Method

Lev Manovich and Jeremy Douglass

While the explosion of new ideas and methods in cultural disciplines from the 1960s onward affected the subjects being written about and exhibited and their interpretations, one important aspect of our presentations of culture did not change. Books and museums devoted to art, design, media, and other cultural areas continue to arrange their subjects into small numbers of discrete categories—periods, artistic schools, -isms, cultural movements. The chapters in a book or the rooms of a museum act as material dividers between these categories. In this way, a continuously evolving cultural "organism" is sliced and segmented into a set of artificial boxes.

The shift from analog to digital media is a rather recent event, we have already "been digital" on a theoretical level for a long time. That is, since the emergence of modern institutions of cultural storage and cultural knowledge production in the nineteenth century (i.e., public museums and humanities disciplines housed in universities) we have been forcing the continuity of culture into strictly discrete categories in order to theorize, preserve, and exhibit it (figures 17.1–17.2).

We can ask: If we are currently fascinated with the ideas of flow, evolution, complexity, heterogeneity, and cultural hybridity, why do our presentations of cultural data not reflect these ideas?

The use of a small number of discrete categories to describe content went hand in hand with the refusal of modern humanities and cultural institutions to use graphical representations to represent this content. Many people know the famous diagram of the evolution of modern art made by Barr (the founder and first director of MoMA in New York) in 1935 (figure 17.3). This diagram still uses discrete categories, but it is an improvement over standard art timelines and art museums' floor plans since it represents cultural process as a 2D graph. Unfortunately, this is the only well-known art history diagram produced in the twentieth century.

In contrast, since the first decades of the nineteenth century, scientific publications began to widely use graphical techniques that allowed the representation of phenomena as continuously varying. According to the online history of data visualization by Michael Friendly and Daniel Denis, during that period, "all of the modern forms of

Figure 17.1
Typical museum floor plan (Spencer Museum of Art).

data display were invented: bar and pie charts, histograms, line graphs and time-series plots, contour plots, and so forth"[1] (figures 17.4–17.5).

Although a systematic history of visual data display remains to be researched and written, popular books by Edward Tufte illustrate how graphs representing quantitative data had already become common in various professional areas by the end of the nineteenth century.[2] The use of visual representations of continuous qualities became especially popular after the 1960s when computers were adopted to create 2D and 3D graphics automatically. In 1960, William Fetter (a graphic designer for Boeing Aircraft Co.) coined the phrase "computer graphics." Around the same time, Pierre Bézier and Paul de Casteljau (who worked for Renault and Citroën, respectively) independently invented splines—mathematically described smooth curves that can be easily edited by a user. In 1967, Steven Coons of MIT presented mathematical foundations for what eventually became the standard way to represent smooth surfaces in computer graphics software: "His technique for describing a surface was to construct it out of collections of adjacent patches, which had continuity constraints that would allow surfaces to have curvature which was expected by the designer."[3] Coon's technique became the foundation for surface descriptions in computer graphics (the most popular such description today is NURBS—Non-Uniform Rational Basis Spline) (figure 17.6).

When design, media, and architecture fields adopted computer graphics software in the 1990s, this led to an aesthetic and intellectual revolution. Until that time, the only practical technique for representing 3D objects in a computer was to model them through collections of flat polygons. By the early 1990s, the faster processing speeds of computers and the increased size of computer memory made it practical to pursue NURBS modeling developed by Coons and others in the 1960s. This new technique for representing spatial form pushed architectural thinking away from rectangular modernist geometry and toward the privileging of smooth and complex forms made from continuous curves. As a result, at the end of the twentieth century the aesthetics

Figure 17.2
Typical art history timeline (Tate Modern, London). Source: Flickr photo by Ruth L. Taken on April 8, 2007. <http://www.flickr.com/photos/ruthbruin2002/464176274/in/photostream>.

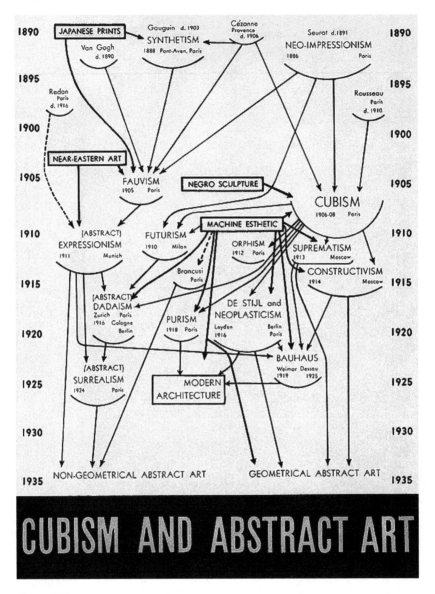

Figure 17.3
Diagram of the evolution of modern art Alfred H. Barr created in 1935 for the MoMA exhibition
Cubism and Abstract Art.

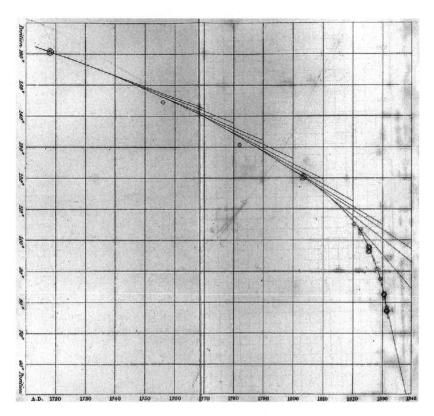

Figure 17.4
The first graph (1832) that fits a smoothed curve to a scatterplot (John Herschel, England).

of such complex smooth surfaces (called "blobs" by journalists) came to dominate the thinking of many architecture students, young architects, and even well-established "star" architects (figures 17.7–17.8). Visually and spatially, smooth curves and freeform surfaces have emerged as the new expressive language for the globalized networked word where the only constant is rapid change. The modernist aesthetics of discreteness and simplicity was replaced by the new aesthetics of continuity and complexity.

In winter 2004 Centre Pompidou organized a show, Non-Standard Architectures,[4] which was followed by a conference at MIT, Non Standard Practice. These terms emphasized both new construction techniques and the new continuous forms enabled by computation.

This change in the imagination of spatial form was paralleled by the adoption of a new intellectual vocabulary. Architectural discourse came to be dominated by concepts and terms that parallel (or directly come from) the design elements and

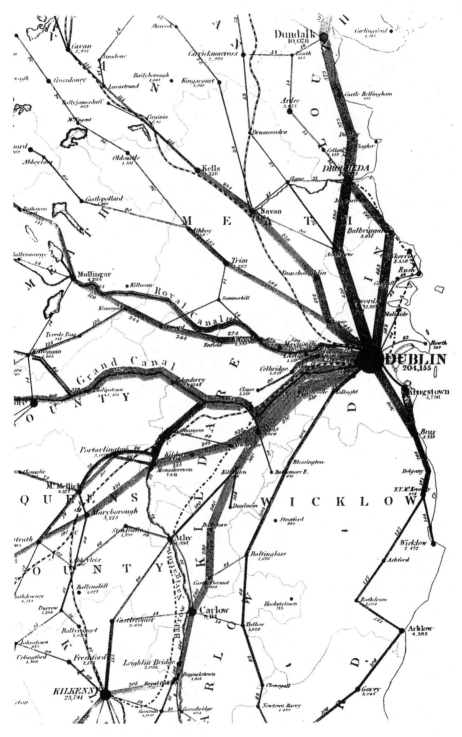

Figure 17.5
First published flow map (1837): transportation patterns are shown as lines with widths proportional to the number of passengers (Henry Drury Harness, Ireland).

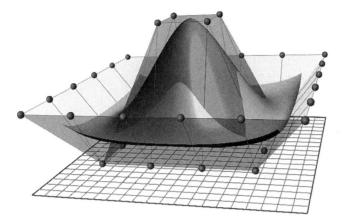

Figure 17.6
3D NURBS surface. Source: <http://en.wikipedia.org/wiki/File:NURBS_surface.png>.

Figure 17.7
Villa in Copenhagen, Denmark, by MAD Office (Beijing).

Figure 17.8
Performing Arts Center, Saadiyat Island, Abu Dhabi, by Zaha Hadid (London).

operations offered by the software—splines and NURBS, morphing, physically based modeling and simulation, parametric design, particle systems, simulation of natural phenomena, artificial life, and so on. Here are a few examples:

The Campus is organized and navigated on the basis of directional drifts and the distribution of densities rather than the key points. This is indicative of the character of the Centre as a whole: porous, immersive, a field space. (Zaha Hadid, description of a design for MAXXI—National Museum of the 21st Century Arts)

Scenarios of hybridization, grafting, cloning, morphing give rise to perpetual transformation of architecture which strives to break down the antinomies of object/subject or object/territory. (Frédéric Migayrou, writing on architectural firm R&Sie [Francois Roche and Stéphanie Lavaux, Paris])

Fuzzy logic thinking is another step of helping human thought to recognize our environment less as a world of crisp boundaries and disconnections and more as a field of swarming agents with blurred borders. EMERGED is investigating the potential of fuzzy logic as a loose-fit organizational technique for developing intelligent, flexible and adaptive environments. Seeing the project as a testing ground for its computational tools and design techniques, the team expands its research territory from focusing and systemizing the dynamic hair tool as generative design machine to a larger scale, involving therefore levels of social, cultural and global organizations. (MRGD [Melike Altinisik, Samer Chaumoun, Daniel Widrig], description of Urban Lobby [research for a speculative redevelopment of the Centre Point office tower in central London])

Although computer graphics was not the only source of inspiration for this new conceptual vocabulary—important influences came from French philosophy (particularly Derrida and Deleuze) and the sciences of chaos and complexity—it obviously played its role. Thus, along with becoming the language of contemporary design and architecture, the language of computer graphics also functions as inspiration for architectural discourse about buildings, cities, space, and social life.

Representing Cultural Processes: From Discrete Categories to Curves and Surfaces

If architects adopted the techniques of computer graphics as theoretical terms to talk about their own field, should we not do the same for all cultural fields? However, rather than using these terms as metaphors, why not actually visualize cultural processes, dynamics, and flows using the same techniques of computer graphics?

The time has come to align our models of culture with the new design language and theoretical ideas made possible (or inspired) by software. Design, animation, and visualization software allow us to start conceptualizing and visualizing cultural phenomena and processes in terms of continuously changing parameters—as opposed to categorical "boxes" still standard today.

Just as software replaced the older Platonic design primitives (cubes, cylinders, spheres) with new primitives (curves, flexible surfaces, particle fields) better suited for representing complexity, let's replace the traditional "cultural theory primitives" with new ones. In such scenario, a 1D timeline becomes a 2D or 3D graph; a small set of discrete categories is discarded in favor of curves, freeform 3D surfaces, particle fields, and other representations available in design and visualization software.

This was one of the motivations behind the establishment of the Software Studies Initiative (see <http://softwarestudies.com>) in 2007—a research lab located at University of California, San Diego (UCSD) and California Institute for Telecommunication and Information Technology (Calit2). Drawing on the recognized strengths of UCSD and Calit2 in digital art and IT research, we have been developing techniques for the graphical representation and interactive visualization of cultural artifacts, dynamics, and processes. Our inspirations come from many fields, which all rely on computer graphics to visualize data—scientific visualization, information visualization, "artistic visualization" (see <http://infosthetics.com>), information design, and interface design. For example, the standard graphical interfaces used in media editing and animation software such as Final Cut, After Effects, Maya, Blender, and others use curves to visualize the changes in various parameters of an animation over time.

Turning Culture into Data

Before we venture into folds, fields, particle clouds, complex surfaces, and other more advanced computer-driven representations, let's start with a basic element of modern spatial representation: a 2D curve. How do you represent a cultural process that unfolds over time as a continuous curve?

If, like many historians of the previous centuries, we were to believe that cultural history follows simple laws—for instance, that every culture goes though a cycle consisting of an early stage, a "golden age," and a decline stage—things would be quite simple. We would use mathematical formulas that represent the processes of growth and change (e.g., trigonometric, exponential, or polynomial functions) and feed their variables with data representing some conditions of the historical process in question. The result would be a perfectly smooth curve that represents a cultural process as a cycle of rise and fall. However, today this paradigm of history is clearly out of favor. What we want to do instead is to create a curve that is based on actual detailed data about the cultural process in question taken as a whole.

A 2D curve defines a set of points that belong to this curve. Each point, in its turn, is defined by two numbers—an x and y coordinate. If the points are dense enough, they would visually form a curve by themselves. If they are not dense enough, we can use software to fit a curve through these points. Of course, we do not always have to draw a curve through the points—for instance, if these points form clusters or any other obvious geometric patterns, this is valuable in itself.[5]

In either case, we need a set of x and y coordinates to draw the points. This means that we have to map a cultural process into a set made from pairs of numbers. In each pair, one number would represent a moment in time (x-axis) and the other number would represent some characteristic of the process at that time (y-axis).

In short, we have to turn "culture" into "data."

Definitions of culture include beliefs, ideologies, fashions, and other nonphysical properties. However, on a practical level, our cultural institutions and culture industries deal in a particular manifestation of culture—material (and recently, digital) objects. This is what is stored in the Library of Congress and the Metropolitan Museum, created by fashion and industrial designers, uploaded by users to Flickr, and sold on Amazon. Spread over time or distance, cultural objects manifest changes in cultural sensibility, imagination, or style. So even though later on we will need to challenge the assumption that a cultural process can be equated with objects, if we can begin by using the sets of these objects to represent the gradual changes in cultural sensibility or imagination, that would be a good start.

Getting numbers for the x-axis (i.e., time) is not difficult. Usually cultural objects have some discrete metadata attached to them—the name of the author, the size (of an artwork), the length (of a film), and so on—including the date and the place of

creation. So if we have the dates when the cultural objects were created, we can plot these numbers as metadata on the x-axis. For example, if we want to represent the development of painting in the twentieth century, we can plot the year each painting was completed. But what do we use for y-axis? That is, how do we compare the paintings quantitatively?

To continue with the same example, we can *manually annotate* the contents of the paintings. However, we will not be able to use natural language precisely to describe the finer details of their visual structure. Alternatively, we can ask experts (or some other group of people) to position the paintings on some *discrete scale* (e.g., historical value, aesthetic preference)—but such judgments can only work with a small number of categories.[6] More importantly, these methods do not scale well—they would be very costly if we want to describe hundreds of thousands or millions of objects. Moreover, even if we can afford it, people have inherent difficulties in subjectively ordering a large number of objects that are all very similar. Therefore, we need to resort to some automatic computer-based method to describe large numbers of cultural objects quantitatively.

In the case of texts, this is relatively easy. Since texts already consist of discrete units (i.e., words) they naturally lend themselves to computer processing. We can use software to count occurrences of particular words and combinations of words; we can compare the numbers of nouns versus verbs; we can calculate the lengths of sentences and paragraphs; and so on.

Because computers are very good at counting as well as running more complex mathematical operations on numbers, digitization of text content such as books and the growth of websites and blogs quickly led to new industries and epistemological paradigms that explore computational processing of texts. Google and other search engines analyze billions of Web pages and the links between them to allow users to search for pages that contain particular phrases or single words. Nielsen Blogpulse mines over 100 million blogs daily to detect trends in what people are saying about particular brands, products, and other topics its clients are interested in.[7] Amazon.com analyzes the contents of the books it sells to calculate "statistically improbable phrases" or SIPs, used to identify unique topics.[8]

In the field of digital humanities, scholars have also been doing statistical studies of literary texts for a long time, although on a much smaller scale. Some of them— most notably, Franco Moretti—have produced visualizations of data in the form of curves showing historical trends across sets of literary texts.[9] During the last few decades Russian scholars have also published a large number of books and articles that use quantitative methods and visualization to study patterns in literature and other arts[10]—although this work is practically unknown in the West.

But how do we automate the description of images or video? Many kinds of visual media such as photographs do not have clearly defined discrete units equivalent to

words in a text. Additionally, visual media do not have a standard vocabulary or grammar—the meaning of any element of an image is defined only in the particular context of all other elements in this image. This makes the problem of automatic visual analysis much more challenging—but not impossible. The trick is to focus on visual form (which is easy for computers to analyze) and not semantics (which is hard to automate).

Since the middle of the 1950s, computer scientists have been developing techniques to describe visual properties of images automatically. Today we have techniques for the analysis of distributions of gray tones and colors, orientation and curvature of lines, texture, composition, and literally hundreds of other visual dimensions. A few of these techniques—for instance, the histogram—are built into digital media editing software (e.g., Photoshop, iPhoto) and also into the interfaces of digital cameras. (Most cameras today can display histograms of the images they capture.) Many more techniques are available in specialized application software or described in professional publications in the fields of image processing, computer vision, multimedia, and media computing.

The field of digital image processing began to develop in the second half of the 1950s, when scientists and the military realized that digital computers could be used to reduce artifacts automatically and analyze aerial (and soon satellite and manned-spacecraft) images collected for military reconnaissance or scientific research. Some Photoshop filters that automatically enhance image appearance (e.g., by boosting contrast, or by reducing noise) come directly from that era. Since that time, image processing has found many applications in robotics, medical imaging, astronomy, neuroscience, and dozens of other scientific fields. Examples of visual features that can be analyzed include brightness, saturation, hue, texture, line orientations, and most important colors.

Our approach (which we call *cultural analytics*) is to use image-processing techniques to automatically analyze images to generate numerical descriptions of their visual structure. These numerical descriptions can then be graphed and also analyzed statistically. For example, if we plot the creation dates for a number of images on the x-axis, we can then use measurements of their visual structure (brightness, saturation, or other characteristics, which can be used by themselves or in combination) to position them on y-axis, and then ask the computer to draw a curve (a spline) through these points.

We use a similar approach to analyze and visualize temporal changes in a video. Since a video is a collection of still frames, we apply the same image-processing techniques to each video frame and then plot values over x and y. In such a graph, x represents the frame's position in time, and y shows the values of some visual parameter.

ArtHistory.viz

For our first study to test this approach, we chose a small data set of 35 canonical art history images that covers the period from Courbet (1849) to Malevich (1914). (figure 17.9, plate 25). We selected color paintings that are typical for the presentation of the history of modern art in an art history textbook or lecture: from nineteenth-century realism and salon painting to impressionism, Postimpressionism, fauvism, and geometric abstraction of the 1910s. Our intention was not to find a new pattern in our set of paintings but rather to see if the cultural analytics method could turn our shared understanding of the development of modern art into a curve based on some objective qualities of these images—thus turning an intuition into a precise model (figures 17.10–17.14).

FilmHistory.viz

In this example, we explore patterns in the history of cinema as represented by 1,100 feature films. The data source is <http://cinemetrics.lv>—a website used by film scholars to collect information about films' editing patterns.[11] The Cinemetrics database includes films from 1902 to 2008—thus giving us an opportunity to visualize changes over a long historical period. As in the previous example, this data set represents a biased selection—i.e., films that interested the film historians who contributed the data—rather than an objective sample of world film production. Also, given the particular process used by film scholars contributing to Cinemetrics for logging shot lengths in a film, the actual numbers for each film are not completely reliable—but since we are interested in the overall patterns across many films, for our purposes the errors in the data set are not significant.

For each film in its database Cinemetrics provides a number of statistics including average shot length (which can be obtained by dividing the length of a film by the total number of shots). These data allow us to explore the patterns in film editing across different periods in the twentieth century and different countries (figures 17.14–17.16).[12]

VideoGamePlay.viz

Video games and other types of visual interactive media pose unique challenges to cultural analysis because of their procedural complexity and the variability of their numerous manifestations. On the one hand, the game experience is the result of a real-time computation that typically involves many thousands of separate computer functions all working in tandem. On the other hand, when compared to watching a

Figure 17.9
A set of 35 paintings by canonical modern artists as discussed in the section "ArtHistory.viz."
See plate 25.

Figure 17.10
X-axis—dates of paintings (in years). Y-axis—reverse skew value of each painting. Skew is a measure of image grayscale distribution. An image with mostly light tones will have a negative skew value; an image with mostly dark tones will have a positive skew value. We have reversed skew values (lighter is positive).

film in a movie theater, the action of playing a video game is different every time. Therefore, the game experience may significantly vary from player to player and even session to session.

How can we quantify and visualize the temporal structure and player's experience of a cultural object that is always changing? We begin by extending our approaches to film and motion graphics and applying them to gameplay. That is, we turn each game session into the equivalent of a film by recording video as it is played. Once we create such a recording, we can use it to analyze a game experience as a process of changes over time. Following this approach, a game is best represented as a collection of gameplay sessions. While each session is unique, their differences are constrained by the logics of the underlying game software.

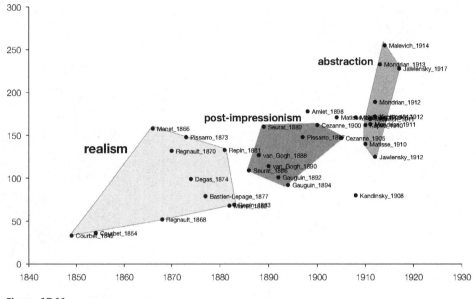

Figure 17.11
Superimposing standard art historical categories on the data.

We can start by graphically representing rhythms and patterns in a single gameplay session. We can also aggregate the data from many sessions to visualize a space of possible experiences enabled by a particular game. We can further create visual "landscapes" of larger areas of video-game culture (similar to how we visualized relationships between 1,100+ feature films in FilmHistory.viz), with sets of data representing different gameplay sessions of a single game, and supersets of data representing the comparison of many games.

The video-game industry already uses representations of gameplay as part of its development cycle. One common practice is to record the internal states of game software as the game is played. In massively multiplayer online games (MMOGs) such as World of Warcraft, statistical analysis of gameplay data drives everything from the advancement of individual characters to the marketplaces of massive auction houses. Game developers also conduct user testing during development through extensive logging of internal gameplay data. For example, during the development of the first-person shooters Halo 2 and Halo 3, Bungie Studios logged statistics on events such as player kills and deaths for hundreds of gamers over thousands of hours of play in order to fine-tune the game's ability to produce a well-balanced experience.[13]

Our initial applications of cultural analytics to games are related to but differ from this industry paradigm in three ways. First, we emphasize games in terms of temporal patterns rather than outcomes. Second, we emphasize exploring gameplay as a total

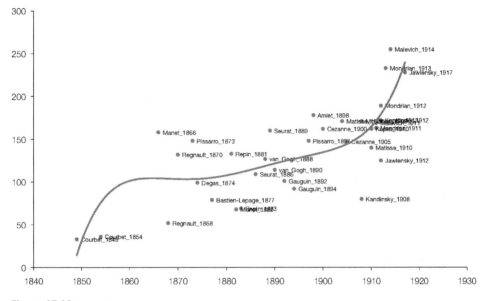

Figure 17.12

Projecting a small set of categories on the data defines each cultural object as either belonging to a distinct category or as being outside of all categories. Instead, we can visualize the overall pattern in their development. This allows us to take into account all objects in the set. In this graph we defined a trend line using all the points (i.e., all 35 paintings). The curve shows that the changes in visual parameters that in our view came to define modern art in the twentieth century (simplified forms, brighter tonality, more saturated colors, more flat images) accelerate after 1870, and then accelerate even more after 1905. To determine y values for this graph, we measured paintings on the following visual dimensions: grayscale mean, saturation mean, the length of binary grayscale histogram, and skew. All values except skew were measured on a scale of 0–255; skew measurements were normalized to the same scale. (The length of the binary grayscale histogram indicates how many different pixel values have nonzero values in the original histogram. If an image has every possible grayscale value, this number will 255; if an image has only two different grayscale values, the number will be 2.)

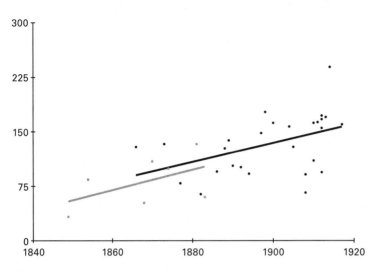

Figure 17.13

Computer measurements of visual structure can be used to find differences between cultural sets, which at first sight appear to be identical—as well as to find similarities between the sets, which are normally thought to be very different. This graph compares the changes in median grayscale values of "realist" paintings versus "modernist" paintings in our set. It reveals that on this visual dimension, the former were changing at exactly the same rate as the latter. In other words, "realist" painters were moving towards abstraction at the same speed as "modernist" painters.

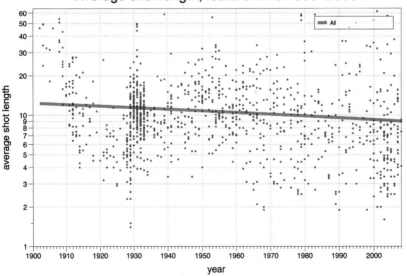

Figure 17.14

Images can be analyzed on hundreds of different visual dimensions. To produce this graph, we used software to automatically count the number of shapes in each image. X-axis—date (in years). Y-axis—number of shapes in each painting.

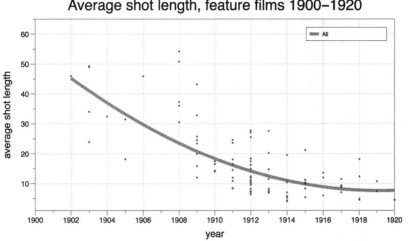

Figure 17.15

X-axis—date (in years). Y-axis—average shot length (in seconds). Each film is represented by a small circle. The trend line through the data shows that between 1902 and 2008, the average shot length for the whole set of 1,100 films decreased from 14 seconds to 10 seconds.

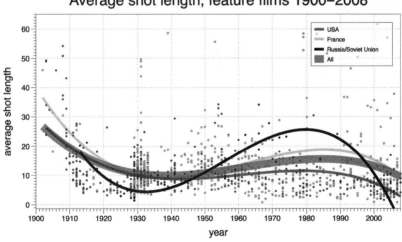

Figure 17.16

During the period when film language shifted from being a simulation of theater to a new system based on cutting between different points of view, the changes occurred at a much faster rate. Between 1902 and 1920, the average shot length decreased by approximately a factor of four.

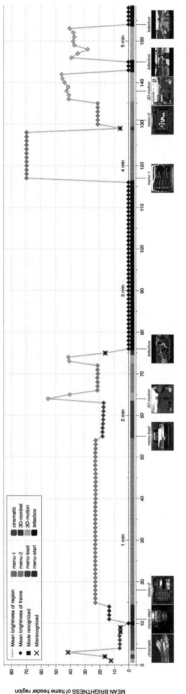

Figure 17.17

Here we compare the trends in the films' shot lengths for three countries: the United States, France, and Russia. The graph reveals a number of interesting patterns. From the beginning of the twentieth century, French films are slower than American films. The two catch up in the 1920s and 1930s, but after World War II French films again become slower. Even after 1990, when both curves start going down, the gap between them remains the same. (This can partly explain why French films have not been doing well on the international cinema market in recent decades.) In contrast to the trend lines for the United States and France, the trend line for Russian cinema has much more dramatic curves—a reflection of the radical shifts in Russian society in the twentieth century. The dip in the 1920s represents the fast cutting style of the Russian montage school (whose films dominate Cinemetrics' selection of Russian cinema for that period), which aimed to establish a new film language appropriate for the new socialist society. After 1933 when Stalin tightens control over culture and establishes the doctrine of Socialist Realism, the films start slowing down. By the 1980s, their average shot length is 25 seconds versus 15 for French films and 10 for American films. But after the Soviet Union is dissolved and Russia starts to adopt capitalism, the films' cutting rates correspondingly start to increase quite rapidly.

The particular details of the trend lines in this graph do not, of course, reflect the "complete picture." The Cinemetrics database contains unequal numbers of the films for the three countries (479 American films, 138 French films, 48 Russian films); the films are not distributed evenly in time (i.e., some periods are represented better than others); and, perhaps most important, the selection of films is heavily biased toward historically important directors and "art cinema" (for example, there are 53 entries for D. W. Griffith). Therefore, if we are to add more data to the graphs, the curves in the graph are likely to appear somewhat different. However, within the particular "canonical" subset of all cinema contained in the Cinemetrics database the graph does show the real trends, which, as we saw, correspond to the larger cultural and social conditions in which culture is formed.

aesthetic experience (color, motion, sound) rather than as predefined event states (deaths, victories, achievements). Third, our ambition is to compare games across titles (Halo 2 and Doom 3), companies (e.g., Bungie and Ubisoft), platforms (e.g., Wii and XBox), and generations of hardware platforms. Only an approach that analyzes videos of gameplay can hope to achieve all these goals. At present, it is not feasible to apply industry approaches to a broad survey of games because of a wide variety of obstacles: (1) Non-networked games cannot be studied by analyzing network traffic. (2) Most game developers obfuscate the rules and protocols of their games to prevent cheating and protect intellectual property. (3) Many industry techniques for game analysis are usable during the development cycle, but cannot be used after publication. (4) The wide variety of legacy PC and console platform hardware makes each game's software inaccessible in different ways.

All video gameplay, however, is accessible to screen recording and visual analysis, regardless of the underlying software and hardware and regardless of when or how the game was published. The time-based video of gameplay also allows for comparative analysis of games, which may differ in platform, genre, length of gameplay, and so on. We can study games, like films, as time-based visual processes. We can further algorithmically extract information about user behavior and game semantics from these gameplay videos, visualizing how game modes change continuously over time.

This analysis is possible because the visual interfaces of games typically inform the player of their continuously changing internal states through displaying stable signifiers—for example, bars indicating health, counters indicating time, frames indicating menu status, text announcing an event, and so forth. In addition to programming a computer to automatically recognize and record states from video recordings of gameplay (e.g., "combat"), we can also quantify signifying images as values (e.g., a green meter as "53%"). We can then visualize the rhythms of those values and states as they change over time (figures 17.18–17.19).

Conclusion

Our work on visualizing cultural changes is inspired by commercial software (Google's Web Analytics, Trends, and Flu Trends; Nelson's BlogPulse) as well as projects by artists and designers (Fernanda Viegas and Martin Wattenberg's seminal *History Flow*; Lee Byron's *Listening History*[14] and *The Ebb and Flow of Movies*).[15] Until now, most visualizations of cultural processes used either discrete media (i.e., texts) or the metadata about the media (i.e., text about images). Thus, *History Flow* uses histories of Wikipedia pages' edits; *Listening History* uses data about Lee Byron's use of last.fm; and *The Ebb and Flow of Movies* uses data on box office receipts. In contrast, our method allows for the analysis and visualization of patterns in the content of images, films, video, and other types of visual media.

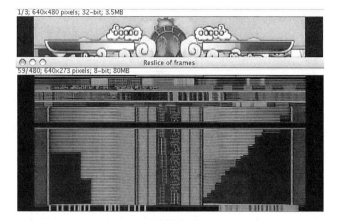

Figure 17.18
Suppose a researcher is trying to discover the "primitives" for types of dramatic conflict in fighting games. How do challenges emerge while fighting different opponents? Here, the length of health bars from the game Naruto: Clash of Ninja Revolution (top) are extracted as a time series of lines that reads from the top down (bottom). The computer opponent's bar (bottom right) gradually fades toward zero, while the player's avatar (bottom left) drops suddenly at two points in time. The drama over who will succeed and who will fail in this fight is a race between the continuous erosion of opponent power and sudden setbacks for the player. This suggests a new question: Are the "curves" that describe this particular experience (continuous success with dramatic setbacks) present in other fight games? Which ones, and why? When we interrogate structures of experience inside games, across games, and throughout game history, this could lead us to new theories of game genre, based not just on how games appear or their affordances, but on the temporal patterns in gameplay.

Our work presented in this essay demonstrates how we can visualize gradual changes over time on a number of scales—from a brief video of gameplay to a century of film history. Google Earth allows you to navigate through space across scales—from the view of the Earth as a whole to a street view that puts you in the position of a driver in a car or a passerby on the street. In the same way, we should be able to navigate through time across scales, moving from the view of a century of cinema to the view of a single shot lasting a few seconds.

Visualization of gradual changes in visual and media culture over longer historical periods is an idea that appears to us particularly timely. Humanities disciplines, critics, museums, and other cultural institutions usually present culture in terms of self-contained cultural periods. Similarly, the most influential contemporary theories of history by Thomas Kuhn ("scientific paradigms") and Michel Foucault ("epistemes") also focus on stable periods rather than transitions between them. In fact, relatively little intellectual energy has been spent on thinking about how cultural change happens. Perhaps this was appropriate given that, until recently, cultural changes of

Figure 17.19
Top: A time-lapse image of the Rock Band rhythm game interface. Left: "Band meter" region as a time series of player in-game popularity. Bottom: "Fret bar" region as a time series of musical tablature.

Suppose a researcher is working on representations of music in games and wants access to all the musical tablature experienced by a player in the rhythm game Rock Band. In particular, the researcher wants a transcript of all the notes missed by a series of players. In this example, a computer program extracts the musical tablature from the middle of the screen, recording a time-series of notes as they zoom by, and also extracts the missed notes from the bottom of the screen, recording only the notes that were not played correctly. With the ability to visualize one song comes the ability to extract and compare all songs—in the game, the franchise, and all other rhythm games that are visually similar. The researcher can now use cultural analytics to ask new questions. What are the patterns of musical-level design in all such games? Which patterns are associated with difficulty or pleasure? How is their use distributed, and how has it changed over time?

all kinds were usually very slow. However, since 1990, these changes have not only accelerated worldwide, but the emphasis on continual change rather than on stability has became the key to global business and institutional thinking, as expressed in the popularity of terms such as "innovation" and "disruptive change." It is time, therefore, to start treating "change" as a basic unit of cultural analysis—rather than limiting ourselves to discrete categories such as "period," "school," and "work."

Notes

1. Michael Friendly and Daniel J. Denis, "Milestones in the History of Thematic Cartography, Statistical Graphics, and Data Visualization" (2001), <http://www.math.yorku.ca/SCS/Gallery/milestone/sec5.html>.

2. Edward Tufte, *The Visual Display of Quantitative Information*, 2nd ed. (Cheshire, CT: Graphics Press, 2001).

3. Steven A. Coons, Surfaces for Computer-Aided Design of Space Forms, MIT/LCS/TR-41, June 1967, <http://publications.csail.mit.edu/lcs/pubs/pdf/MIT-LCS-TR-041.pdf>.

4. See <http://www.designboom.com/contemporary/nonstandard.html>.

5. We are not talking about the statistical technique of cluster analysis but simply about plotting points in two dimensions and visually examining the resulting graph.

6. Such a method is an example of a much more general technique called *scaling*: "In the social sciences, scaling is the process of measuring or ordering entities with respect to quantitative attributes or traits." From <http://en.wikipedia.org/wiki/Scale_(social_sciences)>.

7. "BlogPulse Reaches 100 Million Mark," <http://blog.blogpulse.com>.

8. See <http://en.wikipedia.org/wiki/Statistically_Improbable_Phrases>.

9. Franco Moretti, *Graphs, Maps, Trees: Abstract Models for a Literary History* (London: Verso, 2007).

10. Vladimir Petrov, "Problems and Methods of Empirical Aesthetics" (in Russian), in *Works in Theory of the Arts: A Dialog between Humanities and Sciences*, ed. Vladimir Koptsik, Vladimir Ruzov, Vladimir Petrov (Moscow: OGI, 2004).

11. Special thanks to Yuri Tsivian for generously providing access to the Cinemetrics database.

12. The graphs in this essay were produced using a selection of complete data contained in the Cinemetrics database as of August 2008.

13. Clive Thompson, "Halo 3: How Microsoft Labs Invented a New Science of Play," *Wired Magazine* 15, no. 9 (August 2007).

14. See <http://www.leebyron.com/what/lastfm>.

15. See <http://www.nytimes.com/interactive/2008/02/23/movies/20080223_REVENUE_GRAPHIC.html>.

18 "God Is in the Details," or The Filing Box Answers

Martin Warnke

The title of this essay refers to two eminent scholars. The first quote stems from Aby Warburg, who was born in 1866 and died in 1929, the son of the owner of a bank, who sold his status and his rights of a firstborn to his brother—like Esau did at one time. The brother is called Max and not Jakob, and the price was not a plate of lentils but every book he, Aby, wanted. The deal became dearer than Max thought when he took over the Warburg Bank and promised to buy the desired literature.

Aby Warburg became one of the first and one of the most famous *Kulturwissenschaftler*, scholar in the field of cultural studies, and he built the Kulturwissenschaftliche Bibliothek Warburg in Hamburg, whose stock emigrated in 1933 to the Warburg Institute in London.

Warburg deserves to be called the inventor of iconology. Art history defines iconology as "description and classification of image content aiming to understand the significance of this content."[1] In a way this is the key problem of all scientific use of images.

My other patron is Niklas Luhmann, one of the greatest sons of my town Lüneburg, born 1927, died 1998, sociologist and constructor of modern systems theory, who started his "filing box because of the simple consideration that" his "memory was bad" already at the age of 25.[2] He communicated with his filing box; it was an eminent source of his productivity and he treated it so well that in the end it answered him, surprised him, and gave back more than he had put into it. In other words: The concern is that of media of knowledge.

On the shoulders of these two giants stands my humble contribution, the attempt to combine the sharp-eyed gaze at the details of an image with a comfortable filing box by an implementation in software.

God Is in the Details—A Science of the Sharp-Eyed Gaze—Thinking in Images

Images have a poor scientific reputation. They count only little, if exact conclusions have to be drawn. Since modern times precise thinking is done with text, because

images are reigned by the category of similarity, which is, *secondo* Foucault, since the beginning of the seventeenth century "no longer the form of knowledge but rather the occasion of error, the danger to which one exposes oneself when one does not examine the obscure region of confusions."[3]

In spite of this, great thinkers also after the seventeenth century have thought in images. My favorite example is one by Charles Darwin, who on December 7, 1856, jotted into his notebook[4] "I think," and then afterward expressed what came to his mind by means of an image, with a diagram.

It took until now to understand why thinking in images is not offensive but fruitful. The new science that emerged from that is the reason of this book: *Bildwissenschaft*. I refrain from translating it in English.

Gottfried Boehm wrote: "the notion 'image' concerns a different type of thinking that is capable of clarifying the long-underestimated cognitive techniques that do not use verbal representations. . . . It is an 'iconic difference' with which significance can be expressed without reverting to linguistic models, e.g., syntax or rhetorical figures, because the intelligence of images lies in their respective visual order."[5]

I'd like to point to this extralinguistic aspect of images, to the fact that images and their interrelations could not be totally exhausted by speech and for that very reason could not be explained and described verbally without leaving a residuum.

In very much the same way as language uses words and notions to form reasonable propositions, thinking in images is done using "image atoms," signifying entities. Contrary to language it is all but clear which these are.[6] Language has brought about the dictionary. Image atoms have to be discovered, negotiated, described every time anew.

Aby Warburg was deeply convinced that the cultural historic significance of images lies precisely in these image atoms and their interrelations. On November 25, 1925, he found the following word for this: "Der liebe Gott steckt im Detail."[7] God is in the details. With the full seriousness of scientific endeavor he stated: "Wir suchen unsere Ignoranz auf und schlagen die, wo wir sie finden."[8] We search for our ignorance and beat it where we find it.

One of his endeavors I will have you recall.

Warburg's methodology of cultural historic analysis of image motifs, his iconography and iconology, as we would call it nowadays, traced the path of tradition of image content from the ancients up to now. A famous example of this technique of thorough tracing is written down in his paper about the frescoes in the Hall of the Months at Palazzo Schifanoia in Ferrara.[9] It is a veritable riddle, which he solved with the exactness of an investigator.

The question is: Who is the man in white clothes girdled with a rope?[10]

The answer is: A certain Perseus, who often changed his appearance significantly, which, however, could not irritate the Warburgian serendipity.

Here comes the chain of evidence: The most important information comes from the context of the quested: astrology. The figure is part of the month of March, so the image tradition of the zodiacal sign Aries helped a lot to trace down the personnel under suspicion.

Perseus, from the Greek sky of fixed stars, holds in one hand the gorgon's head and the harp, the scimitar, in the other. He becomes the first Egyptian dean of Aries, the one who rules the first ten days, from *deka*, "ten." He carries an Egyption double axe. He mutates more and more into an Arabic executioner and hangman, immediately after having done his duty. Recall: he cut off the gorgon's head. A Spanish lapidary showed him that way, the double axe is still there, black skin has been added.

According to an Indian tradition, this means:

The Indians say that in this dean a black man rises with red eyes, of big figure, strong courage and great attitude; he wears a big white costume and is girdled with a rope. . . .[11]

Thus we find an Ethiopian hangman in white, using his rope as a belt, showing his service weapon to everybody, as could be observed in Ferrara.

Since all the relevant literature was known to the principal of the Palazzo Schifanoia, we have a complete chain of evidence. The person is convicted of being Perseus.

Aby Warburg also argued visually using images in his Mnemosyne-Atlas,[12] and this is indeed utterly necessary to be able to follow the chain of reasoning in his paper. He used arrangements of images, frames, photographs pinned to black canvases, to relate images from distant times and places.

Wordless image next to image, his iconology began to blossom. Horst Bredekamp and Michael Diers as editors of Warburg's research stressed that the significance of images in the process of civilization lies somewhere between magic and logos.[13] Philippe-Alain Michaud calls it "a mute language, freed from the constraints of discourse."[14]

Warburg's frames served as means and media of reasoning and of presentation. They were relatively easy to carry out but set limits to arbitrary recombination of the contents. So Warburg wrote in his scientific diary:[15]

The regrouping of the photo-plates is tedious. . . . mass displacement within the photo plates. . . . Pushing around frames with Freund. . . . Difficulty: the placement of Duccio. . . . The arrangement of plates in the hall causes unforeseen inner difficulties. . . . Begun to cut out all the gods. . . .

It must have been extremely difficult to relate image details with one another, despite the fact that exactly this was of such importance to Warburg. Peter van Huisstede reports of chains of argumentation like filaments consisting of 15 or 20 images. Whether Warburg actually used a ball of woolen thread is unknown to me, but I am convinced he would have gone a similar way we did.

HyperImage: Working Close to the Digital Image

Our software is a digital filing box for image details. References between these details can be coded without verbalization. Its name is HyperImage,[16] and it is the result of a collaboration between the Humboldt University in Berlin and the Leuphana University of Lüneburg; the German Ministry for Research and Education (bmbf) gave the money.

Images are uploaded from repositories to the editor. There these images are put into groups, metadata are added, image details are marked and linked to one another. With light tables, arrangements of the Warburg frame type can be done, albeit a bit more comfortably. The images can be referred to in multiple contexts and interrelationships at the same time, which Warburg definitely would have liked. And because everything is digital, image indexes and concordances are compiled automatically.

All this results in Flash-based Web pages, which can be put in operation without further ado on any conventional server or even from a local drive. Pilot users tested our application for their own research purposes. A stable final version is online as open-source software.

The editor is programmed in Java, as platform-independent open source software, its architecture strictly following the principles of Web services. After authentication, images are uploaded from the local drive or any repository with a proper interface. The material is grouped, metadata are added, material is decomposed into image atoms, which are then linked together, and all of it exported as an XML file.

Figure 18.1 shows how it looks to link a region that has been marked in the editor to another marked region. The figure in the upper half of the window is linked to the rectangular region with a drag-and-drop mouse gesture. The linkage is stored in the database, indexed, and at the end exported within the XML file.

Regions are marked independent of resolution. This means that they could be of any size and precision; their coordinates are relative to the image's edges, in contrast to pixels. External repositories have to have a WSDL-interface to be connected to the editor. Such an interface could be developed in one or two weeks' programming effort. The editor produces an XML file that is interpreted by a Flash-based reader. A Flash plugin to the browser suffices; the material can be delivered by any Web server or locally from a disc.

Figures 18.2 through 18.9 (see plate 26) show how the Warburg example from the Schifanoia Palazzo looks in the reader—clicking the mouse over the appropriate highlighted region carries the viewer to the next image, where the chain of image links can be carried out. This chain exactly maps the linear argument in the Warburg paper, revitalizing the image frames. Annotations explain the significance of each link. These notes are entered within the editor when specifying the links.

Figure 18.1
Linking the black man to the corresponding detail of the Warburg frame (as all others, from the Mnemosyne-Atlas) with the HyperImage Editor. © Martin Warnke.

Figure 8.10 shows how an arrangement of images looks in a prepared light table. This is a technical realization of Johann Gottfried von Herder's observation that "All notions hang in the chain of truth with one another; the tiniest may not only serve the biggest, but could itself become indispensable."[17] Or: God is in the details!

When the Filing Box Answers

We now arrive at the last section of this essay, at the filing box, which, if properly taken care of, answers its operator.

Luhmann's biggest problem with his box was to correctly move notes back to their proper location after use.[18] At least this is something computer technology has freed us from. Storage and retrieval are the easiest duties for computers.

But: How does the filing box become intellectually productive? This stems from the same sources as the difficulty with rearranging notes: from complexity. The need for a filing box always evolves from the problem of complexity, to the possibility of having much more than could be overlooked. Computers help to govern the masses, but to select the relevant parts, a human brain is necessary.

Figures 18.2–18.9

The Warburg argument, followed from within the HyperImage Reader, from image detail to corresponding image detail. See plate 26. © Martin Warnke.

Figures 18.2–18.9
Continued

Figure 18.10
The light table, compiling all the visual evidence. © Martin Warnke.

What, then, is a good filing box? Does its quality come from the wisdom of its individual notes? Somebody trained in ontology might think so. Luhmann, as usual, takes a totally different approach: "Contrary to the structure of updatable references, the importance of what is noted concretely is small. . . . The communication with the filing box only becomes fruitful at a higher level of generalization, at the level of communicatively connecting the relations."[19]

To put it differently: by cross-referencing and the mashup that follows from it. *The net is the filing box.* By cross-referencing, the spider-like net system[20] of entries emerges. "Every note is an element that gains its qualities only by virtue of the net of reference and cross-reference in the system."[21] It is not just the chain, as Herder thought; in postmodern times, it is the net of atoms of knowledge mutually backing up one another.

But does our filing box called Hyperimage actually give answers to its operators? Some years of use will certainly be necessary before any surprising results occur. As Luhmann states, his "filing box on occasion provides for combinatorial possibilities that have never been planned, thought of, prepared for in advance."[22]

I asked our pilot users, and a very exciting answer came from the biologists and their biodiversity project at the Museum für Naturkunde in Berlin. Prof. Hannelore Hoch and her group search for the inner workings of the evolution of species and can report that the use of images, in this case tomography data, maps, and localizations,

brought about insights that were not possible before, without this kind of media. Additionally, there are new insights concerning the evolutionary status of species that can be gained by locating them on maps and backtracking the findings to their origins, that is, by using the image index. In this way it became clear that one species always occurs "sympatrically," that is, together with another one. This suggests evolutionary dependencies that were not known before.[23]

Final Questions

There are two final questions: What comes after, and a crucial question, following Faust: the so-called *Gretchenfrage*.

First: What comes after. The Deutsche Forschungsgemeinschaft provided financing to build HyperImage into prometheus, the German distributed imaga database for research and academic education.[24] This should bring in the required masses of pictorial references to allow the net of images to grow.

Now the *Gretchenfrage*. Aby Warburg, finding God in the details, obviously stayed with the almighty. But what about the second giant on whose shoulders my other foot rests?

Talking to Alexander Kluge about which character from Faust Luhmann found the most interesting, Luhmann answered: "Probably Mephistopheles. My part is always with the devil. He discriminates the sharpest and sees the most." And being asked about his major character attribute, and whether it may be curiosity, Luhmann, always ready for a surprise, answered: "Stubbornness"—in German: *Bockigkeit*.[25]

I don't know what your interpretation might be of this confusing statement, but I thank you for your attention anyway.

Notes

1. Aby Warburg, "Nachwort des Herausgebers," in *Ausgewählte Schriften und Würdigungen*, ed. Dieter Wuttke (Baden-Baden: Verlag V. Koerner, 1980), 601–602. Translation by the author.

2. Niklas Luhmann, "Biographie, Attitüden, Zettelkasten," in *Niklas Luhmann—Short Cuts*, ed. Peter Gente et al. (Frankfurt: Zweitausendeins, 2000), 33.

3. Michel Foucault, *The Order of Things* (New York: Random House, 1994), 50.

4. See <http://darwin-online.org.uk/content/frameset?viewtype=side&itemID=CUL-DAR121 .-&pageseq=38> from Complete Work of Charles Darwin Online.

5. Gottfried Boehm, "Iconic Turn: Ein Brief," in *Bilderfragen*, ed. Hans Belting (Munich: Fink Verlag, 2007), 27. Translation by the author.

6. See Martin Warnke, "Bilder und Worte," in *Suchbilder*, ed. Wolfgang Ernst et al. (Berlin: Kulturverlag Kadmos, 2003), 57–60.

7. Aby Warburg, "Nachwort des Herausgebers," 619.

8. Ibid.

9. Aby Warburg, "Italienische Kunst und internationale Astrologie im Palazzo Schifanoja zu Ferrara," in *Ausgewählte Schriften und Würdigungen*, 173–198.

10. For the image material see figures 18.1–18.9.

11. Franz Boll, *Sphaera* (Leipzig: Akademie-Verlag, 1903), 497.

12. Aby Warburg, "Der Bilderatlas Mnemosyne," *Gesammelte Schriften*, Book. 2, vol. 1, ed. Martin Warnke and Claudia Brink (Berlin: Akademie-Verlag, 2000).

13. Preface to Aby Warburg, "Die Erneuerung der heidnischen Antike: kulturwissenschaftliche Beiträge zur Geschichte der europäischen Renaissance," Horst Bredekamp, and Michael Diers, *Gesammelte Schriften*, Book. 1, vol. 1 (Berlin: Akademie-Verlag, 1998), 9.

14. Philippe-Alain Michaud, "Zwischenreich," Trivium 1 (2008), par. 30, <http://trivium.revues.org/index373.html>.

15. Quoted in Peter van Huisstede, "Der Mnemosyne-Atlas. Ein Laboratorium der Bildgeschichte," in Aby Warburg, *Ekstatische Nymphe . . . trauernder Flußgott; Portrait eines Gelehrten*, ed. Robert Galitz and Brita Reimers (Hamburg: Dölling und Galitz Verlag, 1955), 130–171. Translation by the author.

16. Key: 01DS004B. See <http://www.hyperimage.eu>.

17. Quoted in Aby Warburg, *Ausgewählte Schriften und Würdigungen*, 604. Translation by the author.

18. We can watch the master himself at work: <http://www.youtube.com/watch?v=7gxXkbEag6k>.

19. Niklas Luhmann, "Kommunikation mit Zettelkästen: Ein Erfahrungsbericht," in *Öffentliche Meinung und sozialer Wandel*, ed. Horst Baier et al. (Opladen: Westdeutscher Verlag, 1981), 227. Translation by the author.

20. Niklas Luhmann, "Biographie, Attitüden, Zettelkasten," in *Niklas Luhmann—Short Cuts*, ed. Peter Gente, et al. (Frankfurt: Zweitausendeins, 2000),

21. Luhmann, "Kommunikation mit Zettelkästen," 225.

22. Ibid., 226.

23. Hannelore Hoch (2008), pers. comm.

24. See <http://www.prometheus-bildarchiv.de> and <http://meta-image.de>.

25. Niklas Luhmann and Alexander Kluge, "Vorsicht vor zu raschem Verstehen," in *Warum haben Sie keinen Fernseher, Herr Luhmann?—Letzte Gespräche mit Niklas Luhmann*, ed. Wolfgang Hagen (Berlin: Kadmos, 2004), 77. Translation by the author.

19 Media Art's Challenge to Our Societies

Oliver Grau

Since the 1970s media art has evolved into a vivid contemporary force, and digital art became "the art of our time" but has still not "arrived" in the core cultural institutions of our societies. Although there are well-attended festivals worldwide, well-funded collaborative projects, numerous artist-written articles, discussion forums, and emerging database-documentation projects, media art is still rarely collected by museums, not often included or supported within the mainframe of art history, and nearly inaccessible for the non-northwestern public and their scholars. Thus, we witness the erasure of a significant portion of the cultural memory of our recent history. It is no exaggeration to say that we face a total loss of digital contemporary art, and works originating approximately ten years ago most likely cannot be shown anymore.

The primary question is: What can we learn from other fields to develop a strategy to solve the problems of media art and its research, to answer the challenges image science is facing today in the framework of the digital humanities? This question opens up a perspective from which to overcome the typical placement of media arts in an academic ghetto. The development of the field is finding increasing support through new scientific instruments, such as online image and text archives, which attempt to document collectively the art and theory production of recent decades. By discussing examples from a variety of projects from the natural sciences and the humanities, this chapter tries to demonstrate the strategic importance of these collective projects, especially their growing importance for the humanities.

Media Art's Revolution?

Media art is the art form that uses the technologies that fundamentally change our societies. Globalization, the information society, social networks, Web 2.0—the list could be far longer—are enabled by digital technologies. Although not all media art comments on social, cultural, and political conditions, it is nevertheless the art form with the most comprehensive potential for cultural necessity. We know that media

artists today are shaping highly disparate areas, such as time-based installation art, telepresence art, genetic and bio art, robotics, Net art, and space art; experimenting with nanotechnology, artificial or A-life art; creating virtual agents and avatars, mixed realities, and database-supported art. These artworks both represent and reflect the revolutionary developments that the image has undergone over the past years (figure 19.1, plate 27).[1]

Currently, we are witnessing the transformation of the image into a computer-generated, virtual, and spatial entity that is seemingly capable of changing "autonomously" and representing a lifelike, visual-sensory sphere. Interactive media are changing our perception and concept of the image in the direction of a space for multisensory experience with a temporal dimension open to evolutionary change and gaming. Images appear whose condition is defined by the functions of display and interface; images serve as projection surface for interrelated information; images enable to move us telematically in immersive scenarios; and reversely images allow us have an affect at a distance. Differences between outside and inside, far and near, physicality and virtuality, image and body, all shrink—this is how digital images more and more seem to act and function.

Contemporary media art installations include digital stills and video, 3D objects and animation, digital texts and music, sound-objects, noises, and textures, while

Figure 19.1
Johanna und Florian Dombois, *Fidelio 21st Century*, interactive installation. Reprinted by permission of the artists. See plate 27.

different meanings of all these may be inscribed and combined with each other. Meaning develops by chance, experiment, and well-directed strategy. The active spirit, the combining user, becomes the new source of art and meaning, if one leaves enough degrees of freedom for him to develop into the actual artist. Dynamic, he is involved in the navigation, interpretation, transfer, contextualization, or production of images and sounds that may come into being by his participation. Memory, thoughts, and experiments by accident may respond to a fertile connection. Increasingly the art system is transforming into an organism with slices that organize themselves while the user has the chance to experience and produce combinative meaning.

Media art makes use of the latest image techniques and strategies for aesthetic and reflective means: With Johanna and Florian Dombois's *Fidelio, 21st Century*, named after Beethoven's "Fidelio," for the first time a classical opera was directed as an interactive virtual 3D experience. The protagonists embody music, follow dramaturgic direction, and react to the interventions of the visitors.[2]

Artist-scientists, such as Christa Sommerer and Berndt Lintermann, have begun to simulate processes of life: Evolution, breeding, and natural selection have become methods for creating artworks.[3] In *Murmuring Fields*, Monika Fleischmann and Wolfgang Strauss create a virtual space of philosophical thought, where statements by Flusser, Virilio, Minsky, and Weizenbaum are stored. The work creates a new type of a *"Denkraum"* (thinking-space)—a sphere of thought.[4] Constructed on a database, the interactive installation *Ultima Ratio*[5] by Daniela Plewe offers a first glimpse at a future system for interactive theater. Intellectually challenging, her concept allows the spectator to solve an open conflict at a high level of abstraction and with combination of different dramatic motifs. Daniela Plewe's goal is to generate a visual language for argument and debate. And there are people today, at the end of the first decade of the twenty-first century, who say that the ever-increasing complexity of financial products is responsible for the crisis facing taxpayers all over the world to bail out banks with trillions of Euros and dollars. Years ago, the architectural studio Asymptote proposed a 3D infoscape for the NYSE to manage financial data within a real-time virtual environment. Such a tool might be necessary for the financial markets to get a better image, and with that a better idea, of what they do.

Media Art and the Humanities

Typical for media revolutions are Platonistic or even apocalyptic commentaries. The espoused positions often exhibit an antitechnology thrust and have developed partly from critical theory and poststructuralism. At the other end of the spectrum are utopian-futurist prophesies. Variations on ideas such as "now we will be able to reach with our bodies far into the distance," and "now the illusion will become total," on the side of the utopians, have collided with fears such as "our perception will suffer,"

or "our culture will be destroyed," and even "we will lose our bodies." This discourse mechanism, provoked by media revolutions, returns again and again. Recall the discussion the discussion around virtual reality in the 1990s, the cinema debate in the early twentieth century, the panorama in the eighteenth century, and so forth. Both poles are either positive or negative teleological models, which largely follow the pattern of discourse surrounding earlier media revolutions.

Seen in this light, we cannot consider the protagonists of this latest media revolution debate with their projections and dark fantasies as contributors to a serious discussion, but rather as meaningful sources of the thinking of their time. In addition, it must to be assumed that not only analogies but also fundamental innovations of current phenomena become clearly recognizable only through historical comparison. "Depth of field" analyses of images can play an important role in facilitating our political and aesthetic analysis of the present. Only if we are aware of our media history with its myths and utopias, its interests and power games, we will be able to make decisions that go beyond the heritage of ancient believers in images. Beyond that, by focusing on recent art against the backdrop of historic developments, it is possible to better analyze what is genuinely new in media art and to better understand our situation and our goals in a period where the pace appears to get faster and faster—that is the epistemological thesis. It is necessary to take stock soberly in the realm of art and media history. This is only possible in the extended context of historically lining up the new images to be described in a qualified way: in their appearance, their aesthetics, their conditions for development; only then can the critique be profound. Consequently, this method changes our view of history and helps us to find new connections.

It is essential to create an understanding that the present image revolution, which indeed uses new technologies and has also developed a large number of so far unknown visual expressions, cannot be conceived of without our image history. Art history and media studies help us understand the function of today's image worlds in their importance for building and forming societies. With the history of illusion and immersion, the history of artificial life or the tradition of telepresence, art history offers subhistories of the present image revolution. Art history might be considered as a reservoir in which contemporary processes are embedded, like an anthropologic narration, on the one hand, but also as a political battleground where the clash of images is analyzed, on the other hand. Furthermore, its methods may strengthen our political-aesthetic analysis of the present through image analyses. Last but not least, the development and significance of new media should be illuminated, since the first utopian expressions of a new media often take place in artworks.

The evolution of media art has a long history, and now a new technological variety has appeared. However, this art cannot be fully understood without its history. So the Database of Virtual Art, Banff New Media Institute, and *Leonardo* produced the first

international MediaArtHistory conference, for which I served as chair. Held at the Banff Centre, Refresh! represented and addressed the wide array of nineteen disciplines involved in the emerging field of media art.[6] It took several years to organize Refresh! from Berlin through the Database of Virtual Art. It was realized through a collective process, involving several producing partners, thirty advisors, and a dozen chairs. Through the success of Re:place (2007) at Berlin's House of World Cultures (the Department for Image Science hosted the brainstorming conference in Göttweig in 2006), Re:live was planned for Melbourne in 2009, and an established conference series was founded with Re:2011 on the way.[7] Re:fresh! was planned not to create a new canon, but to create a space for the many-voiced chorus of the involved approaches. The subtitle, "HistorIES," opened up the conceptual space to include approaches from other disciplines besides art history. The idea was to bring all the partly isolated subfields together, since it is important that we continue to bring media art history into the mainstream of art history and our cultural institutions.

Re:fresh, Re:place, and Re:live were organized via the MediaArtHistory.org platform, which is now developing into a scholarly archive for this multifaceted field, ranging from art history, to media, film, cultural studies, computer science, psychology, and so on. Meanwhile, nearly 1,000 peer-reviewed applications have been coordinated on MediaArtHistory.org.[8] With the nineteen disciplines represented at Re:fresh! serving as its base, MAH.org is evolving with future conferences under the guidance of an advisory board, among them: Sean Cubitt, Paul Thomas, Douglas Kahn, Martin Kemp, Timothy Lenoir, and Machiko Kusahara.

Image Science: From the Image Atlas to the Virtual Museum

The integration and comparison of a "new" image form within image history is not a new method; there were various historic forerunners. Inspired by Darwin's work *The Expression of the Emotions in Man and Animals*, Aby Warburg began a project of an arthistorical psychology of human expression. His famous Mnemosyne image atlas from 1929 tracks image citations of individual poses and forms across media—and most significantly, independent from the level of art nouveau genre. He redefined art history as a sort of bridge building—including many forms of images. Warburg argued that art history could fulfill its responsibility only by including most forms of images. The atlas, which has survived only as "photographed clusters," is fundamentally an attempt to combine the philosophical with the image-historical approach, and Warburg arranged his visual material by thematic areas.

Let's remember that it was art historians dealing with artifacts in a nonhierarchical manner who founded the first arts and crafts museums for artifacts that were not counted as art. Art historians also founded the first photographic collections at the end of the nineteenth century containing, besides art photography, also images of

everyday life. Alois Riegl examined the popular culture of late Roman art industries and Walter Benjamin was drawn to Aby Warburg's cultural studies library, whose ground floor was completely dedicated to the phenomena of the image. Warburg, who considered himself an image scientist, reflected on the image propaganda of World War I through examination of the image wars during the Reformation. Warburg intended to develop art history into a "laboratory of the cultural studies of image history," which would widen its field to "images . . . in the broadest sense [Bilder . . . im weitesten Sinn]."[9]

Let us remember too, that the field of film studies was started by art historians. An initiative by Alfred Barr and Erwin Panofsky founded the enormous film library at the New York MoMA, known by its contemporaries as the "Vatican of Film." In this way, film research as early as the 1930s possessed a dominant image-science approach and cultivated it further. This initiative allowed the large-scale comparison of film for the first time. The same spirit concerned with new investments for infrastructures to provide for and analyze the media art of our time is now needed in the digital humanities.

Art History—Visual Studies—Image Science

We know that for years academic discussions and controversies have been raging around the fields of images and the visual and our perception of them. Specific to segments of the English language Humanities, a not very fruitful and ultimately simplistic polarization continues between art history, which partly is considered conservative, formalistic, aesthetic, sometimes even elitist and male-dominant, and visual cultural studies,[10] which emerged to a large extent from literature studies. Drawing on a multicultural and postcolonial[11] etiquette, visual cultural studies attempts to research the visual within the approaches of societal and identity politics.[12] Within the traditionally strong German language humanities we perceive a twofold development: Art history departments increasingly rename themselves as institutes for art and image history, allowing art history as the oldest scholarly endeavor that deals with images to avoid separation; and at the same time renewing the interdisciplinarity that bloomed in German art and image history before National Socialism, with representatives such as Warburg, Panofsky, Kris, and Benjamin. Since image science, without initially using the term, experienced its founding effectively at the MIT conference Image and Meaning in 2001, the trend toward interdisciplinarity around new forms of images is growing also in North America.[13] Image and Meaning was an event that demonstrated that image science without art history—particularly without its tools for critical image analysis—is incapable of developing a deeper or historical understanding of images. It is in danger of propagating old myths and of succumbing to the power of images, owing to the lack of a trained eye. The rise of media art has added fuel to this debate, since questioning images has not only acquired new inten-

sity but also a new quality. Image science does not imply that the experimental, reflective, and utopian spaces provided by art are to be abandoned. On the contrary, within these expanded frontiers, the underlying and fundamental inspiration that art has provided for technology and media is revealed with even greater clarity.

If it includes a strong representation of art history,[14] the project of image science then expands toward an interdisciplinary development that connects neuroscience,[15] psychology,[16] philosophy,[17] communication studies,[18] emotions research,[19] and other scientific disciplines.[20] Recently, interdisciplinary scientific clusters have been built around the subject of the image that lie increasingly perpendicular to the human, natural, and technical sciences, which have succeeded in profiting from the "Image" paradigm as well as from an increased disposition toward interdisciplinarity. More and more, tendencies emerge that require a farewell to or at least a new evaluation of the relation of word to image in favor of the latter. As early as 1993, Martin Jay triggered with his work *Downcast Eyes*[21] a criticism of the "sight-hostility" of language-fixated French philosophy. More recently, this critique unfolds in terms like "image immersion" (Oliver Grau 1998, 2001);[22] "power of the iconic" (Gottfried Boehm 2004);[23] and "picture act" (Horst Bredekamp 2005).[24] The central thesis is that in every cognition of an image, the eyes cannot be separated out as the sole perception organs; rather, the entire body is the perceiving organ.[25]

Preconditions

In contrast to other disciplines concerned with images, ones that not infrequently try to explain images as isolated phenomena, the primary strength of art history is its critical potential to define images along their historical dimension. Precisely because art history emphasizes a rigorous historicization and the practice of a critical power of reflection, it can make many natural contributions to the discussion around images. A genuine image science is based on three preconditions: (1) definition of the object; (2) the building of an image archive; and (3) familiarity with a large quantity of images. This enables and defines the understanding that images follow a diachronic logic; without this historic base, image science remains superfluous and cannot realize its full potential. If those preconditions are fulfilled, image science may be practiced within any field—medicine, natural science, history of collections, design, or art. If these requirements are not fulfilled, we see merely a form of aesthetics.

All of those approaches of comparison are based on the insight that images are diachronic, within a historical evolution, and never function simply as a solitary act and without reference. This diachronic dynamic of image generation is increasingly interwoven with understanding images alongside other images of their time, the synchronic approach. The dynamic process of change has fueled the interdisciplinary debate about the status of the image, a debate with protagonists such as Mitchell, Belting, Elkins, Stafford, and Manovich.[26]

Figure 19.2
Powerpoint, 360 degree frescoes, the panorama, stereopticon, Cinéorama, IMAX cinemas, or CAVEs.

"Seeing machines" and the image worlds they produce through magic lanterns, panoramas, and dioramas are regarded as having paved the way for photography, cinema, and the digital media of the present day. Yet without the revolution in the spatiality of the image, which the representational technique of perspective wrought in portrait and landscape painting, without the camera obscura, which became the guarantor of "objective observation" before photography was invented, the image media of the twentieth and our century would be unthinkable. At the same time, the prehistory of artificial visualization points the way forward to the digital world and its immediate future.

Image science, or *Bildwissenschaft*, now allows us to write the history of the evolution of visual media, from peep show to panorama, anamorphosis, stereoscope, magic lantern, phantasmagoria, films with odors and colors, cinéorama, IMAX, and the virtual image spaces of computers. The medium of the phantasmagoria, for example,

is part of the history of immersion, a recently recognized phenomenon that can be traced through almost the entire history of art in the West, as I have documented in a previous book.[27] History has shown that there is permanent cross-fertilization between large-scale spaces of illusion that fully integrate the human body (as in 360 degree frescoes, the panorama, the stereopticon, Cinéorama, IMAX cinemas, or CAVEs [figure 19.2]) and small-scale images positioned immediately in front of the eyes (peep shows of the seventeenth century, stereoscopes, stereoscopic television, the Sensorama, or HMDs). Evidently among the latest examples of this development are computer games like Grand Theft Auto, which combine the emotional involvement of the player with immersive graphics. It is, let me underscore, an evolution with breaks and detours; however, all its stages are distinguished by a relationship between art, science, and technology. Image science is an open field that engages equally with what lies between the images.

André Malraux, the adventurer and former French minister of culture, described after World War II the field opened up by photographic reproductions as a museé imaginaire, because it goes beyond the museum and can contain works of art that are bound to architecture, such as frescoes. The famous picture at the introduction of the book shows Malraux in an archival grid, compiling, side by side, the most diverse objects from various epochs and cultures. Recontextualized like this, a crucifix becomes a sculpture and a sacred effigy, a statue.[28] We might say that the museé imaginaire is both product and symptom of globalization. And now we are witnessing the birth of the virtual museum, as a key project for the digital humanities.

The Virtual Museum

The virtual museum represents an extension of traditional museum forms. It is a museum "without walls," a space of living, distributed information, database driven and network oriented. It is a space where artists and scholars can intervene; foremost, it is museum where the documentation and preservation of media art is supported and international networks can develop. Art and all its related information are presented in new forms of displays, via new interfaces within the traditional museum cube, but also via networks beyond the walls to a larger public. The virtual museum offers a multimedia data flow in real time that continuously reconfigures over time, while also preserving the physical elements that media art installations contain.

Collective Strategies and New Tools for the Humanities

In the first generation of digital humanities,[29] data was everything. Massive amounts of data were archived, searched, and combined with other databases in the 1990s, producing interoperable searches yielding a complexity and realization at a previously inconceivable rate. Yet the amount of material to be digitized is so vast that, in real

Figure 19.3
The Virtual Observatory (screenshot).

terms, we are only at the tip of the data iceberg. In nontextual fields, such as visual arts, music, performance, and media studies, we are "at the tip of the tip." Remember that digital art has still not "arrived" in our societies, no matter how well attended digital art festivals are or how many scientific articles the artists have published. Because this art depends entirely on digital storage methods, which are in a constant state of change and development, it is severely at risk. Many artworks that are not even ten years old can no longer be shown, and it is no exaggeration to say that thirty years of art threaten to be lost to future generations.

In recent decades the natural sciences have started to address new research goals through large collective projects. In astronomy, for example, the Virtual Observatory compiles centuries worth of celestial observations;[30] global warming is better understood with projects like the Millennium Ecosystem Assignment, at a level of detail never before calculable, evaluating twenty-four separate life systems and the global changes they are part of[31] (figure 19.3). The rapid expansion of computational power has affected biology, and the Human Genome Project is already a legend.[32] So far, new collective structures give answers to complex problems. The field of media art research and the digital humanities in general require a similar approach to achieve equivalent goals.

Comparable with the natural sciences, digital media and new opportunities of networked research catapult the cultural sciences within reach of new and essential

research, such as the appropriate documentation and preservation of media art, or even better, an entire history of visual media and their human cognition by means of thousands of sources. These themes express current key questions in regard to image revolution. To push the humanities and cultural sciences further in their development, we need to use the new technologies globally. Timelines and new methods of visualization belong to the history of invention of visual techniques, image content, and especially their reception, in the form of oral history in popular and high culture, in the Western as well as non-Western cultures. We live in an exciting time for image science and the humanities. The credo is: Don't give up the established individual research, but complete it in a new way through collective, net-based working methods that allow us to deal with explosive questions in the field of humanities and cultural sciences.

The Database of Virtual Art (DVA)

Begun as a counterpart to the systematic analysis of the triad of artist, artwork, and beholder in digital art under the title virtual art, the first documentation project, the Database of Virtual Art (DVA) (figure 19.4, plate 28), celebrated its tenth anniversary last year.[33] Supported by the German Research Foundation, this groundbreaking collective project has been documenting, in cooperation with renowned media artists, researchers, and institutions, the recent decades of digital installation art. We know that today's digital artworks are processual, ephemeral, interactive, multimedial, and fundamentally context dependent. Because of their completely different structure and nature, they require, as we called it some years ago, an "expanded concept of documentation."[34]

As probably the most complex resource available online—hundreds of leading artists are represented with several thousand documents and their technical data, more than 2,000 listed articles and a survey of 750 institutions of media art—the database has become a platform for information and communication. The database runs completely on open-source technology, and since the artists are members it avoids copyright problems. Besides this group there are theorists and media art historians totaling at this point an additional more than 300 contributors—therefore the Database of Virtual Art is a collective project.

The DVA's advisory board includes Christiane Paul, Roy Ascott, Steve Wilson, and Jorge La Ferla. Whether an artist is qualified to become a member depends on the number of his or her exhibitions, publications, awards, and public presentations; high importance is also ascribed to artistic inventions such as innovative interfaces, displays, or software. The system offers a tool for artists and specialists to individually upload information about works, people, literature, exhibits, technologies, and inventions.[35] Already in 2000 the DVA started to stream video, documenting the processual nature of interactive works. Over time the interlinked layers of data will also serve as

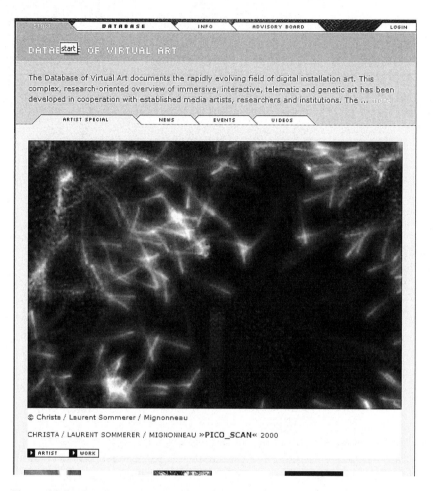

The Database of Virtual Art documents the rapidly evolving field of digital installation art. This complex, research-oriented overview of immersive, interactive, telematic and genetic art has been developed in cooperation with established media artists, researchers and institutions. The ... more

© Christa / Laurent Sommerer / Mignonneau

CHRISTA / LAURENT SOMMERER / MIGNONNEAU »PICO_SCAN« 2000

Figure 19.4
Database of Virtual Art (screenshot). See plate 28.

a predecessor for the crucial systematic preservation of this art. Over the last ten years about 5,000 artists were evaluated, from which 500 fulfilled the criteria to become member of the DVA. Other initiatives allow some artists, often still students, to pay money to be represented; here, the DVA follows systematic criteria of quality through public and scholarly acceptance as much as possible.

The aim of the long-term project is not the documentation of a festival, an award, or something similar; rather, from the beginning its focus has been on a scientific overview and quality. Members have to have at least five exhibitions or articles on their work, or alternatively they could be recommended by the advisory board. The

main challenge during the last fifteen years has been the establishment, maintenance, and advancement of a social corpus that consists in hundreds of living individuals, artists whose affiliation is not automatically assumed since the DVA is not defined like other projects, which tend to focus on a festival or a particular collection.

"Bridging the Gap": New Developments in Thesaurus Research

Together with probably one of the most important unknown art collections, the Göttweig print collection, representing 30 thousand prints emphasizing Renaissance and Baroque works[36] and a library of 150,000 volumes going back to the ninth century like the Sankt Gallen Codex, the Database of Virtual Art strives to achieve the goal of a deeper media art historical cross-examination. Just as the MediaArtHistory conference series aims to bridge a gap, the combination of the two and other databases hopes to enable further historic references and impulses, in the manner that Siegfried Zielinski calls "the deep time of media."[37] The Göttweig collection also contains proofs of the history of optical image media (figure 19.5, plate 29), intercultural concepts, caricatures, and illustrations of landscapes in panoramic illustrations. In the future this collection will provide resources for a broader analysis of media art.

Keywording is bridge building. The hierarchical thesaurus of the DVA constitutes a new approach to systemizing the field of digital art. It was built on art-historical thesauruses from institutions like Getty and the Warburg Institute, as well as from festival categorizations and discussions with artists, so that it supports historical comparisons. From the Getty Arts & Architecture Thesaurus and the subject catalog of the Warburg Library in London, keywords were selected that have relevance to media art. Moreover, the most commonly used terms from media festivals like Ars Electronica, DEAF, and Transmediale were selected as keywords. Important innovations such as "interface" or "genetic art" have also been considered, as well as keywords that play a role in the traditional arts such as "body" or "landscape" and thus have a bridge-building function. It was important to limit the number of keywords to 350 so that members of the database can assign keywords to their works without long studies of the index.

The categories naturally overlap, so that the hybrid quality of the artworks can be captured through clustering. Thematic usability for the humanities was very important—it was necessary to avoid developing something that would be entirely new, separated from our cultural history. The thesaurus had to connect cultural history with media art and not isolate them from another. As expected, the material has produced a multitude of fractures and discontinuities, which we make visible in the terminology of the database.

One of the goals for the future is to document the works within a context of complex information and, at the same time, to allow users to find individual details quickly. In addition to statistically quantifiable analyses and technical documentation,

Figure 19.5
Göttweig Print Collection Online (screenshot). See plate 29.

databases should also present personal connections and affiliations and funding information, the idea being to reveal interests and dependence. The term "database" may be misleading: Like Warburg's image atlas, which supports key icons that define the extent of problems and enables possibilities for comparison, databases should be somewhat experimental in order to find thematic clusters within media art. And yet, the tools only hold the data—the quality of the analysis continues to rely on thoughtful developments in the digital humanities. What we need are tools for the analysis of culturally relevant data, based on open networked systems.[38] We need collective research, which deals with data and presents research strategies that individuals cannot achive. In addition to searching for themes, media art documentation should also admit questions of gender, track the movement of technical staff from lab to lab, track

technical inventions pertaining to art, examine the destinations of public and private funds allocated to research, and, through a thematic index, show echoes of virtual/ immersive art in the forms of its predecessors, for example, the panorama. Media art documentation becomes a resource that facilitates research on the artists and their work for students and academics, who, it is hoped, will contribute to expanding and updating the information. In this way, documentation changes from a one-way archiving of key data to a proactive process of knowledge transfer.

Media Art Education

Bridging the gap for media art also means the use of new telematic forms of education, which enlarge the audience now able to intervene interactively from other continents, as happened with the archived Danube Telelectures.[39] The future of media art within the digital humanities requires the further establishment of new curricula, as we developed with the first international master of arts in MediaArtHistories, with faculty members like Erkki Huhtamo, Lev Manovich, Christiane Paul, Gerfried Stocker, and Sean Cubitt, which deals also with the practice and expertise in curation, collecting, preserving, and archiving of media arts. The necessity for an international program capable of accommodating future scholars from diverse backgrounds and all continents was answered by a low-residency model allowing professionals to participate in the advanced program of study parallel to ongoing employment and activities. Students and specialists are brought together for concentrated blocks of time in an intensely creative atmosphere to focus on the histories of media art and its kindred arenas. The requirements of project work and a master's thesis, accompanied and reviewed by both internal and external scholars, provides another layer of self-directed knowledge production. Additionally, the integration of excursions to media art conferences and festivals acts as a first step of the integration of students into the organized networks of the field.

Some key issues:

• Provide a context where artists and programmers who are not already part of the academic machinery can share their newest insights on the latest and most controversial software, interface developments, and their interdisciplinary and intercultural praxis.

• Provide multiple arenas where students can access quality information on both current and historical media art by using online databases and other modern aids; computer animation, net art, interactive, telematic, and genetic art, as well as the most recent reflections on nano art, CAVE installations, augmented reality, and wearables, can be accessed.

• Tie historical derivations going far back into art and media history in intriguing ways to digital art, including approaches and methods from image science, media archaeology, and the history of science and technology.

The needs of the field required the creation of a course specific to MediaArtHistories with experts that typical universities could not gather all in one institution in order to pave the way for the development of innovative future educational strategies in the field. Giving an overview of the relevant approaches on the one hand and a specialization via project and master's theses on the other hand, the Master of Arts provides an initiation for new students and more depth for seasoned students to this emergent field. The integration and continuing development of the aforementioned projects like the Database of Virtual Art, the Göttweig Graphic Collection online, and the MediaArtHistory.org platform with the MediaArtHistoriesArchive synergize with the development of the courses for the program to support curators and archivists in their professional needs. The ultimate goal is to set a standard for other administrators and policymakers so that in the shared space between art history and media studies we can work toward combining common methods, histories, and research.

What Does the MediaArtHistories Archive Do?

The MediaArtHistories Archive (MAHArchive) is a self-archiving digital repository accessible at <http://www.MediaArtHistory.org>. One duty is to store the proceedings of the Media Art History conference series. Archiving the texts online makes them available to the international community on a system supporting multiple file types that is search-engine friendly. But other scholars writing about media art and its histories can archive their texts in the database as well, so that another gap can be bridged; early writings from the 1960s to the '90s, from cybernetics and Ascott's or Burnham's early writings to the A-life debate, texts that until now have been inaccessible will be available via the MAH platform. The database is built on Dspace software, creating a self-archiving digital repository that captures, stores, indexes, preserves, and redistributes scholarly research material in digital formats. Research findings can be quickly shared with a worldwide audience and be preserved in perpetuity. The archive software captures the contributors material in any format—as text, video, audio, or data—and distributes it over the Web. It indexes users' work, so users can search and retrieve the contributors' items, and it preserves the digital works over the long term. The MAHArchive provides a way to manage research materials and publications in a maintained repository to give them greater visibility and accessibility over time.

The Problem of Media Art Documentation Today—Future Needs

Since the foundation of the Database of Virtual Art, several online archives for digitization and documentation arose: Langlois Foundation in Montreal, Netzspannung at the Frauenhofer Institut, MedienKunstNetz at ZKM—but all these projects were terminated, their funding expired, or they lost key researchers, as did V2 in Rotterdam.[40]

Even the Boltzmann Institut for Media Art Research in Linz faced being closed down. In this way, the scientific archives, which more and more often represent the only remaining image sources of the works, not only lose their significance for research and preservation but also partly disappear from the Web. Not only the media art itself but also its documentation fades, so that future generations will not be able to get an idea of the past, of our time. To put it another way, until now there has been no sustainable strategy. What we need is a concentrated and compact expansion of ability. There is and was increasing collaboration with these projects in a variety of areas and in changing coalitions. But let me add: In the field of documentation—genuine preservation does not yet exist[41]—the focus is still directed too much on particularization, instead of on joining forces, an essential strategy in most other fields. Many individual projects are definitely innovative but are too small and lacking clear, larger scientific strategy and financing, which is not their fault. Some projects have already been terminated and are not being carried out further. So much competence, so much cultural wealth, but so much isolationism.

A New Structure for Media Art Research

Especially the university-based research projects, but also partly those that are linked to museums, have developed expertise that needs to be included in cultural circulation, not only to pass it on to future generations of scientists and archivists but also to give it a chance to enter future university education in the fields of art, engineering, and media history. Clearly, the goal must be to develop a policy and strategy for collecting the art of our most recent history under the umbrella of a strong, "Library of Congress–like" institution. Ultimately, however, this can only be organized by a network of artists, computer and science centers, galleries, technology producers, and museums. Those projects that collected culturally important documents in the past, and which often died out, were not further supported, or even lost their original base of support, must be reanimated. They should be organized like a corona around an institution that is given the duty of documentation and perhaps even the collection of contemporary media art. In the United States, such an institution could be the Library of Congress; in Europe, besides the new European digital libraries database Europeana, it could be the Bibliotheque National, the British Library, the V&A, or, in Germany, besides the ZKM, the Deutsche Bibliothek. Interestingly, many libraries show increasing interest in archiving multimedia works and their documentation; however, they lack the usually complex cultural and technical know-how necessary to preserve principal works of the most important media art genres of the last decades. Not only can the international state of media art be a hindrance in creating common projects; the funding infrastructure of media art so far has normally promoted projects for two, three, or more years, neglecting sustainability. A structure that updates, extends, and contextualizes research—whether in historical or contemporary

contexts—is required. The funding and support infrastructures that have been built at the end of the last century are not suitable for the scientific and cultural tasks facing the humanities of the twenty-first century.

When astronomers like Roger Malina were asked why the Virtual Observatory was successful, they responded that this collective attempt was able to overcome the tendency of researchers to want to keep their databases private or proprietary; the VO was among the first to achieve that goal. Most important for the success of the virtual observatories in astronomy was that, in the United States, "the National Science Foundation (NSF), and NASA set up funding programs and the context for the main data centers to work together on both standards, but also middleware software and tools for cross-database research—the same in France—the CNRS funded and then set up the Strasbourg data center as a main node for French astronomical data bases."[42] The model should be that scientists are funded up front to use the data, and then it is open sourced. What is needed in the humanities is an institutional support equivalent to that in astronomy, biology, or climate research, in order to create enough momentum and adhesion so that the main funding organizations like NSF, NEH, the European Research Council, DFG, Volkswagen Foundation, and so on have to support on an international level the necessary structure for research in media art and the digital humanities in the twenty-first century.

One key issue for the digital humanities is to identify all the existing databases, including those smaller ones in countries where one does not typically think to search. In astronomy, the funding agencies have developed and modernized their systems toward sustainability, which is needed as well in the humanities: The virtual observatory infrastructure is funded on an ongoing basis, and there is international coordination between a dozen or so countries that produce astronomical data. What we need and could archive in the near future is an electronic "Encyclopedia of Visual Media" (EVM) created from a network of databases and the thousands of existing websites. Based on scholarly criteria of every known image medium in history described and on the basis of original sources, it should precisely capture how our forerunners experienced them. The EVM could allow scholars from all over the world to research their image media and discover further unknown treasures of human image making.

We know that a central problem of current cultural policy stems from a serious lack of knowledge about the origins of the audiovisual media, and this stands in complete contradistinction to current demands for more media and image competence. Considering the current upheavals and innovations in the media sector, where the societal impact and consequences cannot yet be predicted, the problem is acute. Social media competence, which goes beyond mere technical skills, is difficult to acquire if the area of historic media experience is excluded.

Today we watch the exciting developments of the Web 2.0 and experiment with new strategies in collective documentation and content management that exceed the work of expert networks. But it must be kept in mind that amateurs without adequate

education cannot replace the work of professionals who have been educated over many years—a process common in other information dissemination systems. Nevertheless, amateurs can play a very important role in facing the enormous challenge of negotiating or traversing through a large and complicated network of information. A commitment by the best experts from the field is needed for a long-term occupation. Let's recall the enormous and sustaining infrastructure that was developed and established for traditional artistic media painting, sculpture, architecture, and even film, photography, and their corresponding archives over the course of the twentieth century. What is urgently needed is the establishment of an appropriate structure to preserve at least the standard 1–6 percent of present media art production, the best works. This important step is still missing for the first two generations of media art. If we compare the worldwide available budget for traditional art forms with that for digital culture, then we understand how inadequate the support for our present digital culture is—so low it is almost statistically immeasurable. The faster this essential modification to our cultural heritage record will be carried out, the smaller the gap in the cultural memory, shedding light on the dark years, which started about 1960 and lasts until now.[43] The hybrid character of media art requires a shift of the paradigm toward an orientation of process and context recording, which tends to include more and more the capture of the audience experience.[44]

But even the best documentation and archiving can not replace preservation, whose research began with a string of international projects such as DOCAM[45] in Canada, the Variable Media Approach or the Capturing Unstable Media project carried out by V2. We should welcome the fact that further basic means are provided, in order to promote media art, even though far larger efforts must be undertaken on a national and international level. At the moment three primary approaches of media art preservation exist: besides (a) emulation, the process of simulating an older operating system on a newer software or hardware platform and (b) migration, upgrading its format from an aged medium to a more current one, in recent years (c) reinterpretation, new development and interpretation on a new platform, is increasingly discussed. This method is naturally the riskiest, because it relies very little on continuity of technique and mostly on written declarations of intention, usually by the artist.[46] Artists who can afford it, because of their technically privileged position, like Christa Sommerer, Char Davies, or Maurice Benayoun, have experimented successfully with migration. Meanwhile the generation of the artists who worked with SGI Onyx machines can transmit their data to several incomparably cheaper PCs. The late-1990s CAVE installation *World Skin* by Maurice Banayoun, which existed in several versions, was recently migrated on home computers, and even the interface (SLR 35mm cameras) and the tracking system was simplified and migrated to a durable form. Instead of the CAVE, Benayoun wrote, he uses two screens. So the artist has chosen that the visual field of the users be filled out with stereoscopic images rather than lock them up in a box.[47] These measures help to reduce exhibition and maintenance costs dramatically;

however, these tasks can only be taken over by artists who have technically experienced structures at their disposal. Taking over the tasks of restorers cannot be assumed to be the future work of artists; they should be allowed to concentrate on their creative work.

Our hope for the future is that we can bring together the expertise of the most important institutions in order to form an up-to-date overview of the whole field, to provide the necessary information for new preservation programs within the museum field, and new university teaching programs for better training of the next generation of historians, curators, restorers, engineers, and others involved in the preservation and provision of open access to media art. Just as research in the natural sciences has long recognized team efforts, a similar emphasis on collaborative research should make its way into the thinking of the humanities.

Conclusion

Perhaps in the very near future we can create visual interfaces that could be further developed as collective tools, as represented in Christa Sommerer and Laurent Mignon-

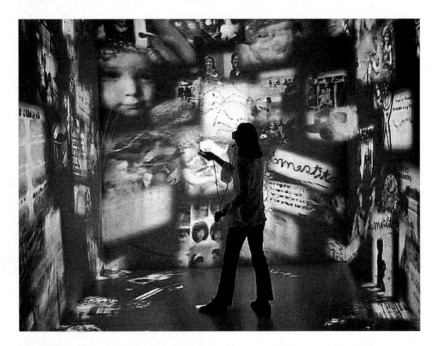

Figure 19.6
Christa Sommerer and Laurent Mignonneau, *The Living Web*, interactive installation. Reprinted by permission of the artists. See plate 30.

neau's work *The Living Web*, which generates a spatial information sphere from search engines for Web images in a CAVE (figure 19.6, plate 30). The work is a new instrument for visual analysis, providing the possibility of comparing up to 1,000 images in a scientific discussion. Media art needs as many bridges as possible: conferences, text repositories, database projects developing collective documentation and preservation strategies—new thesauruses, new curricula for the next generation of teachers and collectors. For this reason it is of paramount importance for art and media history to engage in this debate in as many ways as possible. Only when digital art gains entrance to our science and cultural systems and is accepted there; only when media art—which we know possesses tremendous powers of expression—is collected systematically, and concerted strategies are implemented to conserve it, will its entire technological and intercultural potential be able to enrich our culture.

Notes

1. For an overview, see <http://www.virtualart.at>. See also Edward Shanken, *Art and Electronic Media* (London: Phaidon, 2009); Christa Sommerer and Laurent Mignonneau (eds.), *Interface Cultures: Artistic Aspects of Interaction* (Bielefeld: Transcript, 2008); Victoria Vesna, *Database Aesthetics: Art in the Age of Information Overflow* (Minneapolis: University of Minnesota Press, 2007); Steve Dixon: *Digital Performance: A History of New Media in Theater, Dance, Performance Art, and Installation* (Cambridge, MA: MIT Press, 2007). See also the classic: Christiane Paul, *Digital Art* (London: Thames & Hudson, 2003).

2. Johanna Dombois and Florian Dombois, op. 72, II 1–5, 3D. Beethoven's "Fidelio" in a Virtual Environment. In: *Proceedings of The 5th World Multi-Conference on Systematics, Cybernetics and Informatics*, vol. X, Orlando, Florida, July 22–25, 2001, 370–373.

3. Christa Sommerer and Laurent Mignonneau, "Modeling Complexity for Interactive Art Works on the Internet," in *Art and Complexity: At the Interface*, ed. J. Casti and A. Karlqvist (Amsterdam: Elsevier, 2003), 85–107. See also the overview on Sommerer and Mignonneau's Oeuvre: *Interactive Art Research*, ed. G. Stocker, C. Sommerer, and L. Mignonneau (New York: Springer, 2009).

4. Monika Fleischmann, Wolfgang Strauss, and Jasminko Novak, "*Murmuring Fields* Rehearsals—Building Up the Mixed Reality Stage," in *Proceedings of KES* (International Conference on Knowledge Engineering Systems, Brighton, 2000).

5. Bernhard Dotzler, "Hamlet\Maschine," in *Trajekte: Newsletter des Zentrums für Literaturforschung* (Berlin) 2, no. 3 (2001): 13–16; Daniela Alina Plewe, *Ultima Ratio*, software and interactive installation, in *Ars Electronica 98: Infowar: Information, Macht, Krieg*, ed. Gerfried Stocker and Christine Schöpf (Vienna: Springer Verlag 1998); Yukiko Shikata, "Art-Criticism-Curating as Connective Process," in *Information Design Series: Information Space and Changing Expression*, vol. 6, ed. Kyoto University of Art and Design, 145.

6. Some of the conference results can be found in the anthology *MediaArtHistories*, ed. Oliver Grau (Cambridge, MA: MIT Press, 2007); and, more recently: *Place Studies in Art, Media, Science,*

and Technology: Historical Investigations on the Sites and the Migration of Knowledge, ed. Andreas Broeckmann and Gunalan Nadarajan (Weimar: Verlag und Datenbank für Geisteswissenschaften, 2009).

7. See <http://www.mediaarthistory.org>.

8. The content development of Re:fresh! was a highly collective process. It involved three producing partners, a large advisory board, two chairs for each session, call and review for papers, a planning meeting in 2004, keynotes, a poster session, and the development of application content over two and a half years. Before Banff could host the conference, this was organized by the team of the Database of Virtual Art (DVA).

The international planning meeting at Vigoni, Italy, in 2004 (hosted by the Database of Virtual Art) agreed that it is important to bring media art history closer to mainstream art history by cultivating a proximity to film, cultural and media studies, computer science, and also philosophy and other sciences. After nomination and acceptance of the chairs, a coordinated call for papers, review by the program committee, and selection of speakers by the chairs organized and funded by the Database of Virtual Art—the conference brought together colleagues from the following fields: invited speakers (based on self-description from bios): *history*: art history = 20; media science = 17; history of science = 7; history of ideas = 1; history of technology = 1; *artists/curators*: artists/research = 25; curators = 10; *social sciences*: communication/semiotics = 6; aesthetics/philosophy = 5; social history = 2; political science = 2; women's studies = 2; theological studies = 1; *other cultural studies*: film studies = 3; literature studies = 3; sound studies = 3; theater studies = 2; performance studies = 1; architecture studies = 1; computer science = 2; astronomy = 1.

9. A. Warburg, "Heidnisch-antike Weissagung in Wort und Bild *zu* Luthers Zeiten," in *Zeitschrift für Kirchengeschichte* 40 (1922): 261–262. We know that National Socialism put a sudden end to this work, and although its emigrants could foster important trends in the United States and England, the image science approach did not return until the 1970s with the Hamburg School. See also Michael Diers, "Warburg and the Warburgian Tradition of Cultural History," *New German Critique* 22, no. 2 (1995): 59–73, and Claudia Wedepohl, "Ideengeographie: Ein Versuch zu Aby Warburgs 'Wanderstrassen der Kultur,'" in *Ent-grenzte Räume: Kulturelle Transfers um 1900 und in der Gegenwart*, ed. Helga Mitterbauer and Katharina Scherke (Vienna: Passagen, 2005).

10. Margret Dikovitskaya, *Visual Culture: The Study of the Visual after the Cultural Turn* (Cambridge, MA: MIT Press, 2005); W. J. T. Mitchell, "Interdisciplinarity and Visual Culture," *Art Bulletin* 77 (1995): 540–544.

11. Simon Faulkner and Anandi Ramamurthy (eds.), *Visual Culture and Decolonisation in Britain* (Aldershot: Ashgate, 2006).

12. Mieke Bal, "Visual Essentialism and the Object of Visual Culture," *Journal of the Visual Culture* 1–2 (2003): 5–32. Bal, however, has for decades used a semiotic approach.

13. This very successful conference dealt with the phenomena of the image, especially from the natural sciences, and brought together illustrious contributions from Roger Penrose, Susan

Sontag, and E. O. Wilson with other somewhat naive presentations from natural scientists who proudly showed their "pretty pictures." Sections were interdisciplinary and had titles like Space Imaging, Medical Imaging, Microscopy, Architectural Rendering, GIS, Visualization/Simulation, Molecular Modeling, Mathematical Graphics, the Future of Science Communication, and Science Centers. Critics noted that this National Science Foundation–funded initiative allowed for almost no art or image historians, who turned out to be an important element in the following workshops through congenial work with Felice Frankel and Barbara Stafford. See also Martin Kemp, *Seen I Unseen: Art, Science, and Intuition from Leonardo to the Hubble Telescope* (Oxford: Oxford University Press 2006); Barbara Stafford, *Echo Objects: The Cognitive Work of Images* (Chicago: University of Chicago Press, 2007); and Felice Frankel and George M. Whitesides, *On the Surface of Things: Images of the Extraordinary in Science* (Cambridge, MA: Harvard University Press, 2008).

14. Hans Belting (ed.), *Bildfragen: Die Bildwissenschaften im Aufbruch* (Munich: Fink, 2007); Horst Bredekamp, Mattias Bruhn, and Gabriele Werner, *Bildwelten des Wissens: Kunsthistorisches Jahrbuch für Bildkritik* (Berlin: Akademie Verlag, 2003).

15. G. Leidloff and W. Singer, "Neuroscience and Contemporary Art: An Interview," in *Science Images and Popular Images of the Sciences*, ed. B. Hüppauf and P. Weingart (London: Routledge, 2008), 227–238.

16. See the various publications and research projects of Helmut Leder.

17. Klaus Sachs-Hombach (ed.), *Bildwissenschaft* (Frankfurt: Suhrkamp, 2005).

18. Marion G. Müller, *Grundlagen der visuellen Kommunikation* (Konstanz: UVK, 2003).

19. Oliver Grau und Andreas Keil (ed.), *Mediale Emotionen: Zur Lenkung von Gefühlen durch Bild und Sound* (Frankfurt: Fischer, 2005); Anne Hamker, *Emotion und ästhetische Erfahrung* (Münster: Waxmann, 2003).

20. Although they concentrate on the gravitational field of art history, the courses in image science at Danube University in Göttweig are interdisciplinarily aligned. See <http://www.donau-uni.ac.at/dis>.

21. Martin Jay, *Downcast Eyes: The Denigration of Vision in Twentieth-Century French Thought* (Berkeley: University of California Press, 1993).

22. Oliver Grau, "Into the Belly of the Image," *Leonardo, Journal of the international Society fort he Arts, Sciences, and Technology* 32, no. 5 (1998): 365–371; Oliver Grau, *Virtuelle Kunst in Geschichte und Gegenwart: Visuelle Strategien* (Berlin: Reimer, 2001).

23. Gottfried Boehm, "Jenseits der Sprache? Anmerkungen zur Logik der Bilder," in *Iconic Turn*, ed. Christa Maar and Hubert Burda (Cologne: DuMont, 2004), 28–43, here 30.

24. Horst Bredekamp presented a first glimpse of his theory of "picture act" during his Gadamer Lecture series at the University of Heidelberg in 2005. The research project "Picture Act Research: History, Technique and Theory of the Picture Act" was approved by the German Research Foundation in 2008 and supported with 2.3 million euro.

25. Hans Belting emphasized in 2001 that we, as living media, are the "location of the images," and not the apparatuses. See Hans Belting: *Bild-Anthropologie: Entwürfe für eine Bildwissenschaft* (Munich: Fink, 2001).

26. See David Freedberg, *The Power of the Images: Studies in the History and Theory of Response* (Chicago: University of Chicago Press, 1989); Jonathan Crary, *Techniques of the Observer: On Vision and Modernity in the Nineteenth Century* (Cambridge, MA: MIT Press, 1990); William J. T. Mitchell, *Picture Theory: Essays on Verbal and Visual Representation* (Chicago: University Chicago Press, 1995); James Elkins, *The Domain of Images* (Ithaca: Cornell University Press, 1999); Lev Manovich, *The Language of New Media* (Cambridge, MA: MIT Press, 2001); Barbara Stafford (with Frances Terpak), *Devices of Wonder: From the World in a Box to Images on a Screen* (Los Angeles: Getty Research Institute, 2001); Thomas Gunning, "Re-Newing Old Technologies: Astonishment, Second Nature, and the Uncanny in Technology from the Previous Turn-of -the-Century," in *Rethinking Media Change: The Aesthetics of Transition*, ed. David Thorburn and Henry Jenkins (Cambridge, MA: MIT Press, 2003), 39–59; Erkki Huhtamo, "Elements of Screenology: Toward an Archaeology of the Screen," *Iconics: The Japan Society of Image Arts and Sciences* 7 (2004): 31–82.

27. Oliver Grau, *Virtual Art: From Illusion to Immersion* (Cambridge, MA: MIT Press, 2003).

28. André Malraux, *Psychologie de l'Art: Le Musée imaginaire—La Création artistique—La Monnaie de l'absolu* (Geneva: Albert Skira, 1947).

29. For the discussion and development of the field, see the journal *Digital Humanities Quarterly*.

30. The *International Virtual Observatory Alliance* (IVOA) was formed in June 2002 with the mission to "facilitate the international coordination and collaboration necessary for the development and deployment of the tools, systems and organizational structures necessary to enable the international utilization of astronomical archives as an integrated and interoperating virtual observatory." The IVOA now comprises 17 international virtual observatory projects.

31. The Millennium Ecosystem Assessment assesses the consequences of ecosystem change for human well-being. From 2001 to 2005, more than 1,360 experts worldwide were involved in this work. Their findings provide a state-of-the-art scientific appraisal of the condition and trends in the world's ecosystems and the services they provide, as well as the scientific basis for action to conserve and use them sustainably.

32. The Human Genome Project was an international scientific research project with the primary goal of determining the sequence of chemical base pairs that make up human DNA and identifying and mapping the approximately 20,000–25,000 genes of the human genome from both a physical and functional standpoint. The project started in 1990 with the collective work of more than 1,000 researchers in 40 countries; the plan was to achieve the goal in 2010. A working draft of the genome was released in 2000 and a complete one in 2003. See International Human Genome Sequencing Consortium (IHGSC), "Finishing the Euchromatic Sequence of the Human Genome," *Nature* 431 (2004): 931–945.

33. See <http://www.virtualart.at>; Oliver Grau, "The Database of Virtual Art," *Leonardo* 33, no. 4 (2000): 320.

34. Oliver Grau, "For an Expanded Concept of Documentation: The Database of Virtual Art," in *Proceedings of the ICHIM*, École du Louvre, Paris 2003, 2–15. It was a large development since the classic text by Suzanne Briet, *What Is Documentation?* (Lanham, MD: Scarecrow Press, 2006).

35. The PostGreSQL Database is open Source, and the operating system is Linux based.

36. See <http://www.gssg.at/gssg>. The digitization of the collection is a project developed by the Department of Image Science at Danube University and conducted in cooperation with the Göttweig Monastery. The collection of prints at Göttweig Monastery, which itself was founded in 1083, is based on acquisitions made by various monks since the fifteenth century. The first report of graphic art kept in the monastery dates back to 1621, with an archive record that mentions a number of "tablets of copper engraving" ("Täfelein von Kupferstich"). The actual act of founding the collection is attributed to Abbot Gottfried Bessel, whose systematic purchases in Austria and from abroad added a remarkable total of 20,000 pieces to the collection in a very short span of time. Reaching to the present day, the print collection at Göttweig Monastery has grown to be the largest private collection of historical graphic art in Austria, with more than 30,000 prints. The Department of Image Science's digitization center at the Göttweig Monastery scans paintings and prints from the collection (up to 72 million dpi).

37. Siegfried Zielinski, *Deep Time of the Media: Toward an Archaeology of Hearing and Seeing by Technical Means* (Cambridge, MA: MIT Press, 2006).

38. For example, the NETSCI 2010 conference in Boston or the High Throughput Humanities conference in Portugal, ECCS'10.

39. The Danube Telelectures from the MUMOK in Vienna contained debates between Sarat Maharaj and Machiko Kusahara: "Does the West Still Exist?"; Gunalan Nadarajan and Jens Hauser: "Pygmalion Tendencies: Bioart and Its Precursors"; Christiane Paul and Paul Sermon: "Myths of Immateriality: Curating and Archiving Media Art as Like"; Lev Manovich and Sean Cubitt: "Remixing Cinema: Future and Past of Moving Images." See <http://www.donau-uni.ac.at/telelectures>.

40. Also compare the OASIS (Open Archiving System with Internet Sharing (2004–2007) or the GAMA project (2008–2009), a gateway, a metadatabase, which is not connected with the Europeana. "The issue of generally accepted machine-readable descriptive languages in these semantic and metadata approaches and the long-term interoperability of databases have led to an emphasis on questions concerning the openness of the sources and the source codes." Rolf Wolfensberger, "On the Couch—Capturing Audience Experience," Master's thesis, Danube University, 2009.

41. Although there some promising case studies, such as Caitlin Jones, "Seeing Double: Emulation in Theory and Practice, The Erl King Case Study," <http://cool.conservation-us.org/coolaic/sg/emg/library/pdf/jones/Jones-EMG2004.pdf>.

42. Roger Malina, in an email to the author, July 31, 2009.

43. The loss might be even more radical and total than that of the panorama, the mass media of the nineteenth century. Almost 20 panoramas survived, which is much more than 3 percent—we should be glad if 3 percent of the most important exhibited media art works would survive.

44. See Grau, *Virtual Art*; and more recently, Lizzie Muller, *Toward an Oral History of New Media Art* (Montreal: Daniel Langlois Foundation, 2008).

45. DOCAM is a multidisciplinary research endeavor initiated by the Daniel Langlois Foundation in collaboration with numerous national and international partners who wrote letters of support, including the Database of Virtual Art, and is funded by the Social Sciences and Humanities Research Council of Canada. See <http://www.docam.ca>.

46. Compare the Variable Media Network, <http://www.variablemedia.net>. Also important is the Media Art Notation System (MANS), an experimental proposal developed by Richard Rinehart using the metaphor of the musical score. MANS provides a conceptual model of documentation that links vocabularies of description for variable media with the programming languages of databases. Although the comparison of the processual character of many media art works with music is logic, the object character of many artworks, the displays, interfaces, and designed hardware elements, cannot be preserved, and neither can the connected visual expression.

47. Maurice Benayoun, in an email to the author, October 21, 2008.

IV Coda

20 In and Out of Time: Is There Anything New under the Cyber-Sun?

Martin Kemp

Perhaps, on the grounds that any look forward is irremediably anchored in where we sit now, I might claim the indulgence of an unusually personal introduction.[1] I am literally sitting on the terrace under a thin awning beside the swimming pool in a special kind of hotel called Naturarte, deep in the countryside in the Alentejo region of Portugal. Having temporarily mislaid my American sunglasses (which have, of course, the necessary UV filters), I have bought a Portuguese straw hat. It was made in China.

Packets of sugar, promoting the delights of Delta coffee, arrive in a little Portuguese basket to sweeten my espresso. Each bears a much-degraded image of cultural heroes (no women in my batch), accompanied by short questions in Portuguese (figure 20.1). I recognize Einstein and Gandhi, but others do not ring specific visual bells. I look to the Web for help with translation. A free translation service fed the Gandhi question delivers, "Have something truer to defeat the gallows with the razao?" Ah, I see that I can obtain a "human translation"—at a cost of $40.00 for up to 266 words. I try to search for Gandhi quotes on the Web, but do not succeed in finding anything like the one on the sugar packet before I run out of patience. The collective wisdom of the staff in the hotel office comes up with "Is there anything more real than winning strength with reason?" They ask if I included the diacritical marks, such as the cedilla. I explain that I tried both with and without. I search again to find the quote on the Internet, but any key terms I enter, such as "real" and "reason" are too general to deliver results. I give up; I have a deadline.

I am here, before I go to speak on "Visual Culture" in Lisbon, because I am the host of Marta de Menezes, a former research student of mine in Oxford, who is an artist combining art with science, or, more specifically, collaborating with scientists working with biotechnology. Her husband, Luis Graca, an immunologist, and his brother, Rui, an architect, have created an eco-friendly paradise "hotel" in which modern technologies and traditional materials are seamlessly blended. They see themselves as part of a mission to save the environment from what we are doing to it.

Figure 20.1
Portuguese sugar packets, 2009.

I would not be here without the speed and reach of modern communications technology. I am working on my MacBook Pro, the design of which shouts "modern" and "high tech" in every aspect of its presentation, both to myself and the staff who are plying me with mineral water. I am hooked into the Internet by wi-fi, and can "Google" any topic I wish, from the birth date of an artist to fuzzy group theory, which I am considering as a model for rewriting aesthetics (optimistically).

I can visit Marta's website[2] to see what she has been doing. When I arrived here, she gave me her book on *Decon*, a project centered on Mondrian and pigment-eating organisms (see figure 20.4 below). She wrote a nice note in it, using my Parker fountain pen, which contains "real" wet ink. I would have been disconcerted if she had pulled out an electronic gizmo to make the inscription. The book is well designed and feels good in the hand. Leafing through it, I can gain a very rapid sense of what it contains, and I instinctively plan how I can navigate rapidly through its sections to gain a fair sense of what it is about, in advance of having an opportunity to read it more thoroughly. The clusters of pictures play a vital role in this. I am delighted that she has signed it.

I think about how and why "the book" as a physical object continues to exist and even flourish. Microfilm and microfiche were once heralded as presaging the death of

the book. Where are they now? The electronic era has been with us long enough for the persistence of the book not to be a generational phenomenon. When I worked in Bellevue on a Leonardo CD-ROM for Bill Gates, my collaborators were young computer geeks, a man and a woman. I have never seen so much printing-up of written and visual material, though it was readily visible to us on a large screen at the end of a room. We needed physically to "feel" what it was like, and how it was "shaping up"— even though the end product was to be an electronic disc.

These personal reflections are a way of setting up what I wish to say in the present context as a historian of the visual, who is engaged with contemporary art, science, and media but who spends more time in the Renaissance, above all with Leonardo da Vinci. The Renaissance saw two of the most profound visual revolutions in the history of image making. The first involved systematic naturalism, including the geometrical-optical technique of perspective. The second, closely related to the first, was the invention of the printed image. Together they effected an information revolution. However, as a historian, I spend much time asking where something came from, looking for continuities. Over the years, I have come to regard the information "revolution" as less revolutionary in cognitive terms than it is customarily painted. Too often apparently new means and functions have been confused with new content and new conceptual frameworks. I recall Ernst Gombrich's ironic question, "Why are there no landscape paintings in the Catacombs?" We obviously cannot safely assume that early Christians were unable to harbor a clear mental image of what we would call a landscape. Nor should we assume that, simply because a Renaissance artist could portray an imagined view in a mythological painting with wonderful naturalistic skill, it really existed.

New means in relation to new or old processes, functions, and products need to be handled with discretion and subtlety by the historian. What follows are some remarks under a set of headings. They assume the odd guise of a provisional glossary with some cross-references. Each heading would deserve an essay in itself, and some of the topics are indeed treated in depth elsewhere in this volume. The remarks should be seen as fields for thinking rather than conclusive formulations. They deal with more than visual images, since the visual cannot be readily extracted from other characteristics of modern communication, but they are very much framed from the standpoint of visual history. The tone will be that of the historian as devil's advocate when faced with the "new." The dominant glance will be backward, but I will also indicate what the past suggests we should do when looking forward.

Global Democratization of the Image

It is clear that we can now almost instantly tap into information and visual images from virtually anywhere in the world. An exhibition in Beijing is no more difficult

to access on the Web than one in Boston. Moving images of a celebrity's latest sartorial indiscretion are available at the touch of the metaphorical button. We can ask Google Images to show us Titian's *Rape of Europa* in the Isabella Stewart Gardner Museum. Seemingly, the highest resolution image online is 844k, just about good enough for PowerPoint but usable for an art historian only in a limited way. The museum itself gives us an image at a miserly 44kb. We know we can get a better image only by helping to fill the museum's coffers, either directly or via a commercial picture library. So much for the democratization of visual images! Private property rules continue to operate in the world of those images categorized as "art" (see "Classification," below).

On the broader front of visual images and visually presented information, there are of course vast amounts of material available in almost every field of imaging. This material comes in almost all shapes and sizes, still and moving, straight and manipulated, "real" and fantastic. This is the realm in which the Net evangelicals wax eloquent. Unsurprisingly, Larry Sanger, founder of Wikipedia, is one of those who ecstatically hails the democratization of knowledge. In his essay, "Who Says We Know,"[3] he tells us that

Professionals are no longer *needed* for the bare purpose of the mass distribution of information and the shaping of opinion. The hegemony of the professional in determining our background knowledge is disappearing—a deeply profound truth that not everyone has fully absorbed.

This may be more or less true for his "bare purpose"; but for the way we see images, this is about as "bare" in terms of perception and cognition as saying that everyone's eyes can receive an image of a landscape on their retinas.

Phrases like "the public itself" (adduced by Sanger as the aggregate determiner of what is true, or at least acceptable) are too crude to hold any serious meaning. We are each members of multiple publics, depending on the wide variabilities of context and content. In reality, everyone is some kind of "expert" viewer, bringing his or her own framework of expectation and knowledge to acts of seeing. The important thing remains the nature and level of the expertise (see "Trust," below). A fan of the latest TV sensation is an expert on that show in a way that I cannot hope to be: I do not have a television.

An expert on Renaissance art might bring a "sharp" eye to bear on a Chinese painting, but an expert on Chinese history will tend to make the art historian seem like a member of the "public." On the other hand, someone who rides horses may make well-informed comments about painting of Chinese women horse-riders playing a form of polo.

When it comes to history, the situation is even worse. Sanger informs us (as a democratic act of communication) that

The politics of knowledge has changed tremendously over the years. In the Middle Ages, we were told what we knew by the Church; after the printing press and the Reformation, by state censors and the licensers of publishers.

So much for Thomas Aquinas's wonderful Aristotelian subtleties; so much for the grotesque marginalia in medieval manuscripts; so much for the observational miracles of Islamic optics; so much for the printers of scurrilous broadsheets; so much for La Mettrie's heretical *L'homme machine*. . .

The international spread of knowledge in the Middle Ages was remarkable. Frederick II, the twelfth-thirteenth-century Holy Roman Emperor, who constructed a network of castles across Europe, conducted philosophical correspondence with Islamic scholars in faraway lands. A mathematical and astronomical conundrum was solved for him by the Egyptian, Al-Lam Al-Din Kaisar Al-Asfouni. He dispatched Aristotelian questions to the Andalusian philosopher, Ibn Sab'in, who replied in less than flattering terms. We can also see how the European monastic orders provided effective networks for the transmission of knowledge, not least of visual styles, by dint of personal travel or by forms of "post." We might recall that gunpowder and paper both arrived from China, with equally explosive consequences.

What is new now is not wide transmission in itself, but its *rapidity* and *volume* (see "Speed" and "Quantity and Origination," below).

Space-Time and Nonlinearity

We are also bludgeoned by evangelists of "cyberspace." The term makes an early (its first?) appearance in William Gibson's 1984 novel, *Neuromancer*. There is it described inconsistently as

a consensual hallucination experienced daily by billions of legitimate operators, in every nation. . . . A graphical representation of data abstracted from the banks of every computer in the human system. Unthinkable complexity. Lines of light ranged in the non-space of the mind, clusters and constellations of data.[4]

This is easier said than understood and coherently explicated. In a sci-fi novel, it functions well enough. Adopted as a description of something that really exists, as has extensively happened, it is incoherent. The vision is of some kind of nonlinear transmission across some kind of hyperspace according to a new kind of virtual simultaneity. In reality, we are still dealing with human perceptual and cognitive systems, which are, as the result of evolutionary legacies, awesomely good at structured perception and imaginative synthesis. Let us look more specifically at space and its Einsteinian partner, time.

The representation of space in the computer remains, apart from some very specialist usages, remorselessly anchored via the x-y-z axes to the 3D metrical space that

Brunelleschi invented and Alberti codified in the fifteenth century. This applies not only to the huge quantity of photographic and filmic images, but also to virtual worlds, whether designed for monocular or binocular viewing. Pioneering artists from Umberto Boccioni and Max Bill to Tony Robbin (figure 20.2) have invented various ingenious ways of inserting a fourth dimension into the spaces of their artworks, but these generally operate either by suggestive evocation or perceptual switching of the kind we perform when looking at well-known optical illustrations. We see, as it were, the duck or the rabbit, but not both at the same time. Robbin's methods, well thought through, exploit techniques of projection from four-dimensional arrays in conjunction with a good deal of perceptual acrobatics.

Time, locked traditionally into successive changes of position in regular space, also remains obstinately dominant in the world of new imagery. There may be an increasingly insatiable demand for rapid cutting between view and view, or image and image (see "Speed," below), but this comprises an accelerated and fractured linearity, not some kind of new simultaneity or nonlinearity. To paraphrase Leonardo when he was talking about blur, "the *imprensiva* (receptor in impressions in the brain) reacts faster

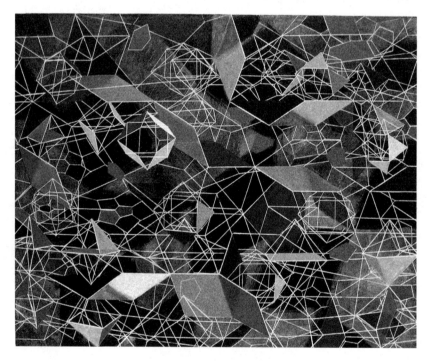

Figure 20.2
Tony Robbin, *2007–4*. Collection of the artist. Reprinted by kind permission of the artist.

than judgment." Because a linear process is too fast for us to pick up as time based does not mean that it is nonlinear.

The cyberworlds are transmitted to us in our moment of time and space from somewhere that is ultimately definable, both in terms of the origination (say, in someone's office) and its reception on our device (however immediate or removed in space and time). We cannot watch the process of transmission itself, but the same applies to the telephone, radio, and television. The transmission is physical and time based, if incredibly fast. It is rather like playing a volley at the net in tennis. It happens so quickly that it is susceptible to linear analysis only afterward. It relies on a sequence of physical and mental events that are in fact sequential, although incredibly compressed and progressing down multiple channels.

Graphics on the Internet do of course present a new and fluid arena in which to exercise imaginative manipulations of time and space, as do computer games, in a spectacular manner. But fictional worlds have always done that. Was Dante's *fantasia* when he envisaged the rule-breaking worlds of *Inferno*, *Purgatorio*, and *Paradiso* (particularly in *Paradiso*, where his standard perceptions collapse) operating at a level inferior to that occupied by the designers of computer games? Dante's narrative is linear, but it can take us on flights of imaginative fancy as wild as any devised with computer software.

Nonlinearity does exist, but not specifically in the exercise of cyberspace (see "Complexity," below).

The Ubiquity of Images

We can be been seen as living in an image-based society. There are certainly plenty of images around of a kind that were not available previously. Via CNN we can witness the second plane crashing into the World Trade Center virtually as it happens. Huge screens in city squares purvey high-resolution images of everything from the joyous consumption of the latest soft drink to the chaos of financial markets. There are now more images than ever before, and they are available to vast swathes of the world's population more or less simultaneously.

But we are also deluged with words. I receive 30 to 100 legitimate emails each day, most of them devoid of images (other than the image of the text itself, its font, etc.). Joggers pounds their beats to the music and words of their preferred soundtrack. The rhythm helps, while the sensory input and content distracts a little from the pain.

But does more in each case mean essentially different? Let us concentrate for a moment on ancient images. Bourgeois householders in Pompeii and Herculaneum lived in residences dense with figurative images on their walls, ceilings, and even floors. They possessed sculptures on varied scales, not least portrait busts of themselves

and their family in the ready medium of terracotta. Some of the flat representations were fully pictorial, while others were in the pixelated form of mosaics. Like us, the later Romans appear to have been image junkies. Temples, public buildings, homes, and brothels all purveyed fine-tuned messages in the pictorial mode.

Later, the Christian church, in apparent defiance of the Bible's proscription against "graven images," proliferated representations of sacred persons and events. The stock justification was that pictures served as the "Bible for the unlettered." Virtually every church contained images. Even Luther, often assumed to be an iconoclast, saw certain kinds of sacred representations as playing a key role in one's understanding of the Bible. The modes of portrayal were widely divergent, running, say, from the formal austerity of an Orthodox icon of the Virgin Mary to the humanized Madonnas of Raphael, and from a naive monochrome wall painting in a small stone building at the edge of a rural village in the Ukraine to the highly theological and formal sophistication of Michelangelo's Sistine Chapel in Rome. Gaining an adequate grip on the ubiquity of images in remote times is made difficult and even impossible by the selective loss of low-grade, ephemeral, and "popular" representations, compared to those we classify as "fine art" (see "Classification," below).

Even societies dominated at various times by iconoclasm, such Islam in many of its phases and the Puritan sects that played such a key role in the early development of America, used images powerfully. For instance, there is hardly a surface in the Alhambra that is not covered in some kind of "decoration," calligraphic or abstract. The "decorations" are saturated with deeply spiritual meanings embedded in both their form and content. Similarly, the Shakers in America made their visual points without resort to figuration. They spoke visually through purity and "honesty" of design rather than "graven images." A white cloth or wonderfully simple chair is as potent a visual metaphor as a rich swathe of brocade or a "Chinese" Chippendale mirror.

Governing elites, or those who make the rules, neglect the power of images at their peril, as practice has long shown. Kings sent copies of their portraits to watch over subjects in all corners of their kingdoms. Mao's officials dispatched countless images of his mighty person to remote parts of China. A railway office in colonial India might well have boasted a framed photograph of King George V. As David Hockney has argued when exploring his thesis about the use of optical aids by Western artists, control of the "realistic" image has long provided a vital lever for the gaining and retaining of power (see "Trust and the Expert," below). Even a coffee company's sugar packets tap into iconic images of cultural heroes.

Ubiquity is not a new aspiration, or even an unprecedented achievement, but the spread of those who can aspire to generate images is something different (see "Quantity and Origination," below).

Quantity and Origination

A search for *Mona Lisa* images delivers 11,100,000 hits. One site lists (as of October 2010) 4,504 *Mona Lisa* variant pictures.[5] They range from the odd to the very odd. Anyone can post an image. Some time ago I posted an image of my face "photo-shopped" onto the *Mona Lisa*, courtesy of Rowan Drury (figure 20.3, plate 31). There it is in the index as *"Kempa Lisa."* Was this a wise thing to do? The rating of the picture is 3.63 out of 5. I gave it a rating of 5, which helps a bit. I try again, but the site seems to resist multiple attempts. I log out and back in again, but apparently I cannot budge the rating any further. If I wanted, I could find a way around this, but it hardly seems worth the effort.

The *Mona Lisa* may be an extreme case, but it ("she?") does demonstrate that images of a linked kind can now potentially proliferate without apparent limit. It also shows how anyone can be the originator and propagator of an image. The status is, of course, entirely unclear. Is the MJK who posted it really me? Does someone who does not know what I look like have any reason for thinking it is a likeness of me? How can the user know that I have not persuaded my friends to vote for *Kempa Lisa*, giving it a skewed rating (see "Trust")?

The criterion of quantity does highlight something real and remarkable. But it deals with numbers, and is in theory neutral with respect to quality and meaning. In practice, multiple repetitions of images tend to result in degradation. Neither the aspiration to proliferate images nor the toleration of degradation is new. When black-and-white prints were made of paintings, as happened increasingly in the sixteenth century, various needs were satisfied: the broadcasting of the image for its content by those who were responsible for its making (e.g., the king who commissioned the portrait); the desire of the artist to spread his fame and show his style; the wish of people to see what a work looked like when they had no chance of inspecting the original; and the commercial interests of the engraver and publisher. It would not be difficult to align these motives with those posting images on the Internet today.

When an engraving or woodcut was made from a reproductive engraving, the resulting print was one further step removed from the original. Often, especially with cheaply produced popular prints, as of English monarchs on seventeenth-century broadsheets, only a few individualizing features remained. One of the characteristics of images that gain iconic status is their tendency to retain robust recognizability when only a few, minimal visual clues remain. A 4kb image of "Mona Lisa smoking a joint" on a site that sells cannabis seeds is crudely pixelated as soon as we zoom in, but its *"Mona Lisa*–ness" holds up incredibly well. Our perceptual system is incredibly good at filling in, as artists have always instinctively known when making a slight sketch of something for future reference. Many Web posters rely on this time-honored ability to do a lot with images of very low resolution.

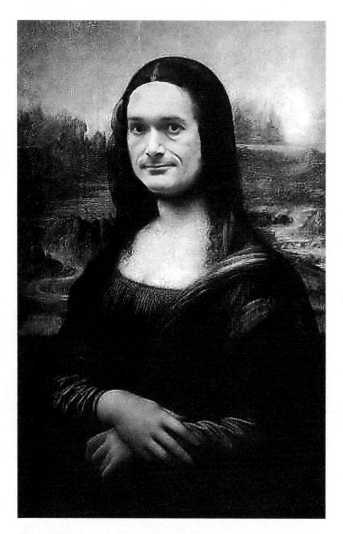

Figure 20.3
Rowan Drury, *Kempa Lisa*, 2004. Reprinted by kind permission of the artist. See plate 31.

Searching for degraded images of the *Mona Lisa* is something I can now do to such an extent that I cannot possibly handle all the results. I can only handle so much quantity before the results become impossible to digest. The rapidity with which I can call them up is also a challenge (see "Speed," below).

Speed

I return to the *Mona Lisa* image search after an interval of no more than an hour. There are now 12,400,000 hits. Can this be right—an increase of 1,300,000? Google tells me that 0.50 seconds have been expended on this massive operation. Or am I misinterpreting the information they provide? In any event, the speed of the search and the speed of proliferation are astonishing. Speed has been the driver (with the associated factor of memory) for much of the development of hardware, software, broadband connections, and search engines.

The quest for speed has always been a potent driving force in any developed society, above all those that practice war and the cluster of related activities. Fast horses and fleet-footed messengers were treasured. The first marathon runner, the soldier Pheidippides, bore news of the Greek victory over the Persians from the battlefield at Marathon to Athens in 490 bce. Much of Cesare Borgia's success in capturing territory for his papal father was due to the extraordinary speed with which he moved his troops from one place to another. Leonardo's map of Imola, made for Cesare, specifically notes the distances to other strategic locations. Speed is a desirable attribute for those collectives that wish aggressively to dominate another, whatever the nature of those collectives and whatever their field of operation. Financial markets depended on speed of information transfer even before the advent of computers.

I suspect that every urban society (and some rural ones) have always felt that things were getting faster all the time. We may lament the results, but we tend nevertheless to be hooked. The human perceptual system, and probably all systems that seek gratification, rely on constantly changing stimuli. Unrelenting exposure to a single color or sweet taste rapidly produces fatigue and a breakdown in perception. We crave new stimuli.

What has served us well in our standard environment can now be exploited with means that go beyond our previous dreams (or nightmares). The most celebrated art now relies on the quick fix. When we look at a Damien Hirst shark in its constricted aquarium of formaldehyde, we see what it is straight away. What we see is what we get—a short-lived surprise and a lingering memory. A work that requires a long period of observation and sustained contemplation is not well attuned to modern patterns of visual consumption, though it will, I hope, have greater staying power over the ages.

Watching a James Bond film, directed by Michael Apted, I try to count the longest that any single shot is on the screen. I detect nothing over 1.5 seconds, before becoming wearied by the exercise. Contrast this with the long, single shots in Hitchcock's *Psycho* from 1960. In Douglas Gordon's extraordinary, slowed-down version, *24 Hour Psycho*, we can see how minimal is Hitchcock's manner. Events that we think we can recall in all their detail are shown by Hitchcock in a series of slow and tense fragments. We fill in the gaps and create an illusion of violence and speed. With James Bond there are no visual gaps. As soon as a camera looks at a building, it blows up. Even in the staid genre of an academic lecture of 55 minutes, I find myself getting through as many as 70 slides (facilitated by modern presentation tools), whereas 30 once seemed fast.

I suspect that we are inventing media for speed gratification that are beginning to operate at a pathological level. The only requirement of the viewer is to be quick, not to exercise imagination or even to think.

Complexity

Handling barrages of images at frantic speeds is certainly complicated, but it does not in itself involve complexity. The sense of complexity that I am using here involves the concept of a system that has definable initial conditions (even of a simple nature), which, when played through, exhibit unpredictable results. There are discernible patterns, operating according to probabilities, as with the kind of chaotic systems for which Benoit Mandelbrot has become famed, but no linear sequence that allows us to forecast a specific outcome.

Although some of the founding mathematical ideas, like Julia sets, were known long before computers were available, the iterative power of computers has been essential in allowing us literally to "see" what happens when we let a chaotic system loose. Given the results of the models, we are now better able to recognize how chaotic systems operate in nature, and, in fact, how many natural processes operate with complexity. With related developments, such a self-organized criticality, complexity theory has rapidly invaded many fields of analysis, from business studies to the understanding of traffic jams.

The potential for acts of visualization is huge, and many of the visual results have been viewed as "beautiful." The modes of analysis are indeed new. But the exploiting of complex or chaotic processes has long been ensconced in artistic practice. Any perceptive artist working with a medium that has specific physical properties learns how the medium behaves in a way that is not subject to absolute control and forecastability. The "happy accident" has always played a role, sometimes small, sometimes large. It seems to have played a conspicuous role in some Neolithic cave painting, when the artist exploited the given contours of the rockface. Titian's use of oil paint

in the *Rape of Europa* relies in part on the serendipity of application, using a loaded brush brandished with spontaneous vigor—and even utilizing his fingers. There are parameters involved—kinds of probability—but no absolute predictability. If a particular accident is not a happy one, the painter can try again. When Leonardo da Vinci recommended that the artist look at stains in walls as an aid to imagining landscapes, he was recognizing instinctively that the process behind the stain somehow resulted in morphologies like those arising from the forces that have shaped our countryside.

An essential feature of the realm of art, as it works with the spectator, is that nonlinear imagination is deployed in a symbiotic way by the creator and the recipient. Complexity theory has laid bare the mathematical anatomy of the process, but I doubt whether an awareness of it makes us better at creating works of art that exploit its potential. Some artists can actively realize the potential; most of us cannot.

Process

Some early computers were called "word processors." Although "process" was a common enough term before computers—I can remember "processed peas" from my childhood—it has assumed a fresh prominence. All sorts of things are seen as passing through processes, or are subject to "due process."

The media of moving images are far better at demonstrating visual processes than static images and wordy descriptions. A major point of the animations of Leonardo da Vinci drawings that we produced for the exhibition at the Victoria and Albert Museum in London in 2006–2007 was to visualize his processes of visual thinking. A truncated and stellated dodecahedron is a difficult object for a nonspecialist audience, and impossible for a label-writer, but once we could show it undergoing the processes that shaped it, as it spun gently before our eyes, all became clear. Motion and process are well suited to stimulate the "ah ha" factor. And, at a more advanced theoretical level, complexity and chaos are realized through processes that need computers.

One of the signal and to my mind most significant characteristics of later twentieth-century art has been the overt use of process to create works and even to destroy them. The pioneer of destruction as an art form, Gustav Metzger wrote his first manifesto of auto-destructive art in November 1959. The second, four months later, inserted the destructive acts into specific political contexts. It begins,

Man in Regent Street is auto-destructive.
Rockets, nuclear weapons, are auto-destructive.
Auto-destructive art.
The drop drop dropping of HH bombs.
Not interested in ruins, (the picturesque)

Auto-destructive art re-enacts the obsession with destruction, the pummeling to which individuals and masses are subjected.

He explains that "there are forms of auto-destructive art where the artist has a tight control over the nature and timing of the disintegrative process, and there are other forms where the artist's control is slight." He finishes by listing possible materials and processes, some of which are uncompromisingly modern:

Acid, Adhesives, Ballistics, Canvas, Clay, Combustion, Compression, Concrete, Corrosion, Cybernetics, Drop, Elasticity, Electricity, Electrolysis, Feed-Back, Glass, Heat, Human Energy, Ice, Jet, Light, Load, Mass-production, Metal, Motion Picture, Natural Forces, Nuclear Energy, Paint, Paper, Photography, Plaster, Plastics, Pressure, Radiation, Sand, Solar Energy, Sound, Steam, Stress, Terra-cotta, Vibration, Water, Welding, Wire, Wood.

Acid, the first on the list, was used, for example, as a painting medium that corroded a succession of white, red, and black nylon canvases to the point at which they disintegrated.

Much engaged with advanced technology, Metzger presented liquid crystal projections in 1965, using them as a setting for musical performances by the band Cream. The chaotic coloristic and formal reconfigurations of the liquid crystals meant that the art work was all process, with no fixed end in view.

Metzger's use of process remarkably predates the extensive public use of computers. It was in 1959, the year of his earliest manifesto, that the first ERMA computers were delivered to the Bank of America, marking the effective beginning of conducting business by electronic device.

His work is an extreme example of what has become a dominant trend in the visual arts, namely, the extension of the media available to and used by artists into a previously inconceivable range of processes and products. There is no indication that this trend is slackening, with artists entering into territories (institutional and intellectual) previously inaccessible to them.

Marta de Menzes is a notable case in point. She has been experimenting for a number of years with biotechnology. A very recent work, *Decon*, consists of what might be called auto-destructive Mondrians (figure 20.4). In collaboration with Dr. Lígia Martins of the Institute for Biochemistry and Biology at Lisbon University, she has constructed a series of shallow partitions in Mondrian-like grids. Each partition contains a pigment that is progressively "eaten" by the bacterium, *Pseudomonas putida*, which is being researched as a means to degrade pollutant textile dyes. The "Mondrians," exhibited in the relatively stable conditions of an art gallery, comprise part of the research into the optimal conditions for the process of degradation. The resonances with Mondrian are multiple and complex—not least with respect to Mondrian's studio as a meticulously organized "laboratory" for the discovery of theosophical "realities" beneath natural appearance.

Figure 20.4
Marta de Menezes, *Decon*, 2008. Collection of the artist. Reprinted by kind permission of the artist.

The other major dimension of art as process resides in strategies of interactivity. Looking at a work of art has always been an interactive process, involving what Ernst Gombrich called "the beholder's share." This share can now be extended dramatically (in the literal sense) by computer-driven systems through which the observed advertently or inadvertently reconfigures some aspect of the work on a permanent or transitory basis. I suspect that we are as yet in the infant stage of the full exploitation of interactivity in various context for viewing.

Art based on process, particularly if the visual results are ephemeral, is clearly dependent for its long-term survival on the modern media of visual recording. Process art tunes in complex ways into our media and our ways of articulating our relationship with nature. It is clearly one of the most potent options for the future of an engaged visual art.

However, faced with what Metzger and de Menezes are doing, the term "art" is becoming increasingly inadequate (see "Classification").

Handmade

Prominent among the sites hit in the search for *Mona Lisa* images are those that offer "hand-painted" replicas. A search for "hand-painted copies of old masters" produced 338,000 hits. Limiting the search to *Mona Lisa*s still returned 52,700. The handmade

still flourishes vigorously, even for replication, in the "age of mechanical reproduc-tion." The "aura" of the work has been hugely enhanced by its serial reproduction and is folding back into the production of handmade pseudo-originals—which one site calls "genuine copies." Another nail in the coffin of Walter Benjamin's famous but misguided essay! Paintings were, of course, much copied in earlier eras (as in our example of portraits of kings, which were often produced with the active studio par-ticipation of the painter of the first version). Copies and skillful copyists were esteemed more highly than they are today, but ran increasingly into art market imperatives to separate the first from the subsequent.

The "original" and the "handmade" continue to exercise a special grip on our imagination. Market forces play a role, but I believe that there is something more fundamental at work. We are tuned with incredible sensitivity into an object that speaks of that intimate communication between the maker's brain, his or her motor impulses, and the operation of the hand, justly called by Aristotle the "instrument of instruments." An example is the way that we can recognize a friend's handwriting in an instant. There is a highly refined level of somatic empathy at work.

Electronic devices have been widely used to produce notable art, particularly when the special proclivities of the electronic medium have been specifically exploited. When a device is used to ape the effects of handmade, the results can be compelling, but there is always (to date at least) just that something we can sense that tells us the work is not made by hand. This applies to music, voice synthesis, and painting in equal measure.

Recently, David Hockney, who has not previously engaged much with computers, has been working with Photoshop and Graphics Tablet to create large landscape "paintings" in limited editions printed on paper by inkjet (figure 20.5). The illustrated example is a little over a meter wide. Only in the last few years has computer software developed to the point at which he felt it could meet his requirements for the hand-made. The medium remains radically different, however, since the physicality of the new process of color application is removed by at least one step from the end product. Getting used to the new interface is demanding. It takes time, patience, and concen-tration if one form of touch is to be traded for another.

The resulting images are remarkable, retaining many of the special qualities of his recent landscape paintings, which rely on a "simple" directness of artful paint applica-tion to speak to us of what he sees. Our act of seeing and registering relies on our instinctive reaction to how the painted mark manifests the conjoined power of the artist's eye and hand. In one sense, the new landscapes are "handmade by computer." But the computer still surreptitiously asserts its presence. There are innumerable tiny signs, some that we can analyze and some that we can only intuit, that these are not material paintings made by varied pigment particles in binders of specific viscosity applied by diverse brushes that possess special personalities of their own. They do not

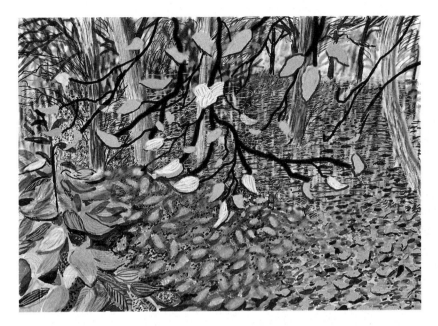

Figure 20.5
David Hockney, *Autumn Leaves*, 2008. Reprinted by kind permission of the artist.

even look precisely like good digital reproductions of oil or watercolor paintings. None of this is a bad thing. In fact, the characteristics of the mark-making on the Graphic Tablet brings something to Hockney's career-long concern with the paradoxical magic of seemingly simple marks performing complex perceptual and cognitive tricks. Part of the delight is that the spectator has an active role to play. Hockney trusts the spectator to work with him.

Trust and the Expert

Communication relies on trust. We need to be able to evaluate the source, but all the signs are that we are not very good at this and that the Internet is making things worse.

There has always been a "democratic" and an "expert" dimension to believing something, often with a complex relationship between the two modes. Let us take the imaginary case of a friend who is feeling increasingly ill. The doctor tells her that it is viral and that she has to wait it out, unless secondary infections occur that can be treated with antibiotics. Her aunt tells her that she had the same thing, and that a patent herbal remedy helped greatly. The aunt's testimony certainly does not count as scientific evidence, but my friend wants to believe her. She takes the remedy and

gets better after three or four days. She will tell her friends about it, and even posts about it on a blog. In no time at all, the aunt's idea is laid down in black and white for everyone to see. But in repeated medical tests, this particular herbal remedy has been shown not to work.

What this story illustrates is that "democratization of knowledge" is accompanied by its mirror image, the democratization of ignorance—or, to put it another way, the mass certification of misplaced trust.

There are some classic academic instances of multiple repetition assuring factual status. The supposedly large number of Eskimo words for snow is a famous case in point. Over the years, the reported number of words grew steadily. Far from Sanger's democratic "mass" detecting the error, it needed specialist research to trace the origins of the problem back to the anthropologist Franz Boas in 1911. The proliferation was driven by a wish to demonstrate the way that language dictates perceptions.

Other repeated factoids are still rampant. An example is the classification of dogs that Foucault adduces near the beginning of *Les mots et les choses*, which he credits to "a certain Chinese encyclopedia":

(a) belonging to the Emperor, (b) embalmed, (c) tame, (d) sucking pigs, (e) sirens, (f) fabulous, (g) stray dogs, (h) included in the present classification, (i) frenzied, (j) innumerable, (k) drawn with a very fine camelhair brush, (l) et cetera, (m) having just broken the water pitcher, (n) that from a long way off look like flies.

Foucault credits the source as the great translator and editor of Chinese texts, Franz Kuhn. The intermediate source is Jorge Luis Borges's essay on John Wilkins. I could find no sign of this encyclopedia in Kuhn's extensive bibliography. It is almost certainly one of Borges's brilliantly deceptive chimeras. The Internet does contain some debunkings, but the process has not gone as far as the Eskimo snowfall.

The issue of trust takes on a special complexion when we look at visual images. Presented with a naturalistic image, especially one that declares itself as a photograph, we automatically work to bring coherence to it, and that very work predisposes us to trust it. We do, of course, know that naturalistic images can lie—like Cranach's beguiling portrayal of a unicorn—and that photographs have been manipulated from a relatively early stage in the development of the medium. However, we want to trust what we see with our own eyes and often have no way of telling if we are being deceived. Convincing "before" and "after" photographs of someone who has taken some anti-wrinkle potion, broadcast both on the Internet and in printed brochures, only reveal that the first photograph has been digitally altered on very close inspection of the precise placement of individual stands of hair (figure 20.6).

A second category of image is that which requires expert decoding. Medical scans present an example. Perhaps the most pernicious recent example is provided by the

Scientifically and clinically tested

Mrs S.T. (65) Sheffield.
Severe wrinkling and deep creasing around the eyes and a discolouration the tone. Within 7 weeks the damage has been completely reversed and the skin tone returned to normal colour and shade.

Ms H.L. (70) Aberdeen
Deep set creasing around the eyes, thick lines and crows feet.
After a 10 week treatment the lines and wrinkles had been removed and skin softness returned.

Mrs J.N. (80) Worthing
Severe facial ageing resulting in wrinkles, darkening and sagging. Treated over a 12 week period has resulted in an eradication of the deep lines and a smoothing out of all creasing

Figure 20.6
"Before" and "After" treatment with Collalift, <http://collalift.com/faqs1.html>.

air reconnaissance pictures used by Colin Powell at the United Nations and included in the British government's "dodgy dossier." They purported to show the extent of Saddam Hussein's nuclear weapons capacity. "Expert" analysis of the images, including digital enhancement and the outlining of significant features, demonstrated what American intelligence operations had observed. It is likely that Powell was oversold on the evidence because he wanted to believe it. In the event, the observations proved not to be true. It is likely that similar spy satellite pictures of the queen's residences in Britain could be used to make a similar point as the one Powell made about Hussein.

The current situation of trust in the digital age appears to be dire. In the field of visual images, education needs to be undertaken in a way that few as yet understand.

Classification

Powell's images can be regarded in a certain way as works of art, or at least as visual rhetoric—with rhetoric understood in Cicero's ancient sense as "the art of persuasion." Where in the world of modern images do the boundaries exist? The boundaries are

clearly permeable to an unprecedented degree. But I would go further and say that our stock taxonomies are no longer viable outside the context of social and institutional conventions. Marta de Menezes's "Mondrians" are simultaneously art and scientific experiment. They leave no conventional artwork behind. They help make a statement about pollutants but are not themselves statements. They look distinctly like Mondrian's paintings, but clearly exist in a quite different sphere of intention and reception. They are visual performance. They only exist as "works of art" because they are most likely to be displayed in an art gallery. If displayed elsewhere, say, in the foyer of a biochemistry building, that foyer would conventionally abrogate to itself something of the nature of a temporary gallery. Their quality and efficacy would to my mind be enhanced if no one was tempted to ask "is it art?" They are wondrous visual creations that can inhabit more than one world, or a new world of their own, shared with the growing number of other "artistic" things that do not "fit." The "experimental" creations of Eduardo Kac, who supplies an essay in this volume, comparably inhabit multiple worlds and do not fit comfortably within the notion of art.

For a parallel we could look at eras or cultures in which there was no definition of a professional artist and there were no discernible institutions of art. Let us take a thirteenth-century gothic cathedral as a test case. There was no profession of "architect." The term "mason" embraced a wide range, from prestigious devisers of buildings to artisans who carved stone into fantastic gargoyles. The structural wisdom required to create the skeletal windows and soaring vaults was immense. Straight-edges and compasses were used with elaborate skill to plot intricate geometries in tracery. The makers of stained glass allied the highest of techniques to the most eloquent draftsmanship. Silversmiths wrought vessels with decorations so fine that it takes a magnifying glass to appreciate their detail. Organ makers plied their mighty trade. Manuscript illuminators produced magnificent volumes of sacred music on large scales. The result was a multimedia extravaganza that did not depend on art or artists in our present social sense. In theory, we could return to such a situation.

In practice, I think there is little chance of our classifications radically changing. The reasons are not primarily intellectual. They are social and above all economic. The institutions of teaching, exhibiting, and marketing of art are deeply locked into the nexuses and public and private finance. Those who work in the institutions, as I have done myself, sustain their territories and maintain their boundaries with a fierceness that equates to their survival as professional and economic entities. All these factors help explain why the careers of specialist Internet artists have taken off to a very small degree compared to those in the more fluid music business. On the credit side, the elasticity of the professional art structures in embracing things like auto-destructive art is admirable. But they are left with no choice by the present generation of visual makers.

Down with "Progress"

Progress is a demon that has pestered the human species since the first flints were shaped into tools and arrowheads. As a conscious concept, progress was first clearly formulated in the Renaissance, not least in relation to the cultural need to revive, emulate, and surpass antiquity. It is a notion locked into the early capitalist society of Renaissance Florence. Vasari tells the story of art from Cimabue to Michelangelo as two and half centuries of progress, reflecting in some measure Pliny's account of the rise of naturalism in classical antiquity. We no longer think—or at least no longer overtly say—that Michelangelo is better than Giotto, but we still tend to tell the story of art in terms of one achievement built progressively on another. And, as Gombrich has shown, there is a genuine story in the perfection of naturalism that can be told and inserted into a broader history of the functions of images.

Our notion of artistic excellence is bound in with what is novel. We praise the first artist to achieve this or that. Even postmodern eclecticism, which ostensibly decried the modernist quest for perpetual change, relied for attention on its newness.

There is perhaps nothing too badly wrong with this. We like to be engaged with something fresh and newly exciting. The problem comes when the tacit sense of artistic progress reflects and reinforces the paradigm of progress on which politicians, businesses, and ourselves have built our modern world. Art as cultural bling becomes part of conspicuous and ever more rampant consumption. It consumes limited amounts of raw material, to be sure, but it conspires with the idea that we can continue to consume indefinitely. There are artists, a growing number, who refuse to be complicit. (The terms "artists" and art" continue to provide an automatic shorthand.)

I suggest that we can look to the arts as a way of defining two kinds of progress. The one, the politico-financial model, says that productivity (and thus the gross national product), must increase incessantly and we may all legitimately aspire to have more of everything we judge that we might want. The other, the artistic model, looks to extend old and new kinds of satisfaction in terms of the quality of human experience. This is not the cultural equivalent of Marie Antoinette's legendary pronouncement, "let them eat cake." Shakespeare does not substitute for a full stomach. Rather, the notion of artistic change and nourishment stands as a model for a form of progress that is not quantitative in material and financial terms. It can stand alongside an aspiration to help people worldwide to live safe and healthy lives. Perhaps we can interest our demon in some other way of feeding its needs. But it will require a lot of trustworthy rhetoric to persuade it to do so.

Notes

1. The scope of this essay is such that providing notes, even on a selective basis, seemed an impossible task. I have limited the reference to a few of the more important websites.

2. See <http://www.martademenezes.com>.

3. See <http://www.edge.org/3rd_culture/sanger07/sanger07_index.html>.

4. Now available as an audiobook: <http://ebook30.com/audiobooks/audiobooks/53292/william -gibson-neuromancer-audiobook-repost.html>.

5. See <http://www.megamonalisa.com/index.php?page=list>.

Contributors

Marie-Luise Angerer is Professor of Media and Cultural Studies and Gender Studies at the Academy of Media Arts Cologne. Since 2007 she has been Head of the Academy. Her publications include: "Vom Phantasma des Lebens," in *Der Einsatz des Lebens: Lebenswissen, Medialisierung, Geschlecht*, ed. Astrid Deuber-Mankowsky, Christoph Holzhey und Anja Michaelsen (Berlin: b_books, 2009), 145–160; *Gender goes Life: Die Lebenswissenschaften als Herausforderung für die Gender Studies (co-eds)* (Bielefeld: transcript, 2008); and *Vom Begehren nach dem Affekt* (Zürich, Berlin: diaphanes, 2007).

Olaf Breidbach is Chair for the History of Sciences and Head of the Institute for the History of Medicine, Science and Technology and the museum "Ernst-Haeckel-Haus" of the Friedrich Schiller University, Jena. His publications include *Die Materialisierung des Ichs* (Frankfurt: Suhrkamp, 1997); *Das Anschauliche oder über die Anschauung von Welt* (Vienna: Springer, 2000); ed., *Naturwissenschaften um 1800* (Weimar: Böhlau, 2001); *Deutungen* (Weilerswist: Vellbrück, 2001); *Bilder des Wissens* (Munich: Fink, 2005); with T. Bach, ed., *Naturphilosophie nach Schelling* (Stuttgart-Bad: Cannstatt, 2005); with G. F. Frigo, ed., *Scienza e filosofia nel positivismo italiano e tedesco* (Il Poligrafo casa editrice srl. Padova, 2005); *Goethes Metamorphosenlehre* (Munich: Fink, 2006); *Visions of Nature: The Art and Science of Ernst Haeckel* (Munich: Prestel, 2008): *Neue Wissensordnungen* (Frankfurt: Suhrkamp); editor of *Theory in Biosciences* and *Yearbook for European Culture of Science*.

Adrian David Cheok is Director of the Mixed Reality Lab, National University of Singapore. He is currently an Associate Professor at the National University of Singapore where he leads a team of over twenty researchers and students. He has been a keynote and invited speaker at numerous international and local conferences and events. He is invited to exhibit for two years in the Ars Electronica Museum of the Future, launching in the Ars Electronica Festival 2003. His works "Human Pacman" and "Magic Land" were selected as one of the worlds top inventions by *Wired* and invited to be exhibited in Wired NextFest 2005. He was invited to show the works "Human Pacman" and "Magic Land" at Wired NextFest 2005. He was IEEE Singapore

Section Chairman 2003, and is currently ACM SIGCHI Chapter President. He was awarded the Hitachi Fellowship 2003, the A-STAR Young Scientist of the Year Award 2003, and the SCS Singapore Young Professional of the Year Award 2004. In 2004 he was invited to be the Singapore representative of the United Nations body IFIP SG 16 on Entertainment Computing and the founding and present Chairman of the Singapore Computer Society Special Interest Group on Entertainment Computing. Also in 2004, he was awarded an Associate of the Arts award by the Minister for Information, Communications and the Arts, Singapore.

Wendy Hui Kyong Chun is Associate Professor of Modern Culture and Media at Brown University. She has studied both Systems Design Engineering and English Literature, which she combines and mutates in her current work on digital media. She is author of *Control and Freedom: Power and Paranoia in the Age of Fiber Optics* (MIT Press, 2006), and coeditor (with Thomas Keenan) of New Media, Old Media: A History and Theory Reader (Routledge, 2005). She is currently finishing a monograph entitled *Programmed Visions: Software, DNA, Race* (MIT Press, 2011).

Sean Cubitt is Professor of Global Media and Communications at Winchester School of Art, University of Southampton, Professorial Fellow in Media andCommunications at the University of Melbourne, and Honorary Professor of the University of Dundee. His publications include *Timeshift: On Video Culture* (Comedia/Routledge, 1991); *Videography: Video Media as Art and Culture* (Macmillan/St. Martins Press, 1993); *Digital Aesthetics* (Theory, Culture and Society/Sage, 1998); *Simulation and Social Theory* (Theory, Culture and Society/Sage, 2001); *The Cinema Effect* (MIT Press, 2004); and *EcoMedia* (Rodopi, 2005). He was the coeditor of *Aliens R Us: Postcolonial Science Fiction* with Ziauddin Sardar (Pluto Press, 2002) and *The Third Text Reader* with Rasheed Araeen and Ziauddin Sardar (Athlone/Continuum, 2002) and *How to Study the Event Film: The Lord of the Rings* (Manchester University Press, 2008). He is an editor of *Cultural Politics* and serves on the editorial boards of a dozen journals including *Screen, Third Text, Visual Communication, Futures,* and the *International Journal of Cultural Studies.* He is the series editor for Leonardo Books at MIT Press. His current research is on public screens and the transformation of public space, and on genealogies of digital light technologies.

Andreas Deutsch is Head of the Department of Innovative Methods of Computing at the Centre for Information Services and High Performance Computing, Technische Universität Dresden. The research efforts of his lively research group are directed toward theoretical biology with an emphasis on modeling key problems of developmental biology and cancer growth. He is author of a monograph on cellular automaton modeling of biological pattern formation (Birkhäuser, 2004).

Jeremy Douglass is a Postdoctoral Researcher in Software Studies at the University of California San Diego, in affiliation with Calit2, the Center for Research in Computing

and the Arts, and Visual Arts. He researches critical approaches to software and code using the analytic frameworks of the humanities and social sciences.

James Elkins is E. C. Chadbourne Professor in the Department of Art History, Theory, and Criticism, School of the Art Institute of Chicago. He writes on art and non-art images; his recent books include *On the Strange Place of Religion in Contemporary Art, Visual Studies: A Skeptical Introduction, What Happened to Art* Criticism? and *Master Narratives and Their Discontents*. He edited two book series for Routledge: *The Art Seminar* (conversations on different subjects in art theory) and *Theories of Modernism and Postmodernism in the Visual Arts* (short monographs on the shape of the twentieth century); currently he is organizing a seven-year series called the Stone Summer Theory Institute (stonesummertheoryinstitute.org).

Oliver Grau is Professor of Image Science and Head of the Department for Image Science at the Danube University Krems. Recent publications include *Virtual Art: From Illusion to Immersion* (MIT Press, 2003); *Mediale Emotionen* (Fischer, 2005); and *MediaArtHistories* (MIT Press, 2007). He has been on international invited lecture tours, and has been presented numerous awards. His work has been translated into twelve languages. His main research is in the history of media art, immersion (virtual reality), and emotions, as well as the history, ideas, and culture of telepresence and artificial life. His awards include, among others: Elected into the Young Academy of the Berlin-Brandenburgische Scientific Academy and the Leopoldina; Media Award of the Humboldt University; InterNations/Goethe Institute; Book of the Month, Scientific American.

Stefan Heidenreich is working as writer and journalist (*taz, F.A.Z., de:bug*), art critic (*F.A.Z., Monopol*), Web consultant (Metaversum, Designmai, Iconicturn), photographer (s.cr&sh.de), and Assistant Professor (Humboldt-Universität Berlin). He studied philosophy, science of communication, German philology, and temporarily economy and physics at Bochum and Berlin. He published "Flipflop: Digitale Datenströme und die Kultur des 21. Jahrhunderts" (2004) and "Was verspricht die Kunst?" (1998).

Eduardo Kac is internationally recognized for his telepresence and bio art. A pioneer of telecommunications art in the pre-Web 1880s, Eduardo Kac (pronounced "Katz") emerged in the early 1990s with his radical works combining telerobotics and living organisms. His visionary integration of robotics, biology, and networking explores the fluidity of subject positions in the postdigital world. His work deals with issuesthat range from the mythopoetics of online experience (*Uirapuru*) to the cultural impact of biotechnology (*Genesis*); from the changing condition of memory in the digital age (*Time Capsule*) to distributed collective agency (*Teleporting an Unknown State*); from the problematic notion of the "exotic" (*Rara Avis*) to the creation of life and evolution (*GFP Bunny*). At the dawn of the twenty-first century Kac opened a new direction for

contemporary art with his "transgenic art"—first with a groundbreaking piece entitled *Genesis* (1999), which included an "artist's gene" he invented, and then with *GFP Bunny*, his fluorescent rabbit named Alba (2000).

Martin Kemp has written, broadcast, and curated exhibitions on imagery in art and science from the Renaissance to the present day. His books include *The Science of Art: Optical Themes in Western Art from Brunelleschi to Seurat* (Yale University Press) and *The Human Animal in Western Art and Science* (Chicago University Press, 2007). He has published extensively on Leonardo da Vinci, including the prize-winning *Leonardo da Vinci: The Marvelous Works of Nature and Man* (1989, 2006). Increasingly, he has focused on issues of visualization, modeling, and representation. He writes a regular column *Nature* (published as *Visualizations*, Oxford University Press, 2000, and developed as *Seen and Unseen*, Oxford University Press, 2006, in which his concept of "structural intuitions" is explored).

Harald Kraemer is a producer, designer and director of online and off-line hypermedia applications. His work includes *Vienna Walk Demo* (1998) with Science Wonder Productions; *Documentation and Methodology of Contemporary Art* (1999–2001) for the German Research Foundation (DFG) at the University of Cologne; and *Artcampus* (2005–2007) for the University of Berne. With his own company Transfusionen he has realized: *Art and Industry* (2000), *Virtual Transfer Musée Suisse* (2002–2003), *Museum Schloss Kyburg* (2004), and *Elisabeth of Thuringia* (2006). He has written and published widely on the subject of hypermedia, museum informatics, and digital collections, as well as contemporary art. After teaching art history and new media at the universities in Berne, Cologne, Constance, Luneburg and Zurich, he is recently Docent at the Department for Design at Zurich Academy of Arts and at the Department for Image Sciences at Danube University Krems. Currently he is working on documentation about *Knowledge Hypermedia Design & Museum*.

Lev Manovich is a Professor in Visual Arts Department, University of California–San Diego, Director of the Software Studies Initiative at California Institute for Telecommunications and Information Technology (Calit2), and Visiting Research Professor at Goldsmith College (University of London), De Montfort University (UK) and College of Fine Arts, University of New South Wales (Sydney). His books include *Software Takes Command* (released under CC license, 2008), *Soft Cinema: Navigating the Database* (MIT Press, 2005), and *The Language of New Media* (MIT Press, 2001), which is hailed as "the most suggestive and broad ranging media history since Marshall McLuhan." He has written 100 articles that have been reprinted over 300 times in 30+ countries. Manovich is much in demand to lecture around the world, having delivered over 400 lectures, seminars, and workshops during the last ten years.

Tim Otto Roth has held lectureships in Madrid, Valencia, and Kassel. He is currently working on a doctoral thesis at the Academy of Media Arts Cologne. His research

focuses a phenomenology of shadow pictures and a redefinition of the postphotographic image. Roth is known for his large art and science projects in public space, including work with scientists of top research institutions especially in biology, astrophysics, and particle physics (www.imachination.net and www.pixelsex.org). He has received numerous awards including the International Media Art Award/Centre for Art and Media ZKM Karlsruhe.

Martin Schulz is Professor at Hochschule für Gestaltung in the Center for Art and Media in Karlsruhe Staatliche Hochschule für Gestaltung, Karlsruhe, and coordinator for the Ph.D. program "Image, Body, and Medium: An Anthropological Approach." He has published numerous texts concerning contemporary art and picture theory, including (with Hans Belting), *Quel Corps? Eine Frage der Repräsentation* (Munich, 2002), *Ordnungen der Bilder* (Munich, 2005); with Birgit Mersmann), *Kulturen des Bildes* (Munich, 2006); "Die Sichtbarkeit des Todes im Medium der Fotografie," in *Die neue Sichtbarkeit des Todes*, ed. Thomas Macho and Kristin Marek (Munich, 2007), 289–313; and "The Immersive Image of Landscape: Space Voyages and Time Travel," in *That's What a Chameleon Looks Like: Contesting Immersive Cultures*, ed. Kiwi Menrath and Alexander Schwinghammer (Cologne, 2009).

Christa Sommerer and Laurent Mignonneau are internationally renowned media artists and researchers. They have jointly created around 20 interactive artworks, which can be found at <http://www.interface.ufg.ac.at/christa-laurent>. These artworks have been shown in around 200 exhibitions worldwide and installed in media museums and media collections around the world, including the Van Gogh Museum in Amsterdam, the Museum of Science and Industries in Tokyo, the Media Museum of the ZKM in Karlsruhe, the Cartier Foundation in Paris, the Ars Electronica Center in Linz, the NTT-ICC Museum in Tokyo, the NTT Plan-Net in Nagoya, Japan, the Shiroishi Multimedia Art Center in Shiroishi, Japan, the HOUSE-OF-SHISEIDO in Tokyo and the ITAU CULTURAL Foundation in Sao Paulo. They have won mayor international media awards, among others the "Golden Nica" Prix Ars Electronica Award for Interactive Art 1994 (Linz, Austria). Mignonneau and Sommerer have published on artificial life, complexity, interactivity and interface design, and they have lectured extensively at universities, international conferences, and symposia. They are currently heading the department for Interface Cultures at the University of Art and Design in Linz ,Austria, which specializes in interactive art, interactive media, and interface design. They have published two books: *The Art and Science of Interface and Interaction Design*, ed. C. Sommerer, L. C. Jain, and L. Mignonneau (Springer Verlag, 2008); and *Interface Cultures—Artistic Aspects of Interaction*, ed. C. Sommerer, L. Mignonneau, D. King (Transcript Verlag, 2008).

David Steinman has spent more than a decade working to integrate the fields of computer modeling and medical imaging. He is a Professor of Mechanical and

Biomedical Engineering at the University of Toronto, where he heads the Biomedical Simulation Laboratory. Dr. Steinman holds a Career Investigator award from the Heart & Stroke Foundation.

Dolores Steinman trained as a pediatrician, before finishing doctoral and postdoctoral research in cancer cell biology. An accomplished photographer, she is interested in the relationship and connection between the humanities and science. Dr. Steinman is currently a Guest Researcher at the University of Toronto.

Thomas Veigl studied and worked at the Institute for Cultural- and Social Anthropology at the University of Vienna. With a main focus on the origination of media technologies and their dependency and influence on social evolution, he wrote his thesis about a cross cultural comparison on the evolution of letterpress printing with movable metal type in East Asia and Europe. Since 2008 he is part of the scientific stuff of the Department for Image Science at the Danube-University Krems, where he was responsible for the organization of the second international conference on image science "Gazing into the 21st Century." Currently he is preparing for his doctoral thesis.

Martin Warnke initiated the Department of Computers and Culture, where he developed a curriculum that combines cultural, artistic, and computer science issues theoretically and practically. Since 1983 he has taught contiously in Lüneburg, Basel, and Klagenfurt. His interdisciplinary methodology is illustrated best by the protection and archiving of the artistic estate of the late Anna Oppermann. This methodology consists of hypermedia, interactive systems, image processing, and media technology. He has completed a number of research projects; HyperImage, funded by the german BMBF (Ministery for Education and Resaerch), is being completed right now. During one of his projects the XML standard PeTAL (Picture Text Annotation Language) was developed, which is now entering the scientific community. A project recently funded by the DFG (German Research Association) carries on this research. Together with collegues from Lüneburg, Berlin and Basel he has established annual "HyperKult" Workshops and the discourse that evolved with it. Since April 2009 he has been the Chairperson of the Kunstverein Springhornhof (an art club in Neuenkirchen).

Peter Weibel was appointed Professor for Visual Media Art at the Hochschule für Angewandte Kunst in Vienna in 1984, and from 1984 to 1989 was Associate Professor for Video and Digital Arts, Center for Media Study at the State University at Buffalo, New York. In 1989 he founded the Institute of New Media at the Städelschule in Frankfurt on the Main. Between 1986 and 1995 he was in charge of the Ars Electronica in Linz as artistic consultant and later artistic director. From 1993 to 1998 he was curator at the New Galerie Graz. Since 1999 he has been Chairman and CEO of the ZKM/Center for Art and Media in Karlsruhe.

Index